Café Society

The publisher and author extend their sincere gratitude
to Baronne Daisy de Cabrol for the warmth of her welcome
and for her generosity in allowing them to reproduce
the wonderful illustrations from her husband's scrapbooks.

Executive editor
Suzanne Tise-Isoré

Editorial assistant
Joy Sulitzer

Editorial coordination
Nathalie Chapuis

Graphic design
Alain Bourdon

Translated from the French by
Barbara Mellor

Copyediting
Helen Woodhall

Proofreading
Helen Downey

Production
Élodie Conjat-Cuvelier

Color separation
Les Artisans du Regard, Paris

Printed by
Gruppo Editoriale Zanardi, Maniago, Italy

Distributed in North America by Rizzoli International Publications, Inc.

Simultaneously published in French as *Café Society, mondains, mécènes et artistes, 1920–1960*
© Flammarion SA, Paris, 2010

English-language edition
© Flammarion SA, Paris, 2010

Flammarion SA
87, quai Panhard et Levassor
75647 Paris Cedex 13
France
editions.flammarion.com

Dépôt légal: 10/2010
12 13 14 5 4 3
ISBN: 978-2-08-030157-4

Café Society

Socialites, Patrons, and Artists
1920 to 1960

Thierry Coudert

Flammarion

Contents

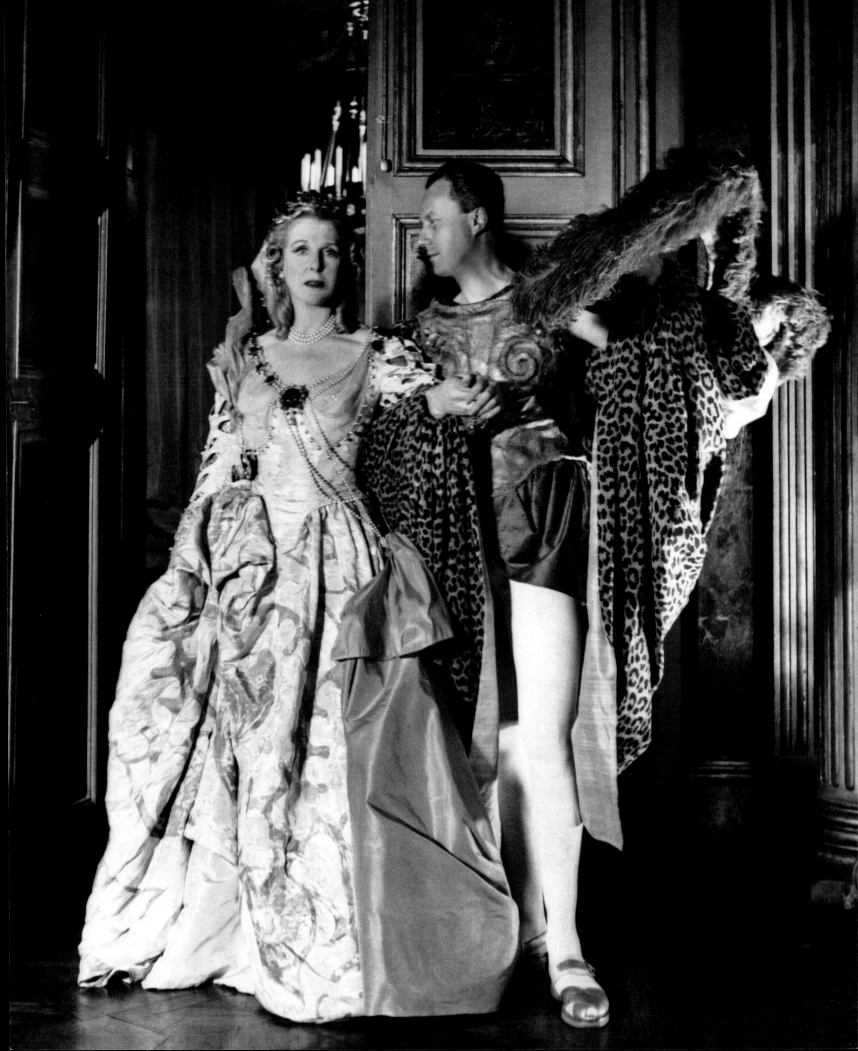

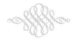

The Heyday of International High Society

Venice, one September evening in 1951: guests arrive for a ball, a costume ball of sumptuous magnificence. At the Palazzo Labia, where once the *procuratore* received emissaries who had traveled from every continent to pay him tribute, now Charles de Beistegui could be seen greeting his friends from all corners of the globe. From both the Old World and the New, for Beistegui—like so many others—could no longer be quite certain to which of the two he belonged. This occasion was another in a long list of grand balls in the eighteenth-century tradition, revived in the nineteenth century and re-created in the twentieth by Étienne de Beaumont, Marie-Laure de Noailles, and others. But this one was different. This was the grandest ball of the century, and not even the Marquis de Cuevas nor Marie-Hélène de Rothschild would succeed in outdoing it in sheer extravagance and splendor.

On September 3, 1951, for a single extraordinary night, Venice became once more the capital of the world. Everyone who was anyone in Paris, London, and New York society planned to meet at the Palazzo Labia. The guest list was studded with aristocrats such as the Prince de Faucigny-Lucinge, Duke Fulco di Verdura, Count Sforza, Baron de Cabrol, and Lady Diana Cooper; millionaires including Barbara Hutton, the Lopez-Willshaws, and Paul-Louis Weiller; artists and writers including Paul Morand, Orson Welles, Leonor Fini, Salvador Dalí, and Violet Trefusis; and a galaxy of all those who had no discernible occupation but whose presence was deemed essential for the success of any party. During the day there had even been a sprinkling of political grandees, including Leslie Hore-Belisha and Winston Churchill, who had many friends among the guests but who dared not brave the crush of paparazzi outside the palazzo gates at night. Beyond the palace gates Venice was *en fête*, as the Venetians tucked into the buffet suppers laid on for their benefit.

Should this be viewed as the first great peacetime celebration in a Europe that was gaining in confidence again after the war? Or was it rather the final mad fling of an eccentric millionaire in a darkening world, overshadowed by the problems of reconstruction and the tensions of the Cold War? "What a tonic to see such magnificent pleasures in the midst of a destitute Europe propped up only by the Marshall Plan," observed Paul Morand,[1] oblivious as ever to what would now be called political correctness. "And to enjoy splendid entertainments for which we are indebted neither to a couturier, nor to an aunt, a pimp, a spy, or the Coca-Cola Corporation."

1. Letter of September 6, 1951 to Josée de Chambrun, in Yves Boucher, *Pierre Laval vu par sa fille*, Paris: Le Cherche-Midi, 2002, p. 456.

That night at the Palazzo Labia, a consummately cosmopolitan tableau of pleasure and taste was on display, the last great manifestation of an influence that was as pervasive as it was intangible, far removed from the power figures of the political or economic establishments. What was on show was the power of money—of aristocratic fortunes, whose whole *raison d'être* was to be squandered with abandon, as opposed to the wealth of the bourgeoisie, hard-earned and husbanded with prudence. In Venice that night, fabulously rich people of every religious persuasion and political belief came together to celebrate a world that—if they only knew—was already in its death throes. And at the center of it all stood the man without whom this ball would not have been possible, a scion of the New World who was king for an evening, and perhaps in a way for ever, over the city that embodied most potently the twilight of Old Europe.

It was the "ball of the century," to be looked back on as the apotheosis of an era that was to have a profound influence on the history of taste

The guests who made their entrance into the Palazzo Labia ballroom, painted in the eighteenth century by Tiepolo, wore costumes designed by Schiaparelli and Cardin; the ball was photographed by Cecil Beaton, Henry Clarke, and André Ostier; and the decorations were of course the creation of Beistegui himself, with his faithful collaborator Emilio Terry. Boris Kochno and Serge Lifar choreographed the entrées, ambitious tableaux vivants that would be immortalized by Serebriakoff. It was the "ball of the century," to be looked back on as the apotheosis of an era that was to have a profound influence on the history of taste, beginning with the Ballets Russes and ending in the New York of Andy Warhol.

With only a few rare exceptions, the Beistegui Ball was a magnet for everyone who mattered in this vivid interlude in the history of taste and fashion that we know as café society. The eclectic make-up of the guests, though they shared the coveted mantle of the ultra-chic, may be taken as a reasonable indicator of the nature of café society. As a phenomenon it remains hard to define; uncertainty surrounds even the origin of the name, though some attribute it to the American gossip columnist, professional hostess, and party organizer Elsa Maxwell.

With its faintly pejorative undertones, it is a name that evokes a cosmopolitan world that was superficial, snobbish, and louche, and sometimes toxic, corrupt, and depraved, before it degenerated into what Loelia Westminster dubbed "Nescafé society," the penultimate stage in the devaluation of taste that has culminated in the vulgarity of the international jet set. In France the figure who best represented (in both senses of the word) this phenomenon was unquestionably Philippe Jullian, who was to café society what the greatly more talented Marcel Proust was to the upper crust: a portraitist who was at once an enthralled devotee and a pitiless observer. Jullian's work is devoted essentially to the depiction of the manners and foibles of café society, but his outstanding contribution, through the title of his eponymous novel, was the introduction of the name into popular parlance. The entry under "Café Society" in his *Snob Spotter's Guide* does not beat around the bush:

> "Leaning against the plinth of a Coysevox marble bust, the Oratorian priest was warming his hands on a glass containing a horrid mixture of vodka and tomato juice called a Bloody Mary. He said: 'Café society is *Tout-Paris* on a world-wide scale.'
> In spite of its elegant precision this formula was too elliptic to satisfy him.
> 'I feel,' he went on, 'that in a town like New York, built in iron on granite, none but a geological comparison would be suitable. Lands overturned by ancient upheavals yield

Facing page
The Beistegui Ball at
the Palazzo Labia,
September 15, 1951.

a variety of stones which, once cut and polished at great expense, show the numerous elements of which they are composed: strata of oxidized minerals, kernels of crystal embedded in iron-ore, and sometimes delicate traces of fossil vegetation caught in their grain. Some especially resilient elements of our society surge, mix and amalgamate to create the brilliantly international set which dazzles us, without having any real value. Only an expert could detect the precious veins lost among the too rapidly gilt sections of society or those elements which have been oxydised or rusted by objectionable habits. Vienna and Alexandria, Stockholm and Sao Paulo rub shoulders; a Gunzburg can be mistaken for a Habsburg and a Prince of the Holy Roman Empire turns out to be a fashion designer."

Victorin protested: he found their hostess extremely distinguished, the Czar's niece absolutely marvellous, and thought that the Baron de Gunzburg looked very much like King Alfonso.[2]

Just as Proust published his great work at the point when the world he described was brilliant with the fading glow of a dying star, so Jullian was describing a reality that was already starting to disintegrate. The other great chronicler and illustrator of the phenomenon, through his photographs, drawings, and diaries, was Cecil Beaton. The concept of café society was widely popular throughout the English-speaking world, moreover. The criteria of membership were elusive. Who was in? Who was out? Frequently the latter category was easier to identify. As so often in any field governed however loosely by the rules of snobbery, the best definitions emerged by default, and the most effective method of selection was exclusion. Before sending out highly coveted invitations to his costume balls, Étienne de Beaumont would draw up a list of those whom he wanted to humiliate by leaving them out. A painful anecdote relates that a celebrated musician who was a member of Marie-Laure de Noailles's circle had the audacity to arrive uninvited at one of her soirées, whereupon his hostess snubbed him with a few acid words: "I'm so sorry my dear, but tonight is just for friends." At the same time, however, the ambience of these café society soirées, with their eternally unchanging guest lists, could take on a nostalgic air. For all its strenuous attempts to banish boredom at all costs, this was a world beset by tedium; for the favored few, their only consolation lay in contemplating the unspeakable lot of those unfortunates who had not been invited and were condemned to languish at home.

The most accurate barometer of belonging undoubtedly lay in the eyes of others. Acceptance or exclusion were the criteria that soon came to define a circle of international snobbery, whose members killed the time that hung heavy on their hands by engaging in a frenetic quest for the ultimate in beauty and good taste. To diehards such as Charles de Beistegui, Alexis de Redé, Emilio Terry, Paul-Louis Weiller, Daisy Fellowes, Mona Bismarck, and of course the Duke and Duchess of Windsor were added numerous artists such as Bérard, Beaton, Horst, and Tchelitchew and fashion editors including Carmel Snow, Edna Chase, and Diana Vreeland. Forming an aristocratic backdrop, meanwhile, were the Comte and Comtesse de Noailles, Princess Paley, Prince Jean-Louis de Faucigny-Lucinge, the Duke Fulco di Verdura, and Nicky de Gunzburg, and it was the luster of their pedigrees that ultimately gave the rest their *raison d'être*. But what was it that really bound this disparate *dramatis personae* together? That is the question that this book—which is concerned more with re-creating the atmosphere of an era than setting in stone the canons of a coterie defined by its weightlessness—sets out to discover.

2. Philippe Jullian, *The Snob Spotter's Guide*, London: Weidenfeld and Nicolson, 1958, pp. 34–6.

Facing page
Patricia Lopez-Willshaw as the Empress of China at the Beistegui Ball.
Photograph by Cecil Beaton.

Following pages
Madame Jacques Fath (in foreground) as the Sun King at the Beistegui Ball, September 15, 1951.

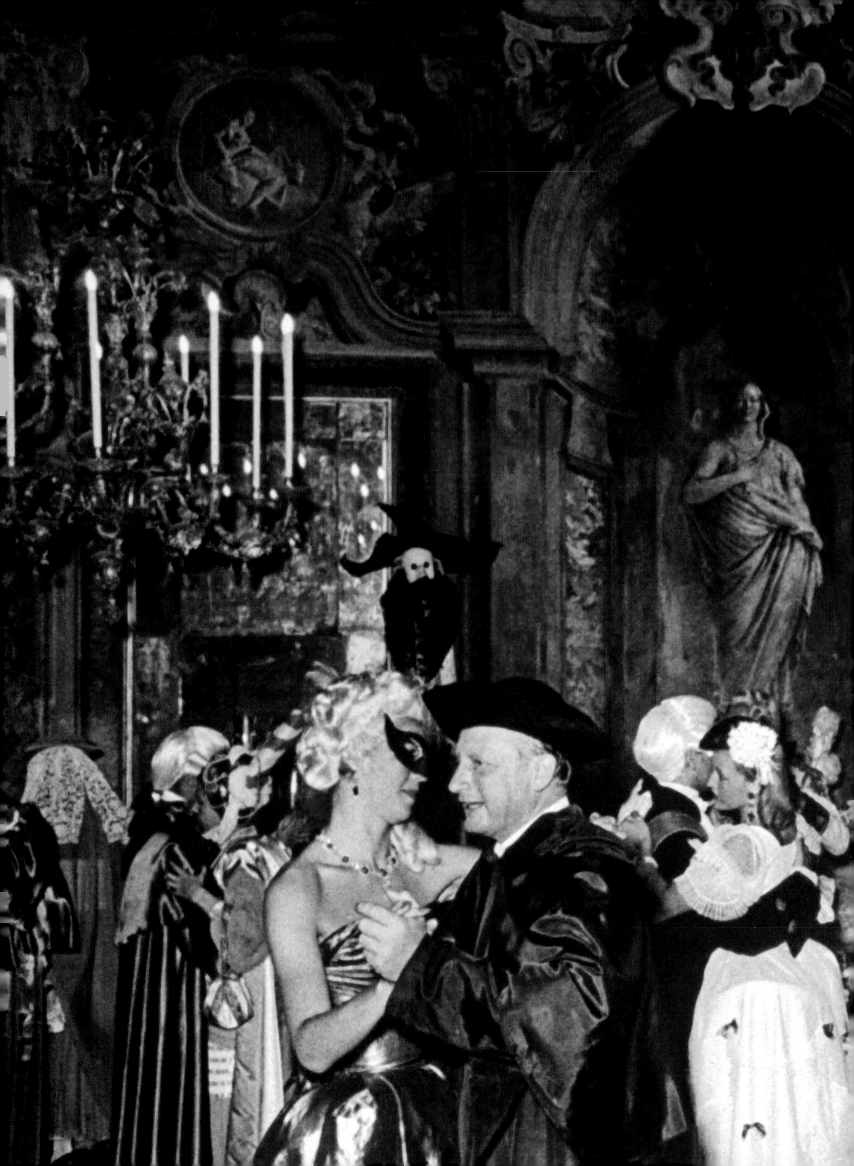

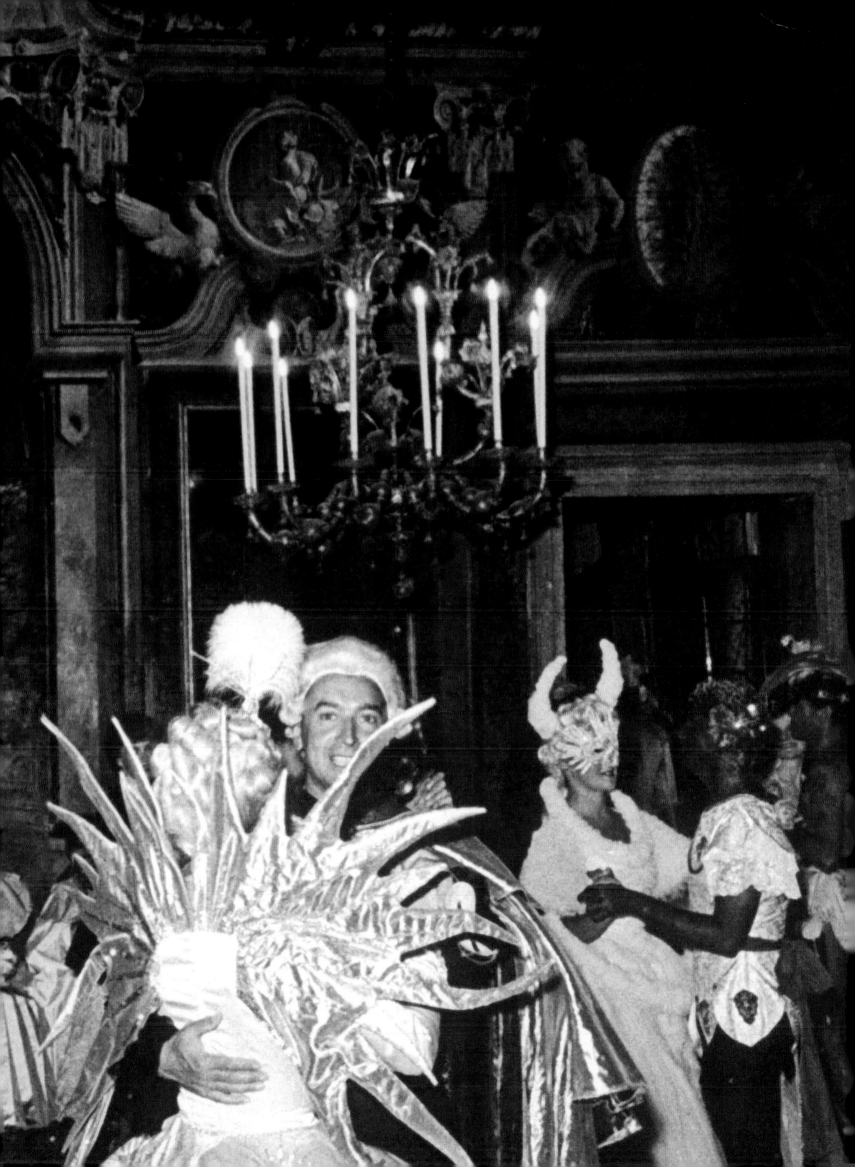

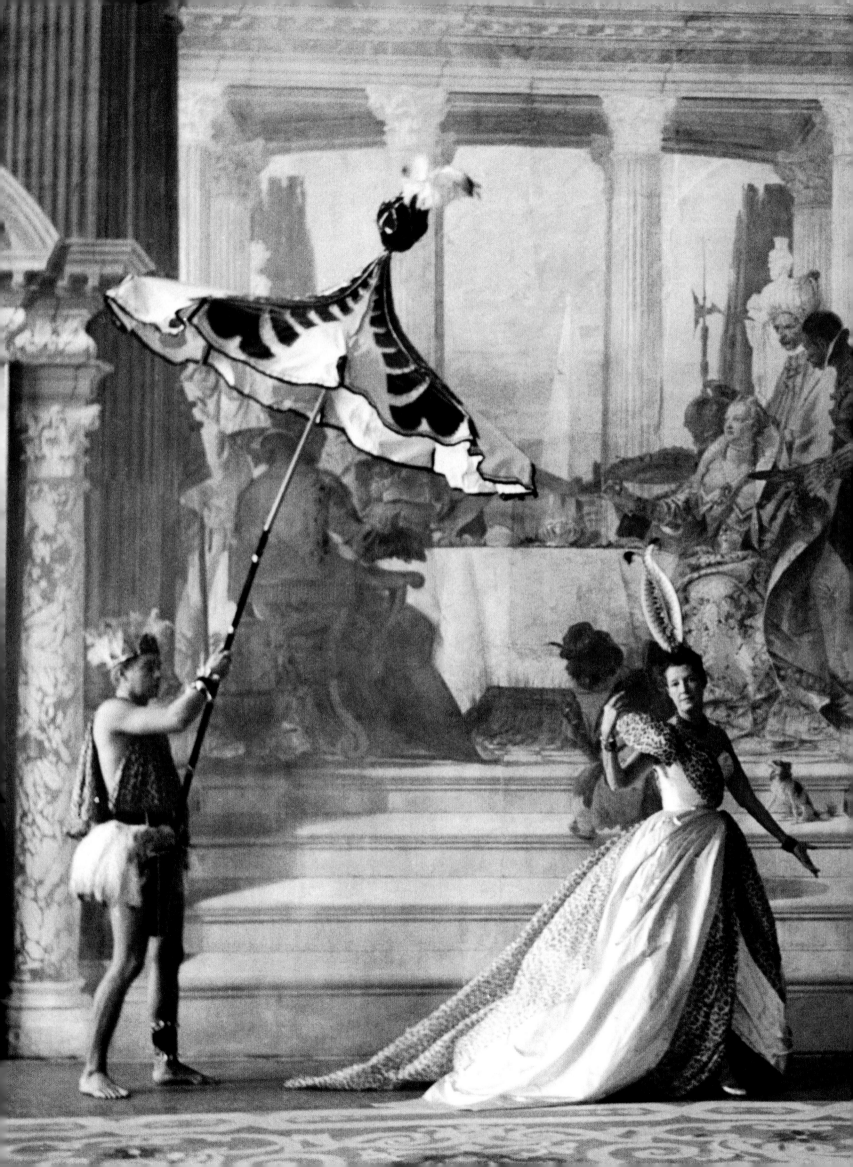

Between Two Worlds

From Old Europe to the New World

Above all else, the age of café society was a period of transition, defined by a tipping of the balance of power from the Old World of Europe to the New World of the Americas. In the wake of the Great War, political, economic, and military dominance swung clearly from one side of the Atlantic to the other. But the cultural fascination of Europe was to survive this change by another few decades. North American "culture vultures" would spend at least part of the year living in Europe, sometimes picking up husbands for their daughters there, as the Singers did in the form of the Prince de Polignac and the Duke Decazes, the Vanderbilts in the Duke of Marlborough, and the Goulds in the Comte de Castellane, followed by the Duc de Talleyrand. They collected and surrounded themselves with artists, both European and—in a curious paradox—American. Paris was still the capital of all that was creative, the birthplace of fashions, trends, and styles. It was a phenomenon exemplified—in their very different artistic and aesthetic domains—by Elsie de Wolf, Gertrude Stein, Princess Chavchavadze, Mona Bismarck, Diana Vreeland, and Peggy Guggenheim, influential women who were patrons and collectors of art, who launched fashions and were in the vanguard of taste. Among their number special mention must go to the woman who, after momentarily threatening the stability of the British throne, reigned as queen of café society: Wallis Simpson, Duchess of Windsor, at whose side the erstwhile King Edward VIII would never again be more than prince consort.

But the truly innovative aspect of café society lay in the appearance of South Americans among the ranks of its tastemakers. Many of them did admittedly have European roots, whether Spanish or Basque. The Anchorenas, Terrys, Patinos, and Yturbes formed multiple alliances with the noble families of de Castries, Faucigny-Lucinge, Castellane, Luynes, and Beauvau-Craon. Dominating the period were three South Americans, chief among them Charles de Beistegui. Scion of a family of collectors and benefactors of the Louvre, Beistegui defined his own style, which was to prove a formative influence on twentieth-century decoration. Arturo Lopez-Willshaw, meanwhile, re-created the world of Versailles both at Neuilly, for his wife Patricia, one of the world's most elegant women, and at the Hôtel Lambert for his friend Alexis de Redé. The Marquis de Cuevas, the third of this triumvirate of the arts, devoted part of his Rockefeller wife's fortune to his ballet companies, while also attempting to rival Beistegui in throwing prestigious costume balls. On the fringes of these new elites was also a sprinkling of princely Balkan families, sporting titles that made up for in prestige what they lacked in precision; Indian princes, such as the Maharajas of Baroda and Kapurthala, famous for their lavish spending on opulent jewelry; and Greek shipping magnates such as the Onassis, Niarchos, and Livanos dynasties, locked in rivalry over the splendor and extravagance with which they lavished their immense fortunes, principally through their luxury yachts.

From Proust's Gratin to the Jet Set

Café society illustrates the transition between two different types of society. For centuries, good taste had been defined by the aristocracy and an enlightened section of the upper middle class. Now a composite society was to usher in new fashions, some of which were not without their paradoxical aspect. While an eccentric aristocratic fringe, including the Beaumonts, Noailles, and Faucigny-Lucinges, was devoted with a passion to the avant-garde in art, the *nouveaux riches* tended to turn to the past, which they re-created sometimes with conscientious application, often with imagination, and invariably with colossal means. Thus Charles de Beistegui, Arturo Lopez, Alexis de Redé, and Paul-Louis Weiller—attended by a new subspecies of hangers-on, gigolos, and womanizers of the likes of Porfirio Rubirosa, Antonio Gandarillas, John Galliher, Tony Pawson, Erskine Saint-Clair, and Raymundo de Larrain—eventually formed a society that could devote money on a breathtaking scale to the sole purpose of satisfying its taste for unbridled luxury. A woman with the sophistication and intelligence of Louise de Vilmorin, but without the financial means necessary to live a life of luxury, would thus be forever on the lookout for opportunities to earn a few francs. The widowed Denise Bourdet, finding that the protection of her friend Charles de Noailles was no longer sufficient for her needs, was also obliged to turn increasingly to occasional writings and profitable social connections.

Some notable figures devoted themselves to the selling of good taste. Thus Elsie de Wolfe (Lady Mendl), Syrie Maugham, and Sybil Colefax defined the canons of a decorative aesthetic that amounted to a dictatorship of style. Under the iron rod of their influence, fashionable interiors in any given season, whether in London, Paris, or New York, grew uncannily similar to each other. Elsie de Wolfe's *The House in Good Taste*[1] went through numerous editions and became a bible of good taste for an entire generation. Elsa Maxwell, meanwhile, like the princess in Edouard Bourdet's play *La Fleur des pois*, spent her time organizing parties, balls, and dinners that offered her *nouveau-riche* clientele an introduction into a world whose strict code of manners they at first struggled to master. Finally, the transition from upper crust to jet set also evolved against a backdrop in which homosexuality played a major part, most overtly in the worlds of art—with key personalities such as Diaghilev, Bérard, Kochno, Cocteau, and Poulenc—and in fashion, but also in high society.

Married though they were, Étienne de Beaumont, Comte Pecci-Blunt, and Arturo Lopez made little attempt to disguise where their interests lay; indeed the Chilean millionaire was one of the first to openly flaunt a homosexual relationship—with Alexis de Redé—in "respectable" circles. Women such as Marie-Laure de Noailles and Barbara Hutton could never resist a gay male conquest, while Gertrude Stein and Alice B. Toklas, Nathalie Barney, Romaine Brooks, the Duchesse de Clermont-Tonnerre, and Violet Trefusis all carried on openly lesbian relationships, continuing after a fashion the louche confusion that movements such as the Bloomsbury Group had sown among the English upper classes. Together all these personalities formed a cosmopolitan set that mixed among themselves, a great deal. Therein lay one of the major differences between café society and traditional high society. Another lay in the fact that all you needed to be accepted into the latter was to be of good birth; the former, by contrast, fostered peerless skills in the many-faceted art of exclusion.

Page 14
James Caffery and Daisy
Fellowes at the Beistegui Ball.
Photograph by Cecil Beaton.

Facing page
Charles de Beistegui at the
Palazzo Labia.

1. Elsie de Wolfe, *The House in Good Taste*, New York: The Century Company, 1913.

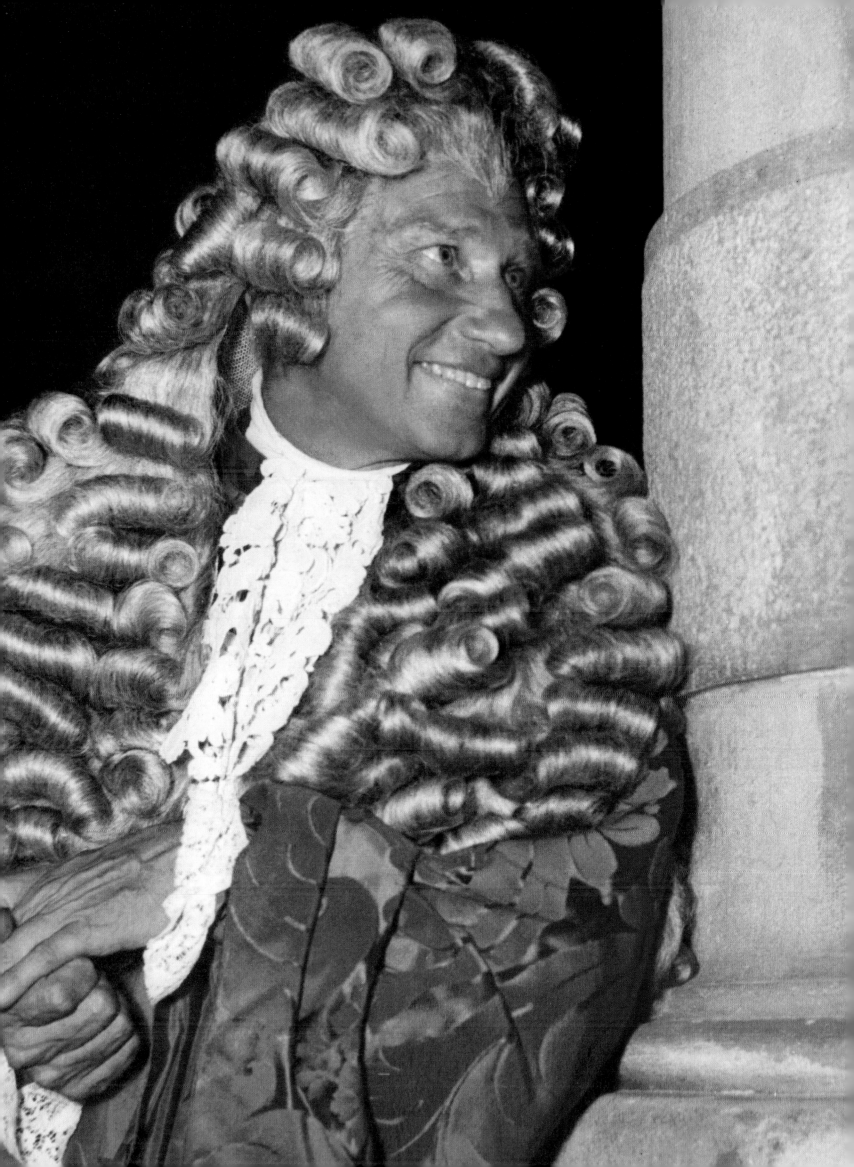

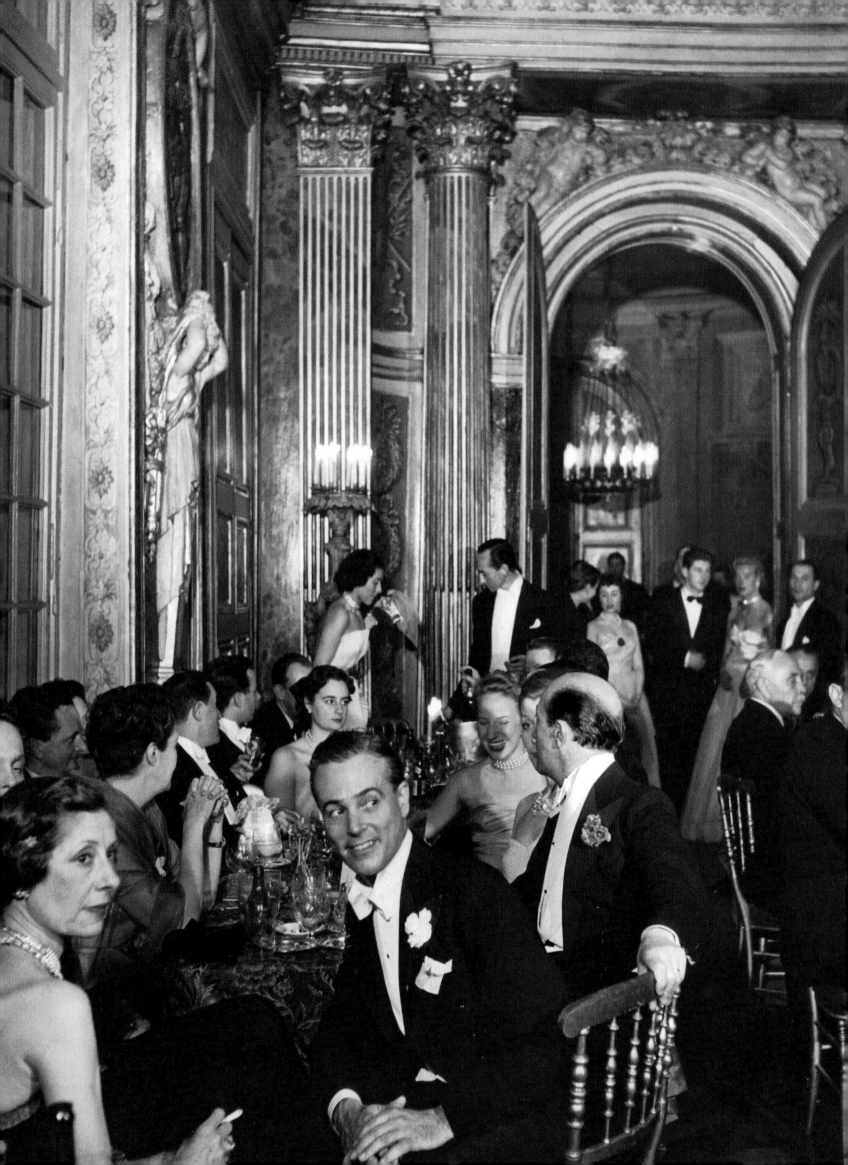

Balls and Parties

Balls and parties were for many the incarnation of café society, to the point where they frequently became indistinguishable in the popular imagination. Jean-Louis de Faucigny-Lucinge summarized their spirit: "What has been called the 'gratin in revolt' was in fact only the objective alliance of a traditional class with new forms. And perhaps the idea of working closely with artists, creating together celebrations with lyrical themes, was a way of paying homage to their work, and of participating in the phenomenon that is the creative process. But I would never deny the importance of the narcissistic pleasure of the actors in these spectacles. The aristocracy has always enjoyed being on stage, from Louis XIV's ballet-carousels and the famous society theatre of the eighteenth century to the little plays staged by the Castellanes under Louis-Philippe. [...]"

> "Imagine an entrée at one of these balls. The décor is painted by Picasso or Derain. Francis Poulenc or Georges Auric has been commissioned to compose a little music. Jean Cocteau has promised a few words of introduction"

"Imagine an entrée at one of these balls. The décor is painted by Picasso or Derain. Francis Poulenc or Georges Auric has been commissioned to compose a little music. Jean Cocteau has promised a few words of introduction, and the costumes—very important!—have been designed by the Hugos and Bébé Bérard. Chanel has consented to have them made in her ateliers, naturally, and—loving to dress up herself—may even have offered them as a generous gift. And there you have it: an exceptional event has been dreamed up in order to bring together a galaxy of talents."[2]

These balls were one of the major threads running through café society, and some of them were to assume a mythical status that outshone even the Beistegui Ball. Étienne de Beaumont was the undisputed master in the field. His most fêted parties—his Sea Ball of 1928, Colonial of 1931, Famous Paintings of 1935, Tricentenary of Racine of 1939, and Kings and Queens of 1949—remain unsurpassed in the annals of such extravaganzas. Thus the figure whom Bourdet lampooned wickedly as Toto d'Anche in *La Fleur des pois* found opportunities to hog the spotlight himself while indulging in a social game of calculated cruelty.

In a different vein, Marie-Laure de Noailles was one of the great hostesses of the age, a self-elected role that offered opportunities to express her imagination, curiosity, and humor. She made an unforgettable contribution to the history of masked balls, embracing as it did her own gala evenings themed around materials (Bal des Matières) of 1929, moon over water (Bal de la Lune sur la Mer) of 1951, and artists of 1956. Other prominent figures also gave legendary balls, including Jean-Louis and Baba de Faucigny-Lucinge with their Proust Ball in 1928, and Nicky de Gunzburg with his Second Empire Ball of 1934, both held in

Facing page
A dinner at the
Hôtel Lambert, 1950.
Photograph by
Robert Doisneau.

2. Jean-Louis de Faucigny-Lucinge, *Mémorables Bals costumés 1922–1972*, Paris, Herscher.

the Bois de Boulogne. Not to be forgotten either were Fulco di Verdura's ball in Palermo in 1929, Countess Pecci-Blunt's White Ball in 1931, Daisy Fellowes' Oriental Ball in 1935, the Marquis de Cuevas' Goya Ball in Biarritz in 1956, and Alexis de Redé's Bal des Têtes at the Hôtel Lambert in 1957. And the annual Bal de l'Essor, finally, presided over by the irrepressible Daisy de Cabrol, was the great charity event of the society calendar.

Around each of these pivotal figures in café society there circled a group of friends. Where guests at nineteenth-century costume and dress balls would all have been drawn from the same social circles, café society events featured an eclectic social mix. Guests would travel long distances from many far-flung lands to attend these balls, mostly in France, although Italy and especially Venice saw events hosted by Beistegui as well as by the Volpis, Aldobrandinis, and Brandolinis. Wherever they took place, they all offered opportunities for the leading lights of café society to gather in the spotlight of the world's media. *Vogue* and *Harper's Bazaar* could be relied upon to send their most famous photographers, including Beaton (who was frequently also invited as a guest), Hoyningen-Huene, Horst, Ostier, Clarke, and even Doisneau for a few years. The hosts and hostesses believed they were creating a total work of art: café society was its subject, with choreography by Kochno and Lifar, decors by Bérard, Jean-Michel Frank, or even Picasso and Derain, and costumes by Chanel or Schiaparelli. Cardin made his debut at the Beistegui ball, Saint Laurent with the headdresses for the Bal des Têtes.

But these events also shone a spotlight on the underlying social rivalries between those who were invited and those who were snubbed (or even blacklisted, as Denise Bourdet was by Étienne de Beaumont after the opening of her husband's play *La Fleur des pois*); between the guests themselves, who strove to outdo each other in their elegance, originality and the power to shock; and between the hosts themselves. After the Palazzo Labia ball, the Marquis de Cuevas strove ostentatiously but in vain to equal or even surpass Beistegui in prestige, while the young Portuguese Bobsy Carvalho earned fame for a season by throwing a sumptuous ball at the Piscine Deligny, a floating swimming pool on the Seine in Paris.

Facing page
Ribbon Ball, June 10, 1948.
From the scrapbook
of the Baron de Cabrol.

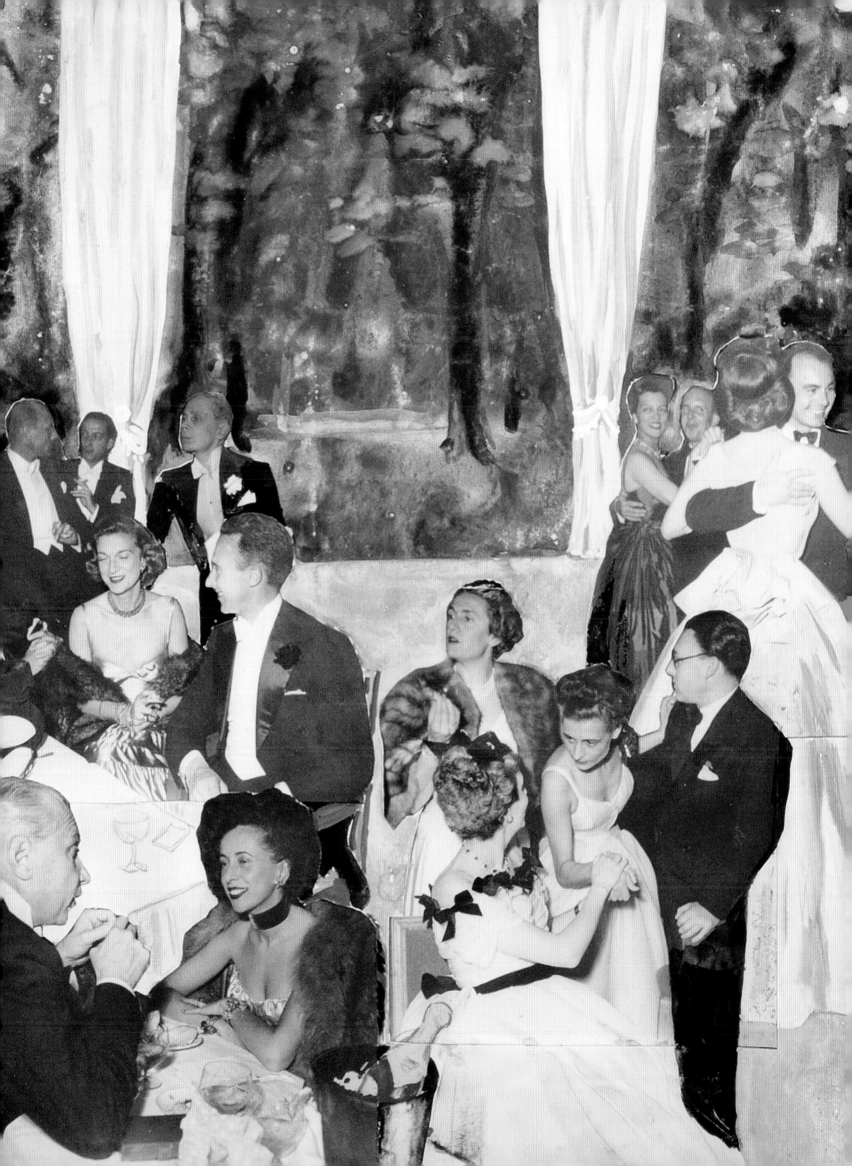

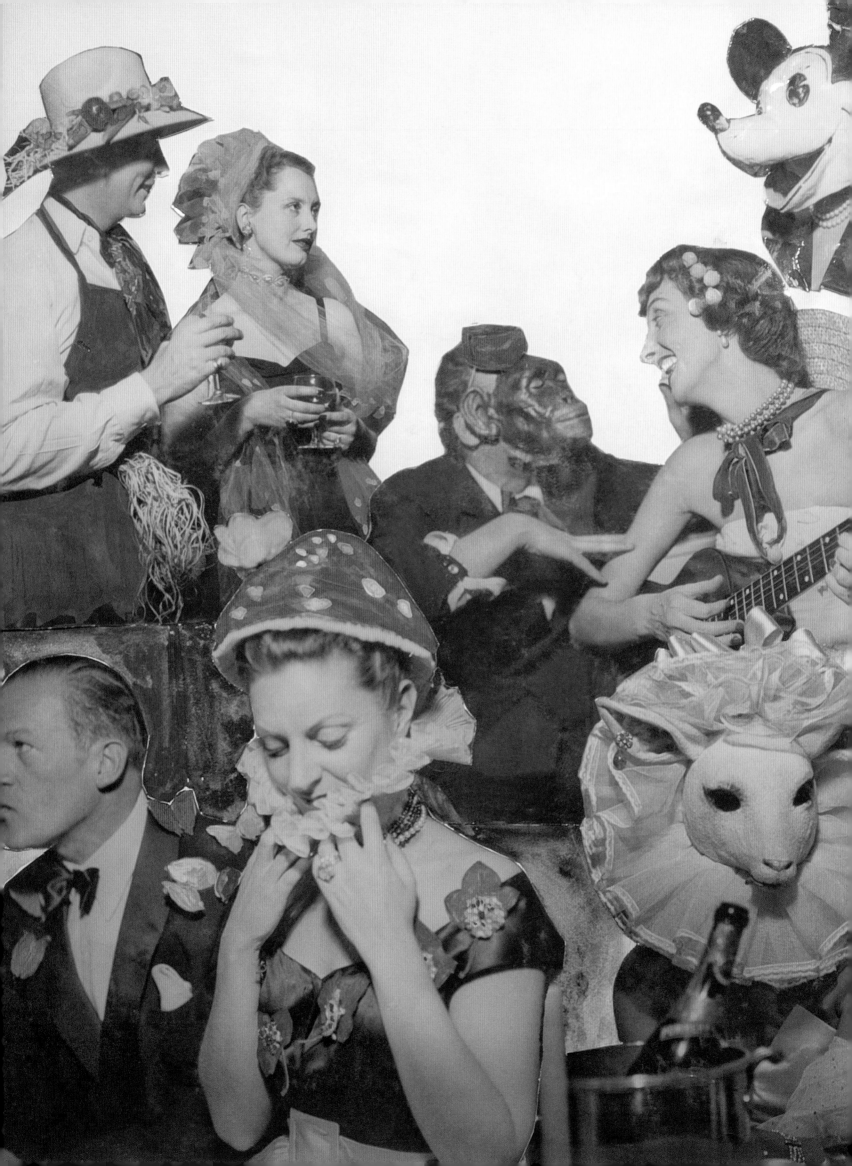

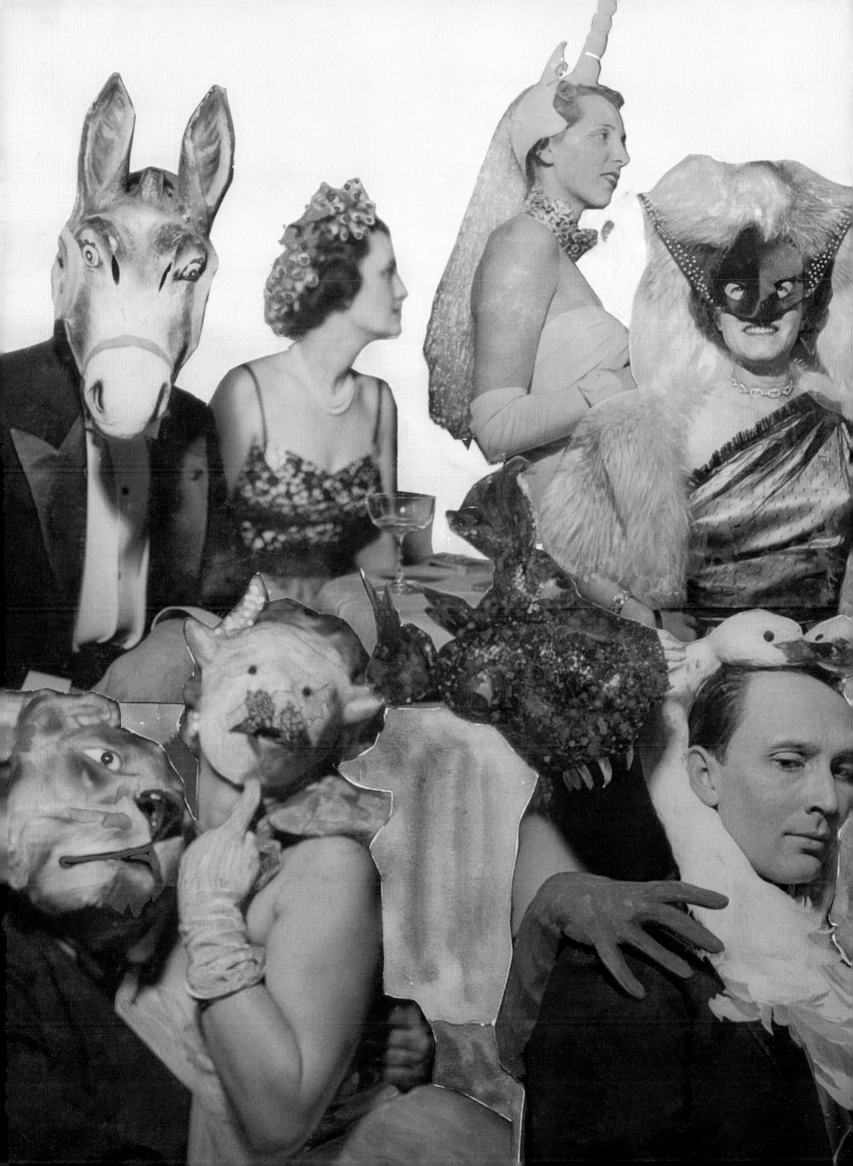

ET LE SECOND FRONT ?

TOUT EST FIN PRÊT

L'attaque d'une ferme prend les proportions d'une bataille rangée

Autres attentats

Un agent de police est tué par des bandits à Chamalières

CASSINO NETTUNO
LES DEUX HANTISES

53 arrestations

L'INVASION du Vieux Continent est-elle pour 1944? Si oui, aura-t-elle lieu au printemps, en été ou au début de l'automne? Quels sont les endroits où les Alliés sont susceptibles de débarquer? Quelles sont, enfin, les chances de succès d'une telle opération?

Mse H. de ROUVRE Dsse d'AYEN DRIAN DAISY

HUBERT MENIER Pse E. de POLIGNAC

diner chez les Cabrol

People

Aristocrats

A few scions of old aristocratic families, from France and elsewhere, hosted and attended café society parties and graced its members with their presence. Nevertheless, they were never true members themselves, and would have disdained becoming so, however enjoyable the company. But without them café society could not have existed: to more recent glories they brought the prestige attached to nobility, the legitimacy of their taste, and the breadth of their influence. Certain members of the aristocracy clearly encouraged the emergence of café society, stimulated its growth, and lent it luster and prestige. They also paved the way for passing on the torch of good taste, for café society was the precise juncture at which the nobility lost its monopoly on matters of taste and distinction, to be usurped by a new and more eclectic fashionable set which continued nonetheless to revere anything that smacked of the aristocratic.

Étienne and Edith de Beaumont, Charles and Marie-Laure de Noailles, Jean-Louis and Baba de Faucigny-Lucinge, and Jean and Marie-Blanche de Polignac were all pillars of café society. In the eyes of café society they were nothing less than demigods. The products of long and distinguished pedigrees, they remained aristocratic to the core, and dutifully donned the mantle of patrons of the arts that an advanced minority of the nobility has always shouldered with such panache. Had they been born two or three decades earlier, they would have been found in the pages of *A la recherche du temps perdu*. The most senior among them, Étienne de Beaumont, had even been close to Proust at the end of his life, and Marie-Laure de Noailles' grandmother, the Comtesse de Chevigné, had been one of the models for the Duchesse de Guermantes.

Their openness of spirit, their hospitality, their readiness to organize soirées at cafés and restaurants (all were regulars at Le Boeuf sur le Toit), their willingness to admit a wide range of people to their circle, united as they were by a particular aesthetic ideal—all this enabled a social class of waning influence to launch itself into a new world. Their aristocratic disdain for puritanical bourgeois conventions also made them more open to new influences. Thus Charles and Marie-Laure de Noailles did not think twice about financing Buñuel's scandalous film *L'Age d'or*, in which many of their friends had acting roles. Following this adventure, Marie-Laure de Noailles continued to raise the art of provocation to new heights, while Charles was suspended from the Jockey Club for a while, and then took refuge increasingly in the world of horticulture.

Developments in England followed similar lines, though in inimitably British ways. Lady Diana Cooper, brought up as the daughter of the Duke of Rutland, the Sitwells, and Violet Trefusis were figures comparable to their Continental counterparts, though with an

added touch of the eccentricity that was so particular to post-Victorian society, as ordained by Oscar Wilde. The way had been opened up by high bohemian sets such as Margot Asquith's Souls, the aristocratic coterie of the Bloomsbury Group, with its muses including Lady Ottoline Morrell and Vita Sackville-West, lover of Violet Trefusis and later Virginia Woolf, and the Bright Young People. For the Russian aristocracy it was flight from the Bolsheviks and exile after the Revolution that catapulted its most free-thinking members into the arms of café society, including notably Princess Natalie Paley, niece of the last tsar, and her half-brother Prince Vladimir, lover and inspiration of Chanel. Prince Yusupov, assassin of Rasputin, was another ornament of café society, while his wife Irina opened a couture house in Paris between the wars. In Sicily it was economic factors that propelled Duke Fulco di Verdura, cousin of Giuseppe di Lampedusa, author of *The Leopard*, into pursuing a career in café society and haute jewelry.

At the same time as marking the demise of high society, with its unchallenged supremacy on matters of taste, café society also relied initially on some of its most outré members, who were happy to play along for the sake of being shocking or simply for amusement, sometimes prompted by the necessity born of hard times. In fact café society can only be understood properly in relation to high society. This aristocratic elite, revealed to ordinary mortals by Proust, was simultaneously both extremely open and very closed, according to certain very precise rules. According to Gabriel-Louis Pringué, himself an accredited member: "It should be acknowledged that the 'gratin' formed a society that was liberal, intelligent, tolerant, skeptical, ironic, voluptuous, affable, overflowing with witty and luxurious charms, devoid of pride unless respect was found wanting, sumptuous, splendid, and magnanimous. The perfection and elegance of its language, the excellence of its perfect good manners, the piquant delights of its tone, and the eloquent charms of its speech, in which mockery was so smoothly disguised as praise—all this lent its daily life a theatrical aspect of supreme elegance and the best taste, and this seduced people by imbuing them with the pleasure and joie de vivre radiated all around them by this milieu."[1]

The fundamental difference between high society and café society lay above all in the nature of what it was that bound their members together. High society was a closed and codified circle, into which one had to be born. One was never co-opted into high society. At the very most, the openness described by Pringué applied to persons of culture and wit who were good company, for culture, wit, and manners were the holy trinity that enabled the privileged few to cross the threshold of a milieu that might consent to admit them as guests, but never as full members. Proust himself suffered torments because his models for the Duchesse de Guermantes, Madame de Chevigné, and Comtesse Greffuhle, never really took him seriously. Artists were the category who lent themselves most easily to being invited in, although Maurice Sachs had no illusions about the true nature of their position: "Society people treat us like unpaid servants." By *us*, Philippe Jullian added, Sachs meant "authors, painters, or musicians. I have found only one or two exceptions to this rule, the cruel truth of which becomes apparent when you begin to find that compliments are much less rare than cash."[2] Doubtless he would have included among his rare exceptions Marie-Laure de Noailles, who had a habit of turning "her artists" into friends or even lovers—that is when she wasn't attempting, as with Oscar Dominguez, to turn her lovers into artists.

1. Philippe Jullian, *Dictionnaire du snobisme*, Paris, Plon, 1958, pp. 87–8.
2. Philippe Jullian, *The Snob Spotter's Guide,* London, Weidenfeld and Nicolson, 1958, p. 28.

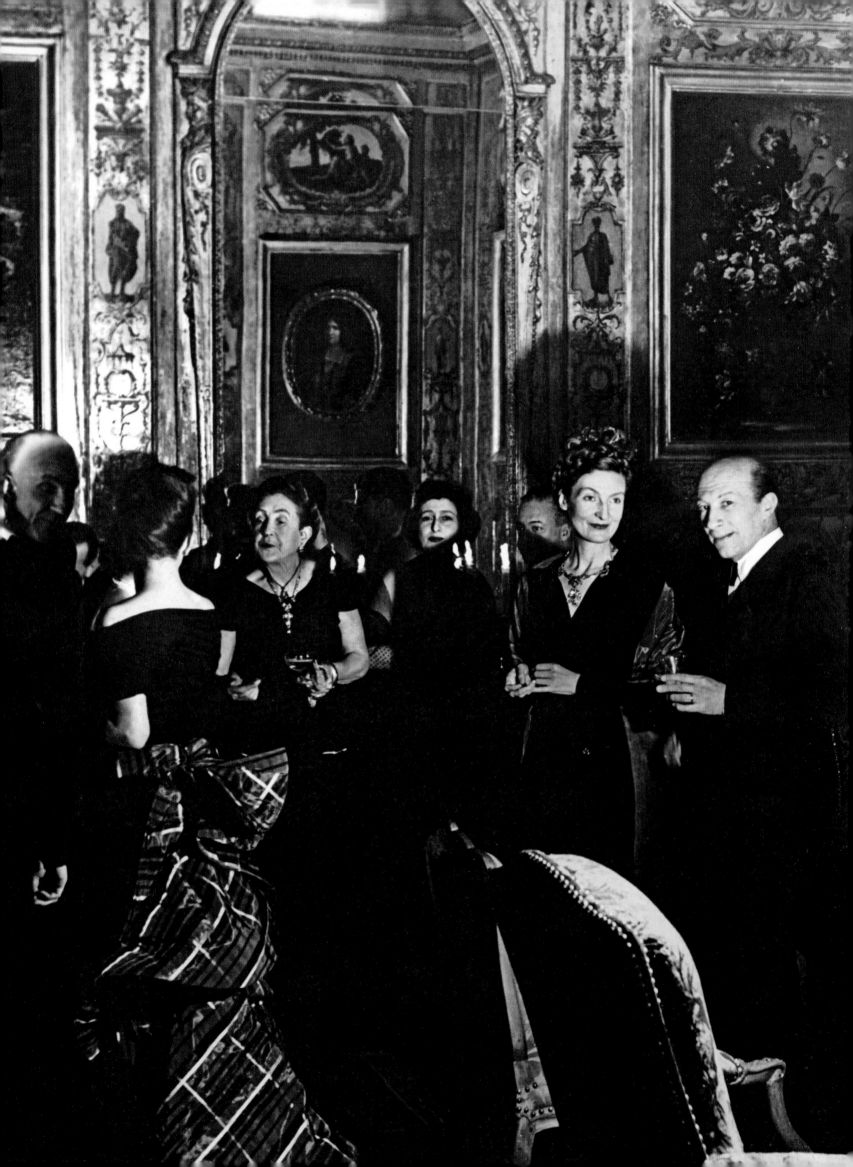

By the 1930s and 1940s, the days of high society were numbered. Composed essentially of great landowners who cultivated a life of extreme leisure, punctuated by a ceaseless round of hunts, balls, and dinners, while younger sons were safely consigned to the army or the church, it found itself out of step with a world that was undergoing massive changes, and in which landed wealth was running out. In Paris, the bourgeoisie had already consigned the aristocracy to the mansions of the faubourg Saint-Germain, or occasionally to the faubourg Saint-Honoré or even the sixteenth arrondissement. The upper middle classes were interested only in making money, however, while the most flamboyant outer fringes of the aristocracy dreamed of perpetuating a world devoted exclusively to *l'art de vivre*, to good taste, to parties, and even to Art (with a capital "A").

Café society was to help the aristocracy to survive, and to do so with élan. Most of the grandees who were to grace it with their legitimacy belonged to families of distinguished pedigree, but who had learned to adapt to changing times in order to preserve their style of life. They tended moreover to belong to the urban aristocracy, more closely attached to life at court than to spending most of the year on their country estates. While it remained one of the favorite sports of the wealthy nobility, hunting to hounds began to play a role of less crucial importance. In the wake of the industrial revolution, followed hard upon by the First World War, the great landowning fortunes were no longer the great power they once had been. Those who still had considerable means to devote to their own pleasure had been canny enough to open their ranks to new elites who, in exchange for their noble names, brought them fortunes acquired elsewhere.

The cosmopolitan nature of this aristocratic elite, who were on familiar terms with each other throughout Europe and whose social diaries took no account of national boundaries was thus to open up new horizons.

In the late nineteenth and early twentieth centuries, as country squires rattled about in their freezing, draffy ancestral piles, the great aristocratic dynasties lost no time in forming alliances with powerful Jewish families such as the Rothschilds, the Cahen d'Anvers, and the Ephrussis. After this came the vogue for rich American heiresses, launched by the arbiter of Belle Epoque elegance Boni de Castellane when he married Anna Gould—of whom he was to remark, following their sensational divorce, "My wife will never know how much I loved her for her money."[3] And lastly there came the South American families, including the Anchorenas, the Yturbes, and Beistegui. Members of the aristocracy who assisted the emergence of café society were often the children of marriages such as these: the mother of Marie-Laure de Noailles, *née* de Chevigné, had married the Belgian Jewish banker Bischoffsheim; the mother of Jean-Louis de Faucigny-Lucinge came from the wealthy Terry family from Cuba; and Daisy Fellowes, *née* Marguerite de Polignac, was the daughter of a Singer sewing machines heiress.

The cosmopolitan nature of this aristocratic elite, who were on familiar terms with each other throughout Europe and whose social diaries took no account of national boundaries, was thus to open up new horizons. It is hard not to see one of the first and last parties

3. Boni de Castellane, *Mémoires de Boni de Castellane*, Paris, Libraire Académique Perrin, 1986.

given by the young Duke Fulco di Verdura on his Sicilian estate, in 1924, as the template for the sumptuous parties of café society. Guests included Jean-Louis de Faucigny-Lucinge, Marie-Laure de Noailles, and Louise de Vilmorin, all proud aristocrats who were to embrace one of the cardinal taboos of the aristocracy at court: "derogeance," or mixing below their rank. Most of them—the Comte and Comtesse de Noailles were the exception—were also for the first time in their families, and often in their mature years, to exercise an activity perilously close to the professional: Étienne de Beaumont and Fulco di Verdura as jewelers working with Chanel; Daisy Fellowes as editor of the French edition of *Harper's Bazaar*; Natalie Paley as a fashion model, actress, and public relations consultant; Nicky de Gunzburg as a stylist; and Frédéric de Cabrol as an interior decorator. At the very start of the twentieth century, Boni de Castellane had blazed a trail once more by selling antiques and putting his taste—generally acknowledged as impeccable—at the service of others in order to finance the life of luxury for which his former wife was no longer footing the bill. In the world of the arts, in fact, the concept of derogeance was really hardly shocking at all. The time had passed when couturiers and jewelers were considered as common tradesmen who should be consigned to the back stairs.

Since the beginning of the century, the Ballets Russes had indisputably paved the way for this great melting pot of the worlds of the aristocracy, art, and fashion. Now entry into society was guaranteed not by birth, but by shared tastes, snobbery, and extravagance. The role played in Paris and London by two icons of the aristocracy, Comtesse Greffulhe and Lady Cunard, was decisive in opening up high society to new artistic influences, and bringing into vogue the marriage of performance, fine art, and fashion. The Ballets Russes were hugely influential in numerous artistic domains, and for years Diaghilev was master choreographer to high society not only in Paris and London but also in Monte Carlo and Venice. Taken up by Misia Sert, Chanel, and Catherine d'Erlanger, mother-in-law of Jean-Louis de Faucigny-Lucinge, Diaghilev employed the greatest artists of the era, including Picasso, Derain, Bérard, Cocteau, and Satie. His lovers, meanwhile, were all to enjoy spectacular careers in parallel to their membership of café society, whether as dancers (Lifar, Balanchine, Fokine), as a choreographer (Kochno), or as a composer and conductor (Markevitch).

Advances in travel and transport took care of the rest. Fashionable life was no longer limited to the salons of *hôtels particuliers*—even if their owners now received a new set in their gilded drawing rooms, including many who dreamed of owning such a place themselves—but spilled over into public places, cafés, restaurants, and nightclubs. Summer watering places multiplied to include Venice, the Riviera, and Tuscany, to be complemented by winter sports stations such as Saint-Moritz, by American country houses on Long Island or Bermuda, and by South American haciendas. Cruises on private yachts, meanwhile, became *de rigueur*.

For many of these members of the aristocracy their fortune now lay chiefly in their title, especially those who emigrated to America at the outbreak of the Second World War. It comes as no surprise to find New York's café society graced by exotic foreigners with romantic titles, such as Princess Paley, the Duke di Verdura, Prince Obolensky, and Baron de Gunzburg. But every aristocracy needs its sovereigns. A number of princely figures might be found rubbing shoulders within the ranks of café society, many of them from Balkan principalities, such as Princess Marthe Bibesco and Princess Soutzo, who married Paul Morand. The vicissitudes of history even ensured that the British royal family furnished this cosmopolitan world with irreproachably blue blood in the form of the Duke of Windsor, accompanied by his duchess, Wallis Simpson. That the English should set the tone was only right and proper, as the snobbery of café society rested on a strong current of genuine Anglomania, the foibles of which Philippe Jullian delighted in depicting (while not sparing himself).

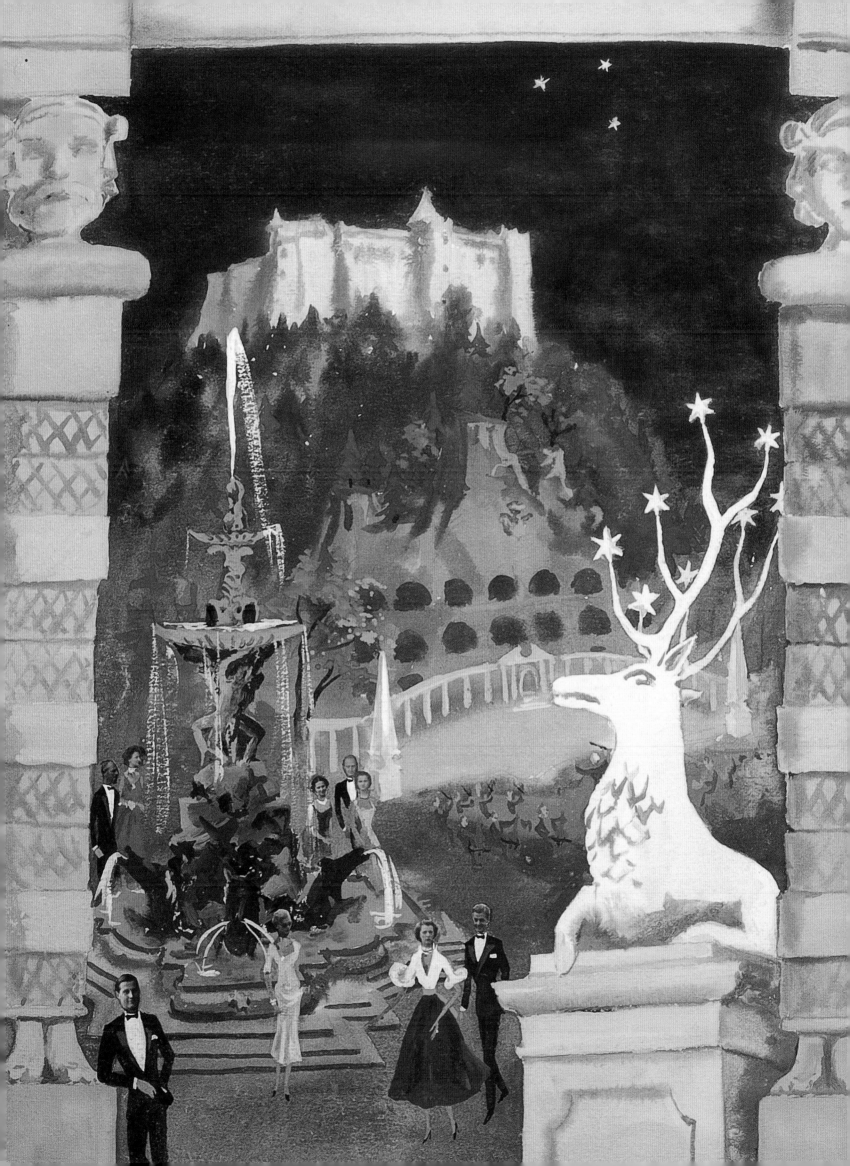

Étienne de Beaumont

Comte Étienne de Beaumont and his wife, *née* Edith de Taine,[1] may be considered as harbingers of café society. One of the most glittering couples in early twentieth-century Paris, they threw sumptuous parties in their magnificent eighteenth-century *hôtel particulier* on rue Duroc, which under the Empire had been the Spanish ambassadors' residence. Even before it became one of the distinguishing characteristics of café society, their parties mingled lofty aristocrats with luminaries of the avant-garde art world, as one contemporary remembered: "M. de Beaumont remained faithful to an old tradition of the French aristocracy in encouraging the artists of his time, even though his tastes inclined him to those who quite rightly liked to show themselves the least faithful to any tradition."[2] Right up to the ends of their lives in the 1950s, the Beaumonts always sought to keep up with the latest trends, to be in the vanguard of fashion. Thus Étienne was one of the first to hang Picassos among the old masters on the walls of his salons, while Edith published a translation of the poems of Sappho with illustrations by Marie Laurencin.

To be invited to one of their soirées you needed to be well born, talented, or amusing, entry qualifications which had the paradoxical effect of ensuring that their salon was one of the most snobbish and exclusive, while at the same time welcoming artists who were never invited elsewhere. In many respects the Beaumonts were perfectly suited as a couple. As Abbé Mugnier, friend to numerous writers and confessor to fashionable Paris, noted in his diary on June 27, 1914, "Comte Étienne and his wife are rather singular, as they say."[3] Like many couples after them in café society (and like Prince and Princess Edmond de Polignac before them), they were united only by their shared tastes for art and the social whirl; each displayed a marked and open preference for their own sex, so guaranteeing this leading couple of Paris society appearances in numerous works of literature. Raymond Radiguet was to draw inspiration from them for his *Count Orgel Opens the Ball*, Edouard Bourdet lampooned Étienne in *La Fleur des pois*, and Dalí transformed him into the Comte de Grandsailles in *Hidden Faces*. The Comte de Beaumont was a dandy *par excellence* who loved to shock. He adored striking poses of majestic hauteur, as in the celebrated portrait by Baron de Meyer, as well as cross-dressing and appearing at his famous balls in an array of astonishing costumes. In his *Journal inutile*, Paul Morand offered the following description of one of these occasions: "We witnessed Étienne de Beaumont receiving his

1. 1877–1952.
2. André de Fouquières, *Cinquante Ans de panache*, Paris: Editions Pierre Horay Flore, 1951, p. 100.
3. Abbé Mugnier, *Journal de l'abbé Mugnier*, Paris: Mercure de France, 1985.

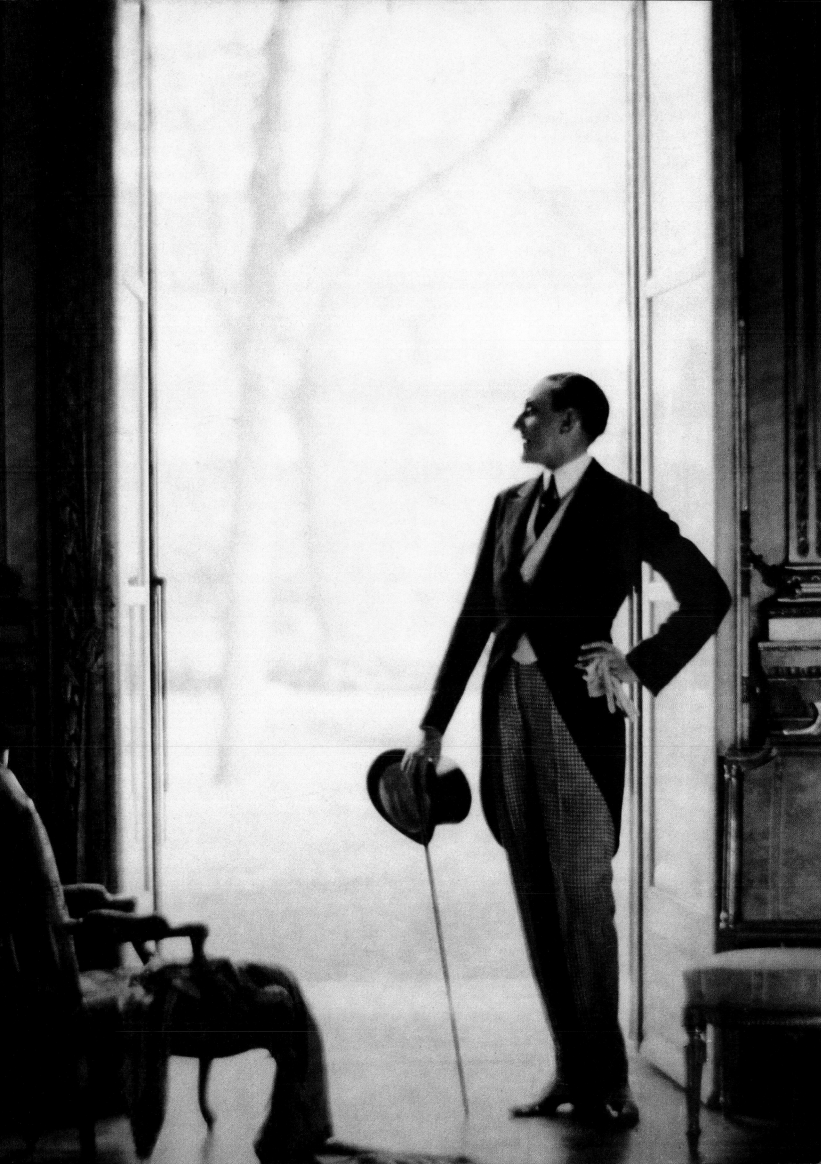

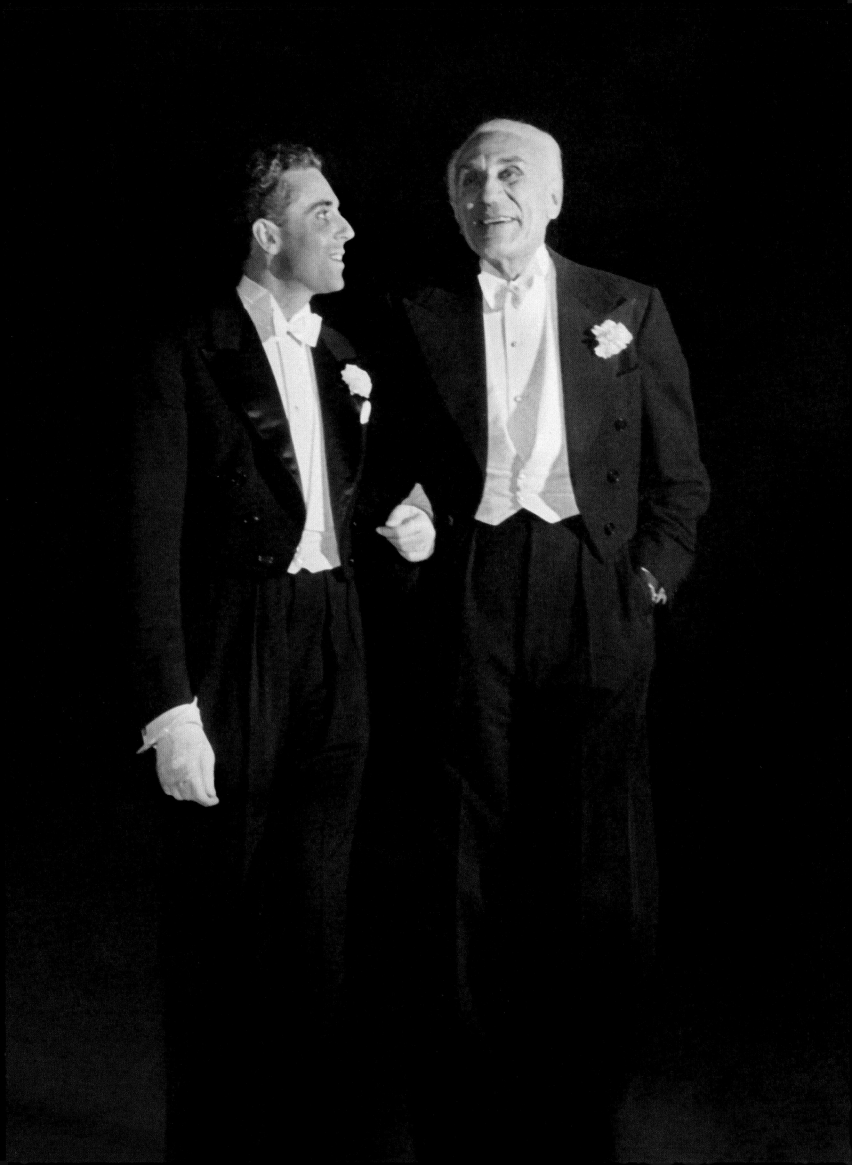

guests, dressed at first in strictly classic drag, then at one o'clock in the morning, when only close friends were left, he changed his costume to reappear as Cupid (in pink swim suit with tulle wings), eyes bulging, with an air of madness (his sister was mad) and as though he had changed his soul, disguised as his Double."[4] Jean-Louis de Faucigny-Lucinge described him as "Very tall, with a physical resemblance to Mr. Punch and a père noble of the theatre."[5] During the First World War, the count organized an ambulance battalion to aid the wounded at the front, a venture in which he enlisted a number of his friends, including Cocteau who described the experience in his novel *Thomas the Imposter*.

His activities as a patron of the arts reached their zenith in 1924 with his *Soirées de Paris*, theater and ballet performances at the Théâtre de la Cigale in Montmartre, for which he commissioned notably *Mercure* from Satie and *Salade* from Milhaud. Massine was his choreographer, while Marie Laurencin and José Maria Sert designed the sets. With help from Cocteau and Picasso, the whole legacy of the Ballets Russes was thus prolonged under the influence of Étienne de Beaumont, a loyal supporter from the time of Diaghilev. It was at this period, according to Paul Morand, that "*chez* Beaumont, Montparnasse and the Faubourg Saint-Germain were mixed up together."[6] The Comte and Comtesse de Beaumont were typical of these aristocratic circles who remained ever open to novelty in all its forms, constantly ready to receive new artists and young society couples, determined above all to remain "in the swim." In exchange, people were willing to turn a blind eye to his arrogance of nature, which—according to rumor—was equaled only by the doubtful pedigree of this branch of the family. When someone expressed surprise that the count had refused to allow himself to be hypnotized during a spiritual séance, for fear no doubt of hearing what his future held, Proust is said to have retorted, "Or more likely his past."[7]

When Misia Sert asked him at the Liberation what he thought of General de Gaulle and the new powers that be, Beaumont—whose own conduct during the Occupation had not been above reproach—replied: "You know, Misia, in the old days my mother used to invite the officers of the Evreux garrison to Beaumont once a year. Nowadays, my dear, they're there every day."[8] Shortly after the First World War, this same arrogance had seen him refuse to invite Chanel to a ball for which she had made many of the costumes. The tables were turned a few years later, however, when he found himself designing jewelry for her. But the most memorable legacy of this man who was at once haughty and frivolous lay in the balls he gave. Of the many hosts and hostesses who threw balls in the period between the wars and just after, no one could rival him (apart from Beistegui in 1951) in his energetic planning and attention to detail. The food might have been deplorable ("grenadine and biscuits," according to Morand), but the events themselves were impeccably choreographed, as Jean-Louis de Faucigny-Lucinge described: "How was a Beaumont ball set in motion? First of all, this brilliant Monsieur Loyal would gather a few friends together in strict secrecy. They would choose a date long in advance. Then Comte Étienne would allow the news to filter out via a few of the initiated: the purpose of this was to set people talking and pique their curiosity, and above all—kindness not being his forte—to worry those unfortunates who trembled at the thought of not being invited." Anyone who gave a ball in subsequent years could not help but be influenced by these defining events, in which Étienne de Beaumont and his wife established the perfect prototype of a genre.

Facing page
Henri and
Étienne de Beaumont, 1950.

4. Paul Morand, *Journal inutile*, Paris: Gallimard, 2001, vol. II, p.115.
5. Jean-Louis de Faucigny-Lucinge, *Un gentilhomme cosmopolite*, Paris: Perrin, 1990, p. 105.
6. Paul Morand, op. cit., p. 729.
7. Ibid., p. 141.
8. Arthur Gold and Robert Fizdale, *Misia: The Life of Misia Sert*, London: Macmillan, 1980.

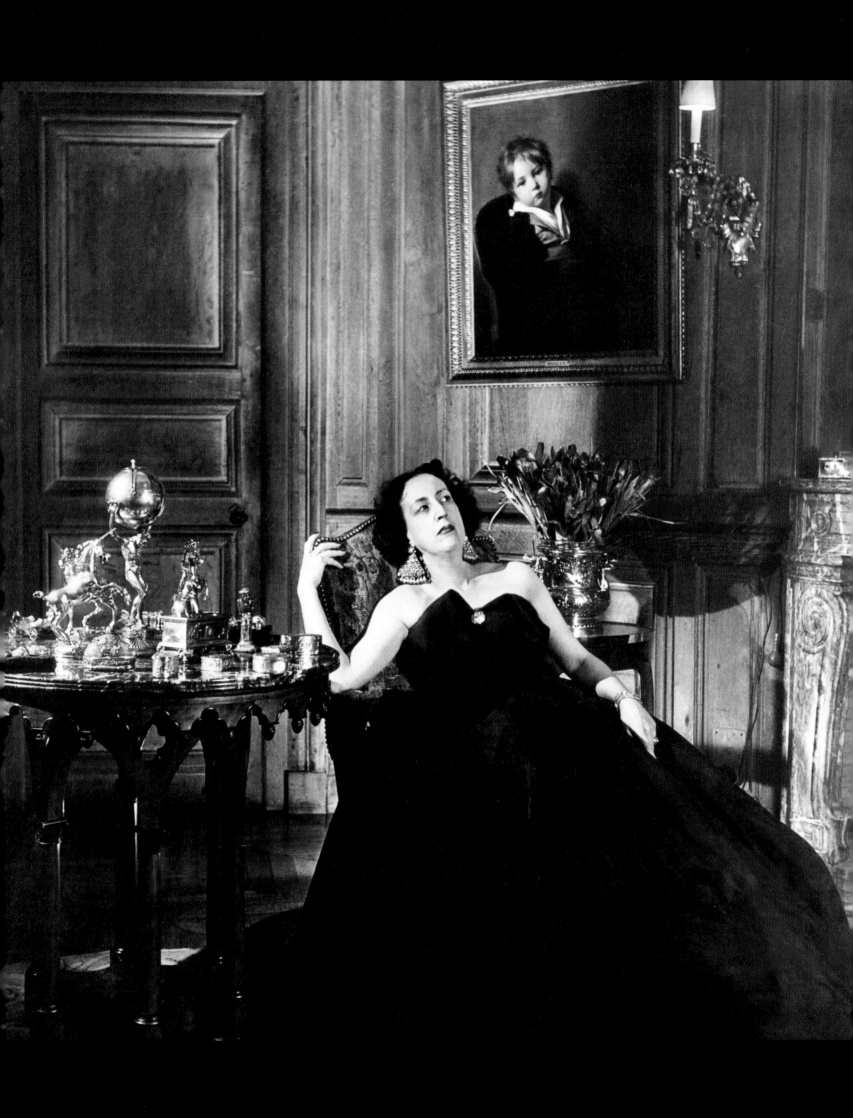

Marie-Laure de Noailles

Marie-Laure de Noailles was a figure of central importance to café society. In many respects she was too aristocratic and too intellectual to be part of it, but she nevertheless exercised a sort of magnetic attraction over those who longed to become part of her circle. As both artist and patron, at once chic and vulgar in her leanings, she was expert in the mingling of genres, backgrounds, and sexes in every field that was so typical of this milieu. Marie-Laure de Noailles was at the crossroads of two worlds. "Every pedigree flows through her veins,"[1] observed Abbé Mugnier, a connoisseur of such matters and confessor to Paris society. On her father's side lay the Bischoffsheim Belgian banking dynasty of Jewish origin, which distinguished itself by financing the Belgian railway system. In 1880 her grandfather, Ferdinand, built an *hôtel particulier* at 11 place des Etats-Unis in Paris, which Marie-Laure was to spend fifty years transforming into a high temple of café society. On her mother's side, her aristocratic credentials could hardly have been grander. Her mother Marie-Thérèse was the daughter of the Comtesse de Chevigné, an inspiration for Oriane de Guermantes, "one of the first society women to say *merde.*" A free spirit married to a dull legitimist nobleman, she loved to shock, and displayed a snobbishness that even art could not moderate: poor Proust might have immortalized her for posterity, but she would always consider him a bore. Born Laure de Sade, she was descended from the Marquis, whose work she despised. It was a lineage that provided Marie-Laure with numerous excuses for her calculated aberrations. Soon after her birth her father died of tuberculosis, and her mother married Frantz Wiener, another Belgian Jew who went by the name of Francis de Crosset in society, and of whom Marie-Laure was always very fond. Her childhood was a solitary one all the same, spent more in the company of tutors than of children of her own age, whom she rarely saw. As a teenager she fell hopelessly in love with a man she was to know throughout her life, and whose mother lived next door to her grandmother in rue d'Anjou: Jean Cocteau. This was the start of an uninterrupted string of infatuations with homosexual men.

In 1923, Marie-Laure married, with great pomp, Vicomte Charles de Noailles, grandson of the Duc de Mouchy and eleven years her senior. Charles was a figure of considerable charm, the embodiment of an aristocrat of noble lineage lost in his own century, who—beneath a polished and attractive veneer of perfect manners and impeccable breeding—had no real feelings for anyone. According to Igor Markevitch, "What was striking about Charles's presence was the degree to which he was absent. He was doubtless insulated from

1. Abbé Mugnier, *Journal de l'abbé Mugnier*, Paris: Mercure de France, 1985, p. 526.

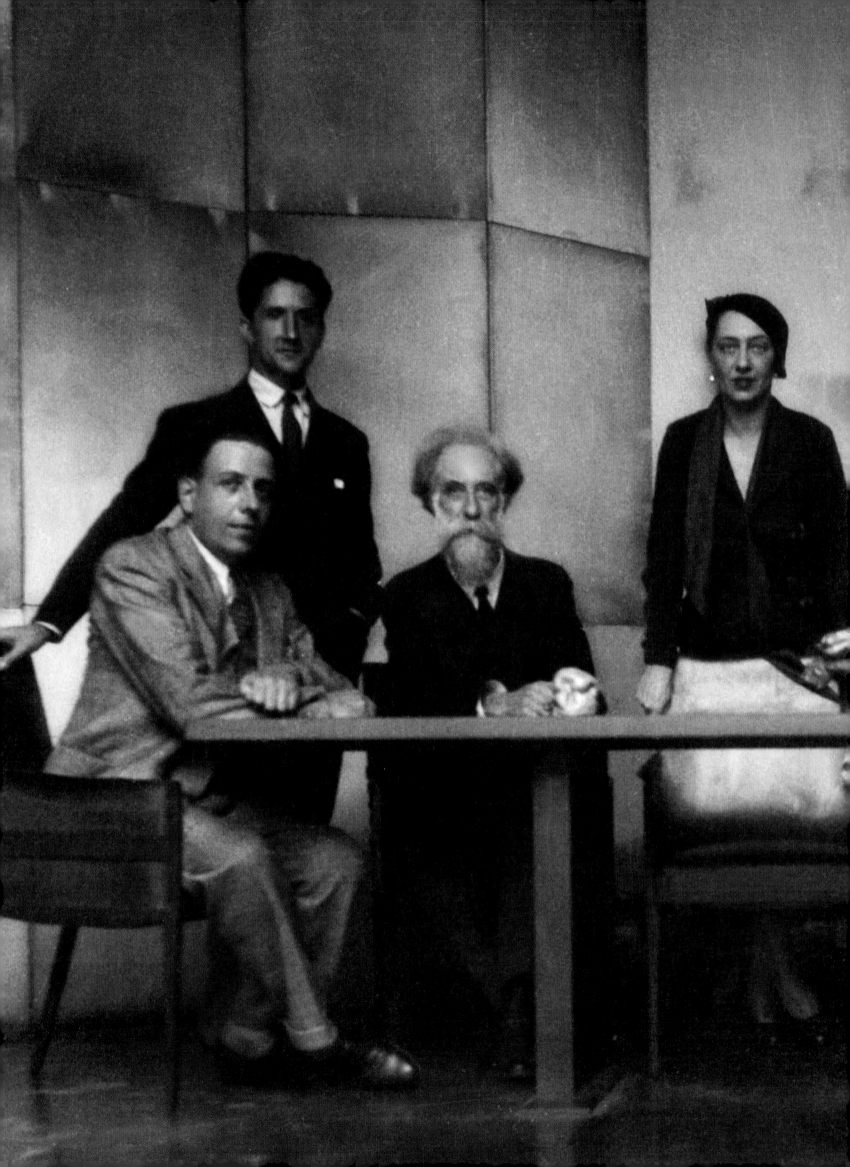

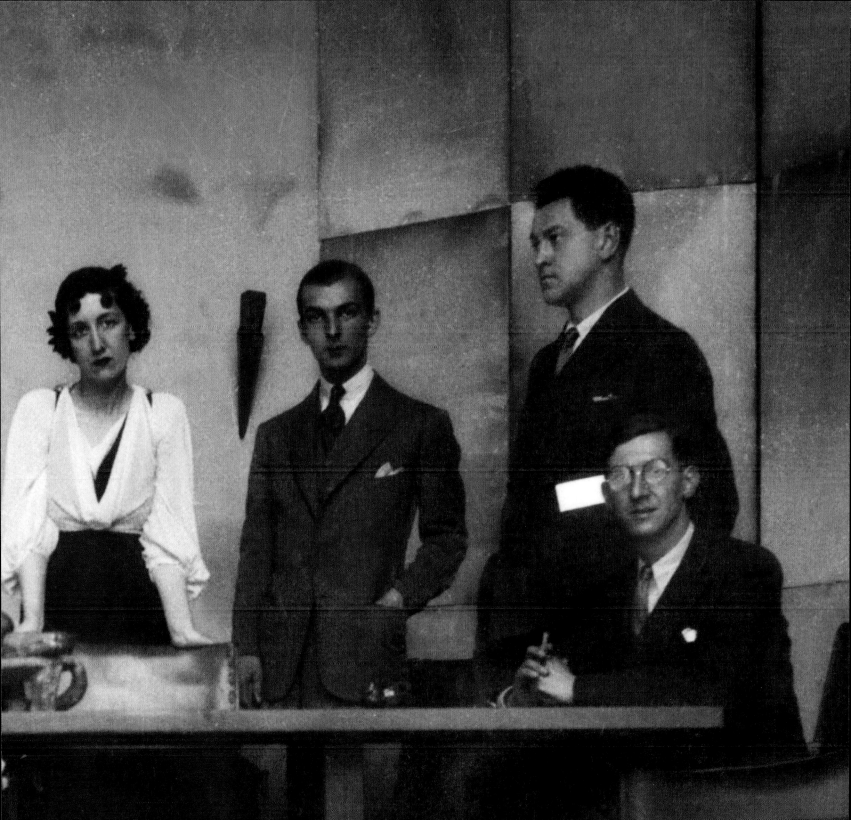

those around him by his own long history. Sometimes one might have taken him for a mere façade, manipulated from a distance by a real but invisible Vicomte de Noailles."[2] Throughout his life he nurtured passions for collecting objets d'art; for sport, which he practiced with his friends Beistegui, Lopez, Alexis de Redé, and Geffroy; and above all for flowers.

In the 1920s "*les Charles,*" as they were known in their circles, were very much in vogue, as well as being very close to the older Étienne and Edith de Beaumont, with their love of balls and youth, and great friends of Johnny and Baba de Faucigny-Lucinge. They lived a short time on rue de La Baume, moving before long to the mansion on place des Etats-Unis, which they redecorated according to their own tastes. To the collections of works by Delacroix, Watteau, Goya, and Gainsborough amassed by the Bischoffsheims, they steadily added canvases by their friends Picasso, Dalí, Balthus, and Bérard. The interior decorator Jean-Michel Frank hung one of the salons with parchment, so making this a *sine qua non* of twentieth-century decorating. For their country house, the couple first consulted Le Corbusier, with whom they did not see eye to eye, before commissioning Mallet-Stevens to design the Villa Saint-Bernard at Hyères, with its famous Cubist garden. In this vast house designed according to the functionalist principles then in vogue, they received all the society and artistic figures of their time. It was here in 1928 that Man Ray made his experimental film *Les Mystères du château de Dés*, and that Lipchitz was to install his first large sculpture, *La Joie de vivre*. The young couple mixed with Cocteau, Gide, Dalí, Bérard, Crevel, Maurice Sachs, Max Jacob, Valentine Hugo, the Boeuf sur le Toit crowd, and the Surrealists. Marie-Laure also counted Breton and Eluard among her friends. Guests at every ball thrown by the Étienne de Beaumonts, the Faucigny-Lucinges, and Nicky de Gunzburg, the "Charleses" also threw their own celebrated parties.

Two episodes were to lead to profound changes in the couple's life together. Going into her husband's bedroom unexpectedly one day, Marie-Laure discovered him intimately entwined with his gymnastics trainer. In the rift that ensued, Marie-Laure decided to live independently, and duly embarked on a ceaseless round of unbridled love affairs and sexual liaisons. Between her first lover, the millionaire Henry James, and her last, Jean Lafon, came a string of other men, many of them homosexuals, including Igor Markevitch, Tom Keogh, Félix Labisse, Alexis de Redé ("I slept with Alexis three times, the first in a bed, the second between two doors, and the third time he didn't show up"), Maurice Gendron, Robert Veyron-Lacroix, Ned Rorem, Pierre Clémenti, and even a German officer during the war. But one name in this roll-call held a special place for her: Oscar Dominguez, her favorite from the mid-1950s, was a late Surrealist painter, a rough character who was also a violent alcoholic, and who after a series of scandals (involving faking old masters and selling the originals) and controversies committed suicide in 1957. He was buried in the Bischoffsheim family vault, where Marie-Laure was to join him in 1970.

Meanwhile Charles, as Morand noted on December 3, 1968 in his *Journal inutile*, "found a new way of being a husband."[3] With Denise Bourdet as his frequent companion in society, he divided his time between the Ermitage de Pompadour, near Fontainebleau, and Grasse, where—having been initiated into the art of gardening in the 1920s under the guidance of his neighbor at Hyères, Edith Wharton—he proved himself a gardener of great talent. His private life remained a matter of the utmost discretion. When Marie-Laure was asked if he preferred men or women she invariably replied: "What? Didn't you know? He loves flowers!"

Facing page
Marie-Laure de Noailles in her salon decorated by Jean-Michel Frank, Paris, 1950.

2. Igor Markevitch, *Etre et avoir été*, Paris: Gallimard, 1980, pp. 229–30.
3. Paul Morand, *Journal inutile*, December 3, 1968, Paris: Gallimard, 2001.

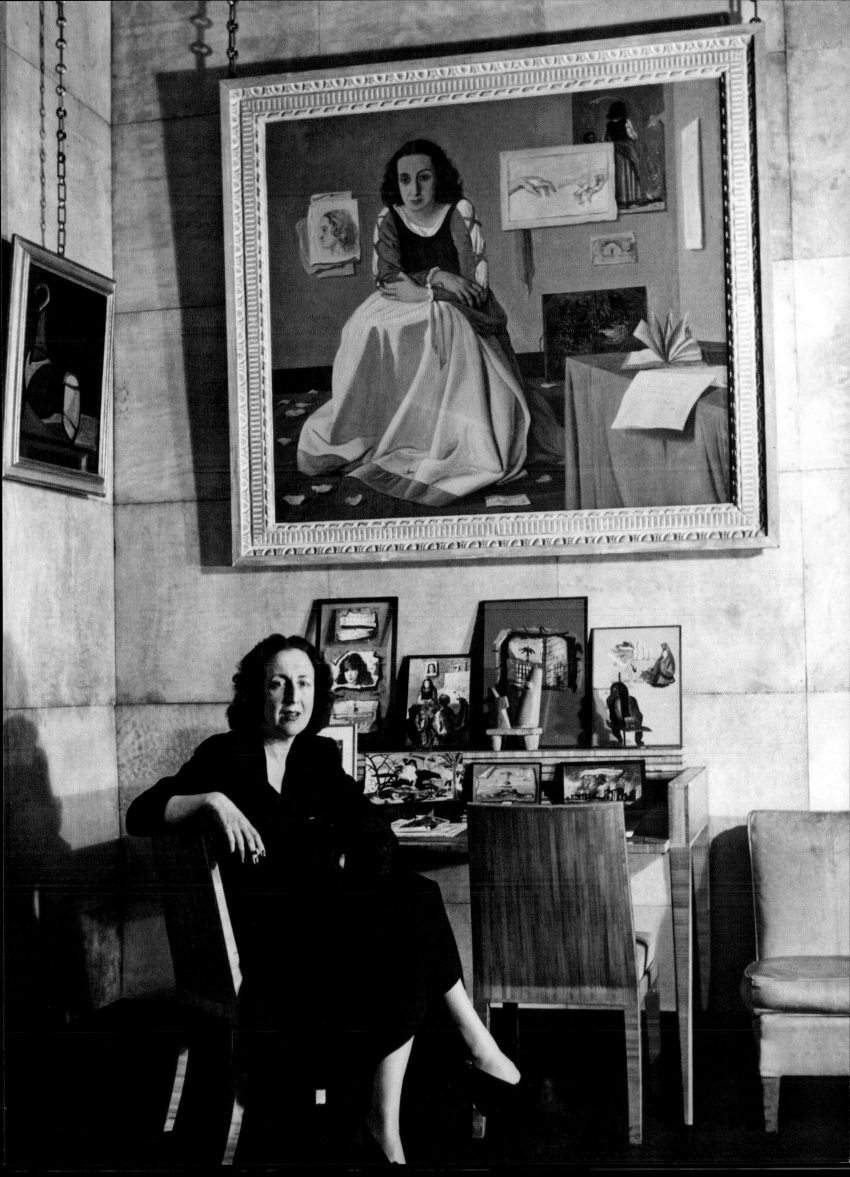

The second major rift between Charles and Marie-Laure came in 1930, with the scandalized reception of two films, Buñuel's *L'Age d'or* and Cocteau's *Le Sang d'un poète*, both of them made under their patronage. They had invited a group of friends to the premiere, including Princess Natalie Paley, Arturo Lopez, the Faucigny-Lucinges, and Lady Abdy. The erotic overtones of some of their scenes were greeted by an atmosphere of profound unease, however, and many of the audience were left shaken. As a result, Charles was suspended from the Jockey Club, and "le Tout-Paris" was split in half. The episode was to make Charles withdraw yet deeper into his private pleasures, while Marie-Laure discovered a taste for scandal and went out of her way to find opportunities to provoke it. These two rifts did not however prevent the couple from staying in constant touch—they telephoned each other several times a day and sought each other's advice—nor from retaining a degree of affection for one another.

During the 1950s, Marie-Laure became the central figure of Paris society, making and breaking reputations and helping to launch the careers of writers, artists, and couturiers—even if she herself was not a figure of outstanding elegance. Everyone who was anyone, or who was about to be, crowded into her salon or tried to get an invitation. By the 1960s, however, society had changed and her influence was on the wane. A living monument to a charm that was sometimes rather outmoded, she surrounded herself with young talents such as the actor Pierre Clémenti and the interior decorator Jacques Grange. In May 1968, by now almost a caricature of herself, she attempted to provoke one last scandal by taking her chauffeur and joining the students of Paris on the barricades. She died before her time in 1970, worn out by life at the age of sixty-seven. Morand described the days after her death in unsentimental terms: "Charles had to chase a whole crowd of young hangers on out of the mansion on Place des Etats-Unis, where Marie-Laure had installed them in the outbuildings. Among them was a certain B., who wept hot tears and clung to his beer as he begged to be allowed to see his beloved for another fifteen minutes. Which exasperated Charles, who was not at all sorry to see the ceremony draw to a swift close. Some of these little queer parasites started taking out manuscripts and paintings; the concierge had to be given orders not to let anything leave the building."[4] Charles survived Marie-Laure until 1981.

What remains of this tumultuous existence? A character of her own creation and works that she supported: her originality, her delight in being provocative, her fondness for youth, for all that was new, her witty repartee, and her self-assurance forged an image that has earned her a place among the great salon hostesses and art patrons of history. In music, painting, and literature she was a discriminating patron: if her fondness for Dominguez was mocked in the 1950s, the art market has in the end proved her right, and his reputation has at last taken off. Like Peggy Guggenheim with Max Ernst and Jackson Pollock, she deliberately mixed her artistic infatuations with her sensual ones, displaying sounder judgment in art than in love. She also tried her hand at painting herself, in a style close to that of her friend Bérard, exhibiting regularly at the Salon de mai and at a few galleries—but the public only came to view and buy because of her stature as a society figure. Finally, she composed poems ("Les Croquevivants," "La Tour de Babel") and a handful of novels (*Les Iles invisibles, La Chambre des écureuils*), and even translated the poems of Edith Sitwell into French. Yet really Marie-Laure de Noailles left only one work for posterity: her own self, as queen of café society.

4. Ibid., February 28, 1970.

Facing page
Marie-Laure de Noailles, Maurice Van Moppes, Oscar Dominguez, and Lucien Coutaud drawing on the wall of the Paris cabaret La Castagnette, 1953.

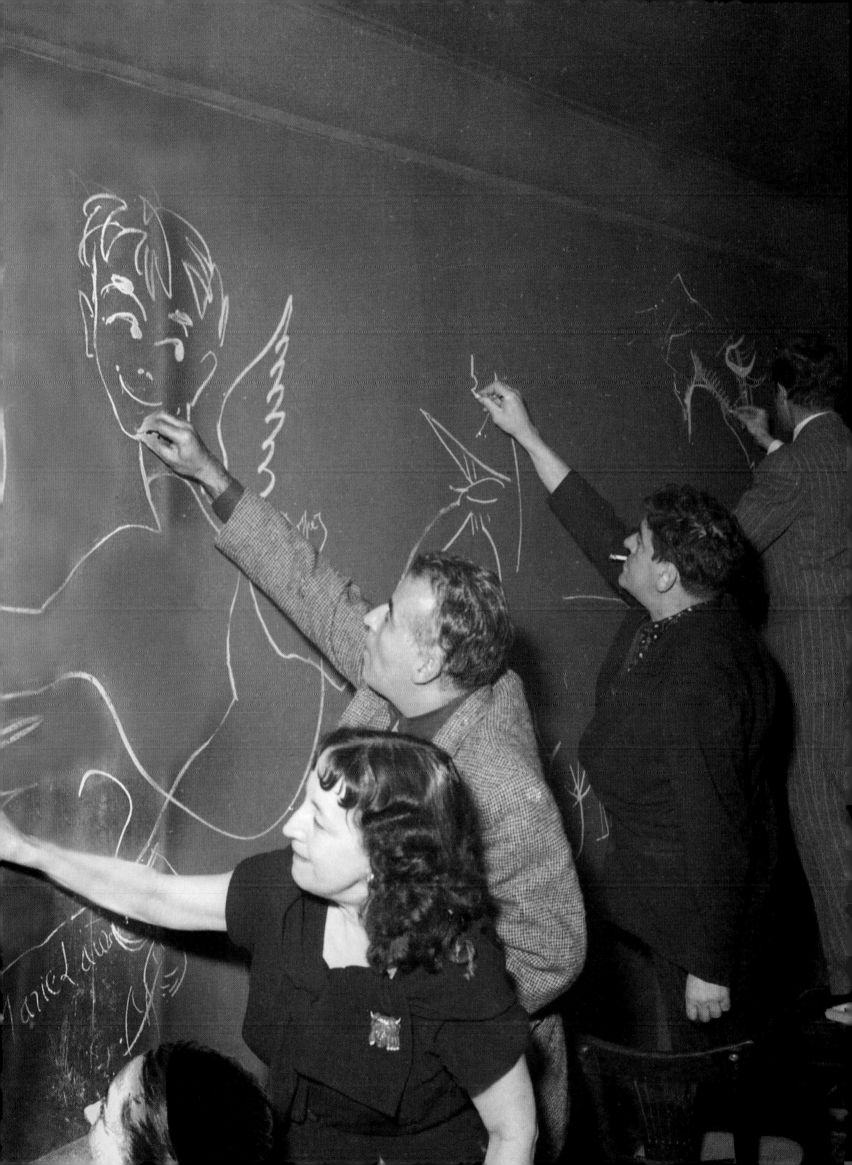

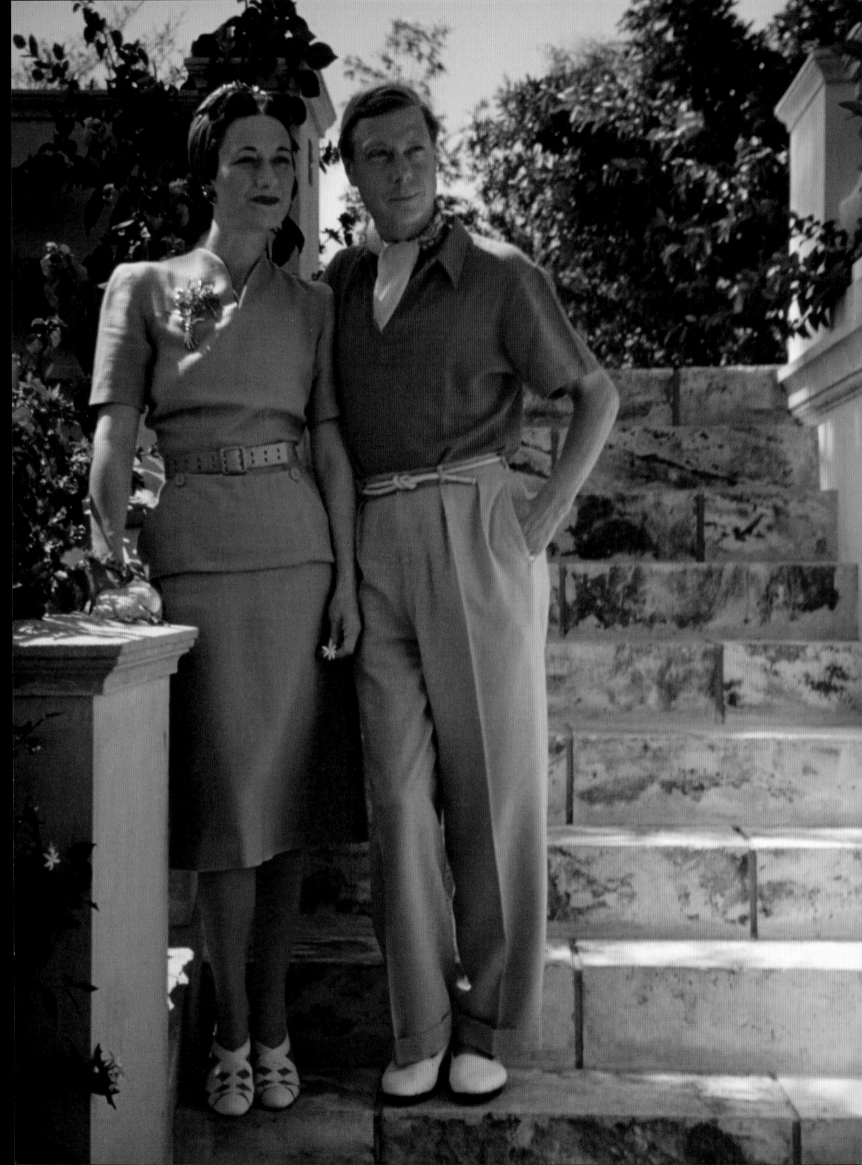

The Duke and Duchess of Windsor

Deprived of the United Kingdom as their realm, the Duke and Duchess of Windsor instead turned their regal ambitions to café society. Having had little experience of holding their own among royalty, they became a caricature of this milieu, and were routinely usurped by others who were more brilliant, more imaginative, and—in sum— more chic. In his memoirs Pierre Barillet gave a coruscating account of this cosmopolitan couple, with their flagrant snobbery and brittle elegance: "Determined to ignore the existence beyond their circles of a world of injustice and poverty, monstrously self-centered, this depraved Philemon and Baucis were bound together by a legend that was bigger than they were. They led a life of idleness, surrounded by a contemptible court of snobs and hangers on, worshippers of the golden calf, joylessly indulging whims whose attractions grew in proportion to their pointlessness and expense, preferably calculated in dollars. Their elegance, celebrated in servile fashion by the popular press, was nothing but ostentatious rags to disguise the repellent nature of their souls."[1]

The story of the Windsors is in fact the extraordinary history of a very ordinary couple, as well as of a style of life that chimed perfectly with all that was worst about café society. It all began in the 1930s, when Edward, Prince of Wales, met the American socialite Wallis Simpson, a twice-married divorcée who had experienced a troubled childhood (her father died when she was an infant) followed by middle-class affluence in Baltimore. Wallis used all her considerable wiles to seduce Edward, with the support of Emerald Cunard, Daisy Fellowes, and even Diana Vreeland, who at this period sold elegant négligées to the woman who, according to gossip, was supposed to have seduced the prince with sexual refinements that she had picked up in Chinese brothels during her first marriage. In 1936, her lover came to the English throne as Edward VIII. His desire to marry an American divorcee whose husband was still alive was not only unconstitutional but hugely unpopular, especially among court circles. What ensued is now part of history: the king abdicated, and in France the following year, at the Château de Candé, married Wallis Simpson, dressed by Mainbocher and photographed—with a regal air—by Cecil Beaton. Was it constitutional concerns or a return to Victorian prudery that exiled Edward and the woman he loved so slavishly from his own country—or was it the taint of fascism that hung over his wife and her close friends Emerald Cunard, mistress of Joachim von Ribbentrop, German ambassador to London, and Diana Mosley (*née* Mitford), wife of the leader of the British Union of Fascists?

Facing page
The Duke and Duchess of Windsor in Miami, 1951.

Following pages
The Duke and Duchess of Windsor at the Château de la Cröe on the Côte d'Azur, c. 1938.

1. Pierre Barillet, *À la ville comme à la scène*, Paris: Editions de Fallois, 2004, p. 370.

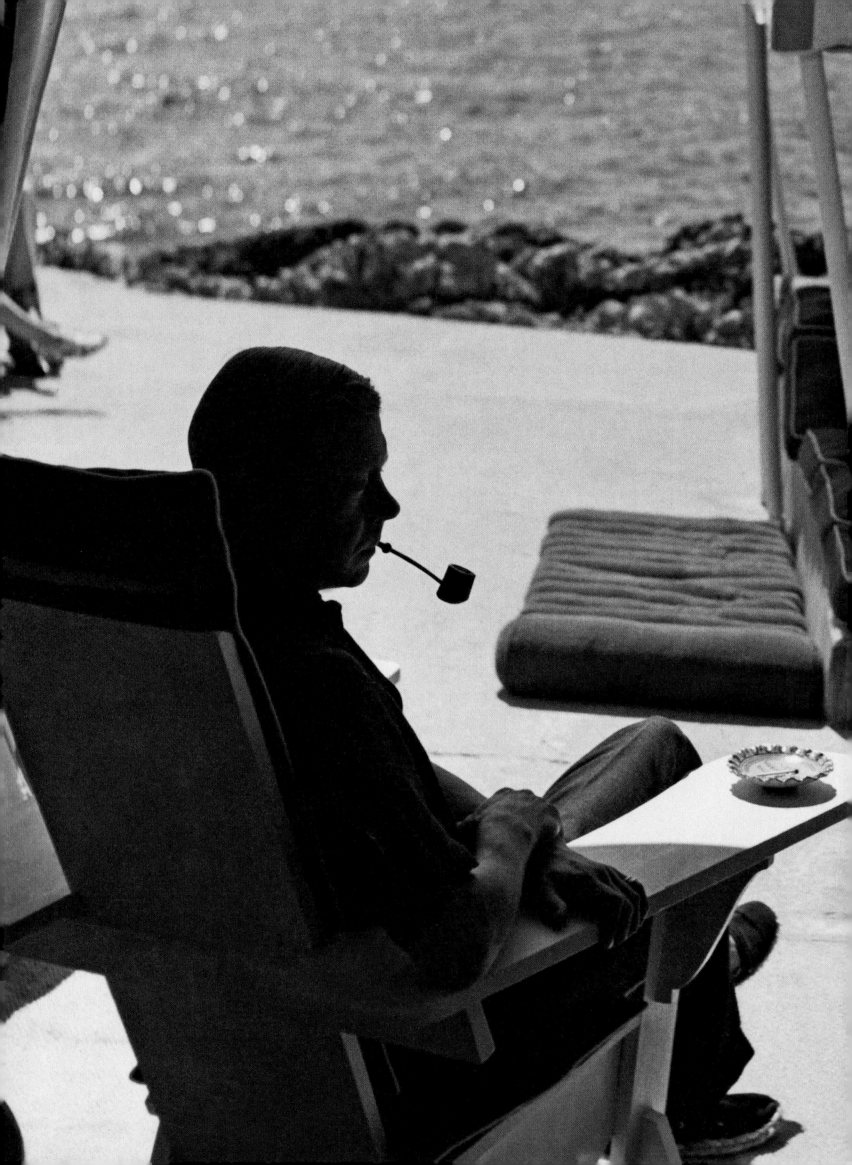

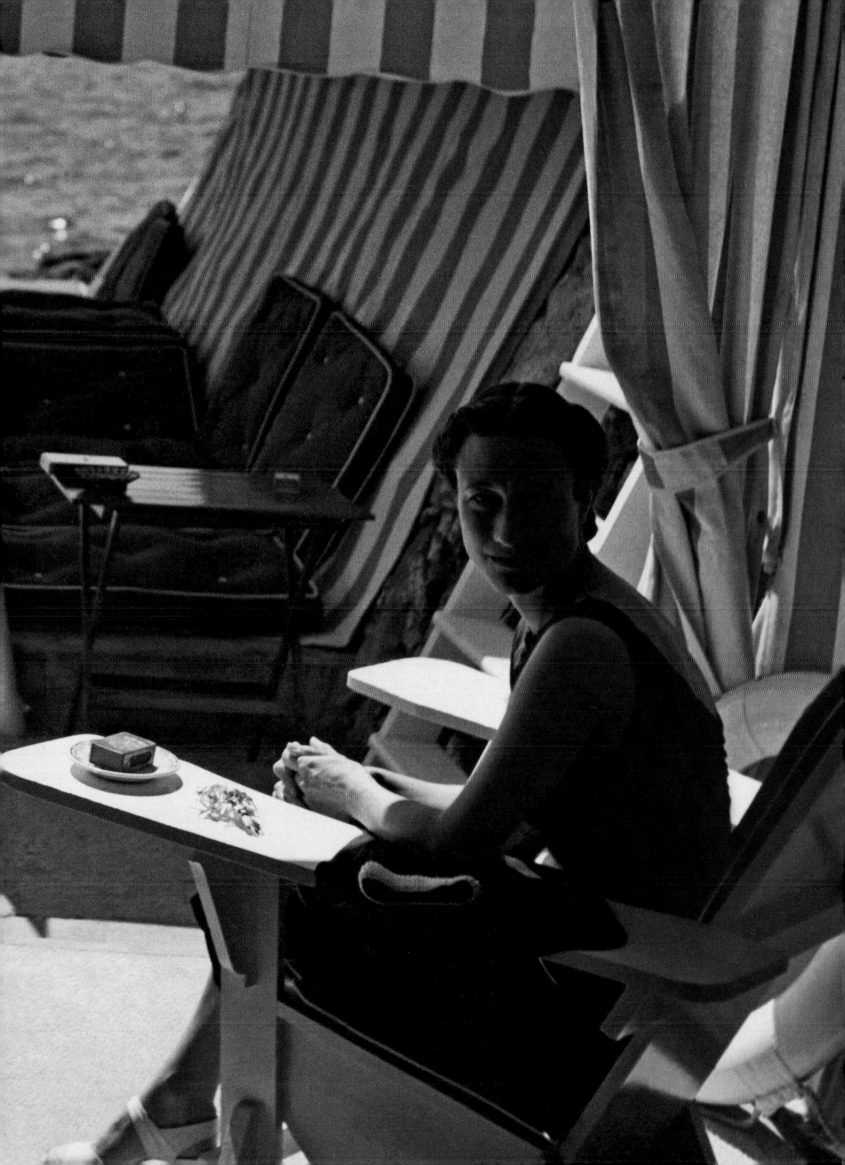

The life embraced by the Duke and Duchess of Windsor, as they were now to be known, was the very epitome of social snobbery. Apart from a brief wartime interlude when Edward was appointed Governor of the Bahamas, they spent most of the year in Paris, with frequent trips to New York, where they invariably took up residence at the Waldorf Astoria, Palm Beach, and the Château de la Croë on the Côte d'Azur. They were constantly surrounded by a crowd of hangers-on and friends, including Baron Frédéric de Cabrol and his wife Daisy, Daisy Fellowes, Ghislaine de Polignac, Mona Bismarck, Paul-Louis Weiller,[2] and Diana Vreeland.

The ease with which the Windsors frequented those who were not of their social rank, especially in New York, was striking. The extreme diversity of their circle, with virtually anything serving as a pretext to ward off the dreaded boredom, was pure café society. This existential ennui even seeped into the cracks of their marriage, when rumors of an affair between Wallis and a young man with whom she was obsessed, Jimmy Donahue—favorite cousin of Barbara Hutton and notorious homosexual, alcoholic, and drug addict—caused a scandal. A fixture at every ball or party of any importance at this time, exploited by Elsa Maxwell with whom they enjoyed an uneven relationship, the Windsors came increasingly to look like puppets on the social scene of the 1960s.

In 1972 Edward died of cancer of the throat; Wallis, gradually incapacitated by Alzheimer's disease, survived him until 1986. They left behind them the memory of what Suzy Menkes called the "Windsor style." More a lifestyle than a true style, as in the sense of "*le style Rothschild,*" this rested on the defining characteristic of the Duchess, as summed up by Annette Tapert and Diana Edkins in *The Power of Style*: "The Duchess of Windsor was, in fact, the most famous housewife in history."[3] When she arrived in London between the wars, Wallis Simpson—without beauty, elegance, or refinement—made use of every means at her disposal to acquire the requisite qualities for the perfect wife and hostess. Though almost certainly never truly in love with Edward, who worshipped her, Wallis did everything to ensure that his life was perfect. As a hostess, an art she learned from her extraordinarily meticulous friend Elsie de Wolfe (Lady Mendl), she set obsessively high standards. Every detail of a dinner or party had to be just so, from the decoration and the standard of the food and drink to the introductions and service—all of which, though impeccable in every way, lent their *style de vie* a starchiness that was perhaps in their view almost royal.

This passion for detail and order ruled all their successive residences in Paris, first of all on boulevard Suchet, then from 1949 to 1953 at 85 rue de la Faisanderie, and finally in their mansion in the Bois de Boulogne. In all of them, Stéphane Boudin of Jansen oversaw the rigid deployment of the Louis XVI-style furniture. The Duchess adored large flower arrangements, massed ornaments, and mirrors everywhere. Neither a patron nor an aficionado of the arts, neither a sportswoman nor an intellectual, she was in fact furnishing the empty spaces of a life that was rivaled in its vacuousness only by the Duke's, whose chief interest was golf. She oversaw every detail of the organization of this world, gave increasing numbers of receptions, and devoted an enormous amount of time to her toilette. The famous Paris hairdresser Antoine revealed that she had her hair dressed three times a day. She also spent more and more time at fittings in the salons of couturiers for whom she became an increasingly demanding client. She favored Mainbocher, Givenchy, and Saint Laurent with her custom, as well as Schiaparelli, some of whose most original creations she wore, including Dalí's infamous lobster dress.

Wallis was equally lavish in her jewelry purchases, giving numerous commissions to Verdura and above all Jeanne Toussaint at Cartier, and contributing to the vogue for animal jewelry,

Facing page
The Windsors on vacation in Rapallo, Italy, 1953.

Following pages
The Duchess of Windsor and Daisy de Cabrol. From the scrapbook of the Baron de Cabrol.

2. Paul-Louis Weiller was to rent them the house at 85 rue de la Faisanderie.
3. Annette Tapert and Diana Edkins, *The Power of Style*, New York: Crown Publishers, 1994, p. 91.

notably with her signature panther pieces. But unlike some women, such as Daisy Fellowes, who nurtured a genuine dialogue with artists, even to the point of creating their own designs, the Duchess was content to wear her gowns with a studied though undeniable elegance that ensured her a permanent ranking among the world's ten best-dressed women. This game of appearances that was the Windsor style existed in fact only to conceal the emptiness of the lives of two people whose existence seemed—even to themselves—ultimately futile.

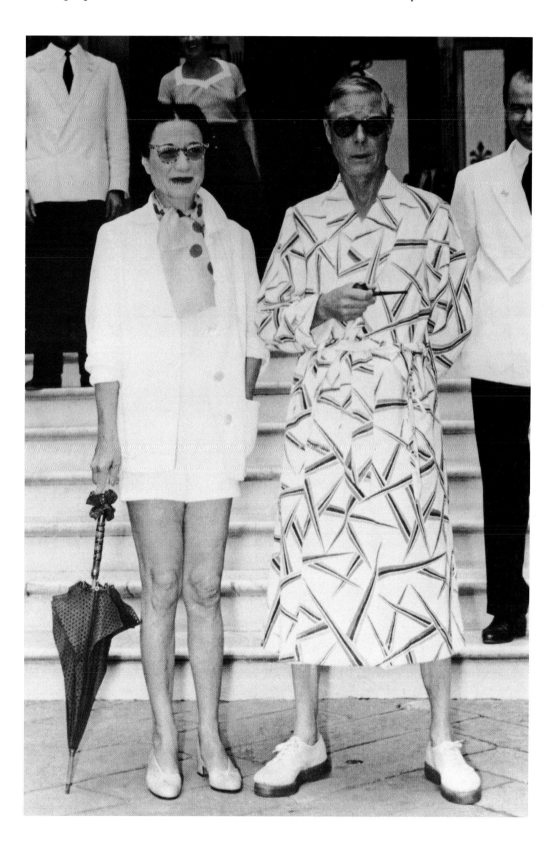

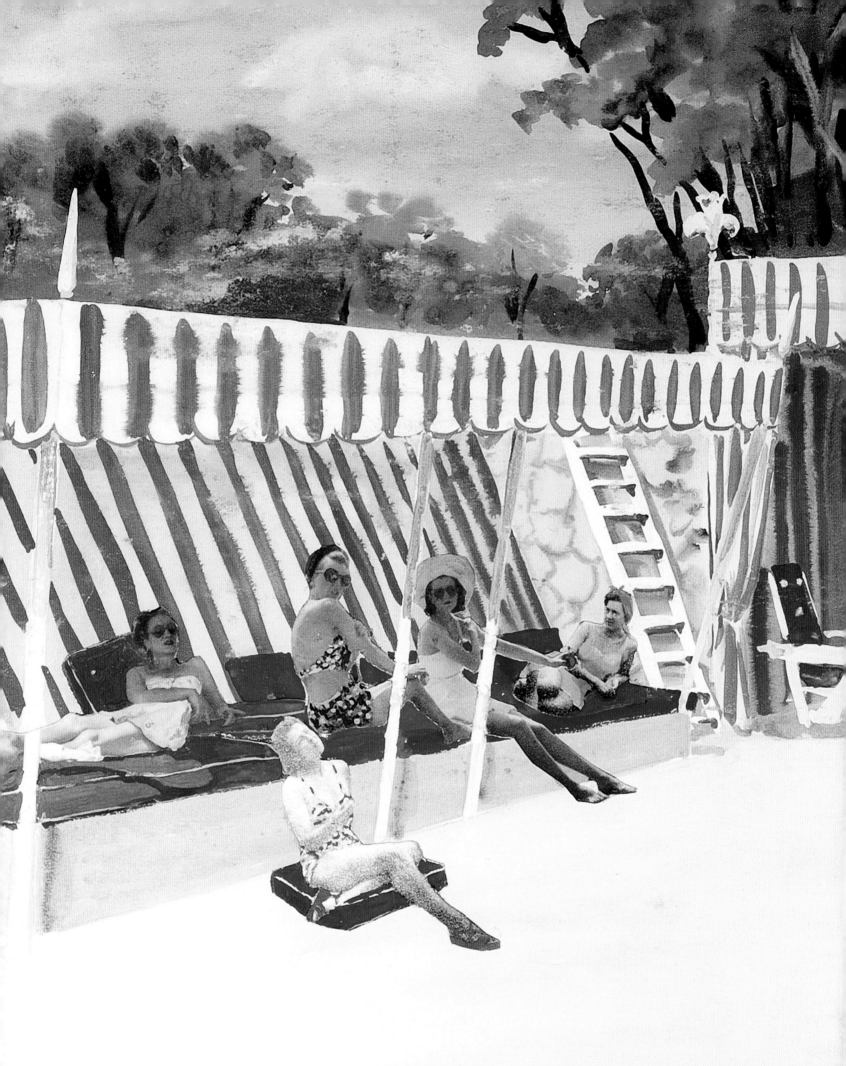

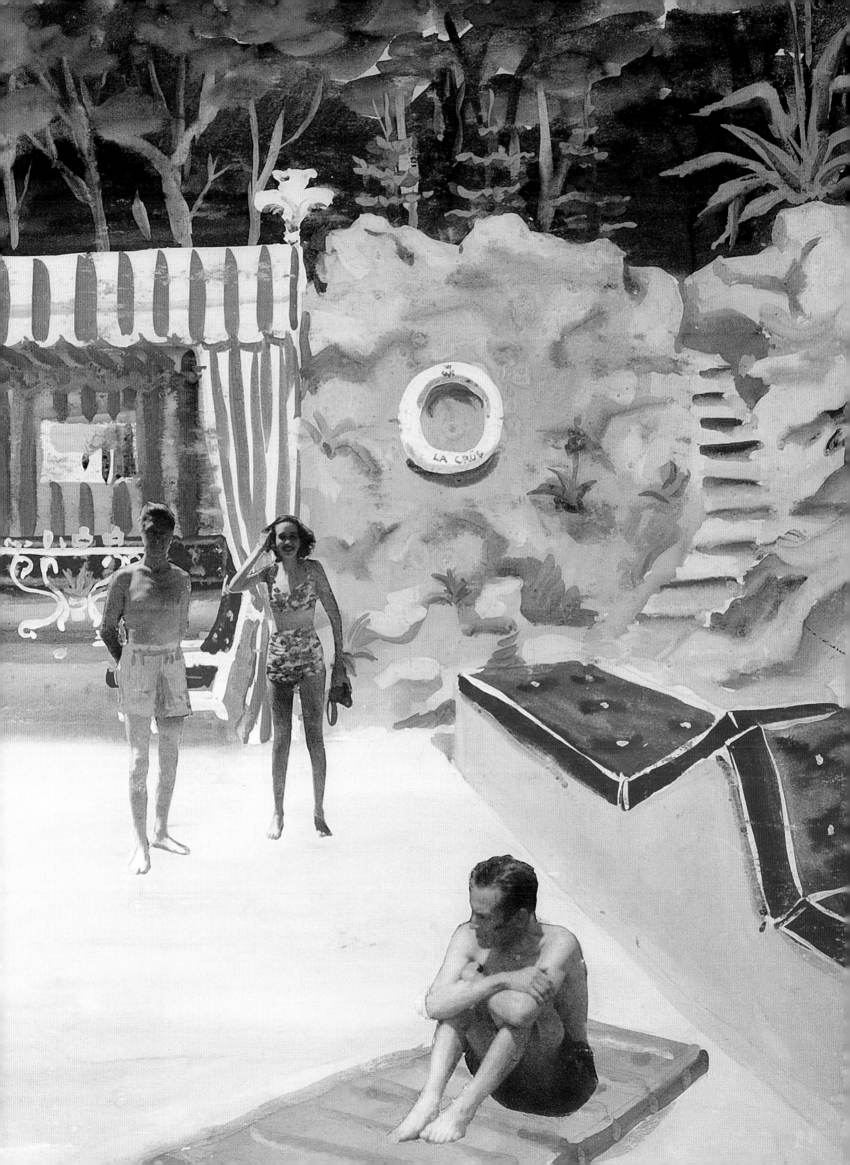

Lady Diana Cooper

Lady Diana Cooper was a rare though typically English bloom that is germinated only on its native soil but that may flourish anywhere. Diana Manners was born into the high aristocracy in 1892, the daughter of the 8th Duke of Rutland (it was thought) and his duchess, the former Violet Lindsay, granddaughter of the 24th Earl of Crawford. Of exalted provenance, Violet was also a gifted artist and sculptor who was a member of the Souls, a group of young aristocratic intellectuals and aesthetes. Conjugal fidelity was not one of the qualities of this woman of character and beauty, and in society it was generally accepted that Diana was the daughter of the journalist and Conservative politician Henry Cust. "Reared in the Edwardian school by a remarkable mother, Lady Diana Cooper is one of the few living aristocrats who can violate all the rules and still keep her balance on the pedestal of *noblesse oblige*," wrote Cecil Beaton, who would photograph her on innumerable occasions throughout her life. "Her roots are so deeply embedded in tradition that, like some incredible plant, she thrives in an atmosphere of bohemianism without ever departing from her origins. English tradition is behind her whether she is cohorting with theatrical people or the highest society."[1]

Fêted while still very young as the most beautiful girl in England, and featured in numerous articles and photographs in the press, Lady Diana—as she was universally known—was before the First World War a member of the Coterie, a group of young intellectuals and aristocratic aesthetes who had inherited the mantle of the Souls. Lady Diana was the muse and goddess of this select group, which also included Patrick Shaw Stewart and Duff Cooper, and which was to be decimated by the war. While many members of the upper crust thought she would make an excellent wife for the Prince of Wales, in 1920 Lady Diana chose to marry Duff Cooper. Decorated with the DSO for conspicuous gallantry during the war, Duff was at this time a promising young diplomat with brilliant prospects. Elected to Parliament in 1924, he was a close associate of Winston Churchill, then Chancellor of the Exchequer.

Diana for her part made forays into journalism, as editor of *Femina* and a columnist on newspapers owned by her friend Lord Beaverbrook. Then she turned to the theater, playing the Madonna in a revival of *The Miracle* with Tilly Losch. Directed by Max Reinhardt and with costumes and sets by Oliver Messel, the play toured America, where it was a triumphant success. She also acted in a number of silent films. But in 1929, after the birth of her son John Julius, she withdrew from the stage to pursue her talents as a

1. Cecil Beaton, *The Glass of Fashion*, London: Weidenfeld and Nicolson, 1954, p. 323.

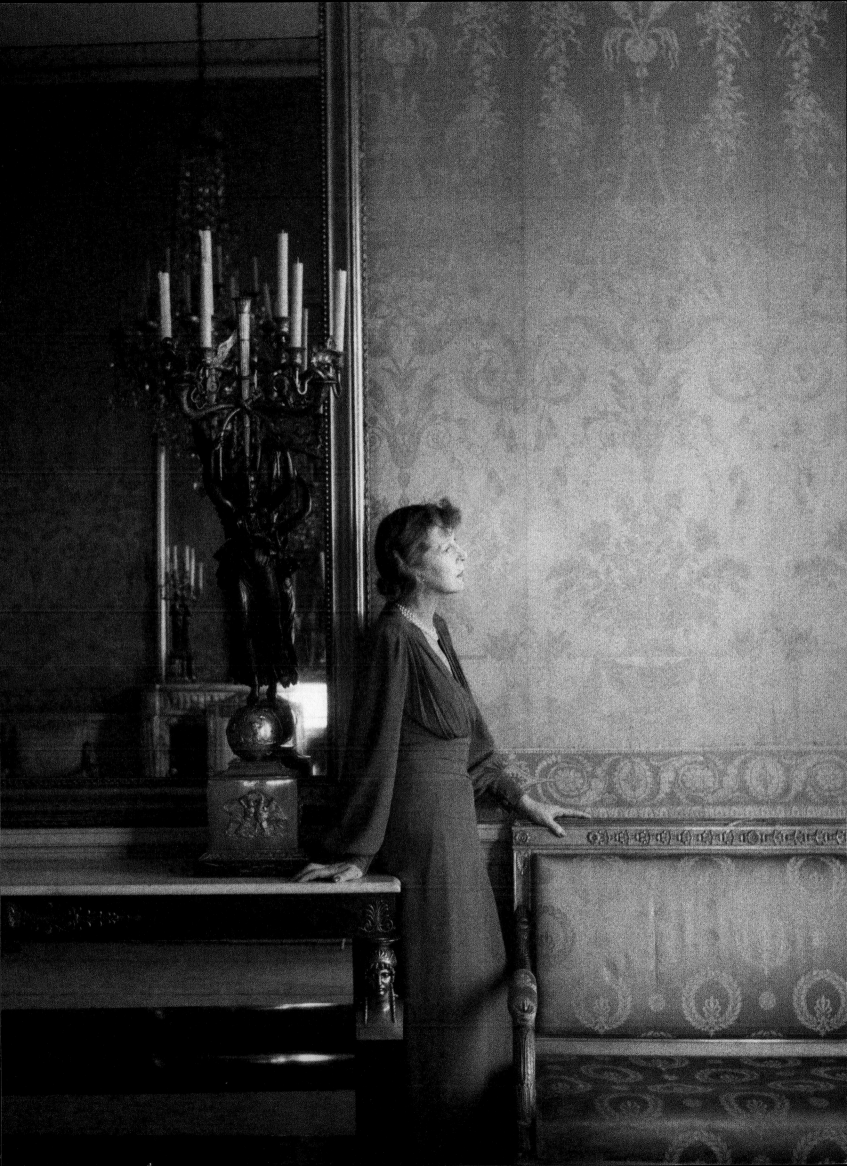

society hostess and celebrity. She also occasionally supported the political activities of her husband, to whom she remained close although their romantic lives followed separate courses. Diana oversaw the decoration of their magnificent house at 90 Gower Street in Bloomsbury, which was to be endlessly reproduced in the glossy magazines—particularly the vast bathroom, with its Chinese wallpaper painted by her mother and inspired by a wallpaper at the family seat of Belvoir Castle. The bright yellow dining room by John Fowler was also to prove highly influential in London interior decoration.

Meanwhile Duff succeeded in regaining his parliamentary seat, which he had lost in 1929, and in 1937 was appointed First Lord of the Admiralty. A prominent critic of Chamberlain's policy of appeasement, he resigned over Munich the following year, returning to serve as Minister of Information under Winston Churchill, before being appointed as government liaison officer with the Free French in Algiers in 1943. With their many contacts in the French authorities and their naturally Francophile tastes, the Coopers were a natural choice to fill the roles of ambassador to Paris and his wife from 1944 to 1947. During this time the ambassador's residence, the Hôtel Borghese on rue du Faubourg-Saint-Honoré, was to host some of the most glittering parties in Paris, as the Coopers passed with effortless ease from London high society to Paris café society, of which Lady Diana was to become a legendary figure. As Jean-Louis de Faucigny-Lucinge remarked, "Diana was famous throughout the world for her wild beauty, her elegance verging on the provocative, and her circle of admirers of all nationalities whom she trailed behind her like a diaphanous Circe."[2]

From her arrival in Paris, Diana had been guided by her friend Cecil Beaton, who introduced her to everyone who was anyone in society and the art world, including Cocteau, Bérard, the Faucigny-Lucinges, the Bourdets, the painter Drian, and the musicians Février and Auric. Together they formed the set that was soon to be joined by Louise de Vilmorin, who had fallen in love with Duff Cooper, and whom—contrary to expectations—Diana loved quite as much, to the point of considering her as her husband's "favorite mistress."[3] Whenever Duff, who also had affairs with Daisy Fellowes, Susan Mary Patten, wife of an American diplomat, Gloria Guinness,[4] and Ghislaine de Polignac, upset Louise, Diana would not only console her but also present a spirited defense of her case to her errant husband.

Diana redecorated some of the rooms at the Villa Borghese, including the famous library, entrusting the work to Terry, Beistegui, and Geffroy, while asking Martin Battersby to refurbish the Château de Saint-Firmin near Chantilly, which she and Duff leased to the Institut de France. It was also the scene of numerous country house parties, with a guest list featuring all the most prominent figures in café society. But in 1947 the Labour government recalled Duff to London. So reluctant to leave were the Coopers that, contrary to the traditions of diplomacy, they decided to continue to live in France for part of the year. In another exceptional development, French *Vogue* marked their departure with an article by Jean Oberlé headlined "Two friends of France" which stressed that, "The 'Duffs' have been great ambassadors for their country, taking their place with ease in the distinguished gallery of 'true Parisians,' that is foreigners who have chosen Paris and who have been adopted in return."[5]

2. Jean-Louis de Faucigny-Lucinge, *Un gentilhomme cosmopolite*, Paris: Perrin, 1990, pp. 192–4.
3. They called her Loulou; she called Diana *Bijou rose* ("Pink jewel") and Duff *Poucet* ("Tom Thumb").
4. Gloria Rubio y Altorre (1912–1980) married successively Count Egon von Fürstenberg, Prince Fakhri, and Loel Guinness.
5. Jean Oberlé, "*Deux amis de la France*," French *Vogue*, 1947.

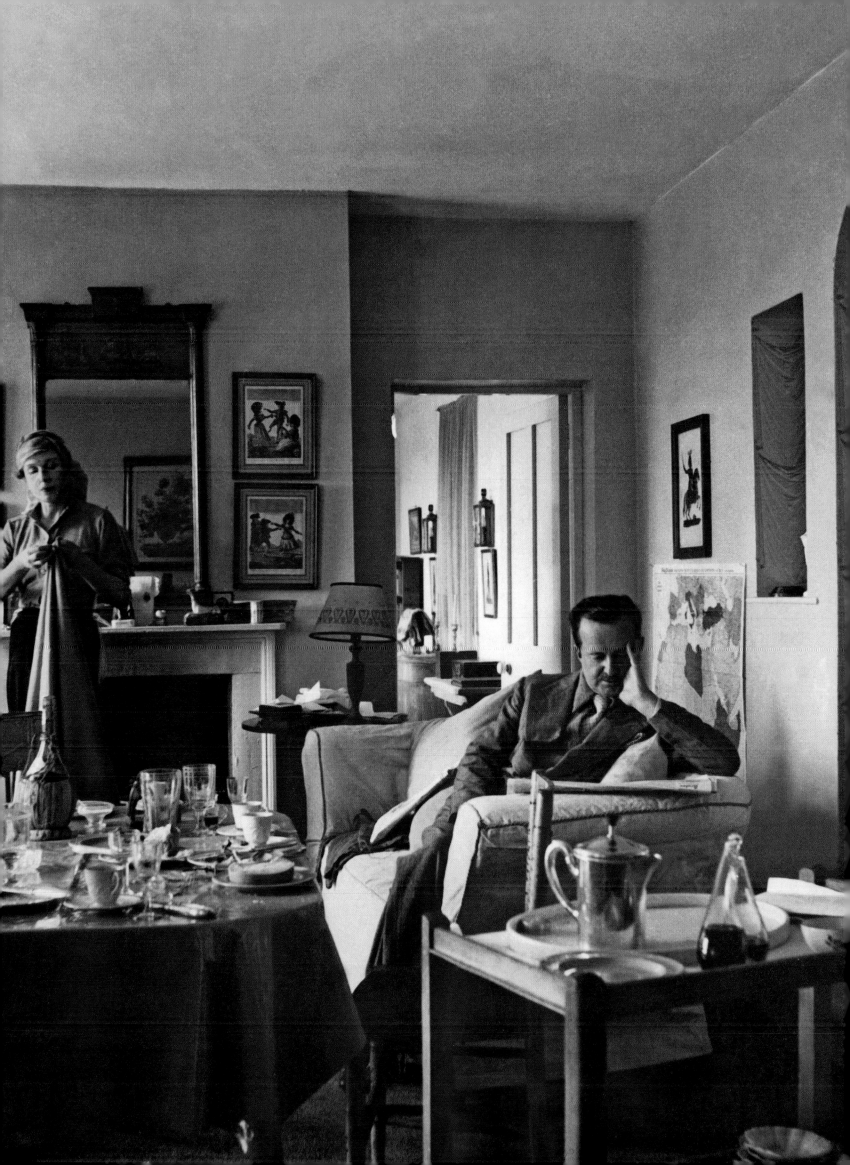

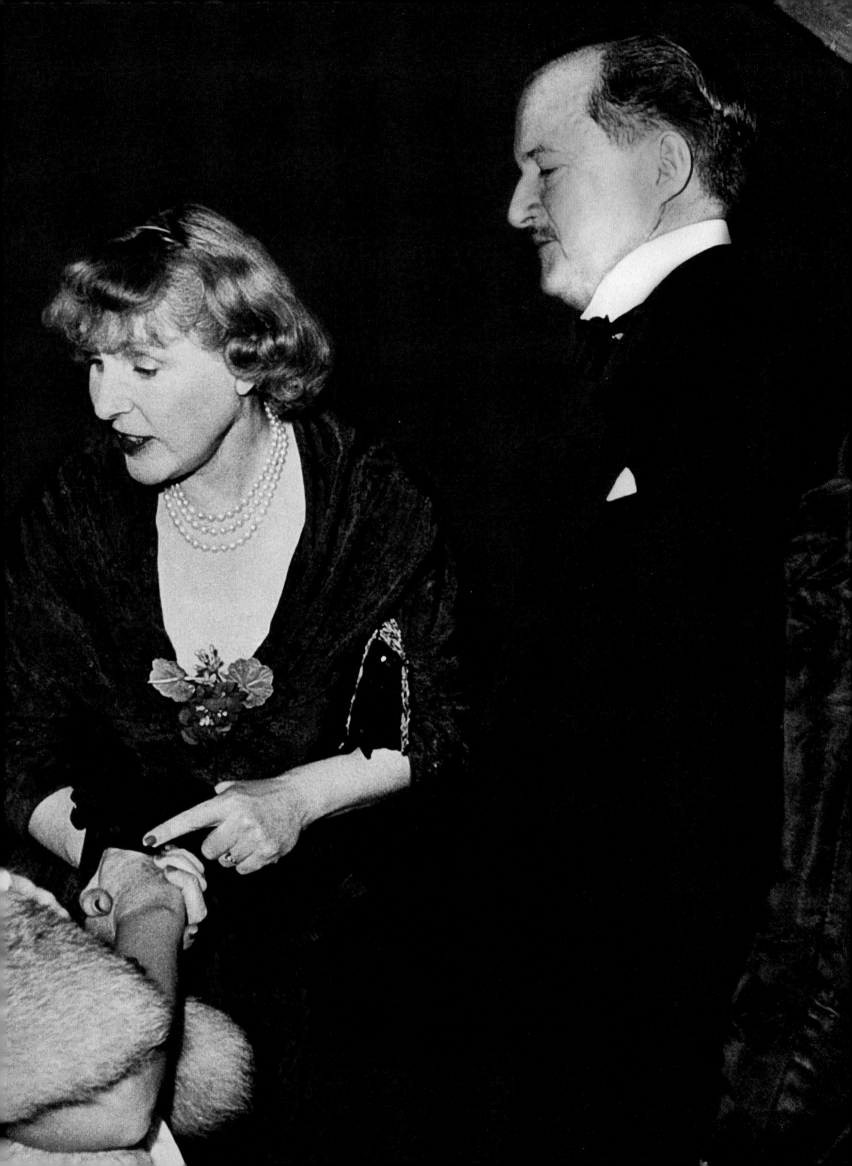

In 1952, Duff was named Viscount Norwich, a title that his wife refused to adopt, claiming that it sounded too much like "porridge." After Duff's death on a cruise in 1954, Lady Diana continued her highly active social life. In her memoirs she left the last word to her friend Cecil Beaton, who had photographed her as a wild and radiant Cleopatra at the Beistegui Ball: "She is an artist in life with countless artistic gifts, a friend with unswerving loyalties, at once business-like, capable, imaginative and full of heartbreak, an eccentric who is frank and outspoken with the knowledge of when not to mention any given subject. Lady Diana, indeed, seems to be a woman with most of the rare qualities."[6]

6. Cecil Beaton, ibid., p. 328.

Natalie Paley

The life of Natalie Paley was marked by exile, both voluntary and involuntary. More than any other figure of the time, she was the embodiment of this essential aspect of café society. Princess Natalie Paley was born in Paris on December 5, 1905, while her family was in exile there after the morganatic marriage of her father, Grand Duke Paul, uncle to Tsar Nicholas II, to the divorcee Olga von Hohenfelsen. The couple chose to move into Princess Yusupov's former residence at Boulogne, where they lived in a social whirl. Dressed by Paquin, Worth, and Poiret, Olga devoted herself to charitable works, threw a party at Biarritz at the end of every summer to which invitations were much coveted, and entertained members of the Paris intelligentsia and Russian artists living in Paris or passing through. Chaliapin and Bakst were members of her close circle, and her husband provided financial backing for Diaghilev's production of *Boris Godunov* in Paris. Natalie therefore spent her early years in an elegant and cultivated milieu, even if they were years of exile.

On the occasion of the tricentenary of the Romanov dynasty in 1912, the Tsar decided to pardon his only living uncle, and Grand Duke Paul returned to favor. Paradoxically, this was to shatter the happy family life that he and his wife had established in the bosom of Paris society. Within a few years of their return to Russia they were caught up in the upheavals of the Revolution, which spared them none of its horrors. The Grand Duke and his son were murdered, but his wife and two daughters escaped, and after a grueling journey managed to reach Paris. Natalie would never forget these years of tragedy, brutality, and flight. Yet her mother was a woman of considerable energies who knew how to make the most of their assets. Selling the large estate at Boulogne, she bought a small *hôtel particulier* at 50 rue de la Faisanderie, in the sixteenth arrondissement, then gave up her finest jewels in order to buy the Balindus estate at Biarritz, the traditional summer resort of the Russian aristocracy. It was there, at a costume ball given by Mme Carlos de Olazabal in the summer of 1924, that Natalie made her debut in society.

In 1927 she married the couturier Lucien Lelong, thirty-eight years old, a hero of the First World War and one of the most prominent figures in Paris society. Although they were not especially well matched as a couple, Natalie's natural elegance combined with Lelong's chic gowns made her one of her husband's star mannequins for some years. Meanwhile the great photographers—Steichen, Beaton, Horst, Durst, and Hoyningen-Huene, whose life had also been turned upside down by the Russian Revolution—adopted her as one of their favorite models for the pages of *Vogue*. Very soon, in addition to these photographers who became her friends, Natalie surrounded

Facing page
Natalie Paley in a Lelong gown. Photograph by George Hoyningen-Huene, published in French *Vogue*, August 1931.

Following pages
Natalie Paley and Charles Boyer in *L'Épervier* by Marcel L'Herbier, 1933.

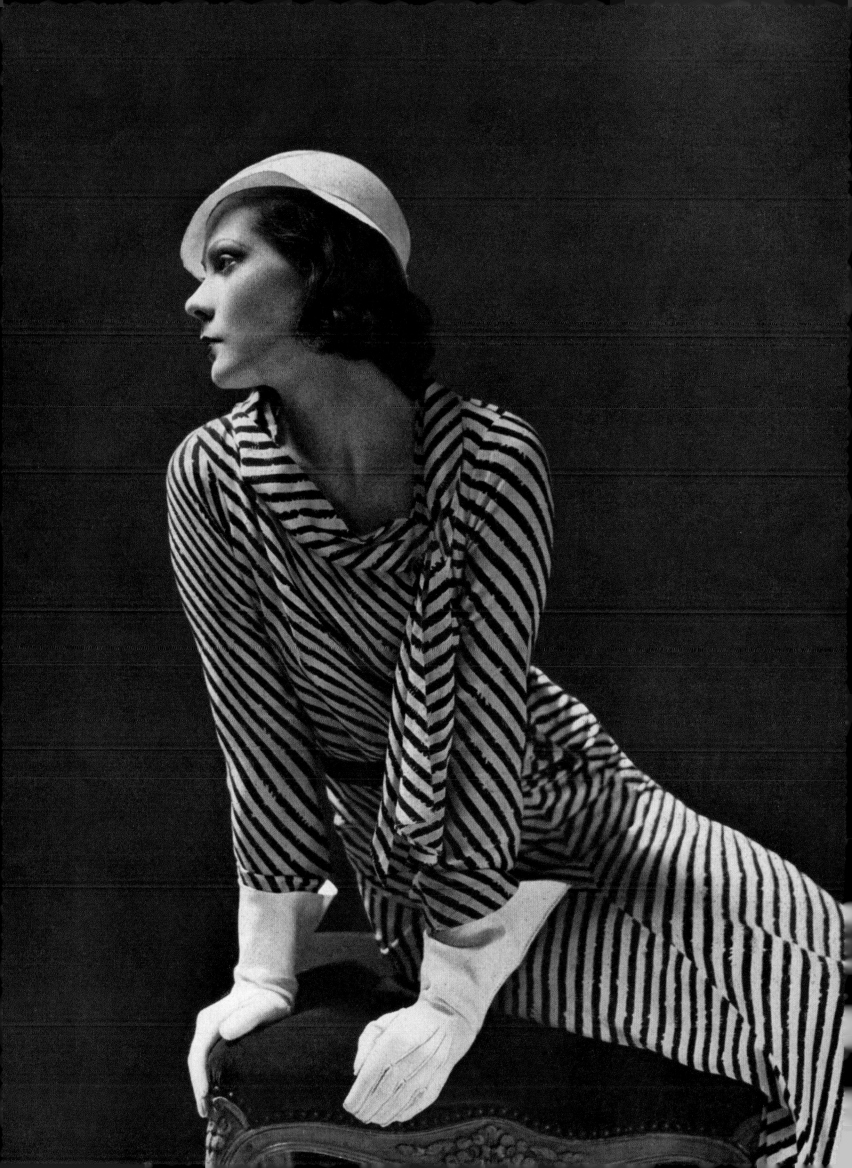

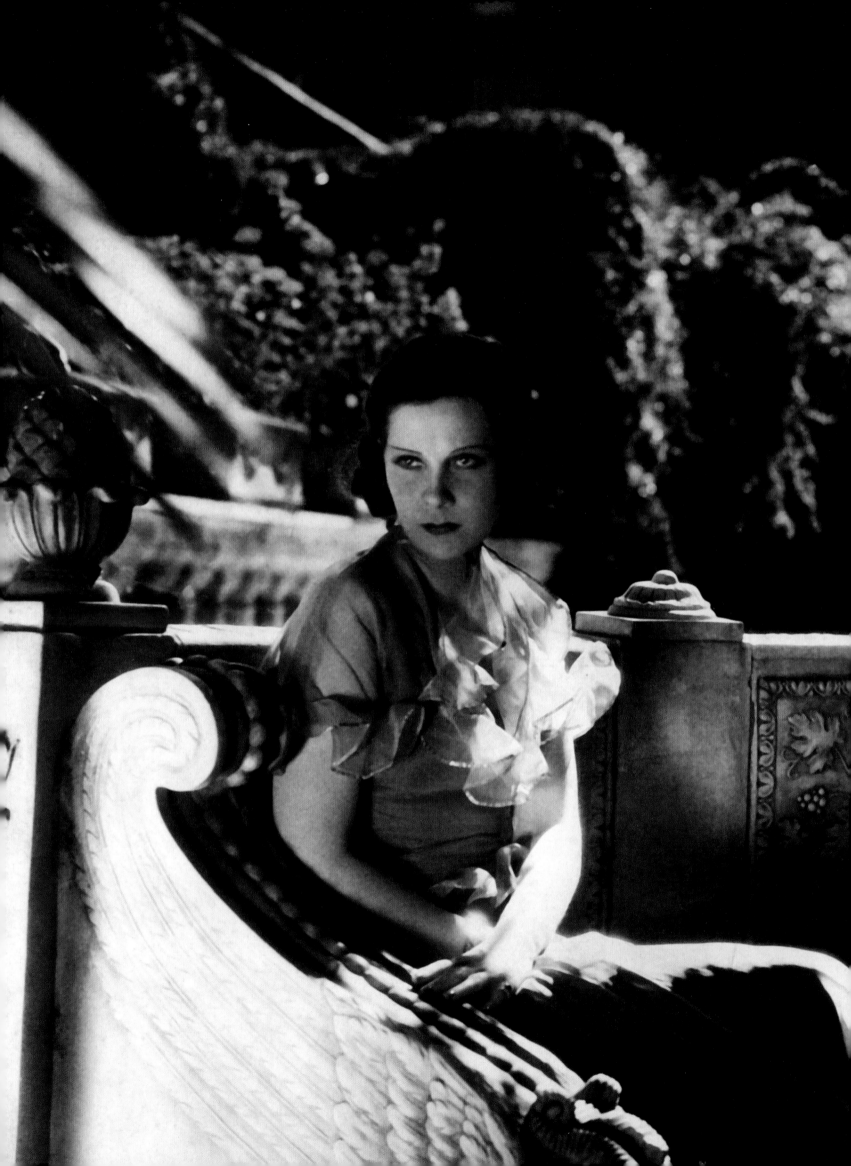

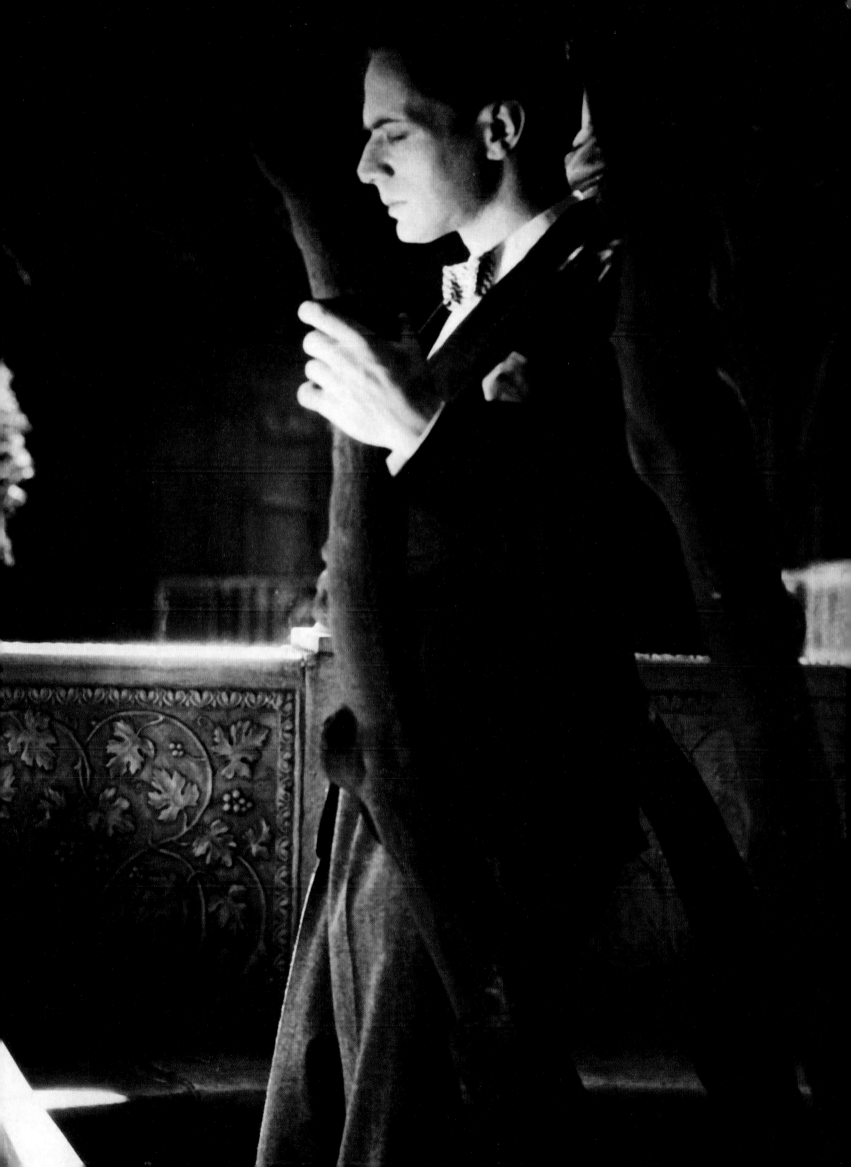

herself with a circle of artists, mostly homosexual, such as Cocteau, Bérard, and Tchelitchew, whose sensibilities accorded perfectly with her own.

An emblematic figure for Lelong, Natalie developed her own—often pared down—notion of chic, and throughout the 1930s exercised a growing influence over the designs of the couture house. She commissioned Jean-Michel Frank and Alberto Giacometti to redecorate its premises on avenue Matignon, and was one of the first to wear the jewelry of Jean Schlumberger and of Fulco di Verdura—who was to become one of her close friends in America. With her circle of friends, who included all the socialites and artists of the nascent café society, Natalie led a dizzying social life. The domestic arrangements of the Lelong household were strictly in conformance with the tenets of café society. The couturier was madly in love with one of his star mannequins for years, until she died of tuberculosis, while Natalie presided over a throng of admirers including among others Luchino Visconti, Salvador Dalí, and especially Serge Lifar. As Jean-Louis de Faucigny-Lucinge noted, "A chilly-natured seductress, she accepted their declarations of love unfettered by sex."[1]

United by their Slav roots and a commemorative ceremony at the tomb of Diaghilev at San Michele in 1930, Natalie and Serge Lifar were inseparable for over two years. But this chaste passion was rudely interrupted by the bombshell that exploded when Natalie was introduced by Marie-Laure de Noailles to Jean Cocteau, causing shock waves to ripple through the select ranks of café society. No one knows whether their affair was consummated, but this did not prevent Marie-Laure from taking umbrage at what she saw as her betrayal by two of her closest friends, especially as she herself had held a torch for Cocteau in her youth, but had been forced to renounce him in the face of his exclusive homosexuality. This return to rather more conventional tastes for Natalie's sake unleashed a violent inner crisis in Cocteau, to which he gave literary expression in *La Fin du Potomak*. In a letter to him, Marie-Laure gave a perceptive description of Natalie's psychological make-up: "She is made to be loved and not to love, she is an exotic plant that in order to thrive must have praise, flattering mirrors, and chandeliers. She knows it. Here all the men are at her feet. She is protected by her love for you and by the fact that she is a masterpiece."[2] Natalie's marriage to Lelong was not to survive her break-up with Cocteau, though she continued to work with his couture house after their divorce.

Hardly had her divorce been pronounced in 1935 than Natalie announced her remarriage to the theater producer John Chapman Wilson, six years her senior. Wilson proved to be another ornament on the list of Natalie's amours. Though his principal claim to fame lay in having been the lover of Noël Coward, he had also had numerous other liaisons, including a celebrated affair with interior decorator David Herbert. He and Natalie nevertheless lived together in harmony for many years, living between New York (on East 57th Street and Park Avenue) and Connecticut, until at last alcohol got the better of him.

In New York, Natalie re-created her life in Paris society, seeking out friends who had emigrated and Russian exiles including her half-sister Grand Duchess Marie, now a fashion journalist; Prince Serge Obolensky who, having married an Astor, was responsible for public relations for The Plaza; not to mention Horst, Blumenfeld, Marlene Dietrich, Erich Maria Remarque, and more. Then she put the skills she had

1. Jean-Louis de Faucigny-Lucinge, *Un gentilhomme cosmopolite*, Paris: Perrin, 1990, p. 136.
2. Letter from Marie-Laure de Noailles to Jean Cocteau, September 31, 1932.

learned at Lelong at the service of the couturier Mainbocher. Left a widow in 1961 by a man who had been dropped by Broadway because of his alcoholism, she gradually withdrew from the society life in which she had played such a major part, barely leaving the house as she aged for fear of puncturing the image that had been so dear to her admirers. She died, sightless, in December 1981.

Right
Natalie Paley and Serge Lifar
in Venice, 1930.

Count and Countess Pecci-Blunt

"An oddly assorted couple, the Peccis. He, Jewish American, Blumenthal become Blunt, is then transformed, having married a niece of the Pope (Mimi), into Count Pecci, valet to the Pope. He stopped selling Blunts ('Don't shut the door, the Blunt will take care of it'). The Blunt opened up Roman society for him." So reported Paul Morand in his *Journal inutile* entry for April 24, 1974. Donna Anna Laëtitia Pecci, known as Mimi, was born into an illustrious Roman family in 1885. Her father, Count Camillo Pecci, was Commander of the Noble Guard at the Vatican and son of the youngest brother of Pope Leo XIII. Cecil Blumenthal was heir to the leather manufacturing fortune of a Jewish family from Frankfurt who had emigrated to the United States in 1875. Although he lived in New York, his father also possessed a Paris residence at 34 avenue du Bois-de-Boulogne, as well as an outstanding collection of nineteenth-century paintings including works by Corot and the Barbizon School.

In 1919, Cecil Blumenthal married Anna Pecci, and was given permission by the Pope to take the title of count and to change his name to Blunt. The name Pecci-Blunt duly replaced that of Malatesta on the pediment of the family palazzo of Ara Coeli in Rome. The couple had five children, including a son Dino who attended the Institut Le Rosey with Alexis de Redé, and a daughter Graziella who would marry Henri de Beaumont, nephew of Étienne. In many respects, the Pecci-Blunts were to Rome what the Noailles were to Paris. Great collectors, they were also passionate about avant-garde art. Thus Mimi opened a gallery in Rome to show the work of young contemporary artists, calling it La Cometa. In 1933, she inaugurated the Concerti di Primavera, which would see performances by Stravinsky, Hindemith, Milhaud, Poulenc, Sauguet, Auric, Honegger, and Markevitch. Some years later, in 1955, the American composer Ned Rorem was to present the world premiere of his *War Scenes* in Mimi's palazzo.

Mimi was also the owner of an *hôtel particulier* on rue de Babylone in Paris, where she threw magnificent balls, including the famous bal Blanc, or White Ball. Like many other couples in café society, the Pecci-Blunts were united in their love of art and parties but were otherwise less well suited. At a dinner in the 1930s, the Count was bowled over by a footman by the name of Cecil Everley, who not long before had had an affair with Arturo Lopez. From that point on and for many years to come, Pecci-Blunt followed the Chilean millionaire's example in dividing his time between his wife and Everley, for whom he bought a New York apartment and a superb villa on Cap d'Ail. The two men also shared a ranch at Santa Barbara that was never visited by Mimi, who became known as "la reine des deux Cecils." This double life continued until Pecci-Blunt's death in 1965, when he left his lover enough of his fortune to ensure that he could continue to live in style. Meanwhile Everley had turned his hand to painting, taking advantage of his social contacts to sell a number of his canvases. Diehard snobs could not resist the odd cutting remark, however.

Facing page
Countess Pecci-Blunt at
a lunch given at the Auteuil
races, 1938.

The Duke and Duchess of Kent

With the exception of their cousin the Duke of Windsor, the Kents were the only members of royalty also to be regular members of café society. Renowned for her beauty, charm and elegance, Princess Marina (1906–68) was much photographed, not only by her friend Cecil Beaton, but also by Horst and Hoyningen-Huene, for *Vogue* and *Harper's Bazaar*. The daughter of Prince Nicholas of Greece and Denmark and Grand Duchess Elena of Russia, in 1934 she married her cousin George (1902–42), fourth son of George V, a career officer in the Royal Navy who also designed jewelry and furniture.

The private life of Prince George was a subject of eager speculation. Rumors were rife of his addictions to cocaine and morphine, and of his numerous liaisons with lovers of both sexes, including the future Duchess of Argyll, his distant cousin Prince Louis Ferdinand of Prussia, and, when he was nineteen, Noël Coward. He died on active service on August 25, 1942, when the flying boat in which he was a passenger crashed in mysterious circumstances. At his death his younger son Michael was just six weeks old.

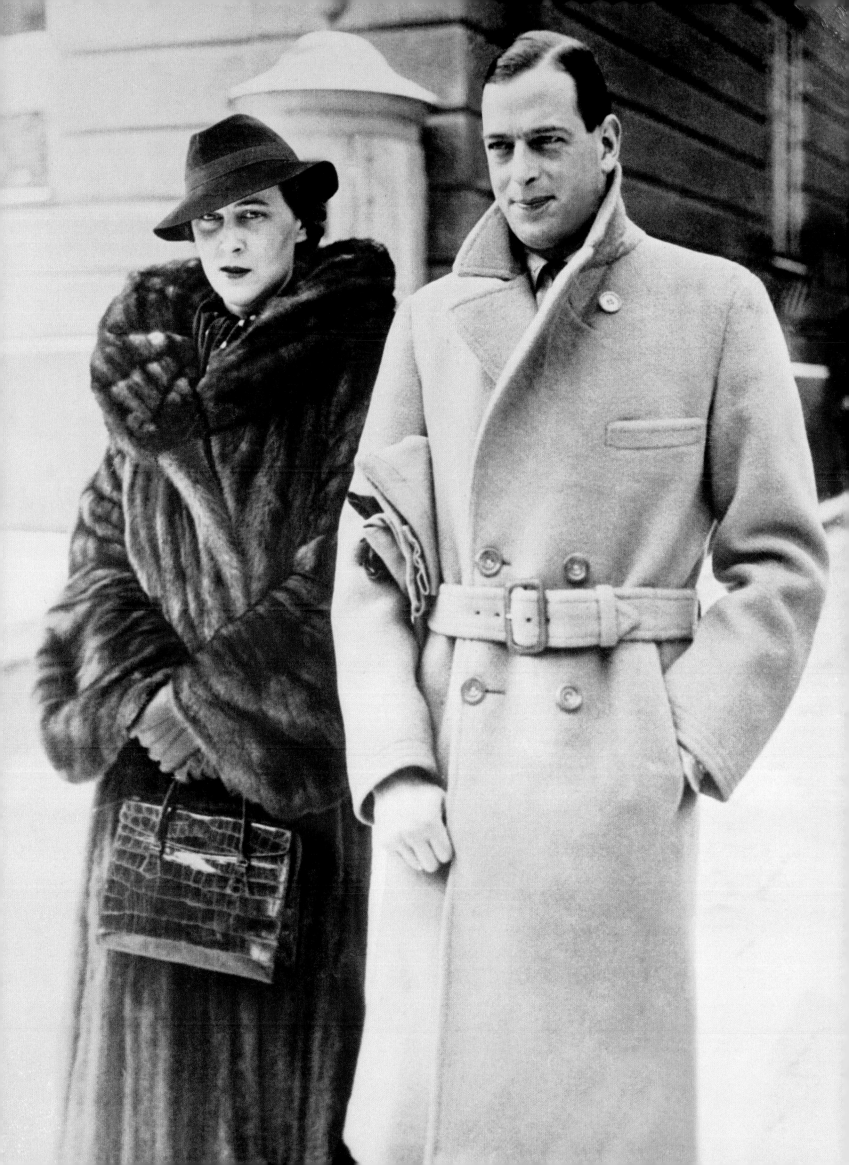

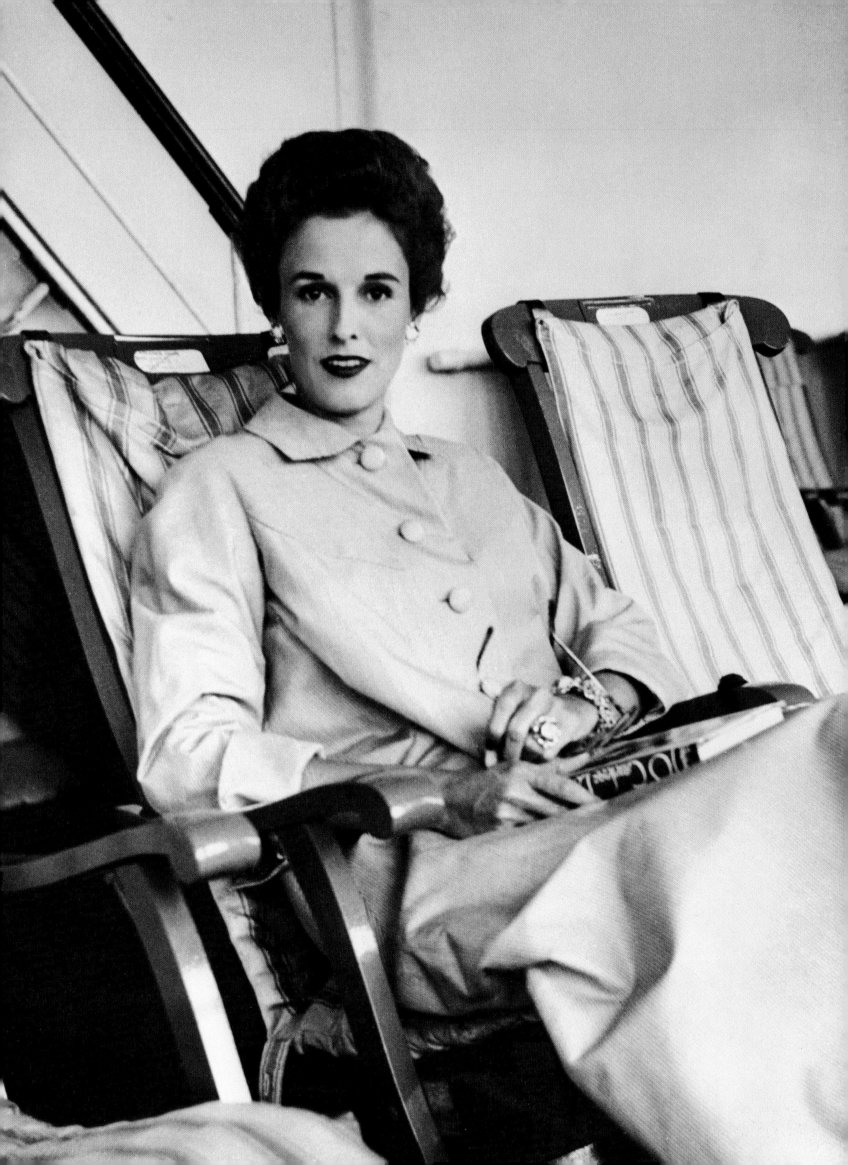

Millionaires and Wealthy Americans

With the emergence of café society, a new breed of arbiters of taste arrived center stage: millionaires, occupying the middle ground between an aristocratic style of life and a social background that was solidly middle class. Presiding over colossal fortunes, they rarely—with very few exceptions—took a direct hand in the management of their business affairs, and on the whole had not had to work for their inheritance, or at least not in any conventional manner. As a result, their relationship with money was remote, and they tended to share the attitudes of the aristocratic elite: as far as they were concerned money was meant to be squandered in lavish style, flying in the face of the thrifty virtues famously espoused by François Guizot. Idleness, frivolousness, aestheticism, and patronage were their watchwords. Having inherited their wealth from earlier generations, many of these plutocrats were well equipped to lead the life of the idle rich.

This was certainly the case with prominent South Americans such as Beistegui and Lopez-Willshaw, alongside North Americans such as Barbara Hutton and Edward James. Others, usually women, married into wealth. Mona Bismarck was a textbook case, working her way through successive nuptials until she managed to cast off all financial cares. But the men were not to be outdone: through his marriage to a Rockefeller heiress the Marquis de Cuevas secured the means of maintaining his sumptuous lifestyle, while also nourishing his artistic fantasies by financing ballet companies for whom nothing was too beautiful or too expensive. Alexis de Redé, meanwhile, extracted from his liaison with Arturo Lopez the means to play the part of a munificent benefactor, while at the same time contriving to increase not only his own wealth but also that of his protector. Some businessmen, such as Paul-Louis Weiller in France, were so slavishly in thrall to high society that they forsook their well-established middle-class status in order to join in the seductive games of café society. In Britain the most remarkable example of this phenomenon was Henry "Chips" Channon, businessman, politician, social climber *par excellence,* and chronicler of his time through his notorious diaries.

Among millionaires, one subspecies deserves particular mention: the wealthy American wife. With husbands who were rich as Croesus and a way of life that was the stuff of dreams, these elegant ladies were frequently photographed for the pages of fashion magazines. They were not patrons of the arts like Peggy Guggenheim and Mona Bismarck, nor were they quite as extravagant as Barbara Hutton, though like her they were often beautiful and neurotic. Their number included Pauline Potter and Millicent Rogers, as well as Truman Capote's "Swans": Gloria Guinness, Slim Keith, Babe Paley, and C.Z. Guest.

Pauline Potter was born in 1908 in Paris, although her parents were Americans from Baltimore, the city that also gave café society Wallis Simpson. Her wealthy background depleted by numerous financial and conjugal setbacks, Pauline had to take herself in hand in order to satisfy her dreams of riches, as she explained to her friend the interior decorator Billy Baldwin, who helped her throughout her life: "A young woman must be a debutante in Baltimore and a young married woman in New York City. An old woman must marry a European, preferably in Paris, and live the rest of her life there."[1] Her first marriage took place in New York, nonetheless, thanks to Billy Baldwin, who introduced her to his friend Fulton Leser, an art restorer at the Frick Collection who was, alas for her, an alcoholic and homosexual. When he lost his job in the Depression, Pauline moved to Majorca and opened a shop selling local craftwork. Then she separated from Leser, who returned to the States, and went to Paris, where she attracted the attention of Schiaparelli, who offered her a job. At the outbreak of war she went back to New York, where Louise Macy, an editor at *Vogue*, was opening her own couture house and recruited her as a designer, while Nicky de Gunzburg opened his address book to attract clients. After this she worked for Hattie Carnegie, so sealing her reputation as a woman of taste. In New York Pauline became celebrated as a hostess, entertaining a great deal in her apartment adorned with Louis XVI furniture.

With her strange, haunting beauty, Millicent attracted attention in the highest places. When he toured the United States, the Prince of Wales fell under her spell.

Among the masculine sex, her impressive string of conquests included a former Russian grand duke, a handful of diplomats, and John Huston. Then one evening in 1950 she met Philippe de Rothschild, then held to be the "character" of the family, passionate about sport, art, and wine. Together they set about putting the Mouton-Rothschild vineyard back on its feet, and restoring and decorating the chateau and bringing it back to life. In all these areas Pauline excelled, to the point that in 1962 her friend Diana Vreeland proposed that they should work together on a piece for *Vogue*, for which Horst was to take the photographs. When they were in Paris, Philippe stayed in his *hôtel particulier* on avenue d'Iéna, while Pauline decorated a large apartment for herself on rue Méchain. She died of cancer in 1976.

The life of Millicent Rogers followed a very different course. Her grandfather Henry Huttleston Rogers was a Wall Street magnate and partner of Rockefeller in Standard Oil. Her parents were an intellectual couple, cultured and elegant, who divided their time between New York and a charming Tuscan-style villa on Long Island, while sometimes renting a Scottish castle for the holidays. Family life was well balanced and well rounded, and Millicent grew up with a solid grounding in culture and the arts. Her mother maintained a correspondence with Mark Twain that was to be published under the title *To Mary, from Mark*. The young Millicent learned French, German, Spanish, Latin, and Greek, and later

Page 70
Babe Paley in New York, 1953.

Facing page
Millicent Rogers. Photograph by John Rawlings published in American *Vogue*, March 1945.

Following page
Pauline Potter, future Baronne Philippe de Rothschild, in the drawing salon at Petit Mouton, her country house. Photograph by Cecil Beaton, c. 1956.

1. Annette Tapert and Diana Edkins, *The Power of Style*, New York: Crown Publishers, 1994, p. 124.

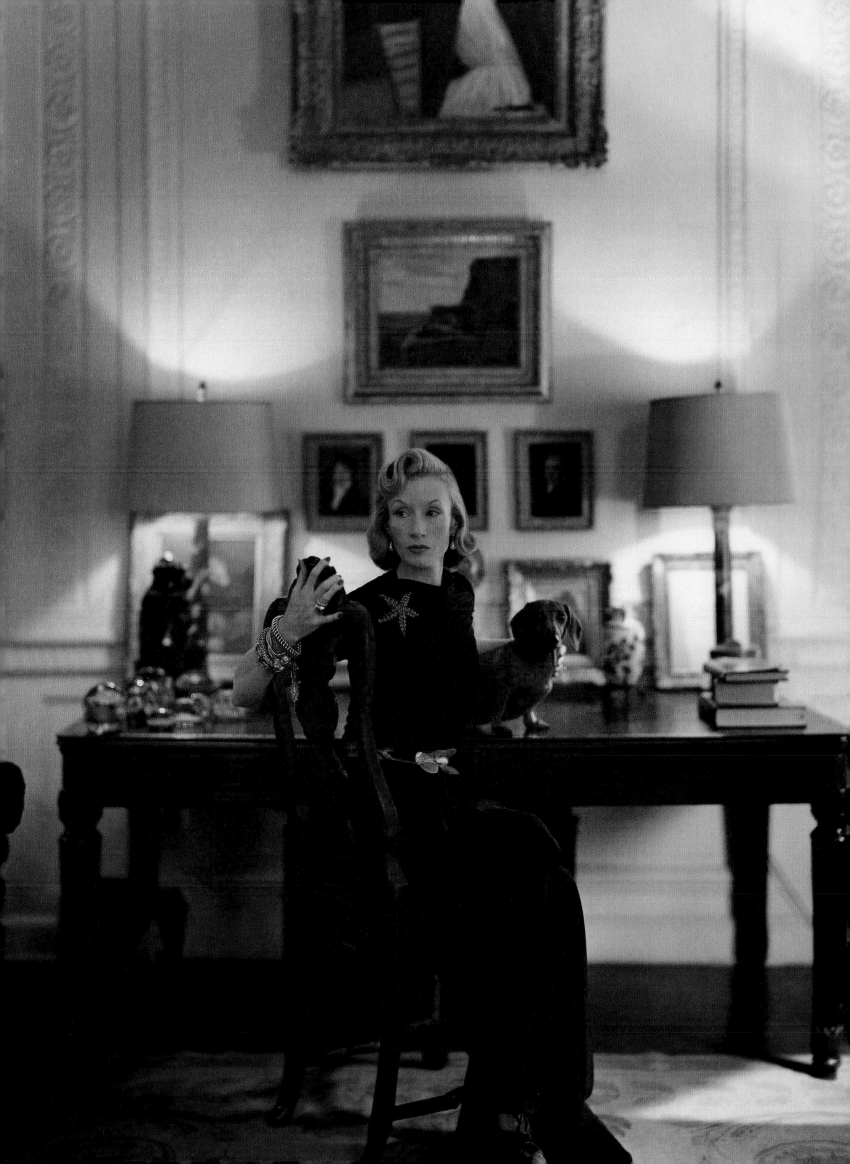

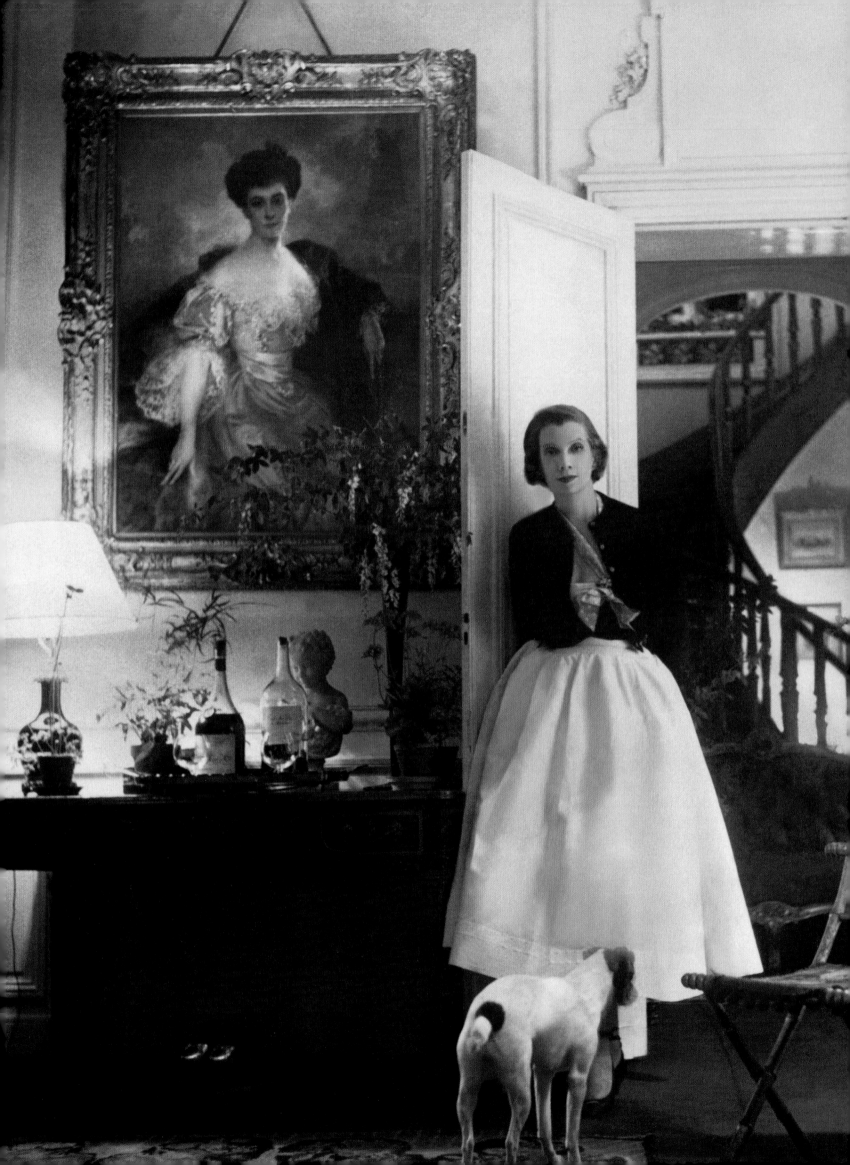

she translated Rilke. With her strange, haunting beauty, Millicent attracted attention in the highest places. When he toured the United States, the Prince of Wales fell under her spell. Soon afterward Prince Serge Obolensky, one of the most prominent Russian figures in New York society, divorced his wife for her. Then the Duke of Aosta, youngest son of the King of Italy, asked for her hand in marriage—but Millicent turned him down, as financially the law would not have been in her favor.

Finally she fell in love with the Austrian Count Ludwig Salin-Hoogstraten, a tennis champion, antique dealer when the fancy took him—and above all dowry hunter. Millicent married him in a secret ceremony at the age of twenty-one and went to live in Europe, her father having virtually withdrawn his financial support. Though short-lived, the marriage produced a son. Soon afterward Millicent married again, this time to a wealthy Argentinean aristocrat, Arturo Peralta Ramos, in a ceremony that took place at her father's house at Southampton. From this union, also brief, two sons were born. A third marriage followed, to the New York stockbroker Ronald Balcom. Once again she moved to Europe, living in Switzerland and Austria until the outbreak of war, before divorcing again in 1941. Right up to her death, Millicent cultivated her own style, which was to prove influential in the fashion world. She engaged in a real dialogue with the couturiers who dressed her, such as Schiaparelli and Mainbocher, and worked in virtual partnership with Charles James, whom she considered as an architect or sculptor rather than a couturier. As her health gradually deteriorated, Millicent Rogers lived increasingly in New Mexico.

Although she never lived a hectic life in society, Millicent was frequently photographed for *Harper's Bazaar* or *Vogue* because of her inimitable sense of style, which was greatly admired by Diana Vreeland among others. When it came to launching trends she had no equal. During her Austrian period she brought the Tyrolean influence into vogue, inspiring Wallis Simpson to commission a Tyrolean-style costume from Schiaparelli and Baba de Faucigny-Lucinge to open a shop in Paris selling Austrian clothes. She also influenced jewelry through the many commissions she gave to Boivin, Verdura, and Cartier, and interior decoration through her residences in New York, Virginia, and New Mexico. In New Mexico, where she was to die in 1952, she became imbued with the work of local native Americans, whose style was to influence her taste in both clothes and decoration.

Capote's Swans, icons of style and fashion, reigned over post-war New York. In a way, Gloria Guinness, Slim Keith, Babe Paley, and C.Z. Guest marked the beginning of the end of café society. Among these influential figures, it was undoubtedly Gloria Guinness who best embodied café society. Born in Mexico of uncertain pedigree—she liked to cultivate the enigma of her origins—she contracted a series of prestigious marriages, deploying her beauty, style, and personality to ensnare first of all Count Egon de Fürstenburg, then the Egyptian Prince Ahmed Fakhri, and finally, in 1951, Loel Guinness, an immensely rich British Member of Parliament. Living mostly in the States, she was also a highly visible figure in Europe, where she had an affair with Duff Cooper in Paris. Her three friends and rivals marked the end of an era in that they lived essentially in the United States, and while they dressed in Paris they also went a great deal to American fashion designers such as Claire MacCardell, Mainbocher, and Charles James. All close friends of Diana Vreeland, they became new style icons for *Vogue* and *Harper's Bazaar*, and established the emergence of American chic.

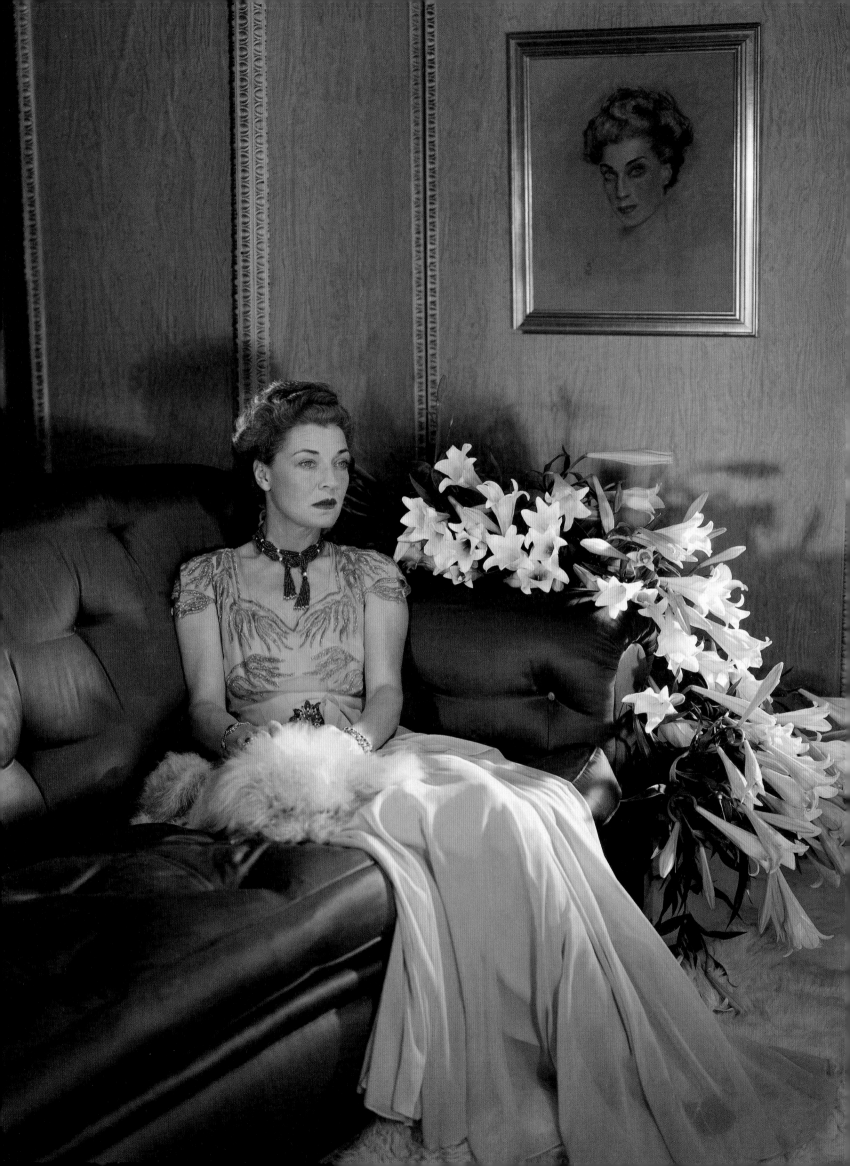

Mona Bismarck

How many people now remember the name of Mona Harrison Williams? A handful of art lovers, at the very most, will recognize the name attached to the foundation now housed in her *hôtel particulier* on avenue de New-York in Paris. Yet the woman who was born Mona Travis Strader, in Louisville, Kentucky in 1897, was for nearly six decades one of the most talked-about figures in international society and artistic life, a great beauty described by her close friend Cecil Beaton as a "rock-crystal goddess." Mona was one of those supremely wealthy Americans who felt more at home in Europe than in the United States—even if, however far from home, they always remained unmistakably American.

Mona's life was like a fairy story that ended as a bad B movie. It consisted above all of her marriages. Like many other wealthy American women, Mona married several times (five in all), which—on the first three occasions anyway—made her even wealthier. At the age of twenty, she married the owner of the farm managed by her father. Eighteen years her senior, Henry Schlesinger was also the richest man in Wisconsin. They lived together for three years in Milwaukee, had a son, Robert, and divorced. A year later, Mona married James Irving Bush, who was both rich and handsome but also an alcoholic. She divorced him in 1924. Mona then moved to New York, where she lived in lavish style, funded by generous alimony payments. This, combined with her beauty and natural elegance, ensured her an enviable place in society. In 1926 she met and married Harrison Williams, a widower who was twenty-four years her senior. This multi-millionaire from Ohio, known as the "utilities king of America," had built one of the largest fortunes in America partly on the expansion of the electricity supply network. From her marriage until her husband's death in 1953, Mona was to enjoy a life of unrivaled luxury, dividing her time between a thirty-room mansion on Fifth Avenue in New York; a thirty-hectare estate with private golf course at Bayville, the most exclusive part of Long Island; a villa at Palm Beach; and an astonishing villa and gardens on the island of Capri. She and her husband relaxed on the largest private yacht in the world, the *Warrior*, equipped with a dozen suites, a crew of forty-five, and a tennis court.

After her husband's death Mona did not wish to stay single, and a few months later she married the man who since the late 1930s had been her faithful escort whenever her husband had been detained on Wall Street, and who had decorated her villa on Capri: Count Edward von Bismarck, known as Eddie, grandson of the Prussian Chancellor Otto von Bismarck. Four years her junior, Eddie was a playboy of slender means between the wars who had nevertheless earned the respect of his peers for his wartime courage. According to Eddie, the couple first met in Venice, where he was staying on a yacht moored near the *Warrior*. Mona's great friend Jean-Louis de Faucigny-Lucinge tells a different version of

the story in his memoirs: "On the Piazzetta (on Capri), a young blond man came up to me and asked, 'Could you introduce me to Mrs. Williams?'... From that moment, [Eddie] never left Mona's side ... Harrison Williams was delighted that someone was looking after his wife and not at all jealous of Eddie, who while utterly devoted to Mona did not conceal his leanings, which were those of the Great Frederick. Only the war sundered this tolerant trio for a time. When Mona was widowed, Eddie naturally proposed that she should become Countess von Bismarck, a suggestion she accepted out of charity as she thought he was dying,[1] though was doubtless also happy to add a noble title to her finery."[2] The couple were to spend thirteen years living between the Villa Fortuno on Capri, the Hôtel Lambert, and the mansion on avenue de New-York in Paris.

Who was this woman who, unlike so many American multi-millionaires of the time, was not simply a collector of husbands or diamonds . . . ?

The death of her fourth husband was to leave this glittering, frivolous woman distraught. The descriptions Cecil Beaton gave in his diaries showed a widow who seemed lost and had suddenly become an old woman. This was doubtless the explanation for her fifth and final marriage to Umberto di Martini, the doctor who had cared for Eddie in his last months, and who was her junior by twenty years. The marriage lasted from 1971 to 1979, when he was killed in a car accident, as described by Jean-Louis de Faucigny-Lucinge in characteristically caustic terms: "Flung from his car when a tire burst, he shattered his skull on a rocky river bed. The Italians cruelly dubbed him 'Martini on the rocks.'" With his death, the painful truth about his financial exploitation of Mona and a complicated parallel life emerged. Her only son, with whom she did not get along, now also reappeared to darken Mona's last years, living a life of debauchery while trying to lay his hands on her money.

What was it that made Mona Bismarck so special? Who was this woman who, unlike so many American multi-millionaires of the time, was not simply a collector of husbands or diamonds, and who inspired the legendary figure of Kate McCloud in Truman Capote's *Answered Prayers*? Unlike the flamboyant stars of café society, she left no legacy of bons mots or shafts of wit. On the other hand, she was a woman of exquisite taste. According to Cecil Beaton: "One of the few outstanding beauties of the thirties was Mrs. Harrison Williams, who represented the epitome of all that taste and luxury can bring to flower. Her houses, her furniture, her jewellery, her way of life were little short of a *tour de force*. She herself was and is today a *chef-d'oeuvre*, breathing a rarefied air of mystery...."[3] Her taste

Facing page
Mona and Edward Bismarck in the Chinese salon of their Paris residence. Photograph by Cecil Beaton.

Page 83
Mona Harrison in her villa on Capri. Photograph by Cecil Beaton, 1959.

1. Eddie was suffering from cancer.
2. Jean-Louis de Faucigny-Lucinge, *Un gentilhomme cosmopolite*, Paris: Perrin, 1990, pp. 126–7.
3. Cecil Beaton, *The Glass of Fashion*, London: Weidenfeld and Nicolson, 1954, pp. 185–6.

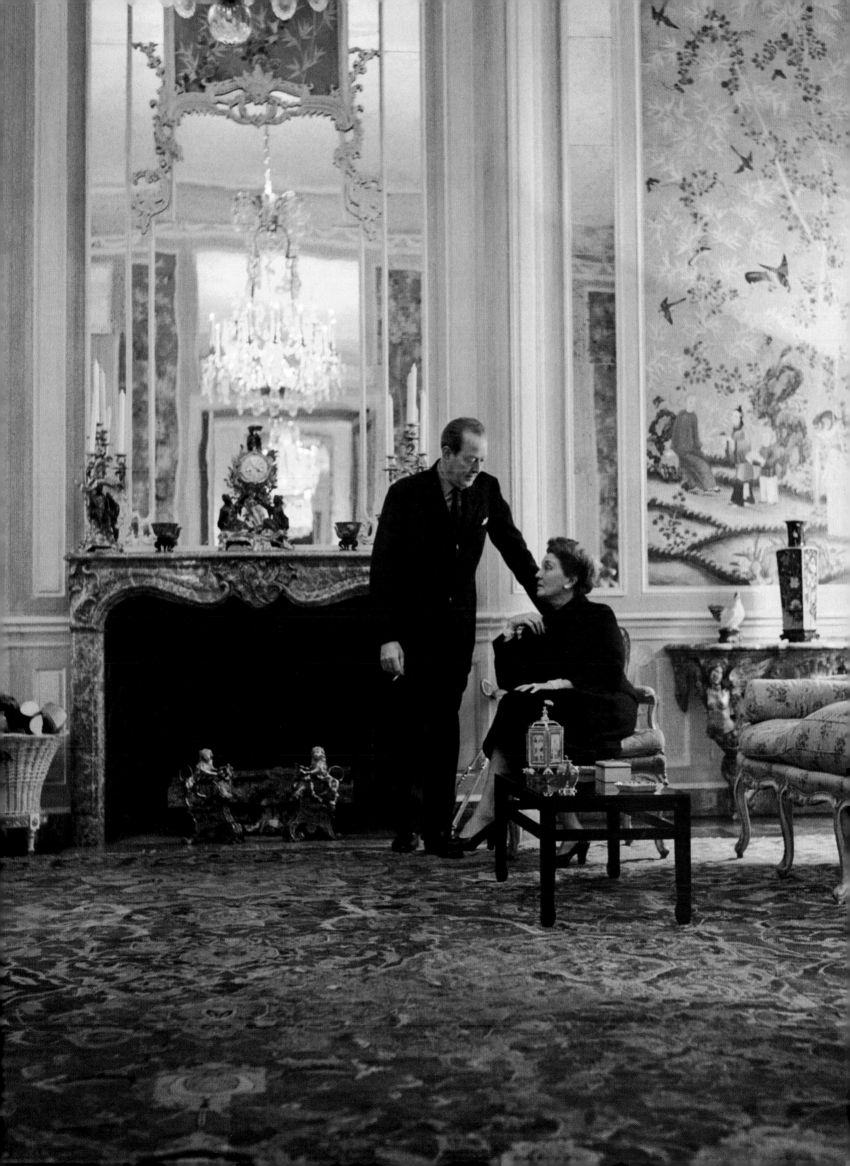

first made its mark in the world of fashion. In 1933, Chanel was a member of the panel of Paris couturiers who named her the "world's best-dressed woman." And in his 1936 musical *Red, Hot & Blue*, Cole Porter, whose wife Lee was one of Mona's close friends, included the lyric: "What do I care if Mrs. Harrison Williams is the best-dressed woman in town?"

Mona Bismarck's elegance was due largely to Cristóbal Balenciaga. She was one of the couturier's most important clients: the catalog to an exhibition devoted to Balenciaga at the Fondation Mona Bismarck lists 88 orders in 1963, 70 in 1964, much the same in 1965, and 55 in both 1966 and 1967. When a friend called her in Capri the following year to tell her that Balenciaga had closed his couture house, she is said to have taken to her bed for three days in despair. In her last years she was dressed by Hubert de Givenchy, who became a friend. On her death, she bequeathed her collection of gowns to the Metropolitan Museum of Art in New York, to the great joy of Diana Vreeland. Her fabulous jewelry collection, by contrast, was dispersed and sold by Sotheby's in Geneva in a sale which, in a final irony, saw her rivaled one last time by the other American byword for elegance in café society, Wallis Simpson.

Mona was also famed for her fabulous gardens, which she created at her various American residences and above all at her villa on Capri. Here from 1936, the year in which she and her husband bought this exceptional site—containing not only the ruins of the Emperor Augustus's summer palace but also those of a true imperial palace built for Tiberius— she gave free rein to her talents. She restored the palace perched on its rocky cliff, built numerous houses for guests and servants, and above all laid out Mediterranean gardens on a vast scale. Charming in Balenciaga shorts, she personally oversaw the work of an army of gardeners.

With her characteristic sense of style, as Mona felt age and illness diminishing her strength and withering her peerless charm, she gradually withdrew from the social scene and forsook Capri. She died in her Paris mansion in 1983, surrounded by a few faithful friends, including Walter Lees. The purpose of the foundation that is now housed there is not so much to perpetuate her name as to provide support for artists and to encourage Franco-American relations.

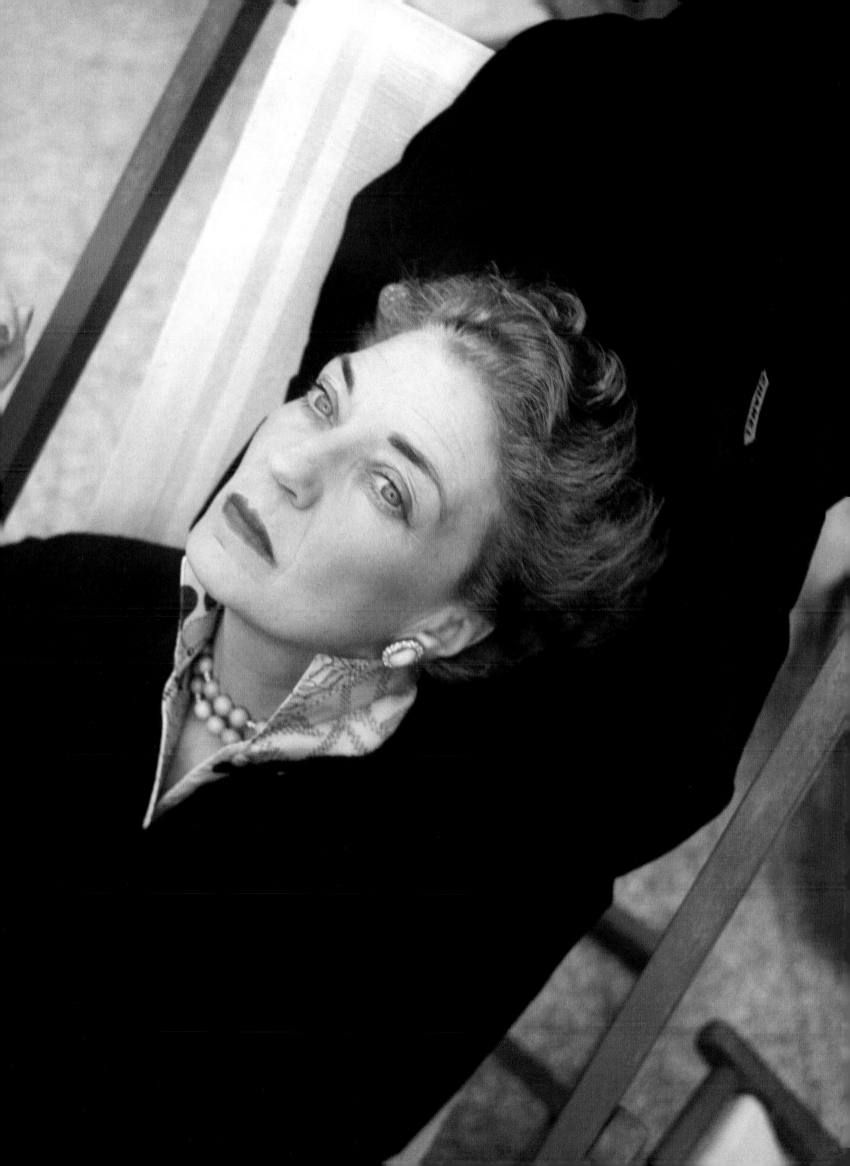

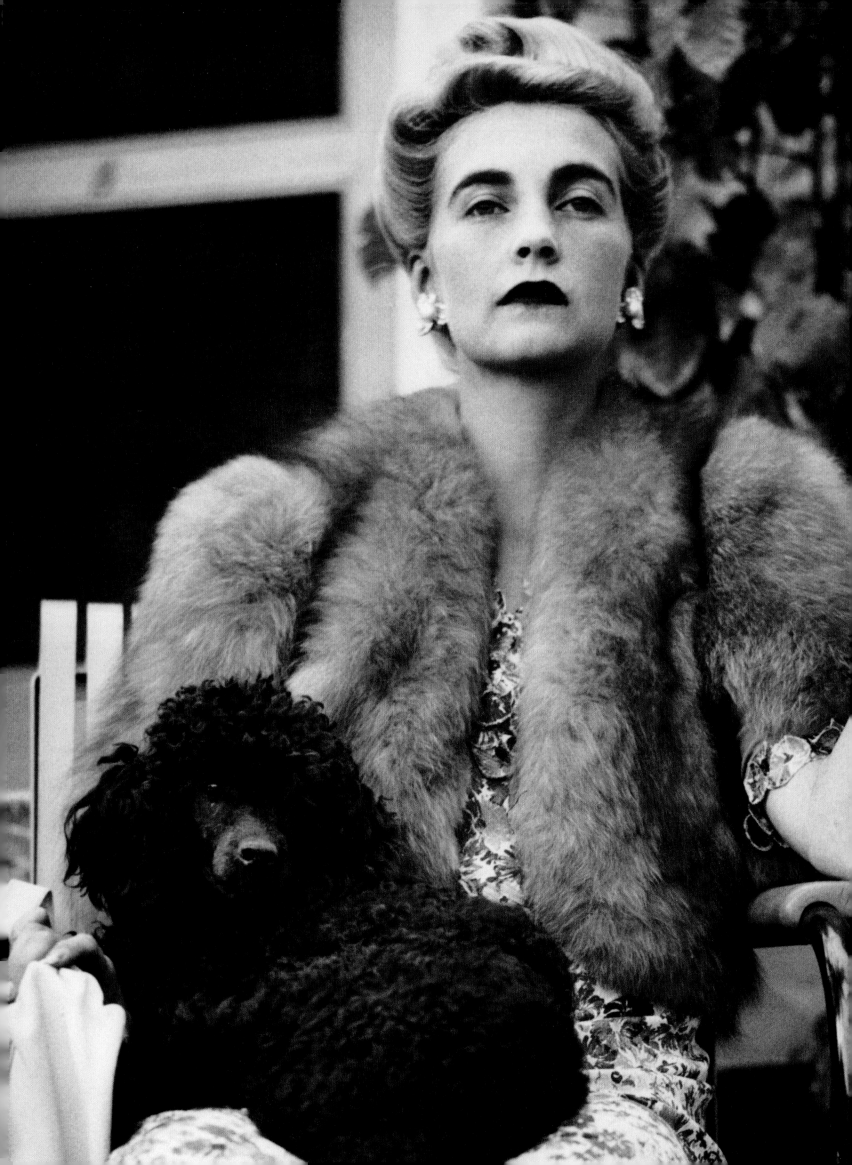

Barbara Hutton

The life of Barbara Hutton reads more like a cheap novel than a glamorous tale of café society. Her untold wealth hung like a millstone around the neck of the woman known from childhood as "poor little rich girl" or "million dollar baby." Barbara was born in New York in 1912. Her father, Franklyn Laws Hutton, was a prominent businessman, but the family's immense wealth came chiefly from her mother, Edna Woolworth, heiress to the successful chain store. The vagaries of Franklyn's private life were to push Edna to suicide, and at the age of six Barbara, who was an only child, found herself sole heiress to a vast fortune. Although from this point until her death her every gesture was scrutinized by a hungry press, her childhood was a lonely one. As her father took no interest in her, she was shunted around other family members and looked after by governesses, including the famous Tikhi who was to stay with her until her death in 1959.

The only other child to whom she formed any attachment until the end of her teenage years was her cousin Jimmy Donahue, who was also fabulously wealthy. He continued to be her confidant and moral support, despite a sensationally lurid life of homosexual affairs and even a liaison with the Duchess of Windsor. This close relationship with her outrageous cousin was to foreshadow Barbara's lifelong fondness for homosexual men, which encompassed at least three of her husbands.

The traditional debutante ball thrown for Barbara's eighteenth birthday was the most lavish and expensive to be seen in New York between the wars. The *crème de la crème* of New York high society was there, including the Astors, Vanderbilts, and Rockefellers, with entertainment provided by Rudy Vallée and Maurice Chevalier. From this first ball, Barbara was besieged by the attentions of prospective suitors, eager to flatter one of the wealthiest heiresses then available. Not until three years later, however, when she was twenty-one, did Barbara gain access to her mother's fortune of some fifty million dollars. The man who captured her heart, a playboy attracted by the Woolworth millions and an aficionado of racing cars (like several of her husbands) by the name of Phil Plant, was put off by her father's schemings. But the sorry round of gold-digging romances and marriages that would punctuate her life was only just beginning.

At a party in Biarritz, organized by Elsa Maxwell in honor of the couturier Jean Patou, Barbara allowed herself to be seduced by the attentions of Prince Alexis Mdivani, known with his four siblings as the "Marrying Mdivanis." His brothers Serge and David married respectively the actress Pola Negri and the Sinclair Oil heiress Virginia Sinclair, while Alexis himself was at the time married to Louise Astor van Alen, a member of the Astor family from Newport. Their sister Roussie had run off with the Catalan artist José-Maria Sert, who had abandoned for her the famous Misia, muse to many artists and close friend of

Chanel. Their title sounded distinguished, but didn't cut much ice. As Jean Patou observed to Elsa Maxwell,[1] "The Mdivanis are from Georgia, and before the war in this part of Russia you only needed to possess three sheep to be a noble." The marriage, celebrated in 1933, lasted only just over a year, during which time Mdivani behaved cruelly to his wife and milked her fortune for large sums. They divorced in 1935, and he died in a car accident soon after. Fatally attracted to European titles, Barbara settled next for the Danish Count Curt von Reventlow, another fortune hunter, who possessed a fine castle in Denmark and not much else. He too proved abusive, subjecting his wife to violence and sado-masochistic "games." Nevertheless they had a son, Lance, Barbara's only child, as complications from this pregnancy prevented her from having more. Already subject to depression, she now started to abuse medicines, alcohol, and drugs. It was at this time that she bought Winfield House, the largest residence in London after Buckingham Palace, which she donated to the US government during the war, to become the residence of the American ambassador to the United Kingdom. She became increasingly generous to causes that mattered to her, giving financial support to the Free French in London and offering a carpet and furniture that had belonged to Marie-Antoinette to the Palace of Versailles during the restoration masterminded by Gerald Van der Kemp—generosity for which she was awarded the Légion d'Honneur.

> Already subject to depression, she now started to abuse medicines, alcohol, and drugs. She bought Winfield House, the largest residence in London after Buckingham Palace, which she donated to the US government during the war.

Barbara divorced von Reventlow in 1938 and obtained custody of their son, whom she proceeded to subject to the same sort of upbringing that she herself had endured, with a string of governesses and a lack of stability and affection that propelled him down a path that bore similarities to her own. Obsessed with racing cars, drugs, and sex, he was to lead a life of gilded, tawdry futility—despite the stabilizing and protective influence of Barbara's new husband, Cary Grant. In 1942, at the instigation of her friend Dorothy di Frasso, who wanted to see her settle down, Barbara had met the celebrated actor, and a relationship of real affection had grown up between them. Yet for a variety of reasons, love failed to materialize. For the first time, Barbara found herself in a relationship that was not embroiled in financial considerations, as Cary Grant was one of the best-paid stars in Hollywood at the time. But as Elsa Maxwell reported, "He was working enormously hard, and when he got home, exhausted after long hours at the studio, he would find the house invaded by noisy, stupid people."[2] They divorced in 1947, but always remained close.

Barbara married again that same year, this time to Prince Igor Trubetzkoy, whose feelings were probably sincere, even if once again a princely title concealed modest means, and the

Page 84
Barbara Hutton, Countess von Reventlow, at a tennis match at Palm Beach, Florida, 1940.

Facing page
Barbara Hutton arriving in New York aboard the *Queen Elizabeth*, after three years' absence from the United States, 1949.

Following page
Princess Trubetzkoy convalescing on the Lido, Venice, 1949.

1. Elsa Maxwell, *I Married the World: Reminiscences*, London, William Heinemann, 1955.
2. Ibid. p. 144

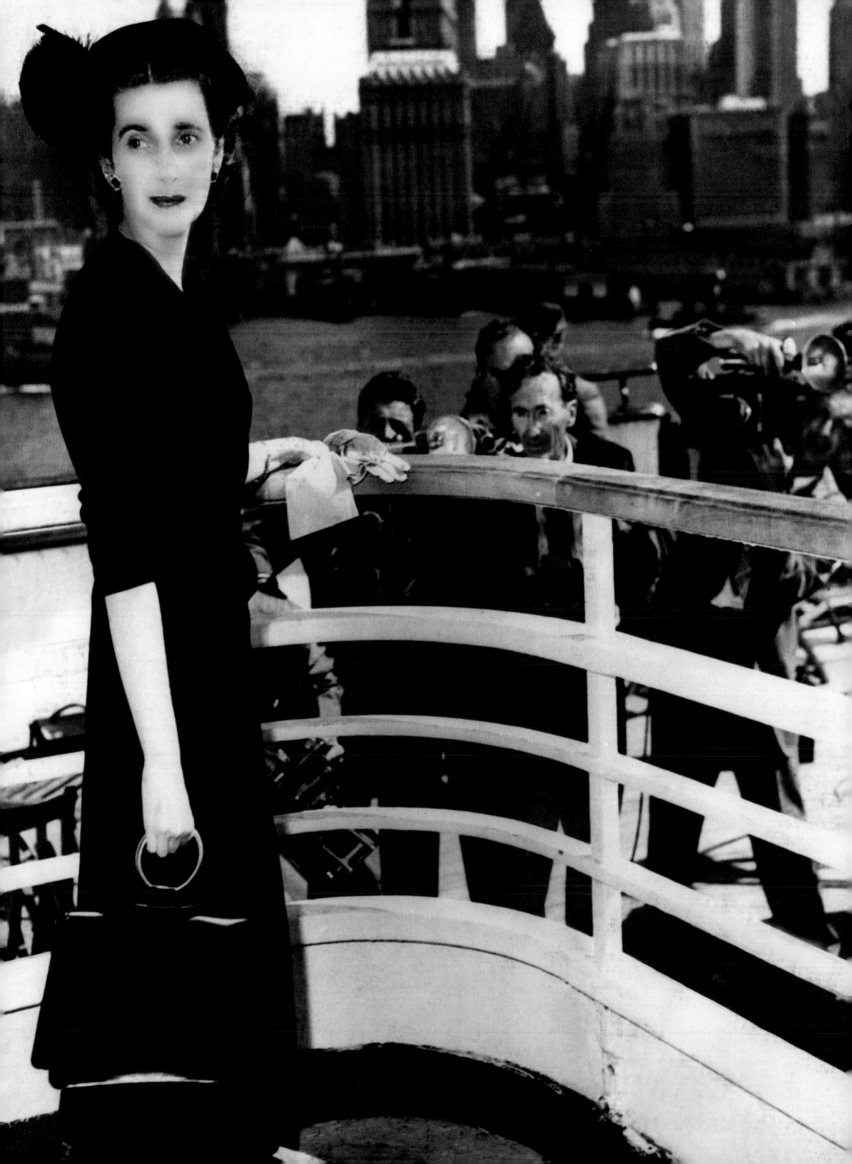

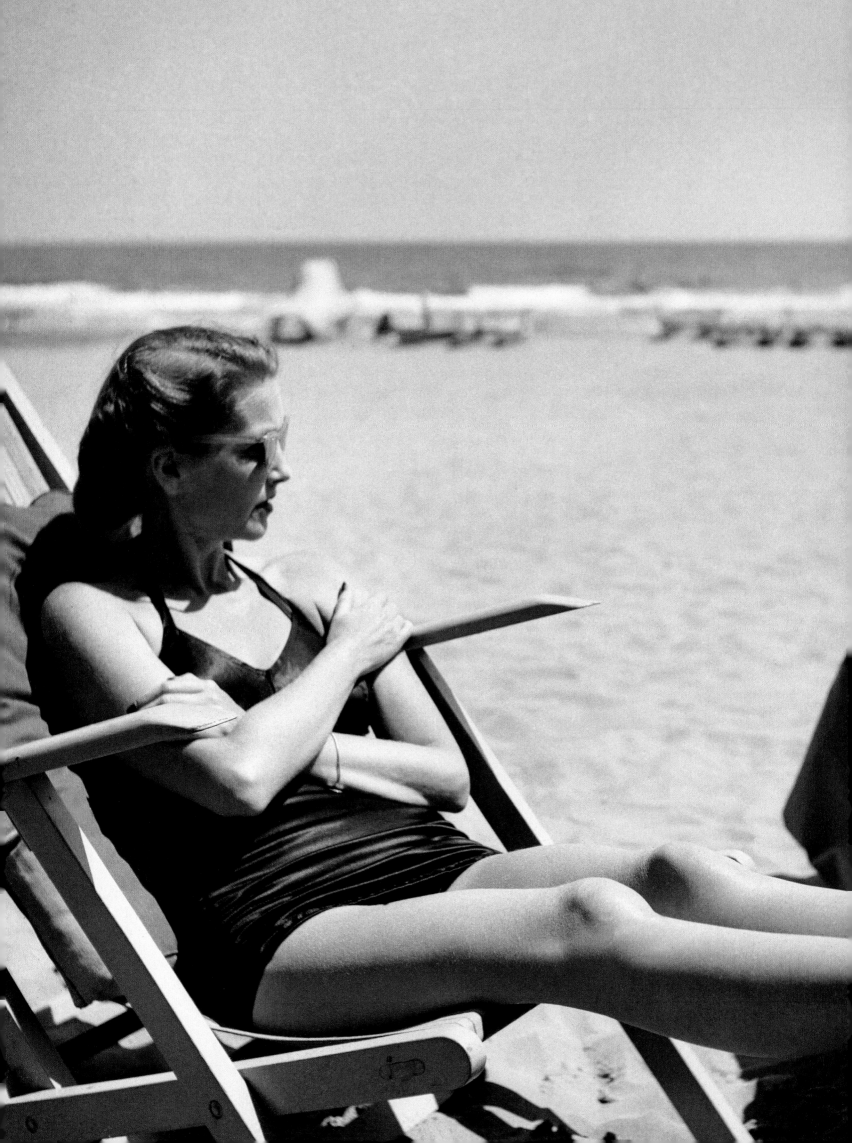

Woolworth fortune would allow the prince to indulge his passion and considerable talent for motor racing. Yet again, the marriage would not last. Then, in 1953, came the Rubirosa episode, the shortest marriage of all (lasting just fifty-three days), and a mere footnote—if a highly profitable one for this professional lothario—in the Dominican playboy–diplomat's stormy relationship with the American actress Zsa Zsa Gabor.

In 1955, Barbara decided to marry one of her old friends, the German baron and former international tennis star Gottfried von Cramm. Though a trusted friend for many years, he too found difficulty in playing the part of a husband, as he was not strongly attracted to women, and the couple never really led shared lives. They divorced in 1959. There followed three years that were among the happiest of Barbara's life, spent in the company of the distinguished and sophisticated American Jimmy Douglas, who also was not attracted to women, and whom she did not marry. Instead, Jimmy attempted to rescue her from the drugs and alcohol that were destroying her health and compromising her behavior. She often arrived at parties drunk, showered anyone she happened to meet with lavish gifts, and slept with any young man who crossed her path. Gradually she abandoned Paris and Europe: the Beistegui Ball of 1951 was one of her last European appearances in all her splendor. In the late 1950s, she built an extraordinary Japanese-style villa at Cuernavaca in Mexico.

> She also bought a palace in the medina at Tangier where she organized extraordinary parties, making the city a fashionable rendezvous for millionaires from all over the world.

At this time she also bought a palace in the medina at Tangier where she organized extraordinary parties, making the city a fashionable rendezvous for millionaires from all over the world. It was there that she met her last husband, Raymond Doan, of French Indo-Chinese birth, who fancied himself as an artist and for whom she contrived, through complex channels, to obtain a title as some kind of oriental prince. During their marriage, which lasted from 1964 to 1966, the newly created prince abused her financial situation, which had been worsened by the actions of her business manager, Graham Mattison, who enriched himself at her expense. The death of her son Lance in a plane crash in 1972 sent Barbara Hutton finally spiraling down into depression and addiction. The woman who died in Los Angeles in November 1979 was prematurely aged, impoverished, and had been living as a recluse at the Beverly Hills Hotel—proof, if proof were needed, that money doesn't necessarily bring happiness.

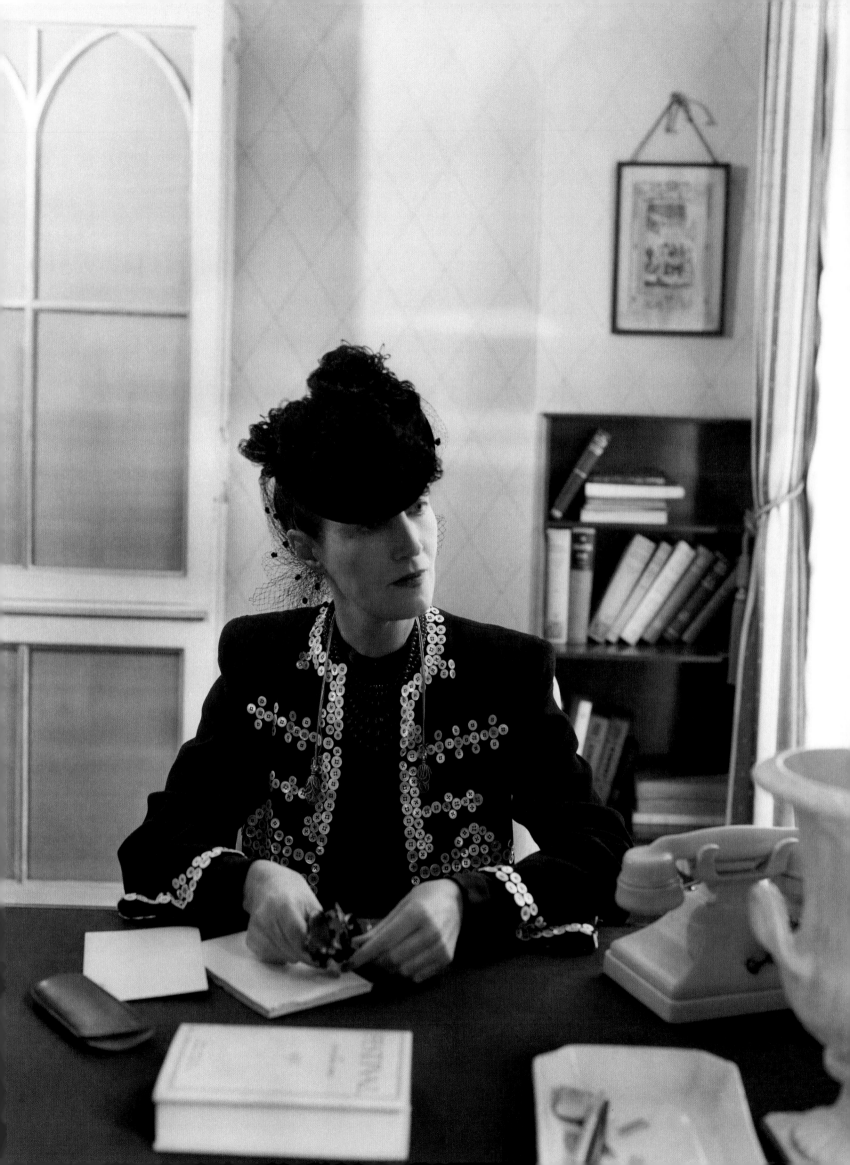

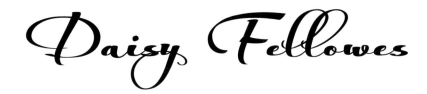

Daisy Fellowes

Mrs. Daisy Fellowes was indisputably one of the "goddesses" of café society. Philippe Jullian depicted her in several of his works, usually under the pseudonym of Cora Edwards: "In whichever country she found herself, all that was most noble, rich, and original lay at her feet, forming a court over which she ruled with an iron fist, offering her approval with a smile or finding fault with a sudden harsh look, launching fashions and ruining reputations, raising up from nowhere those who pleased her, or banishing from her presence—and hence from other salons—those who, over-confident of their place at her side, displayed a lack of tact or taste."[1] For Philippe Jullian, and for many others, she embodied beauty despite her age, grace despite her hardness, and fashion although she followed none.

 She was a legend in more ways than one. First and foremost, she was the quintessence of all that was smartest in cosmopolitan society. The daughter of Duc Decazes and Isabelle Singer, she was heiress—with her aunt Winnaretta de Polignac, who brought her up after her mother's suicide—to the Singer sewing machine fortune. In 1910 she married Prince Jean de Broglie, who was killed in the First World War and by whom she had three daughters: Emmeline (later Comtesse de Casteja), Isabelle (later Comtesse de La Moussaye), and Jacqueline (later Mme Alfred Kraus). In 1919 she married again, this time to the Hon. Reginald Fellowes, an English banker descended from the de Ramsey family, a cousin of Winston Churchill and grandson of the Duke of Marlborough. Despite this marriage, or perhaps because of it (her husband displaying a marked fondness for shooting parties in the country), she lived more in Paris than in London, but also extended her reign in summer to Venice, where the Decazes possessed a charming palazzo. Mrs. Fellowes also made brief but regular appearances in the United States, and cruised the seas in her famous yacht the *Sister Ann*, with the Duke and Duchess of Windsor as her guests.

 She was also legendary for her taste, both in her clothes and in the decoration of her houses, which was highly influential at the time. Among all the best-dressed women of café society, the arbiters of elegance recognized only Mona Bismarck and Daisy Fellowes—a peak of sophistication and refinement that was never to be attained by the Duchess of Windsor and her ilk. In *The Glass of Fashion* Cecil Beaton noted: "Daisy Fellowes enjoyed making other women appear foolish, and would wear plain linen dresses when everyone else was dressed to kill. These linen suits, though simple in tailoring and often of identical shape, were ordered in dozens of different colours and complemented by barbaric jewels—handcuffs of emeralds, necklets of Indian stones, or conch shells of diamonds. She even wore jewellery with her beach suits."[2]

1. Ghislain de Diesbach, *Un esthète aux enfers, Philippe Jullian*, Paris: Plon, 1993, pp. 160–1.
2. Cecil Beaton, *The Glass of Fashion*, London: Weidenfeld and Nicolson, 1954, p. 140.

Her style combined simplicity with extravagance, and she would wear the most sensational Schiaparelli designs, including Dalí's celebrated shoe hat. After being a client of Chanel in the 1920s, Daisy entrusted her wardrobe to Schiaparelli, who responded with her most original creations, knowing that only Daisy would dare to wear them, and that she would do so with her own peerless chic. Aged seventy, she did not think twice about commissioning Hubert de Givenchy to make her a Somali panther coat, shaped like smock with a drawstring waist and a panther tail belt. This she accessorized with gold kid cycling shoes and a necklace of topaz flowers.

A major client not only of haute couture but also of the great jewelers, notably Cartier but also Jean Schlumberger, Boivin, and Van Cleef, she also sometimes designed her own jewelry. Here again she liked to shock, as with the emerald handcuffs she had made for one party. Her highly idiosyncratic taste, mingling classicism with provocation, was also showcased in her houses: first of all in her *hôtel particulier* on rue de Lille, which she commissioned Geffroy to decorate, and later in her residence at Neuilly, where she threw large parties in gardens adorned with statues by Jean Cocteau and interiors designed by Sue et Mare. One room in particular attracted attention: a salon lined with silver leaf and sand-etched mirrors that made a deep impression even on André de Fouquières,[3] who had seen many a salon in his time. The same baroque taste could be seen in her Venetian boathouse, which she chose to hang with Tiepolos.

As well as striking fear into the hearts of elegant society ladies with her defiantly individual tastes and her pitiless dedication to the pursuit of eclipsing them all, Daisy Fellowes was also predatory when it came to other people's marriages. Between the wars she set her ruthless sights on Duff Cooper, to the great consternation of Lady Diana. When in pursuit of her prey, Daisy Fellowes was both implacable and relentless. "A female dictator of untouchable severity," according to Harold Acton, she reigned by means of her acid tongue. "Saint Daisy, speak ill for us," went the saying in society. Her tendency to depression was aggravated by her frequent and unrestrained use of opium; in his *Journal inutile*, Paul Morand recounted how one time in Toulon she had sent him out to get "supplies" for her. Her tyranny even extended to her second daughter and, as she saw it, rival: Isabelle de Broglie, Comtesse Olivier de La Moussaye, an occasional poet and one of the muses of Philipe Jullian, whom she introduced to her mother. The bitter rivalry between mother and daughter recalled that between Emerald Cunard and her daughter Nancy. According to Harold Acton, Isabelle and Nancy were both living blooms who had grown up to rebel against the hothouse in which their childhoods had unfolded.[4] Uncompromising in her devotion to France and the Allied cause during the war, she gave financial support to the Free French and could not forgive her youngest daughter for her more accommodating attitude to the Nazi occupiers. She refused ever to see her again.

Finally, this great fashion icon was for a while editor-in-chief of French *Harper's Bazaar*, and composed an epic poem and a clutch of novellas, including *Les Dimanches de la comtesse de Narbonne* (published in English as *Sundays*) in 1931. Like her rival Mona Bismarck, Daisy Fellowes was one of those women whose life was a work of art and whose way of life set the tone for an entire age, but—as they never themselves created anything (unlike Mona Bismarck and Peggy Guggenheim she did not even bequeath a collection or foundation to the world, but only a few bits of jewelry that she designed)—who have now vanished from the collective memory.

Facing page
Daisy Fellowes.
Photograph by Cecil Beaton,
1930s.

3. André de Fouquières, *Cinquante ans de panache*, Paris: Editions Pierre Horay Flore, 1951, p. 220.
4. Harold Acton, *Memoirs of an Aesthete*, London: Faber, 2008.

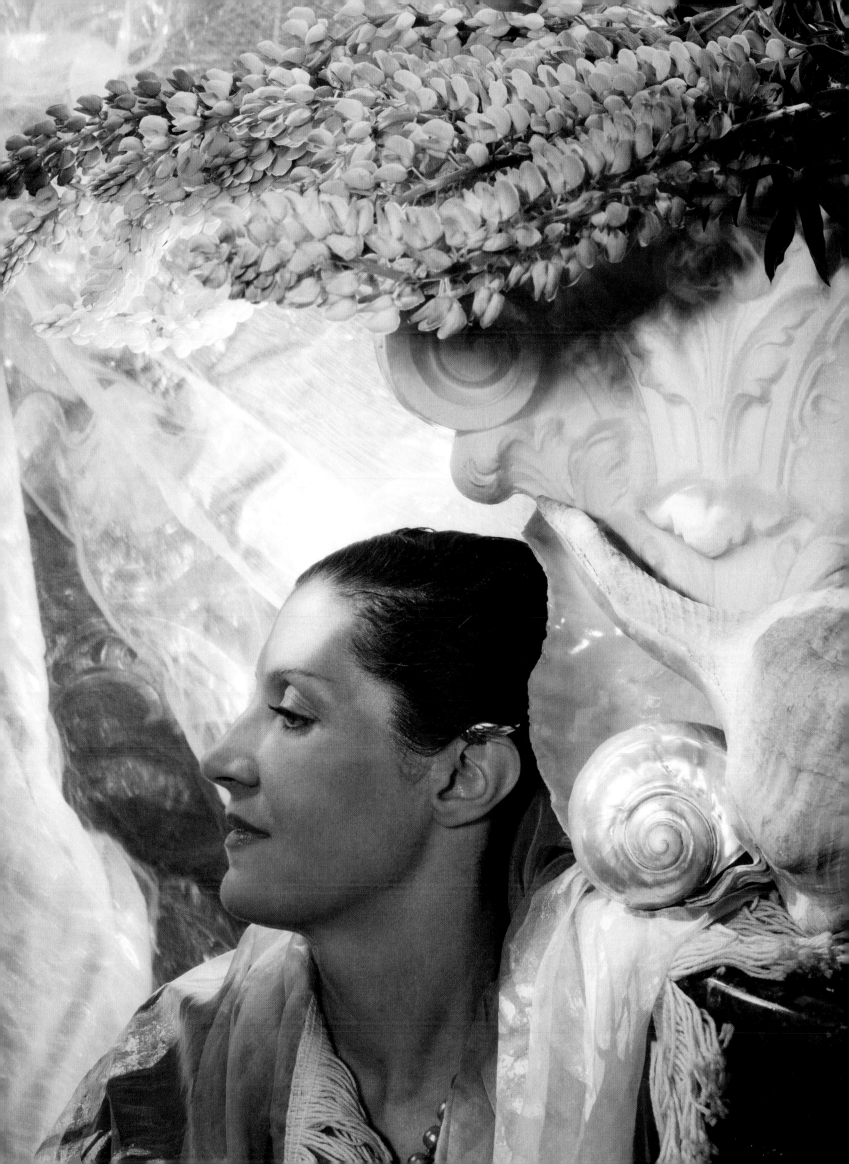

Lady Cunard

Lady Cunard was a café society figure before it even existed. With Sybil Colefax, she was one of the great London society hostesses between the wars. It was from her example that not only Diana Cooper but also Lady Cunard's fellow American Wallis Simpson were to perfect their parts as future stars of café society. As Cecil Beaton observed, "Lady Cunard was unique…. she did more to generate an interest in the major and minor arts than perhaps any governmental body."[1] She displayed all the essential attributes of café society before even becoming one of its earliest luminaries: a dazzling London salon, a penchant for the Continent, especially Paris and Venice, fashion-plate elegance, and a caustic wit. "Esmeralda Cunard was at this time [1942] one of the last and most representative figures of a world into which she was not born,"[2] noted her friend Violet Trefusis. She belonged to that select group of American women who made Europe their home, to the point where their country of birth was almost forgotten.

Maud Burke, as Emerald Cunard was born, emigrated from San Francisco to Europe via New York, where she lived with her French grandmother. She married a wealthy Englishman, older than her and passionately devoted to foxhunting and country pursuits, Sir Bache Cunard. After a decade spent at his country estate at Nevill Holt in Leicestershire, she moved to London, where she set up her own substantial establishment at 7 Grosvenor Square. In this immense house, which she decorated throughout in French eighteenth-century style and filled with works by Marie Laurencin, she hosted one of the most brilliant, elegant, and intellectual salons of her time. The writer George Moore and the conductor Sir Thomas Beecham were among the most assiduous members of her circle, which also included Lady Diana Cooper, Comtesse Phyllis de Janzé, the composer Lord Berners, the writer and literary critic Max Beerbohm, Cecil Beaton, and the Duke and Duchess of Windsor. In his memoirs, Harold Acton recalled how "insipid" London salons seemed in comparison "with Esmeralda's!" There one felt surrounded by people who were simply brimming with life, and it was Emerald herself who was their inspiration. Her friends, he observed, were invariably drawn from backgrounds too diverse to be described as a coterie, and if they exerted any influence it was chiefly in the realm of art.[3] But while Harold Acton and Cecil Beaton were fulsome in their admiration of Lady Cunard's salon, others were distinctly unamused by the glib insouciance with which she collected celebrities and prominent figures—a *faiblesse* that led to her making something of a pet of Joachim von

Facing page
Lady Emerald Cunard and Sir Jey Singh, Maharaja of Alwar, at the Strauss Ball given at the Savoy Hotel, London, 1931.

1. Cecil Beaton, *The Glass of Fashion*, London: Weidenfeld and Nicolson, 1954, p. 315.
2. Violet Trefusis, *Instants de mémoires*, Paris: Editions Christian de Bartillat, 1992, p. 140.
3. Harold Acton, *Memoirs of an Aesthete*, London: Faber, 2008, p. 45.

Ribbentrop, Hitler's gaffe-prone ambassador to London who was held in general disdain. Emerald Cunard was in many respects the prototype of the English intellectual snob who attempts to impose their tastes as a universal rule. Cecil Beaton reported that "when the Duchess of York became Queen of England she sighed, 'I'm afraid even now we shall never be included in Lady Cunard's set. You see, she has so often said that Bertie and I are not fashionable.'"[4]

The war was to change her approach somewhat. At the outbreak of hostilities she had left for New York with Sir Thomas Beecham, the jewel in her society hostess's crown, whose own fame she had helped to promote; although she declared war vulgar, she decided to return to beleaguered London. Beecham chose to stay in safety in America, and the separation secretly wounded her deeply. Arriving in London, she left her residence and took out an annual lease on a suite on the seventh floor of the Dorchester Hotel, which she decorated with the works by Monet, Manet, Berthe Morisot, Guillaumin, and Mary Cassatt that George Moore had left to her on his death in 1937. Having cultivated von Ribbentrop merely because it was the fashionable thing to do, she now turned her attentions equally warmly to Duff Cooper, Churchill, and representatives of Free France, such as Gaston Palewski and General Patroux, while at the same time—faithful member of the Wallis Simpson clique that she was, along with her friend Henry "Chips" Channon—remaining close until the end of her life to the Duke and Duchess of Windsor.

Cecil Beaton summed up her philosophy of life, so typical of café society: "Sometimes she would say in a frivolous manner something that meant more to her than she realized: 'Maternity is a strong natural instinct and I abhor nature. I believe in art.' She made her life a work of art that was as delicate, witty, gay, sensitive and eloquent as herself."[5] Motherhood was so foreign a concept to her, indeed, that she was quite incapable of showing affection to her daughter Nancy, who was to cut a swathe through society and intellectual life. Vehement in her rejection of her mother's world (though not herself entirely innocent of snobbery), Nancy went to Spain to support the Republicans against Franco; flirted with communism; maintained a sensational relationship with Aragon; published *Negro*, a ringing indictment of racial prejudice in America; and worked herself to the point of exhaustion as a translator for the Free French.

Right to the end of her life, despite the reversals of fortune and torments of age, Emerald Cunard continued to host her salon and to hold sway over her small slice of international society. As she lay dying, she urged her closest intimates, who had gathered round her bed, to drink to her death—which also marked the death of the high society that she so loved, and that survived her by only a few more years.

Facing page
Nancy Cunard, Emerald Cunard's daughter, in Harlem, New York, 1932.

Following pages
Masked ball in aid of the children of the Maison de Pange, June 28, 1946. A party given by the Baron and Baronne de Cabrol. From the scrapbook of the Baron de Cabrol.

4. Cecil Beaton, op. cit., p. 320.
5. Ibid., p. 320.

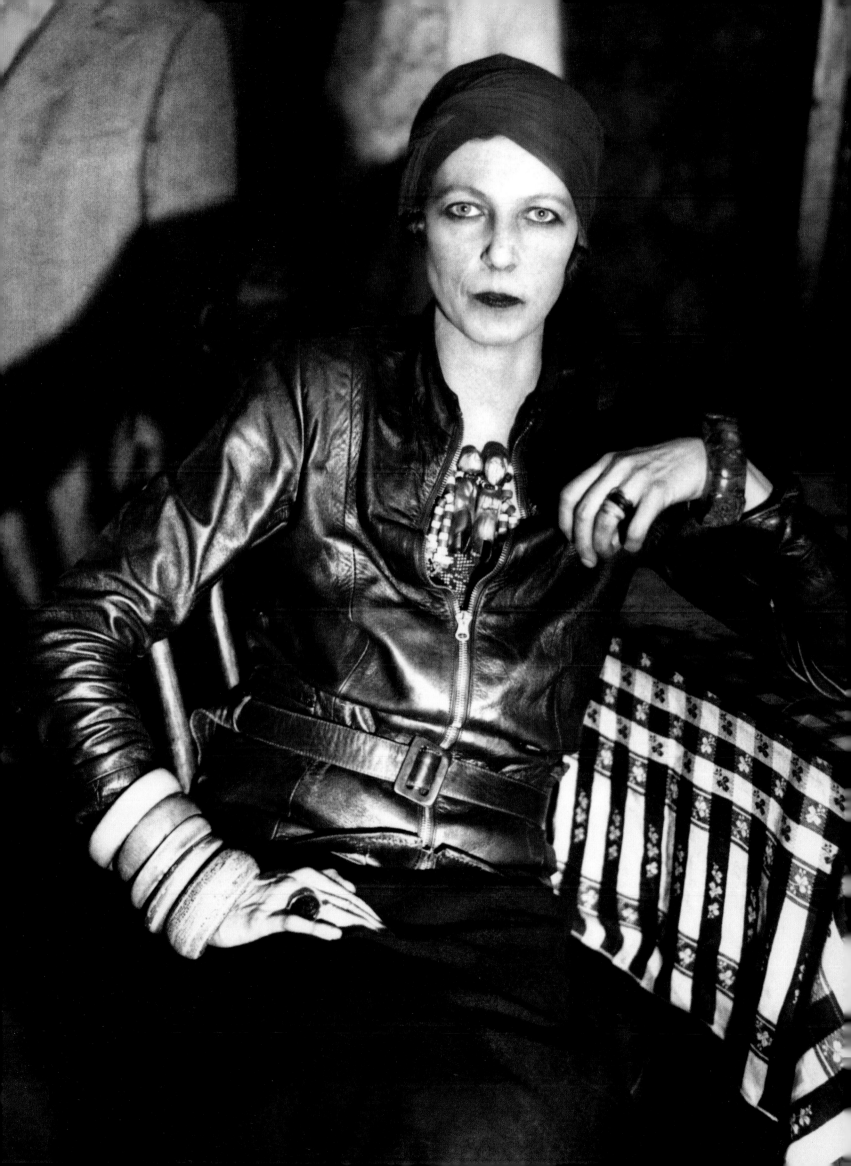

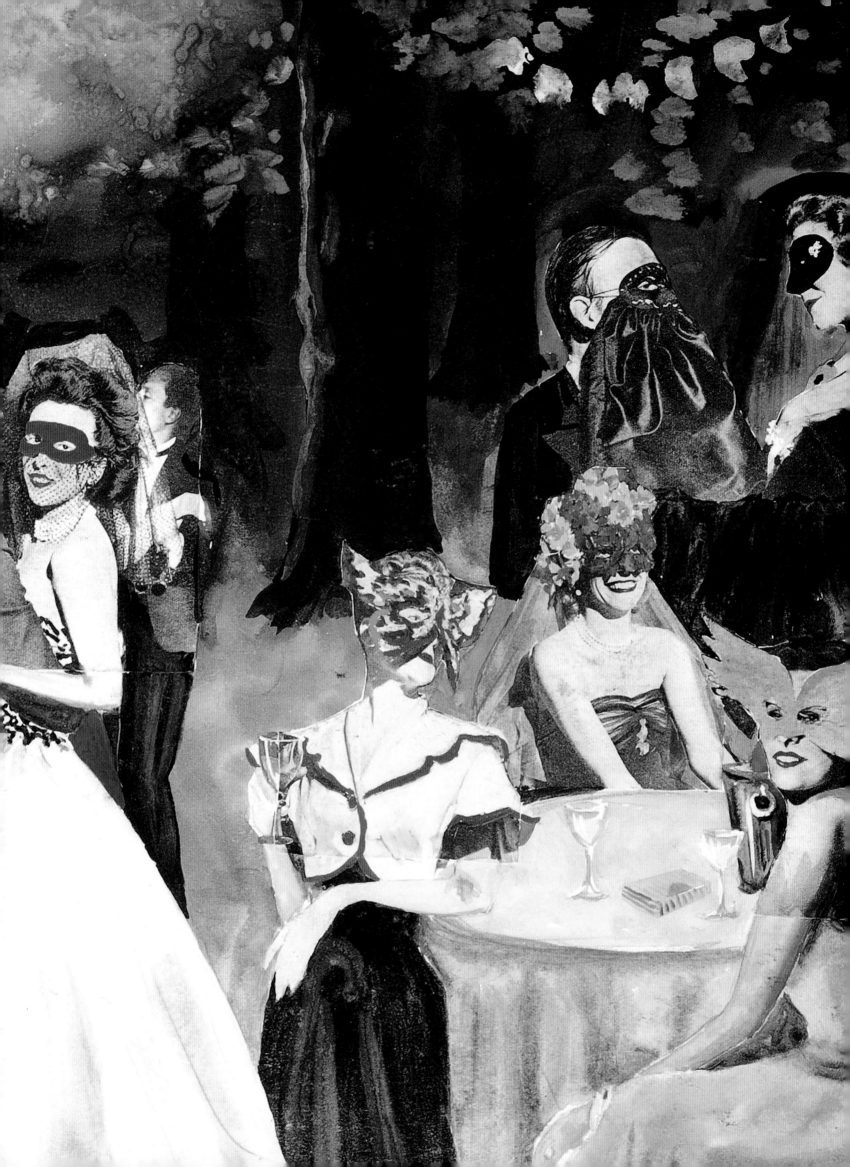

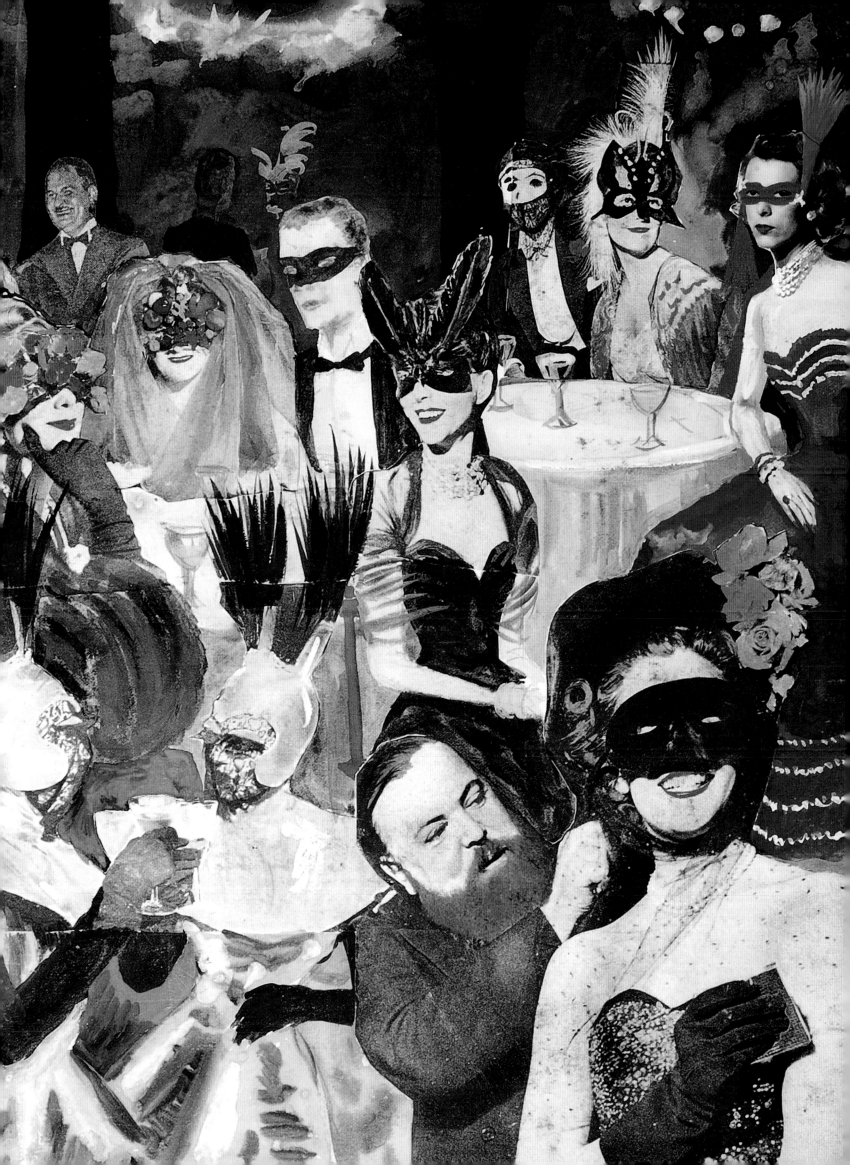

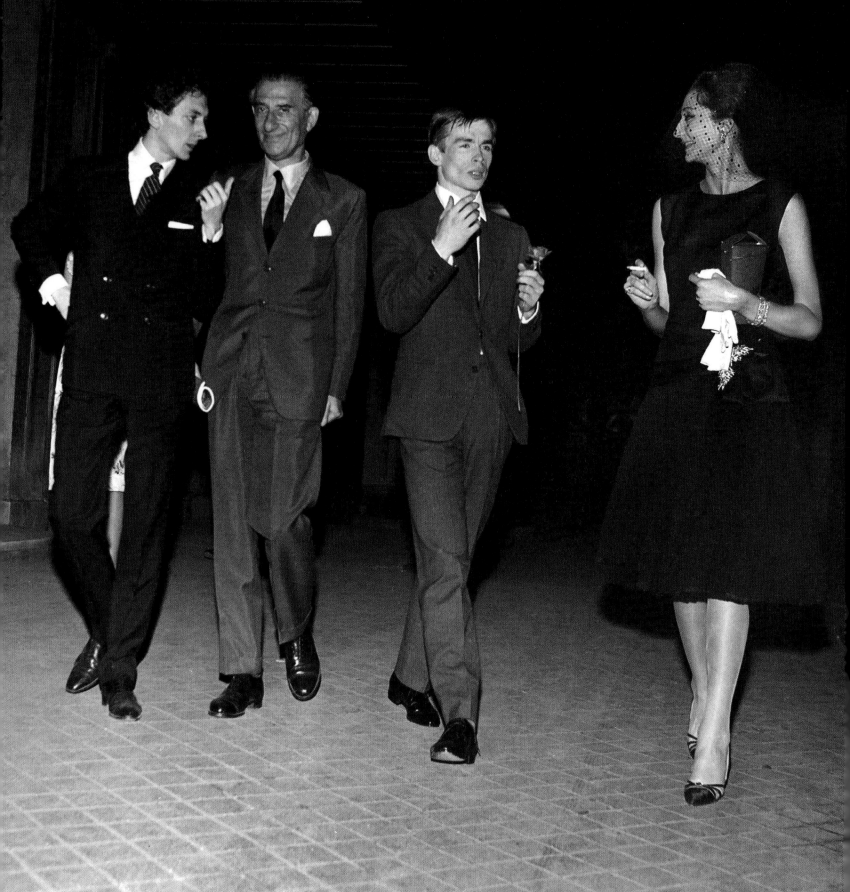

Paul-Louis Weiller

Of all the many different lives that overlapped during his long and eventful existence, the one that Paul-Louis Weiller prized most was undoubtedly that of a leading figure in society. Weiller was the son of an industrialist from Alsace, Lazare Weiller, deputy for the Charente region and later senator for the Bas-Rhin. Weiller *père* had made a fortune from the manufacture of wire, had contributed to a series of scientific discoveries that would lead later to the development of television, and had interests in the aeronautical construction industry. A student of the mathematician Paul Painlevé, the young Paul-Louis studied engineering before going into aviation, soon rising to the very top of Gnôme-Rhône, the world's largest builder of aircraft engines. After the Second World War, Gnôme-Rhône was nationalized as Snecma; at the same time Weiller was also one of the first directors of Air France.

A friend of the celebrated French war hero and fighter ace Georges Gynemer, Weiller was himself a distinguished fighter pilot who was wounded no fewer than seven times during the First World War. His exploits earned him the nickname "Commandant," which was to stay with him throughout his life. But in Weiller's own opinion, all his professional and military exploits were as nothing compared to his conquest of society. His life was a whirl of social events, and especially of female conquests. After a brief marriage to a Princess Ghika, in 1932 he married Aliki Diaplakarou, the beautiful and intelligent daughter of a Greek lawyer, who had been crowned Miss Europe and runner-up for Miss Universe two years earlier. Deserted by her husband, she took advantage of being in the United States during the war to instigate proceedings for a divorce that became the talk of legal and society circles. A great womanizer, Weiller was to continue his conquests right to the end of his long life. And life as an habitué of café society consisted of one long, giddy round of café society parties, where he was constantly encountering bevies of beautiful women who, as Alexis de Redé observed in his memoirs, became steadily younger as he himself grew steadily older. Life was also a glittering succession of residences. In his entry for March 30, 1972 in his *Journal inutile*, Paul Morand noted that, on hearing that Weiller had just bought an island in the Bahamas, his wife Hélène remarked, "You'll see, he'll end up buying the whole archipelago." Passionately concerned with the restoration of historic buildings, he contributed with others such as Arthur Lopez to the restoration fund for the Palace of Versailles. Above all, he restored the Hôtel des Ambassadeurs de Hollande in Paris, in order to be able to entertain the many artists whom he supported. Weiller was a benefactor to a wide range of artists as eclectic as Marcel Pagnol, Roger Vadim, and Roland Petit. He threw parties in honor of Laurence Olivier, Charlie Chaplin, and Yul Brynner.

Weiller used his immense wealth to live a life of luxury and splendor to rival that of the kings whom he liked to emulate at costume balls. Throughout his life he was an assiduous collector of royalty, even accompanying Faucigny-Lucinge on his visits to the Queen Mother, in Alsace.

Facing page
Paul-Louis Weiller with
Raymundo de Larrain,
Rudolf Nureyev and
Jacqueline de Ribes,
Paris, 1961–2.

Edward James

A minor poet and eccentric architect, Edward James was a legendary patron of the arts whose extravagant caprices provided constant fuel for the gossips of café society and beyond. Even his origins were a matter of speculation. His American father, William James, married Evelyn Forbes, who was Scottish; both came from enormously wealthy families, and persistent rumors claimed that she was an illegitimate child of Edward VII. Evelyn herself encouraged such speculation, while also claiming to be the reincarnation of Marie-Antoinette, whom she strove to imitate in all respects. Idiosyncratic and cruel, she detested her son, who at the age of five had inherited a large part of the family fortune. On one occasion, when the governess asked her which of her children should accompany her on her walk, she responded, "What does it matter? Whichever goes best with my dress." Edward's childhood was nonetheless a gilded affair of Rolls-Royces, hunting parties, and prestigious parties, until he was sent away to Eton, which he loathed. As a young man he was introduced into London high society, where he began to move in the exclusive circles of the Cunards, Mitfords, Churchills, and Sitwells.

Amid this social whirl, Edward James met the Austrian dancer and actress Tilly Losch and fell madly in love with her. Their fleeting marriage, which lasted from 1931 to 1934, was a turbulent affair, largely because of Losch's many excesses. But it left a lasting legacy in the form of Les Ballets 1933, the ballet company James founded for her, and for which he enlisted the talents of a galaxy of the era's major artists: Tchelitchew, Derain, and Terry for the sets; Balanchine for the choreography; dancers including, apart from Losch herself, Tamara Tounanova and Roman Jasinsky; and all under the direction of Boris Kochno. This was the period at which James was decorating his London house in Wimpole Street and Monkton House, on his country estate at West Dean in Sussex, in the surrealist style that was to become legendary, featuring iconic pieces such as Dalí's scarlet sofa in the shape of Mae West's lips, and a vast full-tester bed inspired by the funeral carriage that carried Nelson's coffin to St. Paul's in 1805, with palm tree columns and heavy black velvet drapes.

James's taste was a heady blend of the baroque and the surreal: he supported and collected the work of surrealist artists, many of whom became his friends, including Magritte, who painted the back of his head (twice) in *La Reproduction interdite*, Max Ernst, Leonora Carrington, Paul Delvaux, and Tchelitchew. His relationship with Dalí was of crucial importance for the artist. During the 1930s, James bought virtually his entire output, and their friendship was to lead to genuine mutual emulation and collaboration. This fruitful union of two wildly creative imaginations, with all their caprices and paranoias, was bound to end badly, as it duly did in 1937. Their more borderline projects had included a drawing room modeled on the internal organs of a dog, with walls that would dilate and contract

Facing page
Cecil Beaton, Alexis de Redé, Daisy Fellowes and Edward James at a ball at the Hôtel Lambert. Daisy Fellowes is wearing her famous "Hindu" necklace set with emeralds, sapphires, rubies, and diamonds, ordered from Cartier in 1936. Photograph by Robert Doisneau, 1950.

Page 105
Edward James and his wife Tilly Losch, c. 1933.

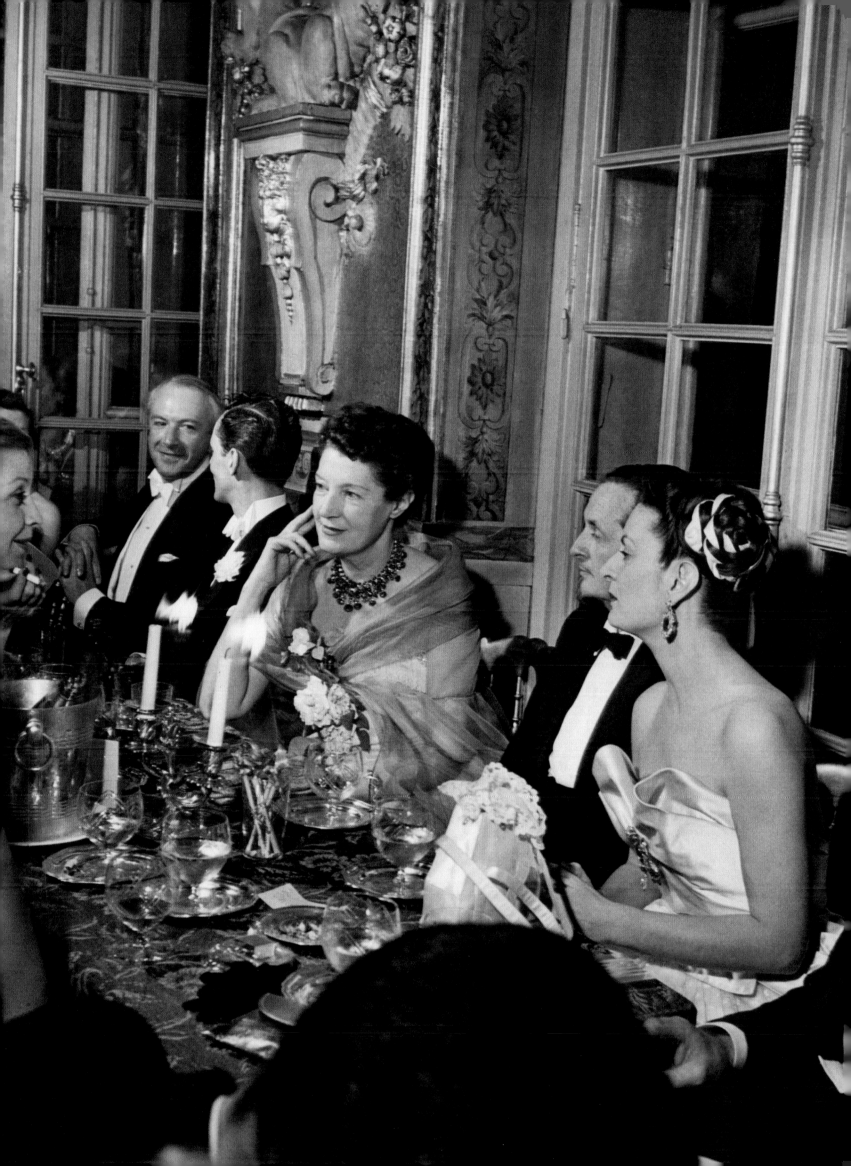

according to the rhythm of its "breathing." As the animal was supposed to be in pain, Dalí wanted its labored gasping for breath to be audible.

James also extended his patronage to the worlds of music (he was benefactor to Poulenc, Stravinsky, and especially Markevitch) and literature, partly through his own press, the James Press. He was a champion of John Betjeman and Dylan Thomas, to whom he had been introduced by Edith Sitwell, and thanks to Dalí he enjoyed the company of Stefan Zweig and Freud. He also wrote himself, publishing several collections of poetry and, in 1937, a novel, *The Gardener who Saw God*, the portrait of an aristocrat who scatters pianos and plastic ants through the grounds of his Gothic pile. A few years after this he penned a collection of memoirs under a title inspired by a Dalí painting, *Swans reflecting Elephants*.

"His personal extravagances were on such a scale that they encouraged those who worked for him to outbid each other in the lunatic nature of their schemes."

Like the Noailles in France, who also played a major part in the development of surrealism in all its forms, James was an outstanding patron of the arts, though his relationships with artists were not without difficulties, as Markevitch remembered: "his own gifts to artists leading him to want to be considered as an artist rather than a benefactor and his immense wealth making him suspicious, while his personal extravagances were on such a scale that they encouraged those who worked for him to outbid each other in the lunatic nature of their schemes."[1]

In later life James continued his baroque lifestyle, but in a context far removed from café society. In 1939 he left Europe for America, where—to the dismay of his English friends—he set up a sort of commune and zoo in New Mexico. From the late 1940s until his death in 1988, he inhabited a surreal palace and garden in the depths of the Mexican jungle, near Tanpico. There he would spend the nights wandering through the jungle-garden like a lost soul, with candles strung round his neck to keep the vampires at bay. So all-consuming was his love of art that his own life had become an authentic work of surrealism.

1. Igor Markevitch, *Être et avoir été*, Paris: Gallimard, p. 334.

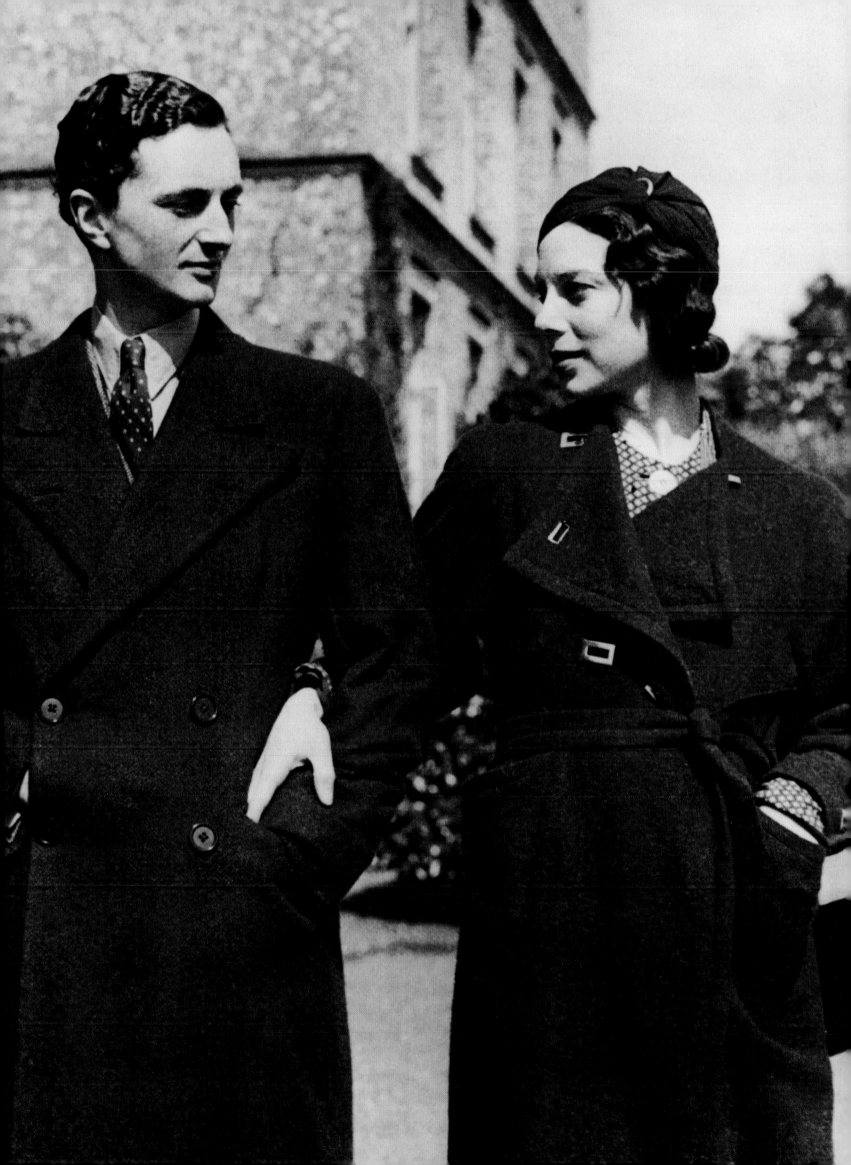

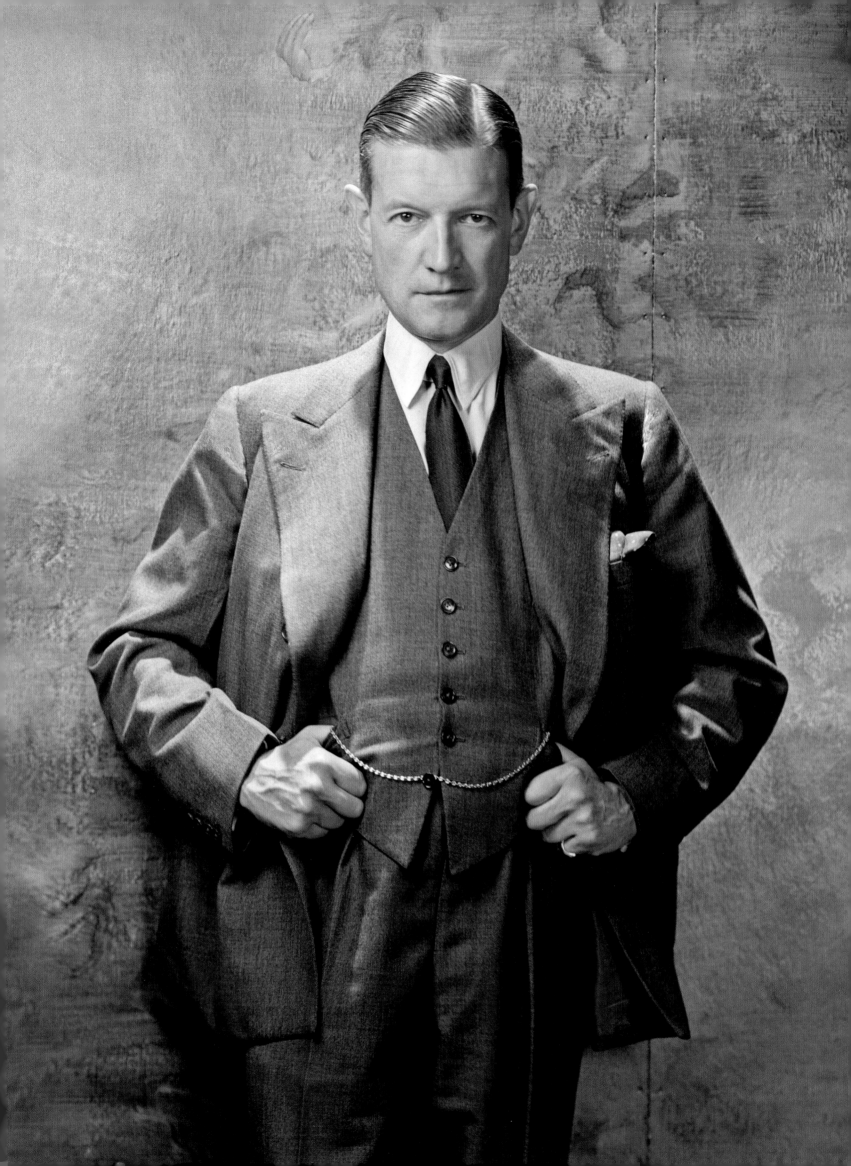

Henry "Chips" Channon

Chronicler *par excellence* of café society through his notoriously indiscreet diaries, which he kept from 1934 to 1953, Henry Channon created for himself a life that itself reads like a novel. Born in Chicago in 1897, he grew up in America and France, before serving in Europe with the Red Cross during the First World War. After returning briefly to the land of his birth, he decided to move to England, where he became a student at Christ Church, Oxford. There he acquired the nickname that to was stay with him for the rest of his life: as he shared rooms with a fellow undergraduate by the name of "Fish," there was a certain inevitability about his becoming known as "Chips." His reasons for choosing to settle in England were clear: "The more I know of American civilization, the more I despise it. It is a menace to the peace and future of the world. If it triumphs, the old civilizations, which love beauty and peace and the arts and rank and privilege will pass from the picture."[1]

In 1924, Channon inherited a vast fortune from his grandfather, which relieved him of the necessity of earning a living. He decided to devote his life to politics, and—being highly conservative by nature—took an active part in breaking the General Strike of 1926. His marriage in 1933 to Lady Honor Guinness, daughter of the second Earl of Iveagh and heiress to the brewing dynasty, facilitated his election as Conservative Member of Parliament for Southend, where he succeeded his mother-in-law, who in turn entered the House of Lords. Rabidly right-wing in his views, he was a close friend of the Duke and Duchess of Windsor, a fervent supporter of Franco during the Spanish Civil War, and an equally staunch enthusiast for the policy of appeasement of Hitler, whom he viewed as a bulwark against Bolshevism. In 1938 he entered Chamberlain's cabinet, to remain in government throughout the Second World War.

His diaries reveal a man preoccupied with the great questions of a period beset by economic and international crises, who was also devoted with a passion to high society. A social climber of the first water, he was to be seen at the Beistegui Ball escorting Elisabeth Chavchavadze as Catherine the Great, and as well as the Windsors he also cultivated Emerald Cunard, the Duff Coopers, Osbert, Edith and Sacheverell Sitwell, the Duke and Duchess of Kent, Cecil Beaton, Noël Coward, Cole Porter, Daisy Fellowes, Étienne de Beaumont, Alexis de Redé, Arturo Lopez, and many, many more. Undermined by ill health, he died in 1958—a year after receiving the satisfaction of a knighthood from the Queen, an occasion marked by a telegram from Princess Bibesco reading simply, "Goodbye Mr. Chips!"

Facing page
Sir Henry Channon.
Photograph by Cecil Beaton,
1943.

1. Robert Rhodes James, *Chips: The Diaries of Sir Henry Channon*, London: Weidenfeld & Nicolson, 1967, p. 10.

Ali Khan

The son of Aga Khan III, Prince Ali Khan was the epitome of a café society playboy, chic, romantic, and tragic. At the age of twenty he was driving speedboats on the Riviera, hunting to hounds in England, and skiing in Gstaad. In 1936 he married the Hon. Joan Guinness, just days after she had divorced Group Captain Loel Guinness for him. On the outbreak of the Second World War he joined the French Foreign Legion and served in the Middle East; in 1944 he served as a liaison officer in the Allied landing in Provence, for which he was decorated. After the liberation of France, he bought the Château de l'Horizon outside Golfe Juan, where he threw lavish parties. Having divorced during the war, he fell in love—thanks to the intervention of Elsa Maxwell—with Rita Hayworth, then at the height of her fame. They married in 1949, but it soon became clear that while the actress dreamed only of a conventional family life around their daughter Yasmina, Ali was not ready to give up his party lifestyle. Following a sensational divorce, he immediately embarked on a short-lived relationship with the other great Hollywood leading lady of the time, Gene Tierney.

In 1955, Ali Khan fell in love with the fashion model Bettina, who by a curious twist of fate had been a studio model for Jacques Fath, where she had modeled Rita Hayworth's wedding gown for her. Now at last he seemed ready to settle down. Before his death in 1957, the Aga Khan gave his blessing to the future marriage—though he nevertheless chose his grandson Karim as his successor. In response, Ali Khan devoted himself increasingly to the Ismaili community and was appointed Pakistani ambassador to the United Nations. But on May 12, 1960, shortly before they were due to marry, when he and Bettina were on their way to a dinner at Ville d'Avray (to which Lorraine Bonnet had invited them along with André Malraux, Baron and Baroness Guy de Rothschild, Stavros Niarchos and his wife, the Lopez-Willshaws, Porfirio Rubirosa, and Ghislaine de Polignac), their car was in a collision with another vehicle. Ali Khan, who was at the wheel, sustained massive head injuries and later died; Bettina miraculously survived.

Facing page
Prince Ali Khan and
Mrs. Alec Head at
Epsom racecourse, 1959.

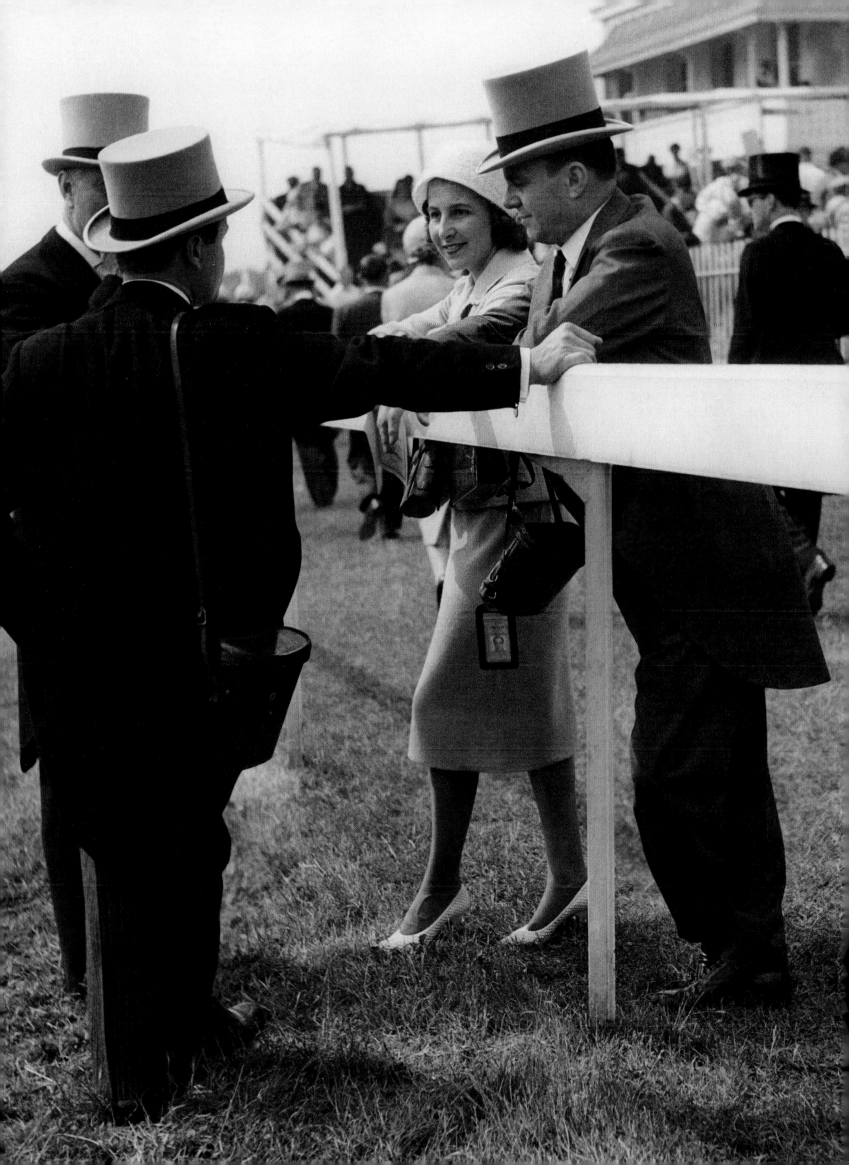

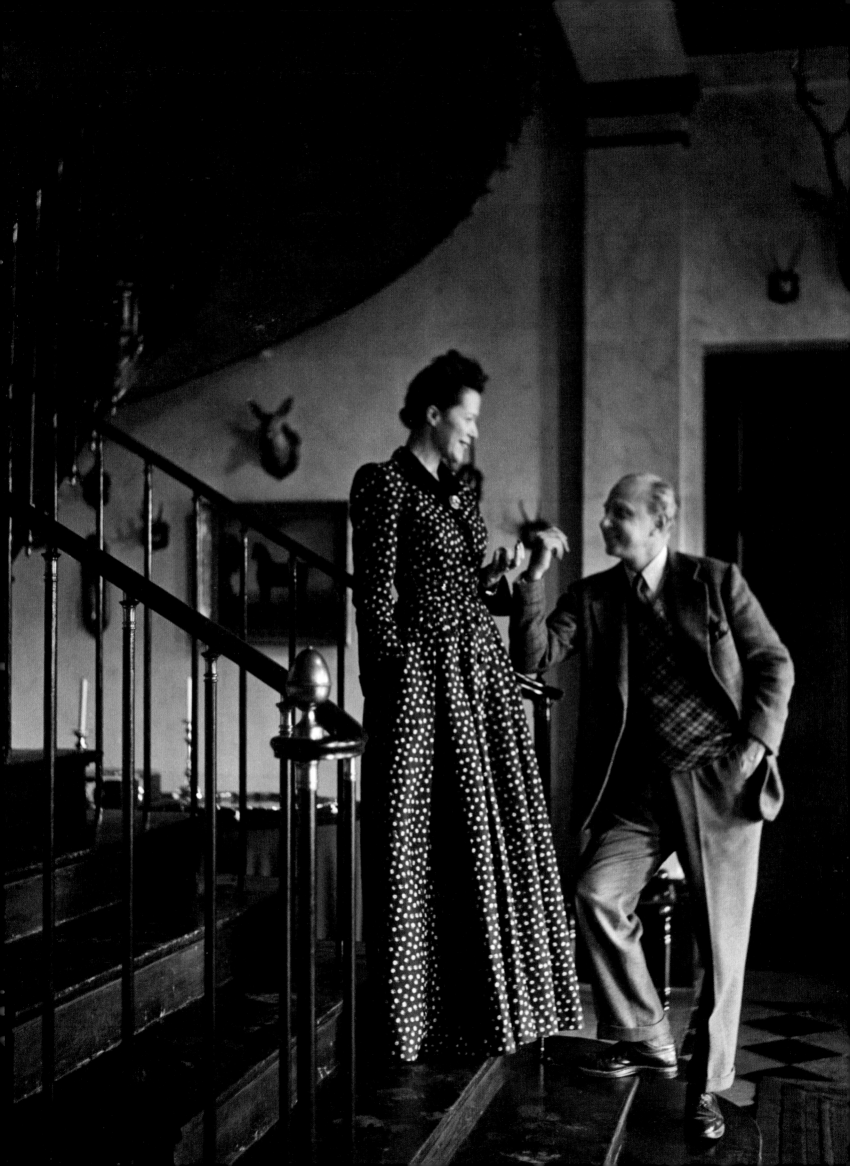

South Americans

In the original French edition of his *Dictionnaire du snobisme*, Philippe Jullian observed that Edouard Bourdet's play *La Fleur des pois* was the finest study of snobbery in high society between the wars: "To remain absolutely topical, it would merely need to be set in South American rather than aristocratic circles."[1] The major influence of prominent South Americans, often sporting more or less plausible aristocratic titles but allied by marriage to families of authentic pedigree, was one of the distinguishing features of café society. Notable among this coterie were Charles de Beistegui, Arturo Lopez, the Marquis de Cuevas, Emilio Terry, Eugenia Errazuriz, Raymundo de Larrain, Tony Gandarillas, and Antenor Patino. Until the early twentieth century, these Mexican, Chilean, and Argentinean families, immensely wealthy and often originally from Spain but also sometimes some centuries earlier from the French Basque country, remained discreet—not so much in their lifestyle as in the minor degree of influence they exercised over matters of taste.

Jean-Louis de Faucigny-Lucinge, whose mother was by birth a Terry—the family whose monopoly over the sugar industry had made it the richest in Cuba—recalled in his memoirs: "At this time we were rather what one might call 'flashy foreigners.' Everything we possessed was too ostentatious and too rich." At the Exposition Universelle of 1889, a grandfather had bought a bathroom made of solid silver, including the bathtub.[2] In his *Journal inutile*, the less tolerant Paul Morand recorded Jean de Castellane's remark: "During my youth I saw Paris fill up with what we called *rastaquouères* (from *rasta cuero*, or 'leather scrapers'). The Yturbes, the La Rivières, the Beisteguis, and so forth. Thirty years on, it is they who are setting the tone in Paris."[3] By around 1900, most families who had made their fortunes in South America spent at least part of the year in Paris. Many of them made prestigious marriages in the faubourg Saint-Germain: thus the Terrys married into the Faucigny-Lucinge[4] and Castellane families; the Anchorenas into the Castries, the Beisteguis into the Rohans, the Patinos into the Beauvau-Craons, and the Aramayos into the d'Arcangues. And so they also put their considerable financial resources at the disposal of an increasingly lavish lifestyle. The Terrys, for instance, bought the chateau of Chenonceaux, which became the setting for sumptuous parties.

1. Philippe Jullian, *Dictionnaire du snobisme*, Paris: Plon, 1958, p. 79.
2. Jean-Louis de Faucigny-Lucinge, *Un gentilhomme cosmopolite*, Paris: Plon, 1990, p. 30.
3. Paul Morand, *Journal inutile 1968-1972*, Paris: Gallimard, 2001, p. 689.
4. After the death of Baba, Jean-Louis de Faucigny-Lucinge was himself to marry a Brazilian, Mlle de Oliveira, and to represent the Order of Malta in Brazil.

From the turn of the century, Eugenia Errazuriz was a style leader in both London and Paris where, as Cecil Beaton related in *The Glass of Fashion*, she supported Picasso from the beginning of his career, along with many other artists. She also revolutionized the arts of decoration and the table, as well as fashion. In this she was succeeded by Beistegui, Lopez, and Terry, whose influence on twentieth-century decoration was to be so decisive. All three played an important part in café society, invigorating it, putting it center stage, and attracting attention to it with their grandiose and often outrageously extravagant schemes. These wealthy landowners devoted their fortunes to an *art de vivre* that had formerly been the preserve of the French aristocracy, who now either lacked the means to pursue it, or—given the context of the times they were living in—felt discretion was a wiser course.

Bound together as they were by many common factors, these South American families sometimes also nurtured bitter rivalries. Some of their feuds were well known, such as the competition between Charles de Besteigui and the Marquis de Cuevas to throw the ball of the century, the former at the Palazzo Labia in 1951, the latter at Chiberta in 1957. More importantly, in a milieu driven by snobbery, nuances of birth might bring with them superiority complexes that were beyond the understanding of mere mortals. To the observer schooled in the ways of society, however, Charles de Besteigui would always remain a "Monsieur," while Arturo Lopez was always considered a bit of a fantasist.

In his *Dictionnaire du snobisme,* Jullian explained: "Mexico, the native land of M. de Beistegui, is with Peru the best provenance for South Americans. Mexicans who remain in their own country, by contrast, take a fierce pride in their native Indian blood, and show off their Aztec profile or Maya coloring as though they were Hapsburg lips or a Bourbon nose."[5] Then he adds a note of caution: "No South American, however rich, and descended supposedly from ancestors however noble, will ever be thought smart in Spain. They, and particularly their accent, are laughed at more fiercely in Spain than North Americans ever are in England."[6] Chileans living in France, meanwhile, invariably hailed from Valparaiso, and had nothing but contempt for their fellow citizens, however wealthy, from Santiago.

The brazen snobbery of the South Americans (of which they were targets in turn from the French gratin, who on occasion snubbed the prospect of fabulous alliances with them), was accompanied by an almost universal taste for pomp and splendor, a return to the Grand Siècle, to which Beistegui was as susceptible as his Lopez and Cuevas rivals. But far from reinforcing hackneyed clichés about the vulgar ostentation of South Americans, we should give credit to the elegance and refinement they often displayed, spicing classic French taste with a certain *je ne sais quoi*—all very far from the prejudices evident in Paul Morand's *Journal inutile*: "I detest liveries *à la française* in the country; it looks South American and reminds me of a picnic in Argentina, on the outskirts of Buenos Aires, where servants in white stockings, frogging, frock coats, and panne velvet breeches served guests on the lawn! Or *chez* Beistegui at Groussay too."[7] In the slipstream of South Americans such as these also came characters of more dubious origins, such as the professional lotharios Porfirio Rubirosa and Raymundo de Larrain. The provenance of the Marquis de Cuevas, meanwhile, gave rise to endless speculation.

5. Philippe Jullian, *The Snob Spotter's Guide*, London: Weidenfeld & Nicolson, 1958, p. 119.
6. Ibid., p. 177.
7. Paul Morand, *Journal inutile 1968-1972*, Paris: Gallimard, 2001, p. 689.

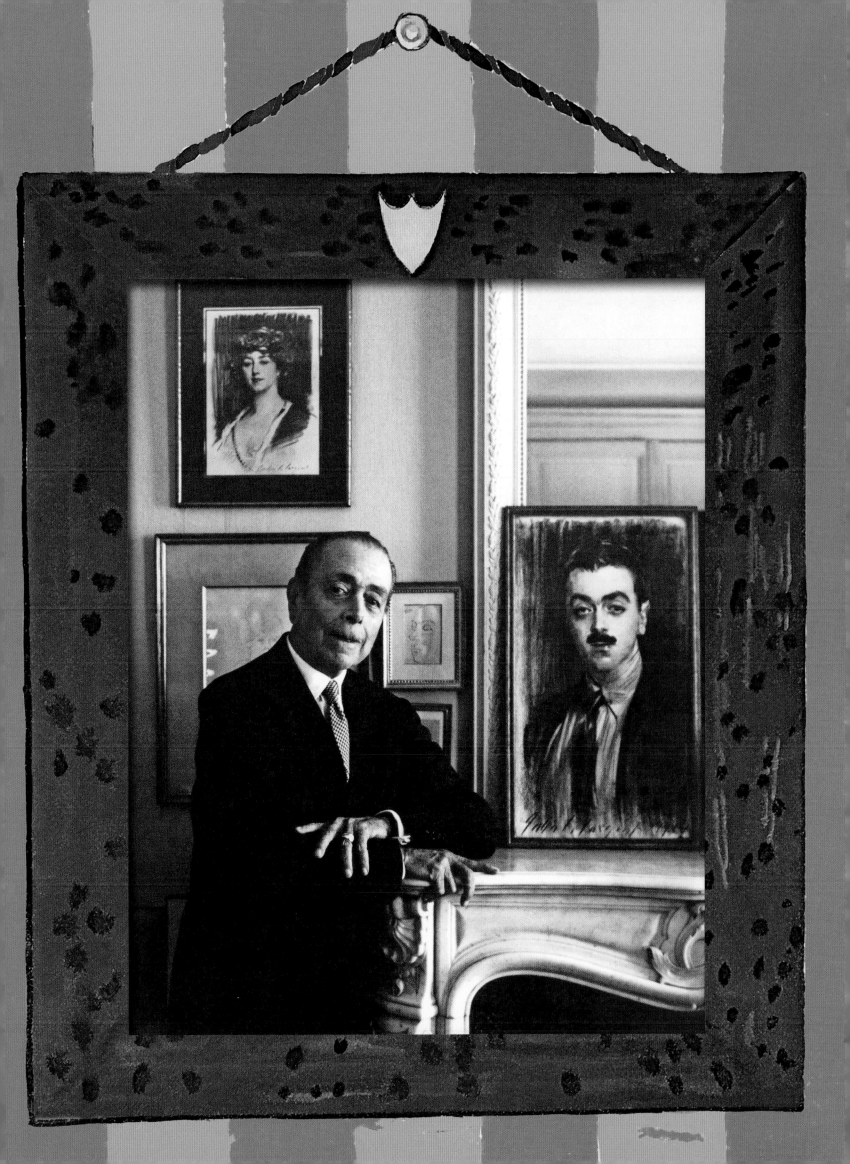

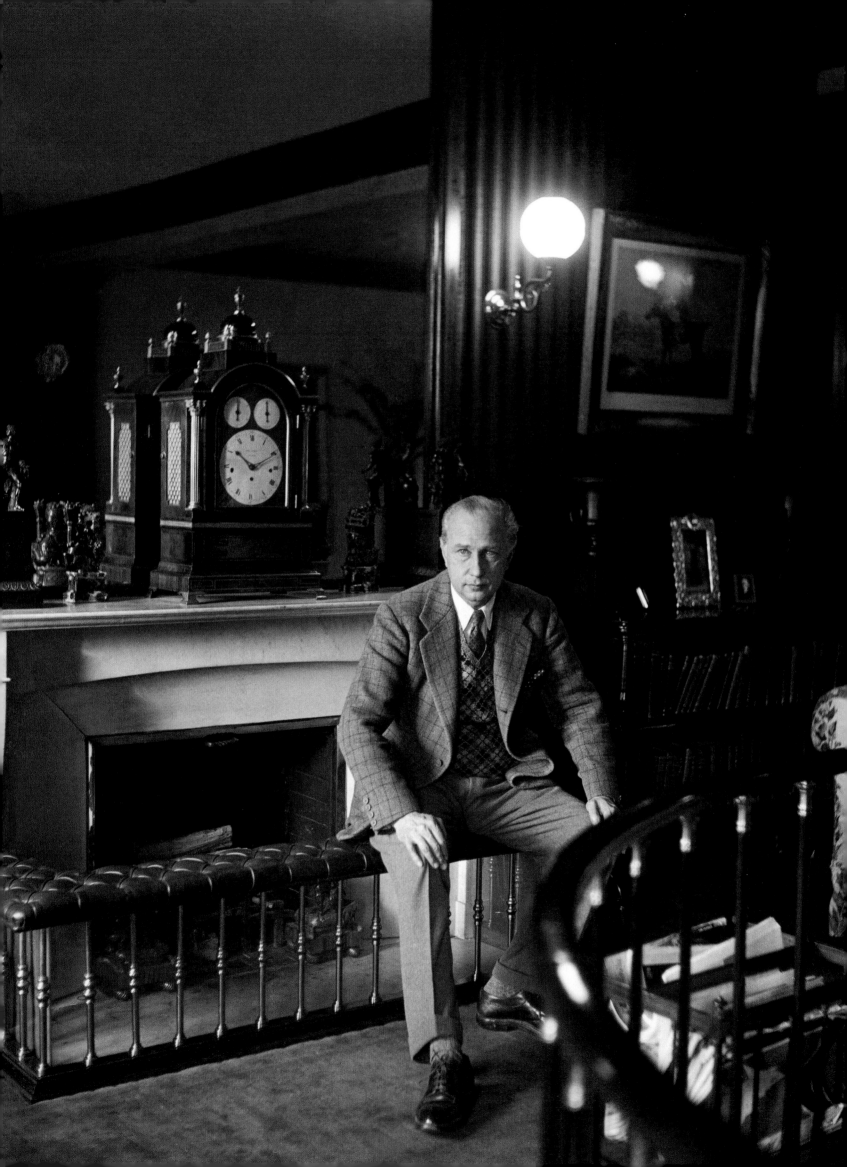

Charles de Beistegui

Charles de Beistegui was one of the key figures of café society, and the historic ball that he gave at the Palazzo Labia in Venice in 1951 was its apotheosis. He was born into one of the prominent South American families of European origin whose descendants returned to Europe to live in lavish style on the fortunes they had amassed. He was also the most European of this coterie. After several centuries in Mexico, where they owned pewter mines, his family returned to Europe in 1867, soon after the fall of the Emperor Maximilian. His grandparents and after them his parents lived in luxury in a mansion they had built on rue de Constantine in Paris (a stone's throw from Les Invalides), which Charles was to redecorate with the help of Emilio Terry. His parents were highly cultivated and great collectors, and his uncle, also called Carlos, bequeathed an outstanding collection of paintings to the Louvre. After serving as Mexican ambassador to Spain, Charles's father acquired Spanish nationality. Charles himself, known to all his friends as Charlie, became an attaché to the Spanish embassy in Paris, which enabled him to sit out the war with a diplomatic immunity that was convenient for both his travels and his lifestyle.

Though more Mexican than Spanish, and despite his deep attachment to Paris, where he was to have a succession of residences, Beistegui was above all a cosmopolitan figure. This was clear not only from his friends and lifestyle (he traveled for at least three months of the year), but also from his tastes, which were steeped in French classicism but also mixed with English influences—doubtless dating from his time at Eton, where he was friends with Sacheverell Sitwell—as well as Spanish, Flemish, and Italian. Above all, Beistegui was an aesthete whose life was a performance, a man who lived purely for pleasure. Misanthropic by nature, he surrounded himself with a small group of friends with whom he liked to go hunting antiques twice a week, consisting of Emilio Terry, Charles de Noailles, and Alexis de Redé (whom he helped to decorate the library of the Hôtel Lambert), as well as Louise de Vilmorin, Denise Bourdet, the English designer Nathalie Tree, the Faucigny-Lucinges, the Duff Coopers, and Christian Bérard. He fostered excellent relationships with his neighbors, the Lacretelles at Gambais and the Cabrols at Grosrouvre, but for the rest of humanity he manifested an ostentatious contempt. His rank snobbery was such that when Lady Diana Cooper invited him to dinner with the American General George C. Marshall, then in charge of reconstructing Europe after the war, he asked, "Is he of good family?" An inveterate womanizer, he would never pay court to any woman below the rank of duchess.

An unalloyed aesthete, Beistegui devoted his time and money to putting himself in the spotlight and to creating decorative schemes for his own pleasure. A Don Juan of interior decorators, he adored hunting down pieces that were sometimes authentic and

Facing page
Charles de Beistegui at home at the Château de Groussay. Photograph by Cecil Beaton, 1944.

costly, sometimes modest and purely decorative. Once he had bought them, however, he lost interest in them. "Perhaps some of De Beistegui's decorating is cold, without soul or heart, and one suspects that he possesses a secret disregard for quality . . . He will happily mix imitation classical statuary with the superb ormolu and mahogany of Roentgen; paintings seem to be decoration and not art when hung on the walls of his room," observed a purse-lipped Cecil Beaton.[1] Often, and without compunction, he would have pieces by illustrious cabinet-makers cut down in order to fit one of his own designs. Although this millionaire had naturally never been a professional interior decorator, he created so many decorative schemes for himself and his friends that his work became a strong influence on the decoration of his time, and even of later generations. Designers such as David Hicks believed they owed him a great debt.

> He created so many decorative schemes for himself and his friends that his work became a strong influence on the decoration of his time.

There was certainly such a thing as "Beistegui taste." Again, Cecil Beaton had a view: "Charles de Beistegui is a *pasticheur par excellence* . . . More often than not, his intention is to produce character rather than to create loveliness . . . De Beistegui's taste is essentially masculine: bold, uncompromising, sometimes even slightly acrid . . . [He] avoids mere reconstitutions of exact past styles and epochs. His imagination is so rich that his imitators can never keep up with him or guess what he will make fashionable tomorrow."[2] It was a taste that had itself evolved a good deal. Beistegui's first apartment was a rooftop dwelling on the Champs-Elysées, which he entrusted to Le Corbusier to create a "machine for living." At this point the young dandy was seeking to outdo the Noailles, who had commissioned Mallet-Stevens to design their house at Hyères. But Besteigui very quickly grew tired of Le Corbusier's extreme austerity, and transformed it into the first surrealist interior. Subsequently his taste became at once more classic in form and more eclectic in the choice of furniture and decorative features, adapted to the family mansion on rue de Constantine, the Palazzo Labia in Venice, which he bought in the late 1940s, or the Château de Groussay at Montfort-l'Amaury, which he acquired in 1938.

For Beistegui, all these interior decorations projects for houses on which he lavished his unceasing attentions were constant works in progress. Having enlarged the original chateau, he opened a bijou theater in 1957 with the *Impromptu of Groussay* penned by Marcel Achard; and to the end of his life he had follies in the grounds decorated by Emilio Terry. None of the prodigious energy that he devoted to hunting down pieces (often working from his bed, as did his rival in lavish entertainments the Marquis de Cuevas) was ever transformed into affection for his creations, however. Only the creative process itself interested him. Thus in 1964 he had no qualms about parting from the Palazzo Labia, the scene of his greatest success in 1951, or about dispersing the collections he had amassed there. According to the fashion historian Katell le Bourhis, "He created the Disneyland of 1950s café society—and he was Mickey Mouse at the center."[3]

1. Cecil Beaton, *The Glass of Fashion*, London: Weidenfeld and Nicolson, 1954, p. 286.
2. Ibid., pp. 284–7.
3. Katell le Bourhis quoted by Suzy Menkes in "Under the Hammer: A Magic Kingdom," *New York Times*, May 25, 1999.

Facing page
Charles de Beistegui at a tea party given by Contessa Morosini in Venice. From the scrapbook of the Baron de Cabrol, 1953.

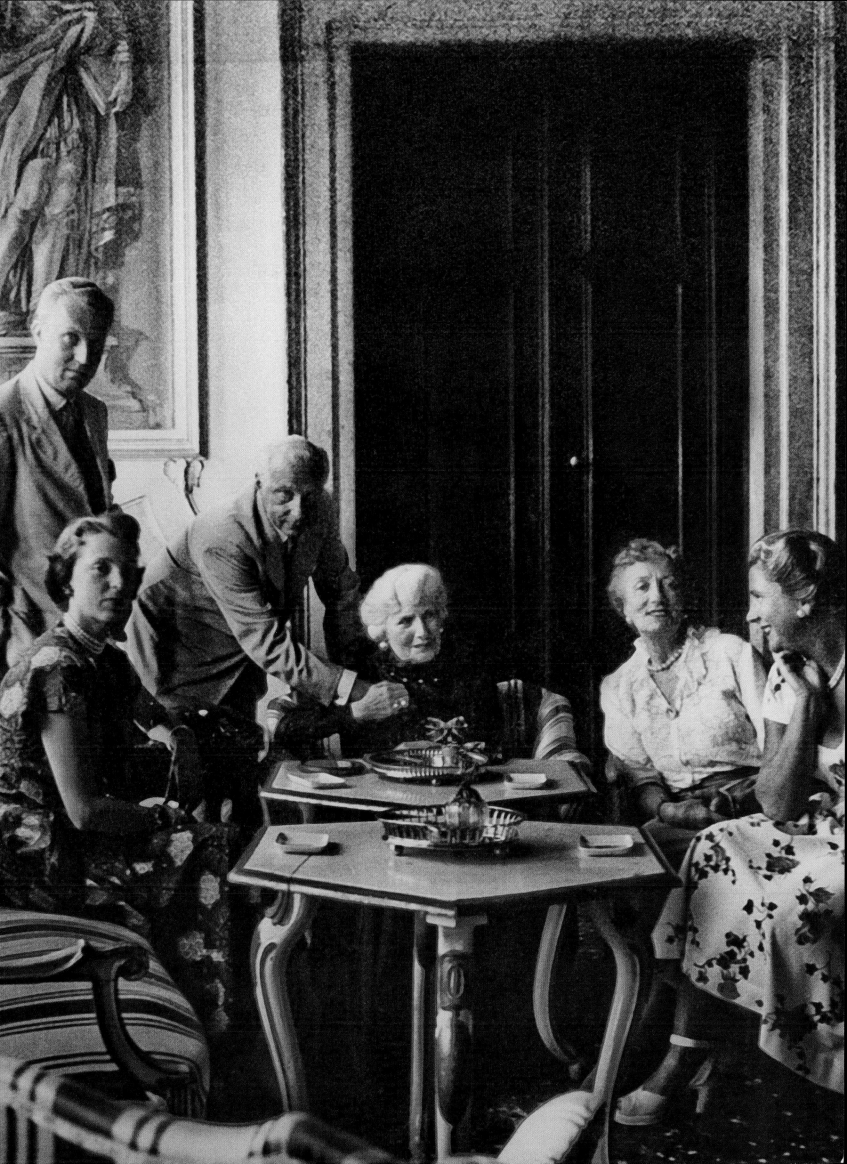

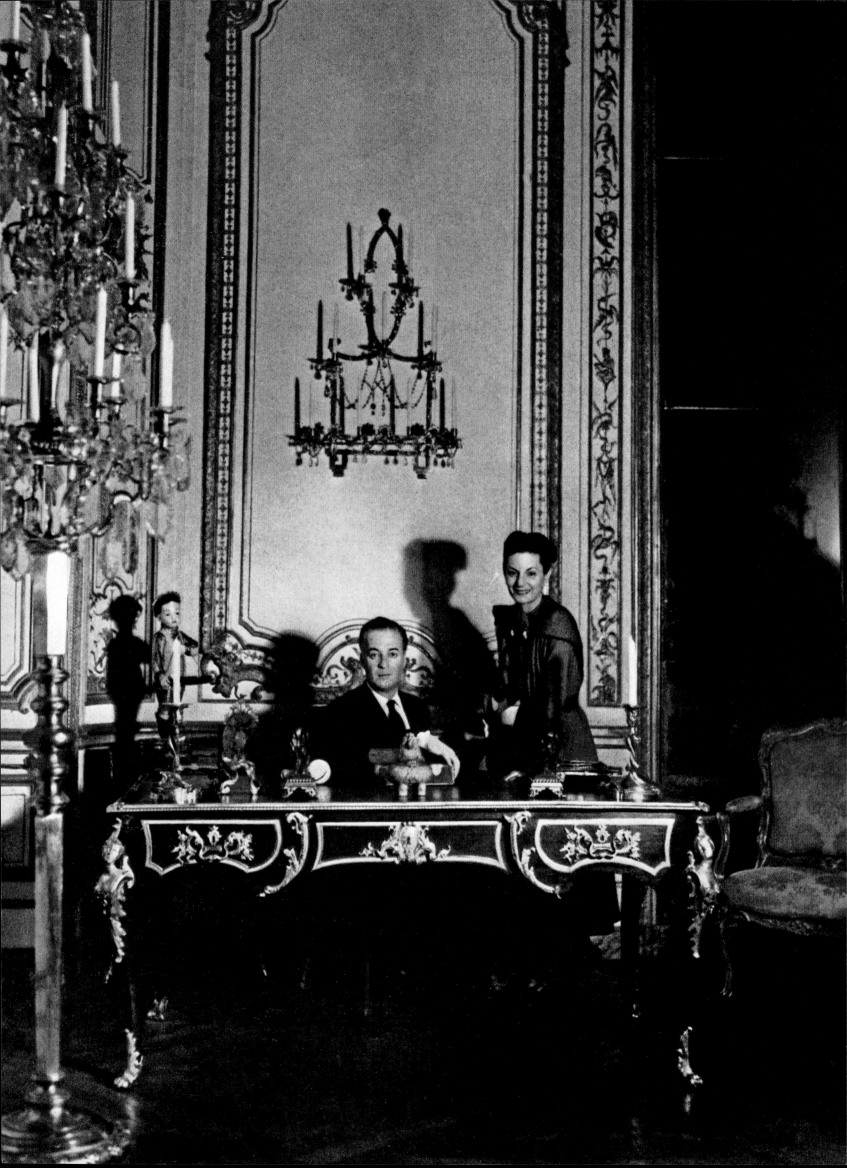

Arturo Lopez-Willshaw

With Charles de Beistegui, Arturo Lopez-Willshaw was undoubtedly one of the most conspicuous figures among the South American coterie of café society. Heir to an immense family fortune amassed from the pewter mines and guano trade of Chile, Lopez-Willshaw devoted himself essentially to indulging his passions: this was a man simultaneously in thrall to society life and to collecting, which he did on a grand scale. Sybaritic and in search of distractions from an early age, he lived in a frenetic social whirl. Given to over-indulgence in alcohol and drugs, which were prematurely to erode his health, he could be relied upon to be the life and soul of the party. He also adored young men, with a string of lovers including Cecil Everly, later the companion of Count Pecci-Blunt, and Tony Pawson. In 1937, wanting to have children, he married Patricia Lopez-Huici, a cousin from a considerably less wealthy branch of the family. Patricia was the great-niece of the famous Eugenia Errazuriz, a woman of exquisite taste who left her mark on early twentieth-century interior decorating, and who was among the first to collect Picasso's work.[1] Another relative was the consummately elegant Antonio Gandarillas, friend of Daisy Fellowes and Louise de Vilmorin and a notorious opium addict. Sadly for Arturo, the marriage was to prove childless. Arturo then set about elevating his wife into an icon of elegance, a constant presence on the list of the world's best-dressed women, whose purchases of jewelry from Verdura and Cartier were legendary. Together they became one of the most fashionable couples of the 1940s and 1950s, not only in Paris but also in New York, where they spent the war living at the St. Regis.

The marriage did not by any means spell the end of Arturo's homosexual adventures. In New York during the war, thanks to Elsa Maxwell, he met the young Alexis de Redé, who was to be his lover until his death. On his return to Paris he installed Alexis in the Hôtel Meurice, before renting the Hôtel Lambert for him and having it redecorated at enormous expense by his friend Georges Geffroy. Henceforth, Arturo divided his life between Alexis at the Hôtel Lambert and Patricia in their Neuilly mansion. This very Parisian *ménage à trois*, in which everyone was accommodated, was at the center of café society life. Their parties were legendary, and they were always to be seen at the soirées of Marie-Laure de Noailles, Étienne de Beaumont, the Faucigny-Lucinges, Charles de Beistegui, and Elsa Maxwell, with whom Arturo was close friends. After the war he developed a passion for sailing: having rented the Embiricos' yacht, in 1950 he bought the *Gaviota*, with cabins on board for both Patricia and Alexis. Several times a year they would invite close friends on cruises to the Mediterranean, the North Sea, or far-flung archipelagos. Venice and Saint-Moritz were also regular ports of call.

1. For years, Eugenia Errazuriz rented a wing of the Beaumonts' *hôtel particulier*.

Arturo Lopez was also a great and influential collector, with an eye for rare and exceptional pieces. His collections of Louis XIV, Louis XV, and Louis XVI gold and above all furniture were worthy of the Wallace Collection. He turned his residence at Neuilly, built by Pierre Rodocanachi[2] in the 1920s and decorated by Geffroy (as was the *Gaviota*), into a miniature Versailles[3] over which he reigned like an absolute monarch. Cecil Beaton could not help but be struck: "If his taste treads little new ground in its grandeur of style and perfection of theatrical effect, it at least continues to keep open the path trodden by Largillière and Cécile Sorel in the style of Louis Quatorze. To look at the house in Neuilly, one can hardly believe this transformation is of recent development . . . Likewise, the yacht in which Mr. and Mrs. Lopez-Willshaw sail the Mediterranean Sea, with its ormolu, *chinoiserie* and its furniture, the work of *maîtres ébénistes*, must be unique in the history of navigation."[4]

His collections of Louis XIV, Louis XV, and Louis XVI gold and above all furniture were worthy of the Wallace Collection. He turned his residence at Neuilly into a miniature Versailles

In addition to collecting for himself, Arturo Lopez was also, with Paul-Louis Weiller and Barbara Hutton, one of the principal benefactors who supported Gerald Van der Kemp in his campaign to refurnish Versailles with its original furniture. When he died of a heart attack in 1961, his fortune was divided between Alexis de Redé—who had succeeded in warding off the intrigues of his potential rival Raymundo de Lorrain—and Patricia. After leading a glittering social life and being one of the most photographed women in *Vogue* and *Harper's Bazaar*, Patricia now lives discreetly in Kitzbühel and Saint-Tropez.

2. Pierre Rodocanachi later designed his tomb in the cemetery of Père-Lachaise, in which Alexis de Redé is also buried.
3. He asked Philippe Jullian to write an exceptional book on his residence and collections, with a limited edition of only 266 copies.
4. Cecil Beaton, *The Glass of Fashion*, London: Weidenfeld and Nicolson, 1954, p. 278.

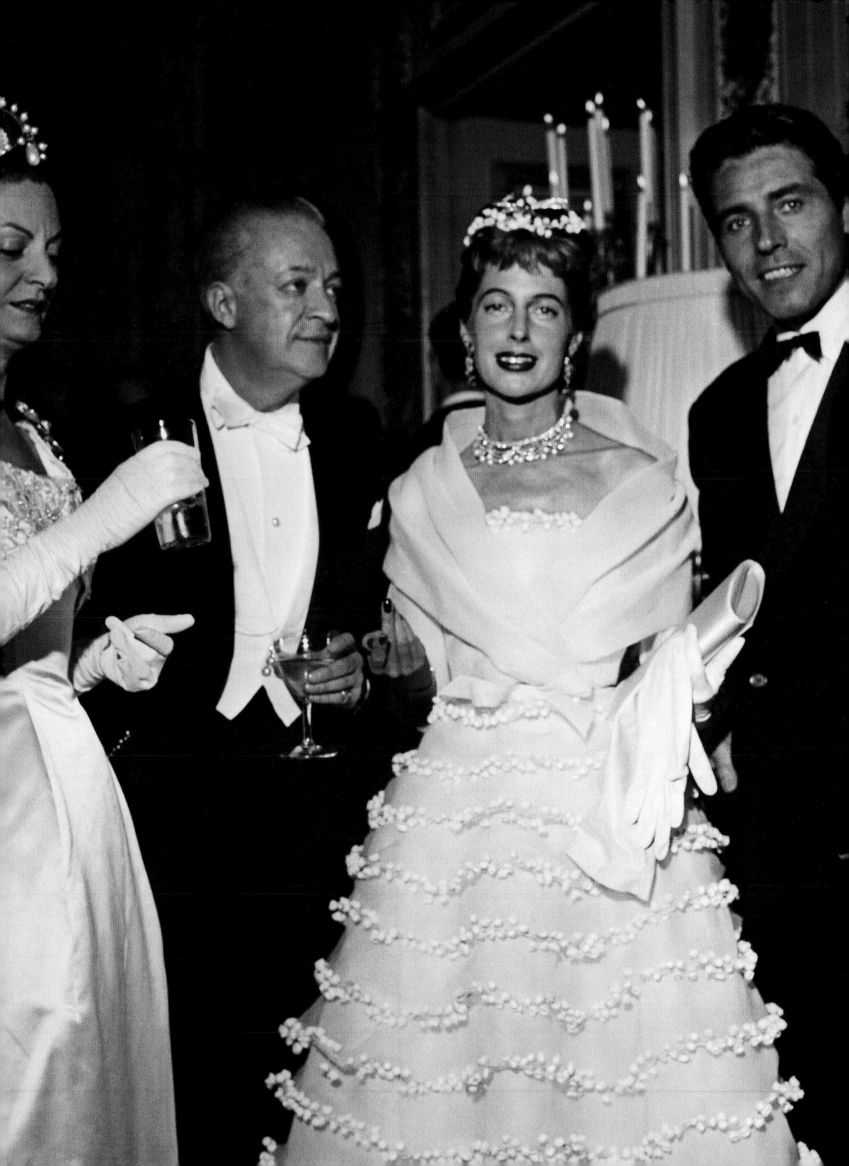

The Marquis de Cuevas

After starting a dance school for the children of French refugees in New York during the war, the Marquis de Cuevas took over the running of the Ballets de Monte Carlo, then experiencing difficulties. From 1951 the company became known as the Grand Ballet du Marquis de Cuevas. Thanks to his energies and above all to the fortune of his wife, a Rockefeller granddaughter, the company enjoyed a period of outstanding success, both in the quality of their performances and in the splendor that attended them. Cuevas was one of the most unusual and idiosyncratic figures in café society. Just as his origins were hazy, so no one could be sure whether his love of the ballet was more about the dance or the dancers. Born in Santiago in 1885, George de la Cuevas de Bustillo y Terrar, created Marquis de Piedrablanca de Guana by royal decree of 1931, was—it was said—the son of a great aristocrat and member of parliament who was also director of the Chilean postal service, railways, and national bank.

Yet the young man who arrived in Paris in the early years of the twentieth century had not a penny to his name. Accounts of his activities at that time vary—porter, delivery boy, society dancer?—but we know that he worked for a while for Prince Yusupov's fashion house, and that he saved up to buy a small apartment in the Alma district, where he entertained *le Tout-Paris* until his marriage to Margaret Rockefeller Strong in 1927. But it was not until after the war that he became one of the major figures of café society and the world of ballet. *Pièges de lumière*, to a book by Philippe Hériat, and *Roméo et Juliette* by Berlioz, performed in the Cour Carrée of the Louvre in 1955, were major highlights of the social calendar. In 1957, the Marquis attempted to outdo Beistegui by throwing a grand ball at the Chiberta Country Club; Biarritz proved no match for Venice, however.

In 1958, the Marquis—whose lavish lifestyle verged on self-caricature—fell out dramatically with Serge Lifar over the rights to a ballet, and challenged him to a duel, in a gesture that was generally dismissed as grandiloquent and slightly ridiculous. He insisted on being present at his company's performances to the very end of his life, in 1961. Whatever his foibles, the celebrated patron of the arts, described by Lifar as "Rameses strayed into our era," who spent his days receiving visitors in bed in Cécile Sorel's former apartment at 7 quai Voltaire, had succeeded in bringing together everyone who mattered or who was about to matter in the world of 1950s ballet. He engaged not only John Taras as ballet master, but also a galaxy of celebrated ballerinas who would later join the Paris Opera company, including Rosella Hightower, Yvette Chauviré (considered the greatest of French ballerinas), Ghislaine Thesmar, Solange Golovine, and Liane Daydé. It was with the dazzling Marquis de Cuevas Ballet that the young Rudolf Nureyev—introduced to café society in its final throes by Alexis de Redé—made his first sensational appearances after defecting to the West. Soon after the death of the Marquis, his widow attempted to keep his work alive; despite her efforts, the Cuevas Ballet closed its doors for ever.

Socialites

Café society was swarming with characters of doubtful usefulness, inveterate socialites, hangers-on and social climbers, and lotharios and gigolos. It offered them an environment in which they could flourish and prosper. For some, being part of it was an end in itself. Apart from their names—and even those were often borrowed—no one really knew who they were, where they came from or where they were going, what they did or had done. They were simply there, thanks to merits that they either had or were rumored to have. If they made it onto a coveted guest list, it was by virtue of a name with cachet, an enviable physique, a caustic wit, a desirable address book, or an impressive degree of culture—some rare aspirants displayed all these attributes at once; others, even rarer, none at all. They could be spotted hovering around a charismatic figure, on the arm of a celebrity, and sometimes on their own at parties and balls or in the pages of fashion magazines. Yet they were neither artists nor patrons of the arts.

Café society comprised numerous "sets" that overlapped, sharing common elements and mutual jealousies. First of all—*noblesse oblige*—came the Windsor set, with an inner circle consisting, at their successive Paris residences, on the Côte d'Azur, and on cruises, of Daisy Fellowes, Emerald Cunard, Henry "Chips" Channon, and the Duke's faithful aide-de-camp "Fruity" (Major Edward Dudley) Metcalfe, who might be joined by other friends such as the Cabrols or Ghislaine de Polignac. Charles de Beistegui, meanwhile, was constantly surrounded, in Paris, at Groussay or in Venice, by a bevy of charming acolytes including Denise Bourdet, Odette Pol Roger, Odette Massigli, and Aude de Mun. The Cabrols were loyal courtiers too, as they were of Arturo Lopez, whose hand-picked cruising companions were otherwise Clé-Clé de Maillé, Jimmy de Cadaval, the Castejas—and Alexis de Redé, naturally.

Louise de Vilmorin mixed and matched some of her Verrières set with the inner circle of Diana Cooper, her friend and rival for Duff's affections, which also included many artists as well as faithful friends such as Elizabeth Chavchavadze, Jean-François Lefèvre-Pontalis, Sacha de Manzarly, Anthony Marecco, and Tony Gandarillas. Other sets were more specific in their membership: Marie-Blanche de Polignac's circle brought together essentially artists, particularly musicians; Florence Gould's consisted largely of writers; and Marie-Laure de Noailles attracted artists of every persuasion and intellectual pleasure-seekers, so creating a set that was far from typical of café society.

Some people were simply ubiquitous. The Cabrols were a case in point: Frédéric was an interior decorator, while Daisy, *née* Marguerite d'Harcourt, presided over the good works

Facing page
From the scrapbook of the Baron de Cabrol, 1957.

Following pages
The Boisgelin and Cabrols at Ascot. From the scrapbook of the Baron de Cabrol, 1957.

Page 129
Daisy Fellowes and Alexis de Redé at a ball given at the Hôtel Lambert. Photograph by Robert Doisneau, 1950.

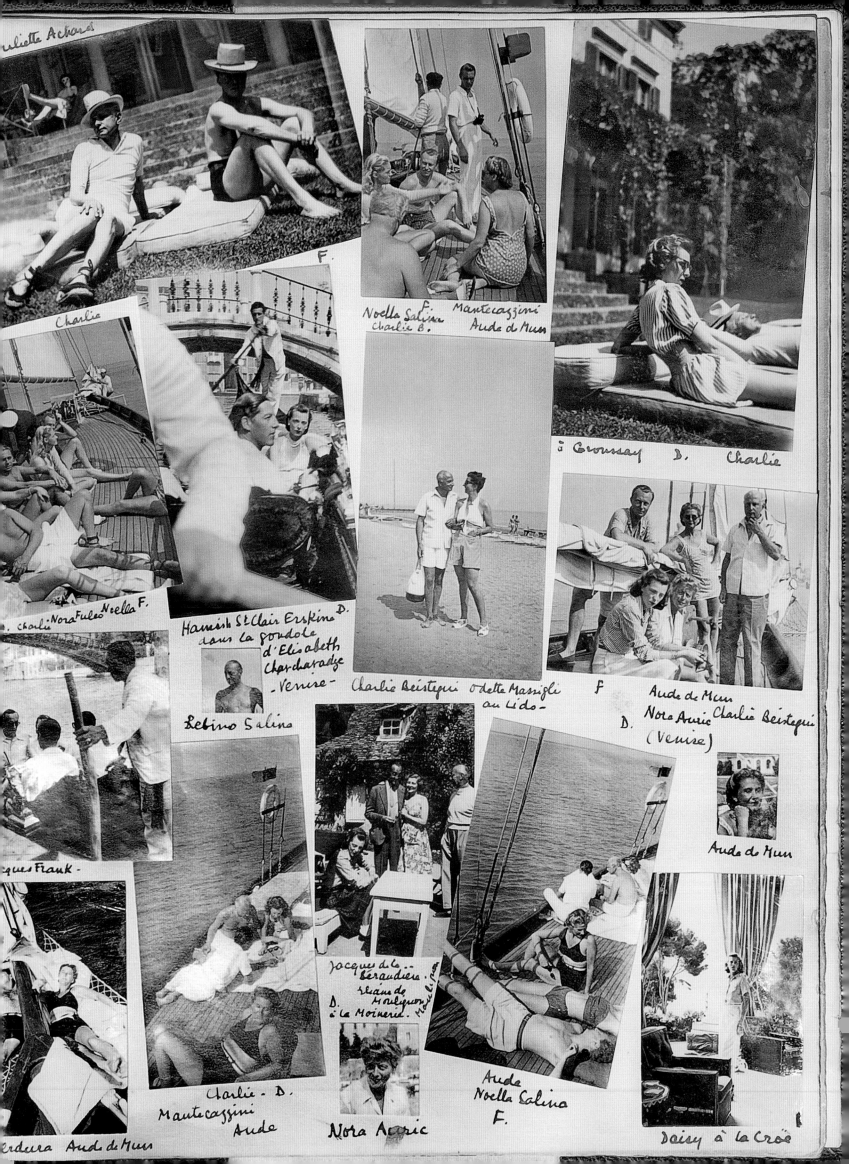

Juliette Achard

F.

Noella Saline
Charlie B.

Mantecazzini
Aude de Mun

à Groussay D. Charlie

Charlie

Charlie Nora Fuleo Noella F.

Hamish St Clair Erskine D.
dans la gondole
d'Elisabeth
Charcharadze
- Venise -

Lebino Salino

Charlie Beistegui Odette Massigli
au Lido -

F. Aude de Mun
D. Nora Auric Charlie Beistegui
(Venise)

Aude de Mun

Jacques Frank -

Jacques de la
Béraudière
D. relais de
Houlgnon
à la Moinerie.

Charlie - D.
Mantecazzini
Aude

Nora Auric

Aude
Noella Saline
F.

Verdura Aude de Mun

Daisy à la Croë

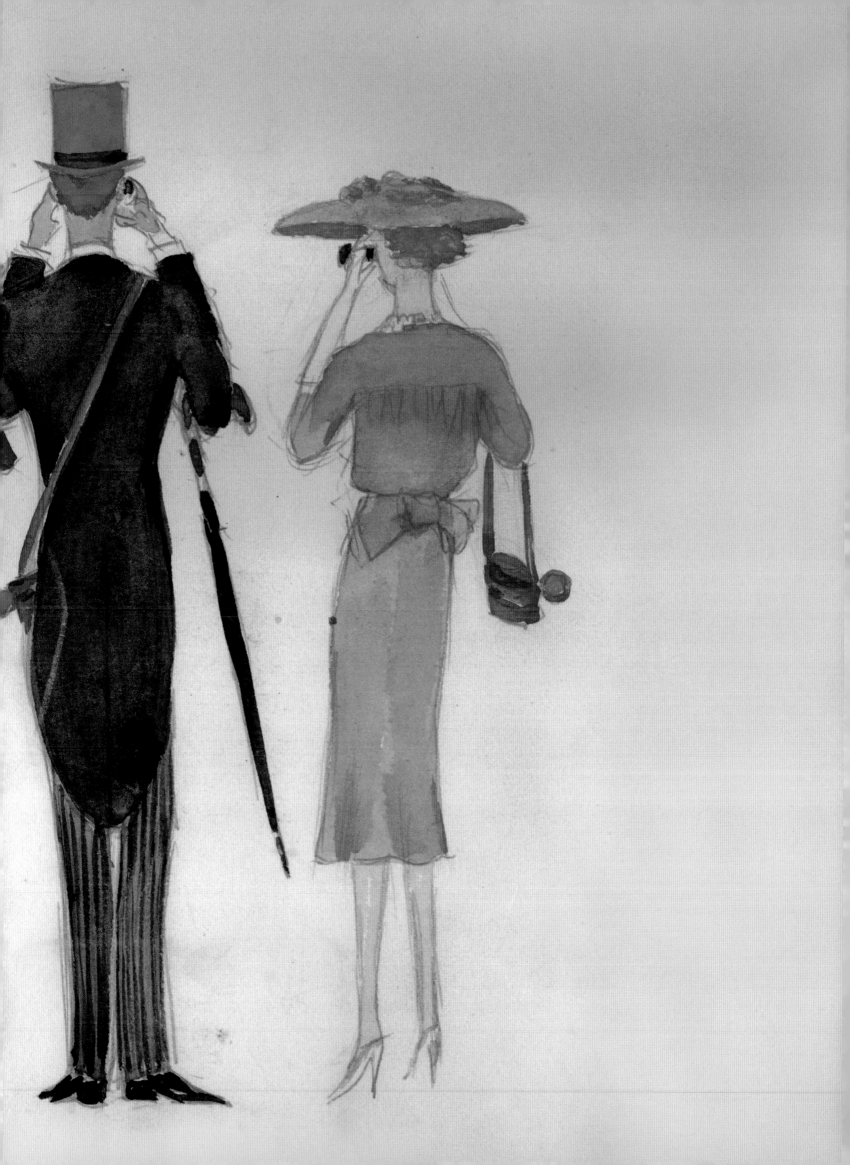

of the highly select charitable foundation known as l'Essor, whose annual ball was the pinnacle of elegance and style. They were also a fixture on every guest list, indeed their presence was a measure of the success of any event and testimony to the chic of their hosts. Daisy was one of the most elegant and photographed women of her time, and yet she and her husband were neither patrons nor muses to any artists. They simply set the tone. The same was true of Ghislaine Brinquant, for whom a brief marriage to a Prince de Polignac enabled her to embellish the stylish looks and piquant wit of a typical Parisienne with the prestige of a smart name. Writers such as Philippe Jullian and photographers such as Cecil Beaton led parallel lives in high society of such strenuous inclusiveness—being "in" with virtually every set and coterie—that, as with many other artists, their professional standing tended to suffer as a result.

Escorts were another important species of socialite, who lived off the fame of prominent figures, whose glory rubbed off on them. Some, like Alexis de Redé, became society figures in their own right, attracting in turn their own circle of courtiers. Many leading ladies of café society were escorted by their favorites, loyal friends whose habits and morals might often be described as ambiguous. Lady Mendl would generally be seen on the arm of *Vogue* journalist Johnny MacMullin; Misia Sert was accompanied in her final years by Boulos Riestelhuber; and even the Duchess of Windsor had her own loyal friend in the form of Barbara Hutton's cousin Jimmy Donahue, eventually giving rise to gossip about an affair between them. Barbara Hutton herself was prey throughout her life to men attracted by her fortune, some of whom were little more than gigolos. Only Jimmy Douglas proved a disinterested escort, who did what he could to extract her from the many imbroglios into which she found herself plunged. Others were unabashed gold diggers, attracted purely by money and prestige. Tony Pawson was such a figure for Arturo Lopez before he met Alexis de Redé, and Cecil Everly made a fortune out of Count Pecci-Blunt.

Some of these young men, such as John Galliher, boasted looks that were as striking as their poses of ennui. In a very different vein, even more aesthetic and refined, Tony Gandarillas bestrode the entire period, juggling all the various sets and milieus by virtue of his varying status as nephew of Eugenia Errazuriz, cousin of Patricia Lopez, friend of Louise de Vilmorin, and opium companion of Daisy Fellowes. Also featuring in this gallery of escorts were the seducers and Don Juans, a field in which Porfirio Rubirosa displayed remarkable prowess, closely followed by Raymundo de Larrain, who intriguingly lived off his concurrent seduction of both the Marquis de Cuevas and his wife, whom—to general outrage—he later married.

A final category of socialite, whose sole *raison d'être* seemed to consist of being seen in glossy magazines or at society events, consisted of beautiful foreigners, elegant, thoroughbred, and deeply enigmatic, such as Ninet Eloui Bay, Helena Kuo, Lady Abdy, and Mme Martinez de Hoz. Of all these fashion icons we know little. Perhaps, behind the glossy photographs, there was little to know.

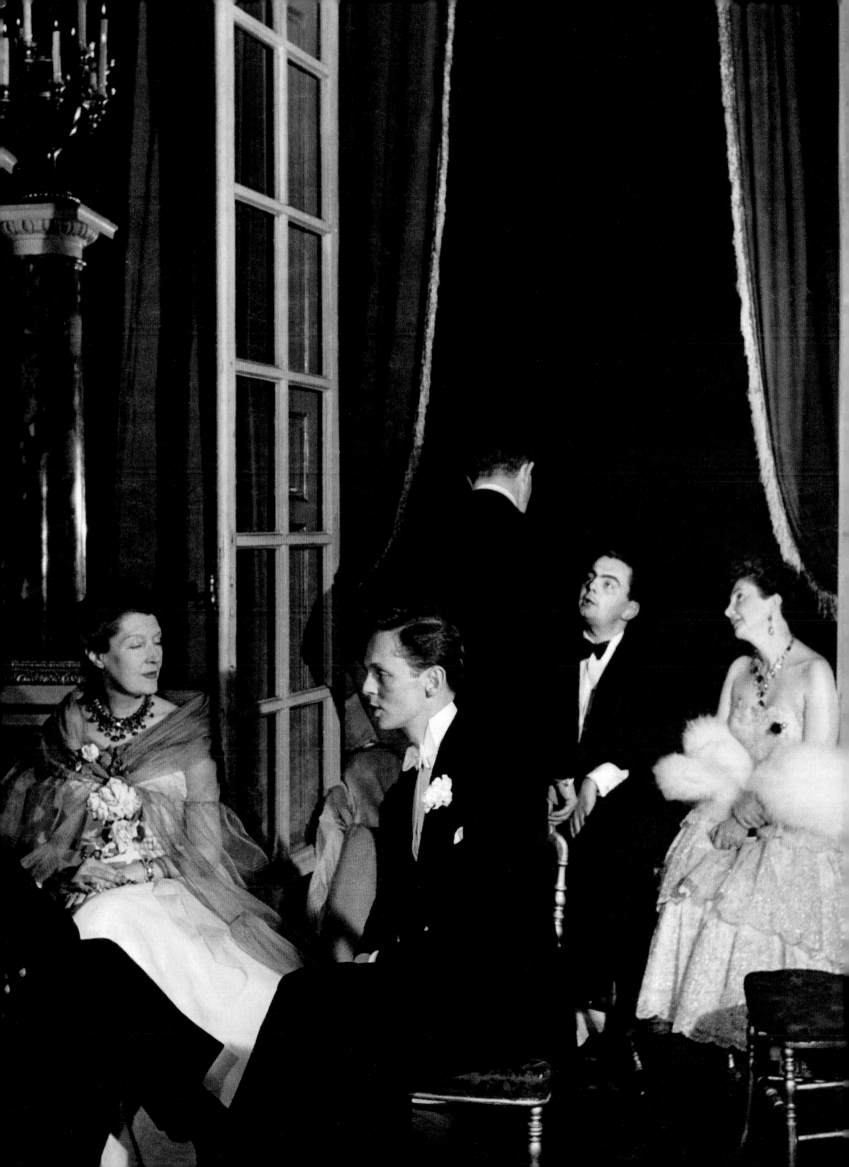

Alexis de Redé

Though undoubtedly one of the conspicuous and emblematic figures of café society, which he outlived with panache, Alexis de Redé was also one of its most impenetrable members and also in the end one of the most misunderstood, even by those who rubbed shoulders with him at innumerable society events. His extreme elegance, impeccable manners, and British-style sangfroid disguised the depth of his nature, leaving the best as much as the worst to the imagination. The official imagery was perfect: launched on the world in 1946, at the age of twenty-four, the young baron became a major player in Paris high society. In 1949 he moved into the most magnificent apartment in the whole of the capital, the piano nobile of the Hôtel Lambert at 2 rue Saint-Louis-en-l'Ile, built by Le Vau and described by Voltaire as "the house of a sovereign who would like to be a philosopher." He restored and redecorated it with the help of his friends Charles de Beistegui, Emilio Terry, and Georges Geffroy, and it became the setting for balls of the utmost splendor, including some, such as the "Bal des Têtes" in 1957 and the "Bal Oriental" in 1969, that went down in the annals of the greatest costume balls ever known. He became the attentive escort of Marie-Laure de Noailles, and above all of Marie-Hélène de Rothschild, his neighbor and the owner of the Hôtel Lambert. Princesse Ghislaine de Polignac and Comtesse Bismarck were also his neighbors and friends.

If one man were to embody late twentieth-century aestheticism, elegance, and refinement, Alexis de Redé would have no rivals. But the appearance of a life of ease and leisure earned him comments that were less than admiring. In her diary, Louise de Vilmorin noted that, "He carried his handsome death's head with great elegance," and described him as a "handsome skeleton."[1] Others were more scathing: for Nancy Mitford he was *La Pompadour de nos jours,*" while for Henry "Chips" Channon he was the "Eugène de Rastignac of modern Paris." In fact his life was not always as easy as it appeared. Certainly he was ambitious, and he mixed friendships with money, but what struck those who got close to him was another image beyond the glossy pictures of a rather haughty fashion plate—that of a reserved, modest, generous man, who loved money only in order to devote it to art and beauty, and who was less concerned with honors and vanities than with striving to transform his life into a work of art.

Born on February 4, 1922 in Zurich, Alexis was the son of an Austro-Hungarian Jewish banker who had become a citizen of Liechtenstein, on whom Emperor Franz Josef had conferred the title of Baron de Redé shortly before his death in 1916. While his father lived mostly in Vienna, the young Alexis was given a Protestant upbringing by his mother in Zurich. She died of leukemia in 1931, shortly after discovering that her husband was keeping a mistress in Paris. Alexis was sent as a boarder to the prestigious school of Le Rosey, where his fellow pupils included the scions of numerous royal and millionaire families, a factor that

1. Louise de Vilmorin, *Intimités*, Paris: Gallimard, 2001, pp. 50, 71.

undoubtedly influenced him in forging his formidable social ambitions. The distinguished education he gained there ensured that, even if later some might contest the validity of his title, no one could ever fault his aristocratic ways.

The second great shock of his life came in 1938, when Hitler invaded Austria. Facing severe financial difficulties, his father committed suicide, leaving his children only modestly provided for. At the same time, a pupil at Le Rosey informed young Alexis, then aged sixteen, that he could no longer speak to him because he was Jewish. This was the turning point, when he decided he had to take his chances in life. With his modest savings, he embarked for America. There he lived at first in New York, before moving to Hollywood, where he worked for an antique dealer in West Hollywood. Luck was on his side: he became friends with Lady Mendl and Salvador Dalí, and started moving in fashionable circles where his European accent, impeccable education, and elegance were bound to attract attention. Back in New York, in a restaurant one evening, he met the famous Chilean millionaire Arturo Lopez-Willshaw. This encounter—engineered by Elsa Maxwell and the playboy Jimmy Donahue, heir to the Woolworth fortune, cousin of Barbara Hutton, and future escort to the Duchess of Windsor—was to change the course of his life. Arturo Lopez was officially married to his cousin Patricia Lopez-Huici, but was also carrying on a relationship with a young Englishman called Tony Pawson, whom he had installed in Paris in a sumptuous eighteenth-century *hôtel particulier*. Arturo fell madly in love with Alexis de Redé, and, according to some, offered him a million dollars to go back with him to Paris.

In the event, however, it was with Lady Mendl that Alexis sailed for Paris. He had forged a close friendship with Elsie de Wolfe, who introduced him to everyone in Paris society, and he made his debut at the opening of Le Grand Véfour. His relationship with Arturo Lopez quickly became established, enduring until the latter's death in 1961. In 1949, Lopez installed Alexis in the Hôtel Lambert, with regular cruises on his yacht, the *Gaviota*. Rather looked down on at first by Paris high society, Alexis de Redé was soon to become a major figure in café society: the balls and dinners that he gave at the Hôtel Lambert were the most magnificent of the 1950s, their invitations the most coveted. Beaton evoked the flamboyant scale of these events: "In his principal apartments the note of splendour is given the slightly wry expression of today. . . . When the frail and good-looking young Baron entertains, dozens of chefs in their tall white hats can be seen through a window as the guests mount, from the Court of Honour, the stone staircase."[2]

When Arturo Lopez-Willshaw died, he divided his estate between his widow and Alexis de Redé, between whom a special friendship was to develop. And not without reason, for beneath his dandified ways, the Baron was in fact an outstanding businessman who had ensured the considerable growth of Arturo's fortune. He furthered this talent by going into partnership with Prince Rupert zu Loewenstein and taking over control of the bank of Leopold, Joseph and Sons, which specialized in the management of the finances of celebrities such as the Rolling Stones. He also set up Artemis, an investment fund specializing in the purchase of fine art, exhibiting many works of art and selling them to the great museums. Alexis de Redé was one of the few members of café society to outlive the period, partly because of his youth at his debut, but mostly because he was able to adapt his elegant, old-school style to the changes in Paris high society. Having helped to launch Yves Saint Laurent, who in 1956 designed his "Bal des Têtes," he remained at the vanguard of fashion throughout the 1960s and 1970s, was very close to Georges Pompidou, and appeared in the society columns of fashionable magazines until the last few months of his life.

Page 130
Alexis de Redé on the *Gaviota*, Palma, Majorca, 1954.

Facing page
Alexis de Redé at Saint-Moritz, 1957.

2. Cecil Beaton, *The Glass of Fashion*, London: Weidenfeld and Nicolson, 1954, p. 278.

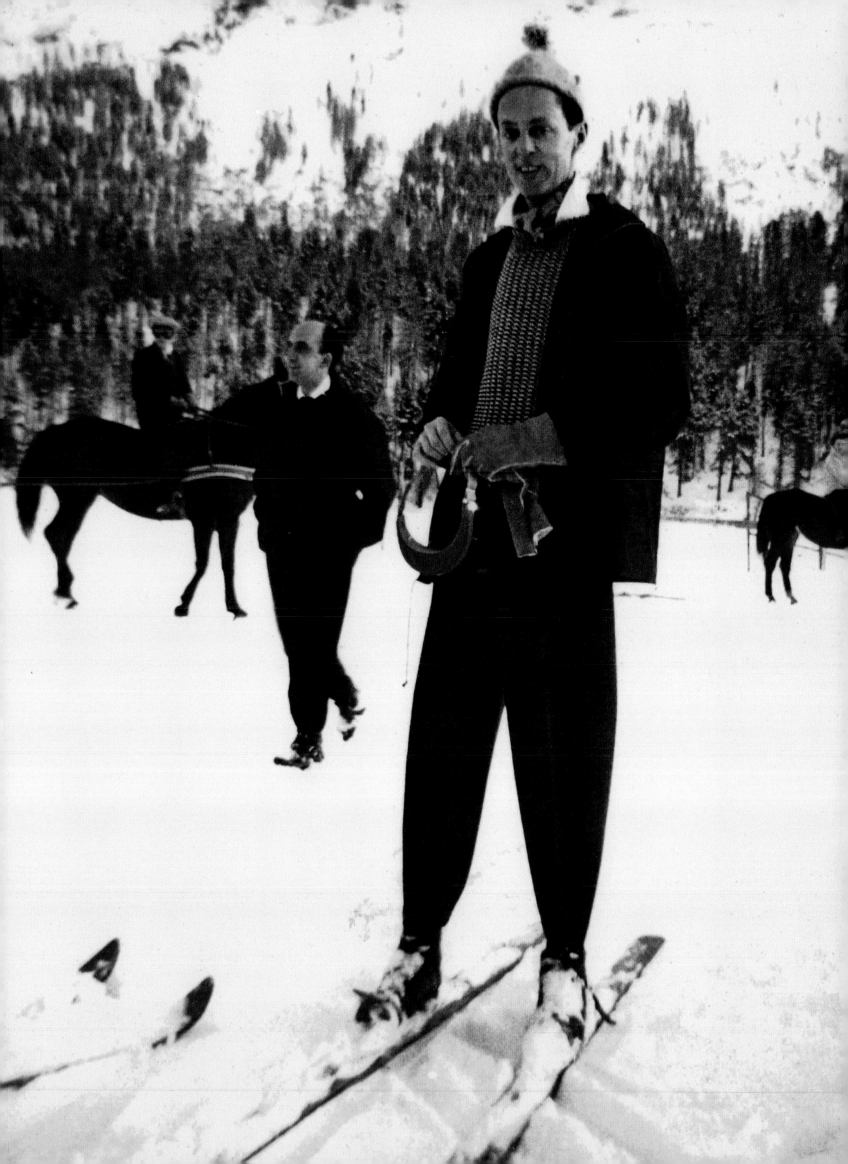

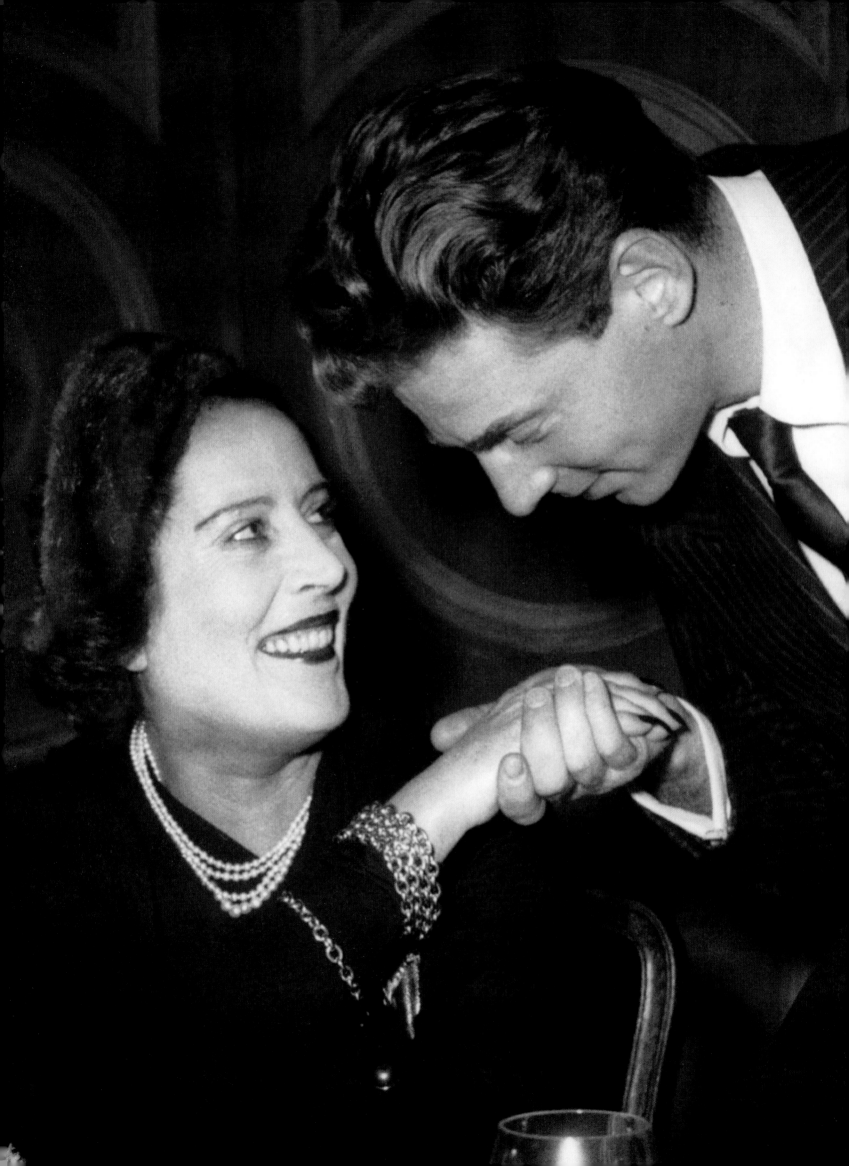

Denise Bourdet

Facing page
Denise Bourdet and Jean-Pierre Aumont at the Prix de la *Chronique Parisienne*, 1949.

Page 137
Jean-Pierre Grédy, Marie-Laure de Noailles, and Denise Bourdet at a book signing by Nancy Mitford, Paris. Photograph by André Ostier, 1954.

There was no corner of café society with which Denise Bourdet was not familiar. A ubiquitous figure at balls given by the Beaumonts and the Noailles, *chez* the Faucigny-Lucinges in Venice, and by Louise de Vilmorin at Verrières, she also herself entertained Cocteau, Bérard, and Morand at Tamaris. Yet she was not for all that either a great hostess or a muse, nor was she one of the period's *grandes élégantes*. She was simply Denise Bourdet: a bridge between high society and the world of art, and a sincere and sensitive companion. Born in 1892, she was the daughter of Maurice Rémon, a university professor who had been a childhood friend of Paul Morand's father, a connection that was to form a special lifelong link between their children. The family lived in literary circles, and Rémon was not merely an academic but also a well-regarded translator of English literature. He was a friend of Sarah Bernhardt, Réjane, Guitry, and Colette, as well as of Giraudoux and Mauriac, both of whom also formed close friendships with his daughter.

Denise was married very young, at nineteen, to Comte Edouard de Saint-Légier, a country landowner in the Charente region—whereupon Giraudoux affectionately nicknamed her "*la comtesse aux seins légers,*" a play on words that translates literally as "the countess of the buoyant breasts." Bored stiff in her new home at Cognac, the Countess was soon dreaming of getting back to Paris and to society life. In 1919, after meeting Edouard Bourdet, whose theatrical career was then on the ascendant, she pressed for a divorce. She and Bourdet did not marry until 1921, by which time his wife Catherine Pozzi, herself in thrall to Paul Valéry, had had time to divorce him. From that point on Denise Bourdet would be seen everywhere in Paris society between the wars—at premieres, private views, balls, and soirées. Among her friends were authors such as Morand, Mauriac, Giraudoux, Cocteau, and Noël Coward; musicians including Jacques Février, Robert Veyron-Lacroix, Francis Poulenc, and Henri Sauguet; artists such as Christian Bérard and Cecil Beaton; and prominent aristocratic socialites such as the Noailles, Beaumonts, Faucigny-Lucinges, and Polignacs.

Wherever people were having fun, creating, or innovating, Denise would be there. "I only ever used to wear evening gowns," she later recalled, "I would get up in time to go into town or to the theater, and I wouldn't be back home before dawn."[1] Often she was fulcrum between different groups, enchanting everyone with her charm and beauty. With professional concerns in mind, she would always be seen at the side of her husband, whose plays—often dealing with subjects inspired by the eclectic circles in which they mixed—were wildly fashionable between the wars. *La Prisonnière* was one of the first plays to be set in a lesbian milieu, with which Denise was doubtless intermittently familiar; *La Fleur des pois* described the beginnings

1. Marcel Schneider, *Le Palais des Mirages*, Paris: Grasset, 1992, p. 230.

of café society, taking its inspiration largely from Étienne de Beaumont, as a result of which the thin-skinned Count blacklisted Denise for years; *Le Sexe faible*, meanwhile, evoked the world of gigolos. The crowning achievement of Bourdet's career came as a surprise, when the Front Populaire government appointed him, a man of the left, to run the Comédie Française, which had been stagnating for years.

Though inseparable in society, their private life as a couple was not so united. Although by her own admission Denise was not especially sensual by nature ("I'm a bell that never rings"[2]), she nevertheless had numerous affairs, including a liaison with her husband's arch-rival Henri Bernstein, which culminated in a duel. Meanwhile Bourdet, ever unlucky in love, languished for the affections of Marie-Blanche de Polignac, daughter of Jeanne Lanvin. When Bourdet died unexpectedly in January 1945, Denise's life changed. She did not curtail her social life, rather the contrary, but now she had to write to support herself. Thus she wrote a column in *La revue de Paris*, in which she drew psychologically penetrating portraits of writers, translated Beaton's *Glass of Fashion*, and published several volumes of memoirs, and above all of interviews with authors. "I am the familiar spirit of dead celebrities," she remarked to Jean Chalon. "People come from all over the world to ask me about the famous writers I have known: Cocteau, Radiguet, Giraudoux."[3] Her own literary tastes tended toward the avant-garde and the *nouveau roman*, as represented by Butor, Robbe-Grillet, Marguerite Duras, Nathalie Sarraute, Sollers, Le Clézio, F.R. Bastide, and Ionesco, among others. A place on the jury of the Prix Médicis gave her the opportunity to champion her advanced tastes, so prompting Sauguet to dub her "Belise Bourdet." In music she was a supporter of Boulez from the very beginning of his career, and she also contributed to the success of the Avignon Festival.

On the fringes of her cultural activities, she was very close to Charles de Noailles, whom she accompanied in society until her death. Marie-Laure put on a show of indignation over this more or less platonic relationship, when she herself was living a life of considerable freedom at this time. Though she meant to be malicious, she in fact merely spoke the truth: "Before he married, Charles knew only duchesses and ladies of easy virtue. Then one day he met Denise, and he believed he had found an undiscovered continent, a phoenix, a rare bird. . . . Imagine this unheard-of novelty: a *bourgeoise!*"[4] And indeed Charles adopted bourgeois ways, taking out a life annuity on the quai d'Orsay apartment so as to increase his income. And every Sunday evening, Denise would organize dinners there with a small circle of close friends, including Suzy Mante-Proust, Jacques Février, Henri Sauguet, Francis Poulenc, Georges Auric, and Robert Veyron-Lacroix. In parallel, she was a fixture at Beistegui house party weekends at Groussay, and at Louise de Vilmorin's soirées at Verrières (who nicknamed her roguishly but affectionately "Dame Bourde," meaning literally "Lady Blunder"), often with Charles de Noailles as her faithful escort. She continued this routine until the last weeks of her life, until cancer finally overcame her in October 1967.

Numerous literary works saw the light of day at the Villa Blanche at Tamaris, where the Bourdets happily welcomed friends in search of inspiration, including Paul Morand, François Mauriac, Jean Giraudoux, and Jacques de Lacretelle, with a special place always among Denise's writer friends for Roger Peyrefitte. "Every woman has her bad boy," as Jacques Février observed. But the last word must go to Pierre Barillet: "In reality, she always remained the provincial girl dazzled by her place in society, the doors of which had been opened for her by her marriage to Edouard Bourdet."[5]

2. Pierre Barillet, *A la ville comme à la scène*, Paris: Editions de Fallois, 2004, p. 135.
3. Jean Chalon, *Journal de Paris*, Paris: Plon, 1999, p. 15.
4. Marcel Schneider, op. cit., p. 241.
5. Pierre Barillet, op. cit., p. 136.

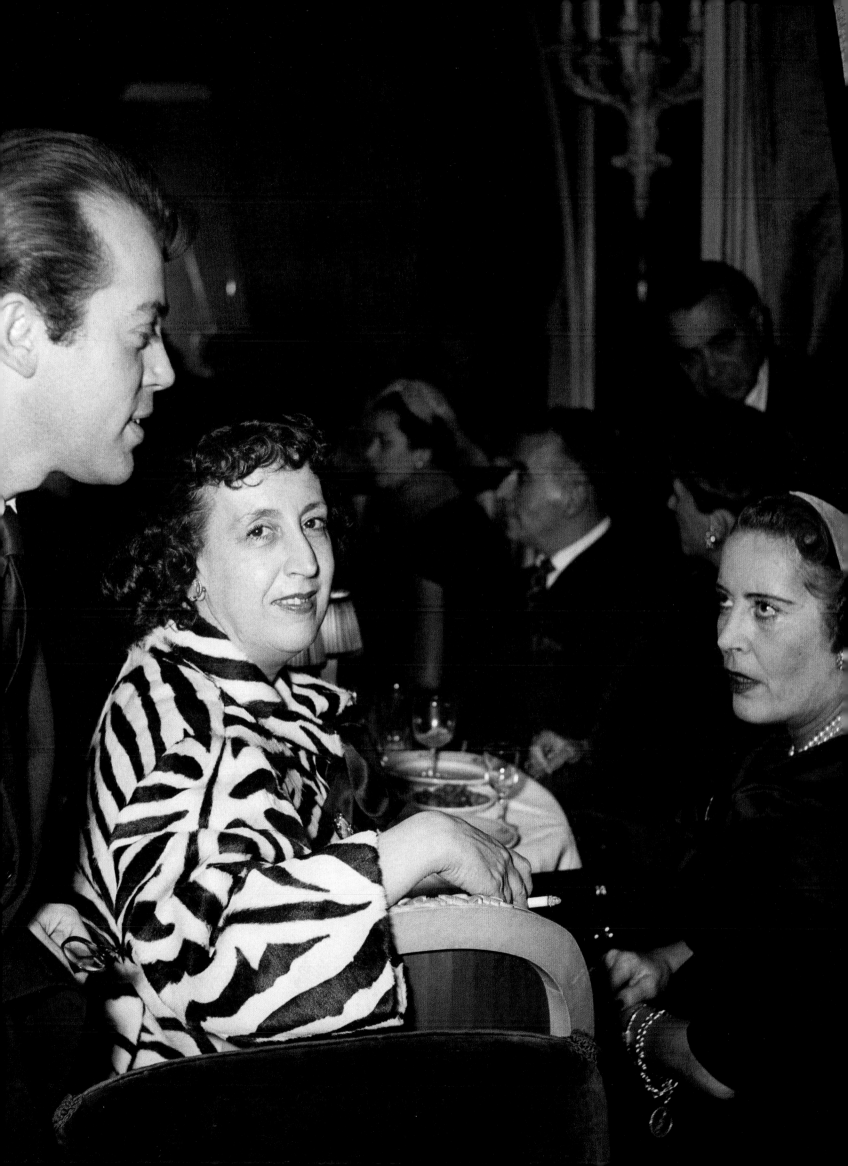

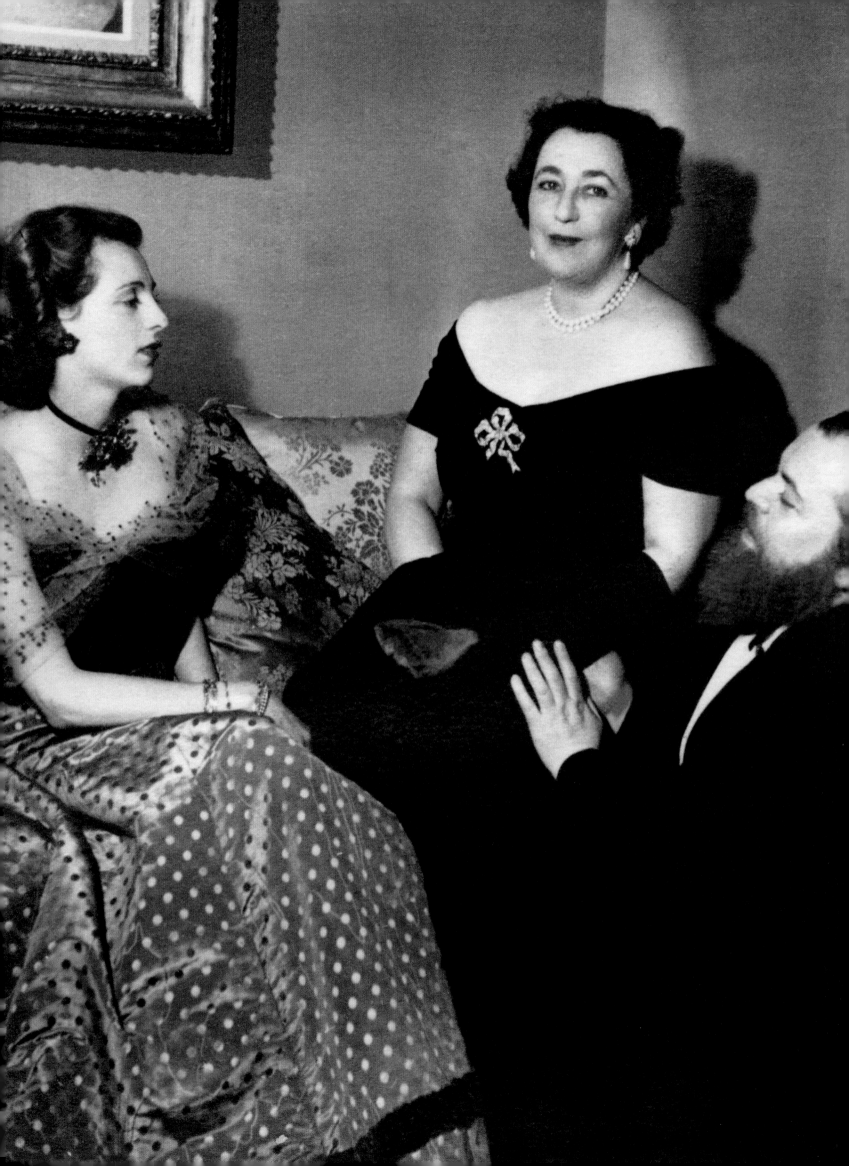

Princess Chavchavadze

Princess Chavchavadze was the living embodiment of the cosmopolitan essence of café society. Born into a wealthy American family, Elizabeth Ridgeway moved to France with her first marriage, to a Breteuil. She did a great deal of entertaining in her Paris apartment on rue de la Bellechasse, and at her country house near Auxerre. Then she married again, this time to George Chavchavadze, a Russian prince of Georgian origins who was also a distinguished composer and concert pianist, and who was himself very café society. One of his notable commissions was for the music for *L'Aigrette*, a ballet written by Princess Bibesco for the Grand Ballet of the Marquis de Cuevas; but despite (or perhaps because of) this constellation of talent, the ballet was a resounding flop.

Very close to Louise de Vilmorin and a member of her inner circle at Verrières, Elizabeth also presided over her own court, which included a young singer of Russian songs who appeared destined for a promising career in the world of film, whose name was Yul Brynner. The Princess spent part of each year in Venice, where she rented a floor of the Palazzo Contarini Polignac. She was regularly to be seen at costume balls, where she often appeared as Catherine the Great, which particularly suited her imposing silhouette (as may be seen in photographs of the Beistegui Ball at the Palazzo Labia), though she also liked to appear—as at Marie-Laure de Noailles' "Lune sur Mer" Ball—as a tobacconist selling cigarettes and chocolate.

She and her husband were both killed in a car accident in the 1960s.

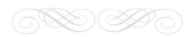

Facing page
Baronne de Cabrol,
Princess Chavchavadze,
and Christian Bérard.
From the scrapbook
of the Baron de Cabrol.

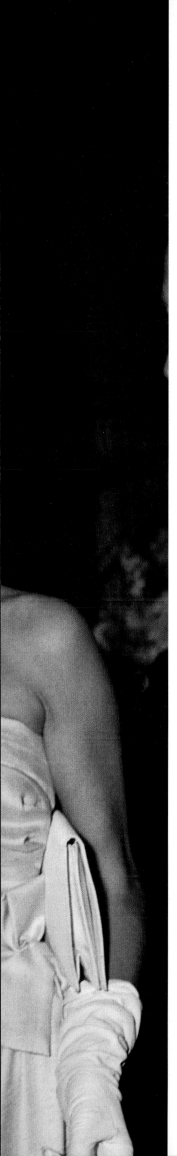

Lilia Ralli

Though discreet by nature, Lilia Ralli still managed to be a ubiquitous figure in café society. Born in Athens, the young Lilia Pringo had as childhood playmates the young Princesses Marina (later Duchess of Kent) and Olga (later Princess Paul of Yugoslavia). Therein doubtless lay the seeds of the extraordinary social success of this fragile-looking young woman who, thanks to the Greek princesses, enjoyed close relations with all the royal families of Europe. Jean-Louis de Faucigny-Lucinge, who was in love with her before she decided to marry Jean Ralli, recounted that because of her tiny physique and her closeness to so many crowned heads, she was known as "la puce des trônes," or (roughly) "the pocket princess." Her royal connections possibly explained the fascination she held for Cecil Beaton, who was her close friend for life after a brief romance in 1937.

Outside the courts of Europe, her circle of acquaintance at the heart of café society was unusually wide. She would be seen on Arturo Lopez's yacht, at Alexis de Redé's balls, at Louise de Vilmorin's soirées at Verrières, at Paul-Louis Weiller's lunches at Versailles, in Venice with Princess Chavchavadze, at Groussay with Charles de Beistegui, and on the quai d'Orsay with Denise Bourdet. She was famous for starting every sentence with the phrase "*Figure-toi*" ("Just imagine"), which earned her the nickname "Figgi."

Lilia put her enviable address book at the disposal of Christian Dior, whom she helped with public relations, and it was she who was instrumental in giving one of the master's young assistants, Yves Mathieu Saint Laurent by name, the opportunity to design Alexis de Redé's "Bal des Têtes" in 1957, so launching one of the most distinguished careers in haute couture.

Facing page
Lilia Ralli at the Bal des Têtes
given at the Hôtel Lambert.
Photograph by André Ostier,
1957.

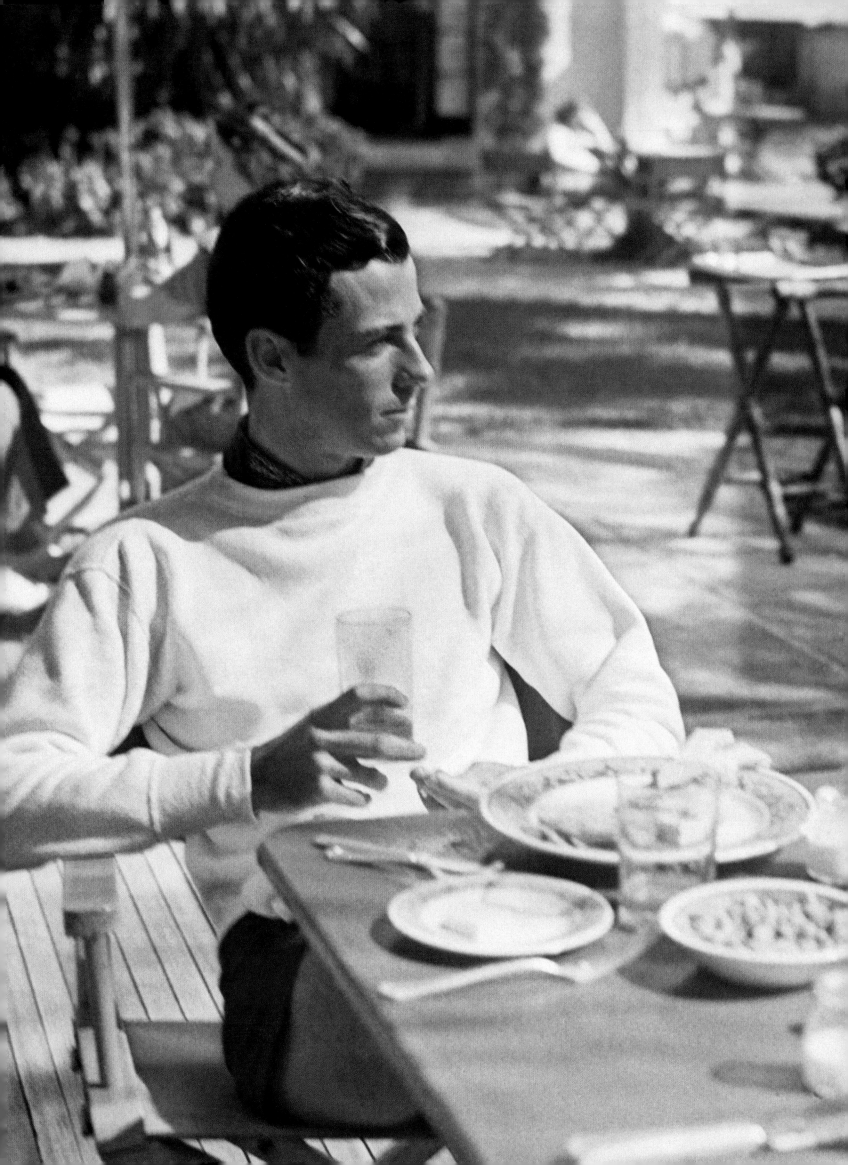

John Galliher

John Galliher was an archetypal figure of café society: everybody knew him, but very few knew much about him. Were men like Galliher rich playboys living a life of leisure, self-seeking adventurers, or simply gigolos? With his impeccable manners, his elegant ways and his glorious looks (piercing blue eyes, a thick head of wavy dark—later white—hair, and the profile of a Greek god), John Galliher was always a welcome guest: a brilliant conversationalist and perfect companion whether at a cocktail party or on a cruise, always surrounded by touches of luxury and tremendous style. After his death, it was discovered that he had left a fortune of over a million and a half dollars.

John Galliher was born in Washington D.C. on May 24, 1941, the second son of a wealthy family of five children, of whom only two would survive into adulthood. As a young man, he was spotted by one of the most prominent ladies in Washington society, Evelyn Walsh McLean, owner of the famous Hope Diamond. It was she who oversaw his first steps in society. After studying at Lehigh University, he served in the Second World War as a naval lieutenant. After the war he moved to Los Angeles, where he shared a house in Beverly Hills with Diana Barrymore, sister of the actor John Barrymore, and the poet Blanche Oelrichs, who wrote under the nom de plume Michael Strange. It was in Beverly Hills that he made his entrée into café society, thanks (as with so many others) to Elsie de Wolfe, Lady Mendl, who introduced him notably to Greta Garbo, whose close friend he became.

In 1948, John Galliher came to Paris to help implement the Marshall Plan for post-war reconstruction, working under the auspices of the American embassy. He rapidly became a prominent figure in Paris society, seen regularly with Cocteau and Gertrude Stein; with the Windsors, the Rothschilds, Mona Bismarck, Daisy Fellowes, Barbara Hutton, Marie-Laure de Noailles, the Lopezes; and when they were in Paris with Cole Porter, Noël Coward, and Elsa Maxwell. He also gave numerous dinners in his apartment on rue de Bourgogne. At the same time, he made frequent trips to London, New York, the West Indies, and Mexico, as well as going cruising on his friends' yachts. As his reputation spread, Hubert de Givenchy enlisted his services as an interpreter, as he spoke French beautifully. In the early 1960s, after fifteen years in Paris, he moved to London, buying a house in Chester Square, before moving on in the 1980s to New York. It was in his apartment off Madison Avenue that he died of pancreatic cancer, aged eighty-eight. To the end of his life he was a constant presence at society events, always eager to see and be seen in the right places.

Facing page
John Galliher at the Sun
and Surf Club, Palm Beach,
Florida, 1939.

Porfirio Rubirosa

Porfirio Rubirosa was the epitome of the café society playboy. His cynicism and self-assurance, combined with a certain élan and crowned by a tragic death, defined a life that was exceptional in many respects. Rubirosa was born in 1909 in Santo Domingo, where his father was a general who was later appointed head of the Dominican mission in Paris. Porfirio spent part of his youth in France, where he went to university, excelled in numerous sports and developed an active nightlife. On his return to the Dominican Republic he enlisted in the army, where his early years were overshadowed by the looming presence of the notorious dictator Rafael Trujillo. In 1932, as a lieutenant, he became part of Trujillo's entourage, and during a polo competition (his favorite sport) he met the dictator's eldest daughter, Flor de Oro, who like him had just returned from studying in Paris for two years. They were married the same year, and he was showered with a succession of titles and honors: under secretary-of-state to the presidency, under secretary-of-state for foreign relations, and deputy in congress. In 1935 his name was linked to the assassination in New York of a leading Dominican exile, Sergio Bencosme. He was also implicated in a number of dubious financial dealings, but with his appointment as the head of the Dominican delegation to Berlin he was protected henceforth by diplomatic immunity.

It was in Berlin that he forged his reputation as a playboy and athlete. His divorce in 1937 did not detract from his position—far from it, indeed. He became friends with his wife's brother, who like him was an inveterate womanizer and socialite. In 1938 he was appointed ambassador to Argentina, a post that he left the following year in order to take up diplomatic duties in Paris, where he was the object of a mysterious assassination attempt in the street. During the war he ran into difficulties and, arrested by the Gestapo like other diplomats, spent six months in prison. His marriage at Vichy to the actress and singer Danielle Darrieux did nothing to curtail his activities. Five years later he married Doris Duke, the Duke Tobacco heiress. Though the union was short-lived, it was extremely profitable for "Rubi." His next affair was to be the talk of international society. Wanting to take revenge on her husband, George Sanders, for having an affair with Doris Duke, Zsa Zsa Gabor, then at the height of her fame, embarked on an affair with Rubirosa—from which she was to emerge with her face bruised and swollen. Undeterred, her sister Eva later married him.

Rubirosa's pursuit of wealthy marriages was by now frenetic, and even his friendship with Trujillo could not contain its damaging repercussions on his diplomatic career. When he was cited in a string of sensational adultery suits, notably by the Reynolds Tobacco heir Richard Reynolds and the British golfer Robert Sweeny, Trujillo had no choice but to remove him from his diplomatic duties. In 1953, Rubirosa set his sights on a new prey, the

Facing page
Porfirio Rubirosa at a polo
match at Deauville, 1956.

Page 147
Porfirio Rubirosa and his
wife, the actress Odile Rodin,
1959.

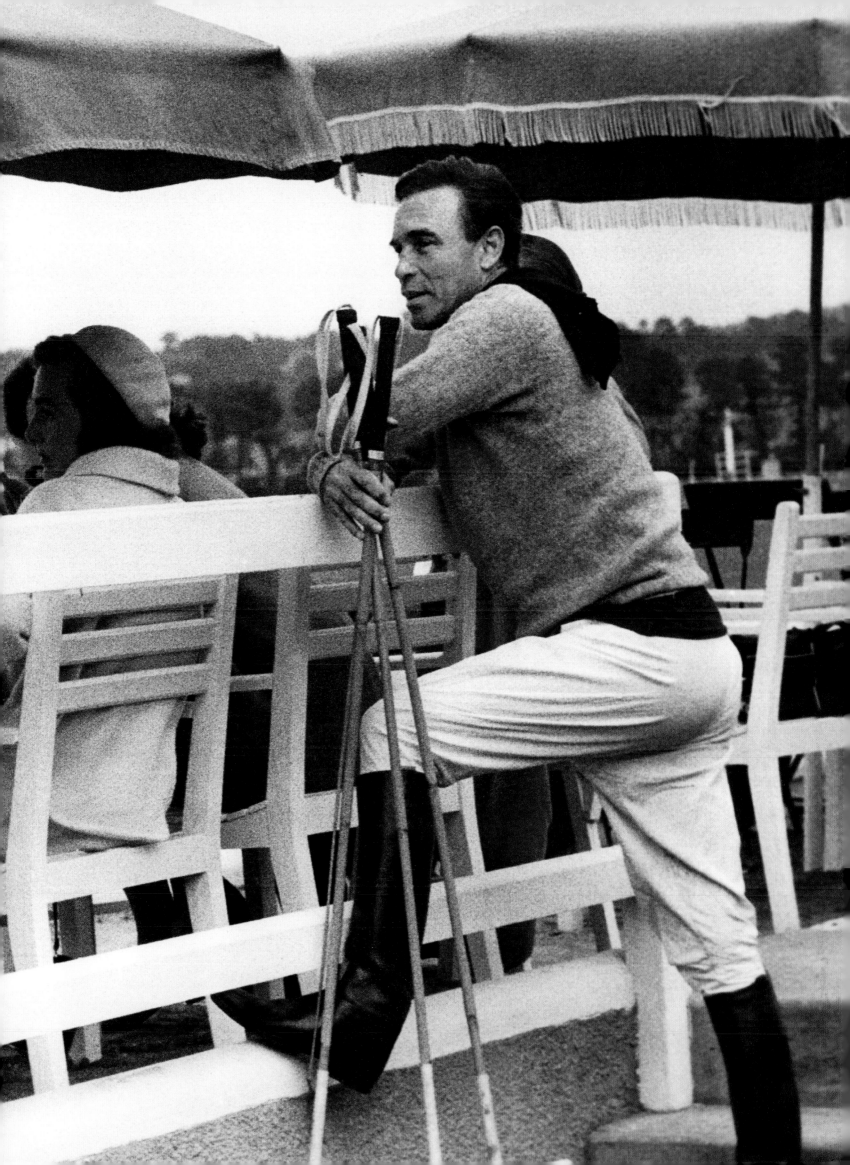

Woolworth heiress Barbara Hutton. The marriage lasted only a few months, interrupted by his rekindled affair with Zsa Zsa Gabor. A plan hatched by the two lovers that same year to act opposite each other in a film called *Western Affair* hit the buffers when the American authorities refused to allow Rubirosa to play the part. By this time, he was devoting his life exclusively to his amorous, sporting, and society conquests: when asked if he worked, he replied, "Work? I haven't got time for work." He lived according to his maxim: "Not living up to your reputation is an unforgivable crime."

In 1953, Rubirosa set his sights on a new prey, the Woolworth heiress Barbara Hutton. The marriage lasted only a few months.

In 1956, Rubirosa's name was once more linked to an assassination, the victim this time being Professor Jesus de Galindez, an opponent of Trujillo in the United States. That same year he married the nineteen-year-old French actress Odile Rodin, continuing—despite mounting tensions—to play polo and race his Ferraris. In 1960, America sanctioned the Trujillo regime. Rubirosa tried in vain to set up a meeting between President Kennedy and the dictator, but in May 1961 Trujillo was assassinated, and Rubirosa was relieved of his functions as inspector of embassies. Having lost the protection of diplomatic immunity, he now risked prosecution for the assassinations with which his name had been linked. In July 1965, as an armed rebellion tried to overthrow the civilian junta in Santo Domingo, Rubirosa's car crashed into a tree on avenue de la Reine-Marguerite in the Bois de Boulogne: he was killed at the wheel.

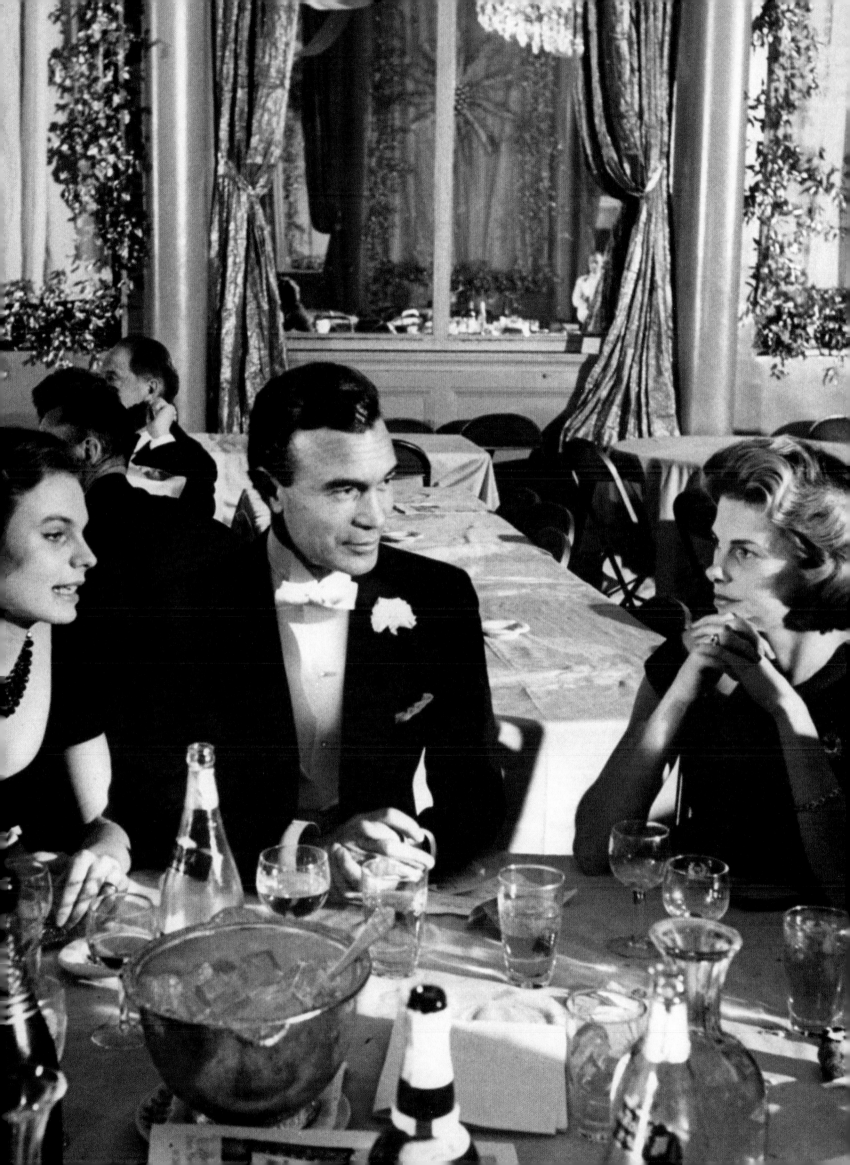

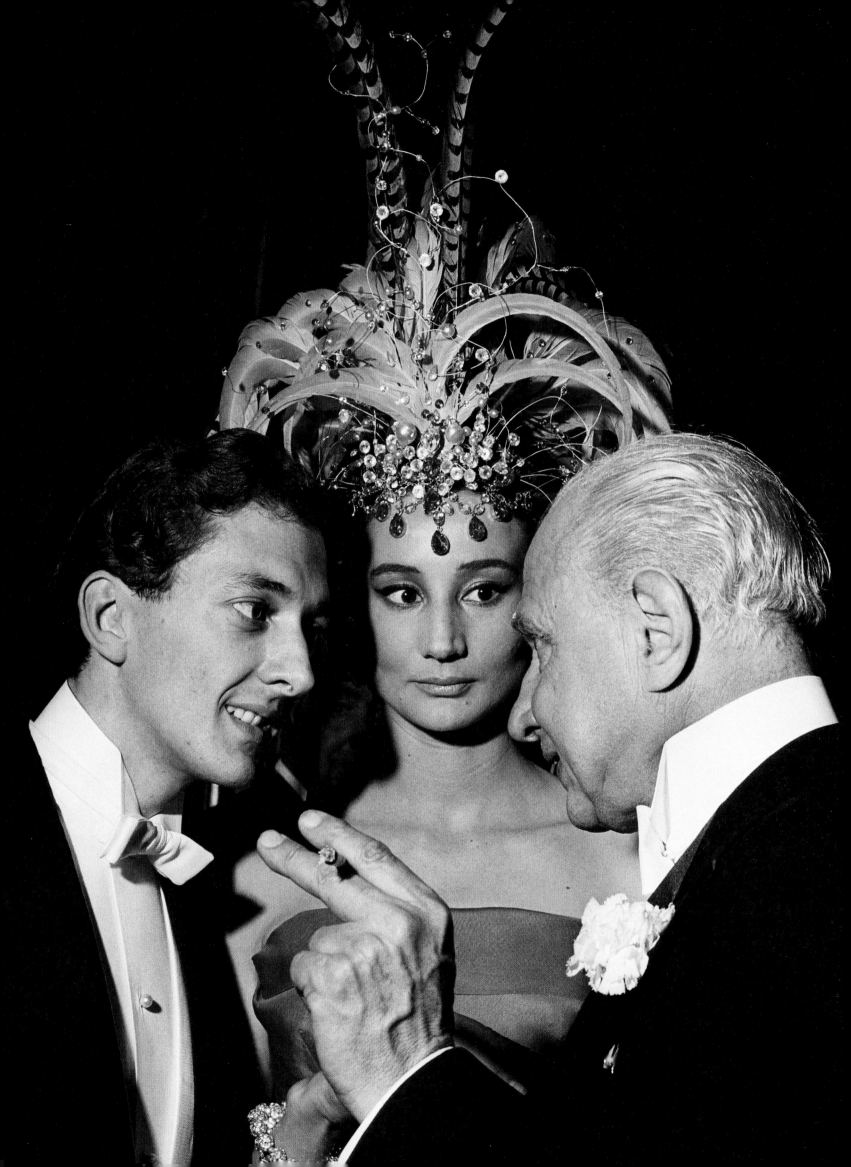

Raymundo de Larrain

Raymond Larrain, or—as he became through the mysterious ways of café society—Raymundo de Larrain, was the epitome of a breed of young men of seductive if demonic charms, of questionable backgrounds and suspect motives, who hovered in the wake of the wealthy at this period. The exact origins of the aesthetic youth who would become successively a dancer, choreographer, and above all designer of ballets—an area in which his talent was as obvious as his preciousness—were never clear. Appearing in the entourage of the Marquis de Cuevas, he claimed to be a fellow Chilean, a fellow marquis, and even the nephew of the famous ballet impresario. Although the veracity of all this was highly dubious, there is no doubting the fact that he became the lover of Cuevas—and after the latter's death, his widow's second husband.

The constant thread running through Raymundo's life was a heady mix of sex, money, and ballet. His appointment by the Marquis de Cuevas as design director of his ballet company led to violent disagreements within the troupe and the resignation of the choreographer Nijinska. In his favor, Raymundo played a key part in Rudolf Nureyev's 1961 decision to defect to the West, and to the Cuevas Ballet—before falling out with him. When he saw that Cuevas and his era were coming to an end, he cast around for other benefactors. When he paid court to Arturo Lopez's niece Douce François, on the assumption that since she lived with her uncle at Neuilly she must be immensely rich, Arturo was smitten. Larrain miscalculated by introducing Douce to Nureyev, with whom she fell madly in love, trying in vain to tempt him into marriage. Larrain also seduced Jacqueline de Ribes, who shortly after the death of Cuevas agreed to underwrite the ballet *Cinderella*.

When the Cuevas Ballet went out of business, Larrain became a photographer in New York, while Cuevas' widow Margaret—"*tante* Margaret" to Larrain—lived as a recluse in her many properties. The announcement in 1977 of the marriage between the eighty-year-old Rockefeller granddaughter and Larrain, thirty-eight years her junior, caused a sensation. The shock was even greater when, on her death in 1985, her children learned that Larrain had inherited or spent her entire fortune. He was not to have long to enjoy it, however, as three years later he died of AIDS.

Facing page
Raymundo de Larrain, the Vicomtess de Ribes, and Charles de Beistegui at the Bal des Têtes given at the Hôtel Lambert, 1957.

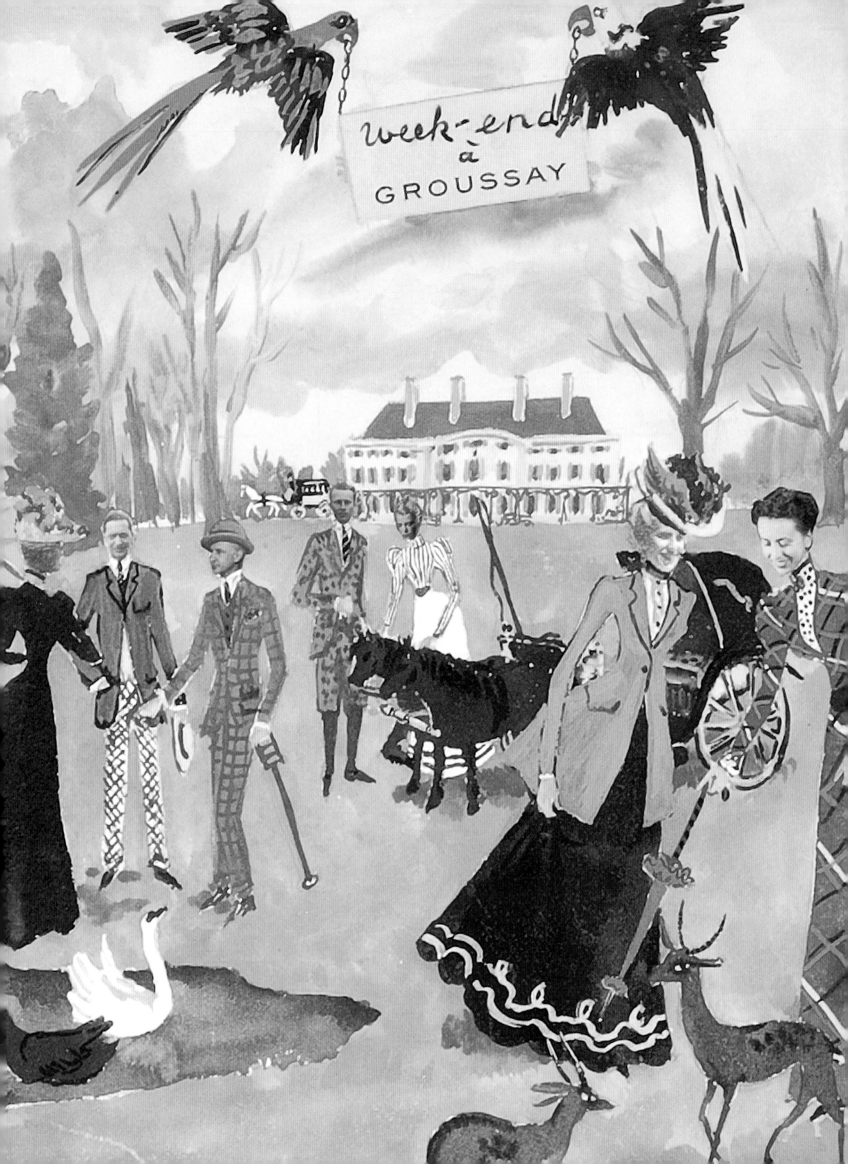

week-end à GROUSSAY

Places

Between Town and Country

Never before or since has Paris been so indisputably the capital of the world, and of international high society, as it was in the heyday of café society. That the City of Light was already the world center of the arts was of course part of the attraction for café society. Every great writer, musician, or painter of the period came to Paris to hone his or her art, to work, and to find patrons and collectors. As capital of the worlds of haute couture and jewelry, the capital was also a magnet for the world's richest and most elegant women, who during the couture shows at least would arrive with their entourages to spot the latest trends, buy clothes and, have fun. All of the world's great newspapers had Paris bureaus. And the city's social life, above all, attracted a wealthy crowd, whether cultivated or frivolous. Paris was the place *par excellence* to spend the money made throughout the rest of the world, and everyone knew that in Paris the art of spending money required more talent and savoir-faire than did the business of earning it.

Everybody also knew of the legendary places where this equally legendary crowd met. There was the Hôtel Lambert, over which Alexis de Redé reigned for half a century, and which was also home to its owners, Guy and Marie-Hélène de Rothschild, and at times to Ghislaine de Polignac and Mona Bismarck. Then there was place des Etats-Unis in the sixteenth arrondissement,[1] where Marie-Laure de Noailles threw spectacular parties, and where Edmée de La Rochefoucauld entertained in her *hôtel particulier*—though the salon held by this friend of Proust, Valéry, and numerous other fine minds from the 1920s to the late 1980s was too serious and erudite to truly belong to café society. Also in place des Etats-Unis was Francine Weisweiller, muse of Cocteau in the post-war years. Place du Palais-Bourbon, meanwhile, was the setting for the salon held by Marie-Louise Bousquet, French patron of *Harper's Bazaar* and major driving force of café society. It was also home to the offices of *Vogue*, and to the apartments of the interior decorator Emilio Terry—relative of the Faucigny-Lucinges and close friend of Beistegui—and of Josée de Chambrun, daughter of Pierre Laval and an ardent socialite.

Fashionable life in Paris was no longer confined, as in Proust's time, to the family mansions of faubourg Saint-Germain or perhaps faubourg Saint-Honoré. Nonetheless, the seventh and eighth arrondissements retained their powerful attraction, and their *hôtels particuliers* now opened their doors to a public uninitiated in the ways of good society. But it was above all the sixteenth arrondissement that was now viewed as the ultimate in chic, and not only because of the arrival of wealthy Americans and nouveaux-riches. At the same time, Neuilly attracted Daisy Fellowes and Arturo Lopez, among others. When café society came to an end, in a world where new modes of transport made travel so much easier, Paris gradually gave way to New York,

Facing and following pages
Pages from the scrapbook of the Baron de Cabrol, 1941.

Pages 154–5
Cecil Beaton and the Bright Young People, Ashcombe, Sussex. Photograph by Cecil Beaton, 1927.

Page 157
Mme Jacques Balsan in her Grand Siècle-style salon re-created for her residence at Southampton, Long Island. Photograph by Horst P. Horst published in American *Vogue*, 1963.

1. Rue de la Faisanderie, then boulevard Suchet.

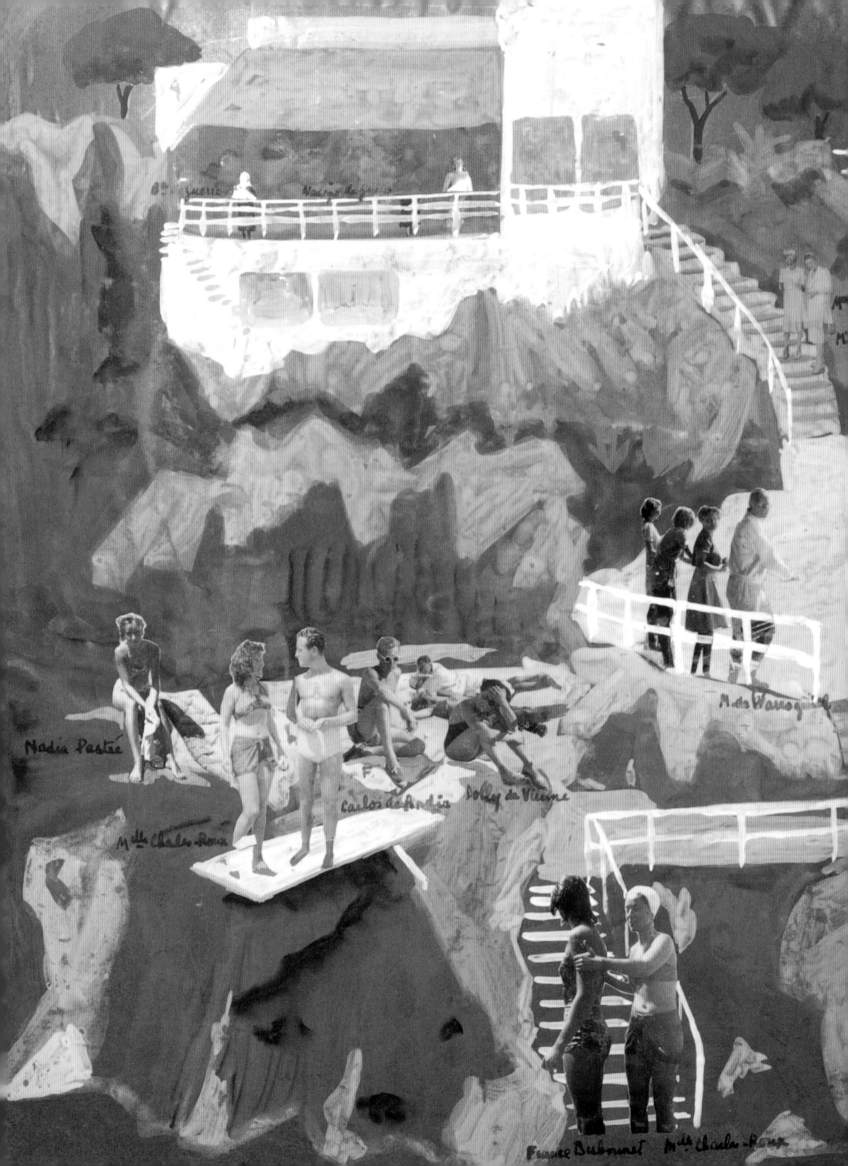

EDEN-ROC _ CANNES _ Août 1941

Ch. de Gramont

Geneviève de Noailles

Mll de Boisgelin
Pesse M. de Broglie

Nadia Pastré

Brenda de Roure

F.

Mme R. Arisson du Perron

Ph. de La Rochefoucauld

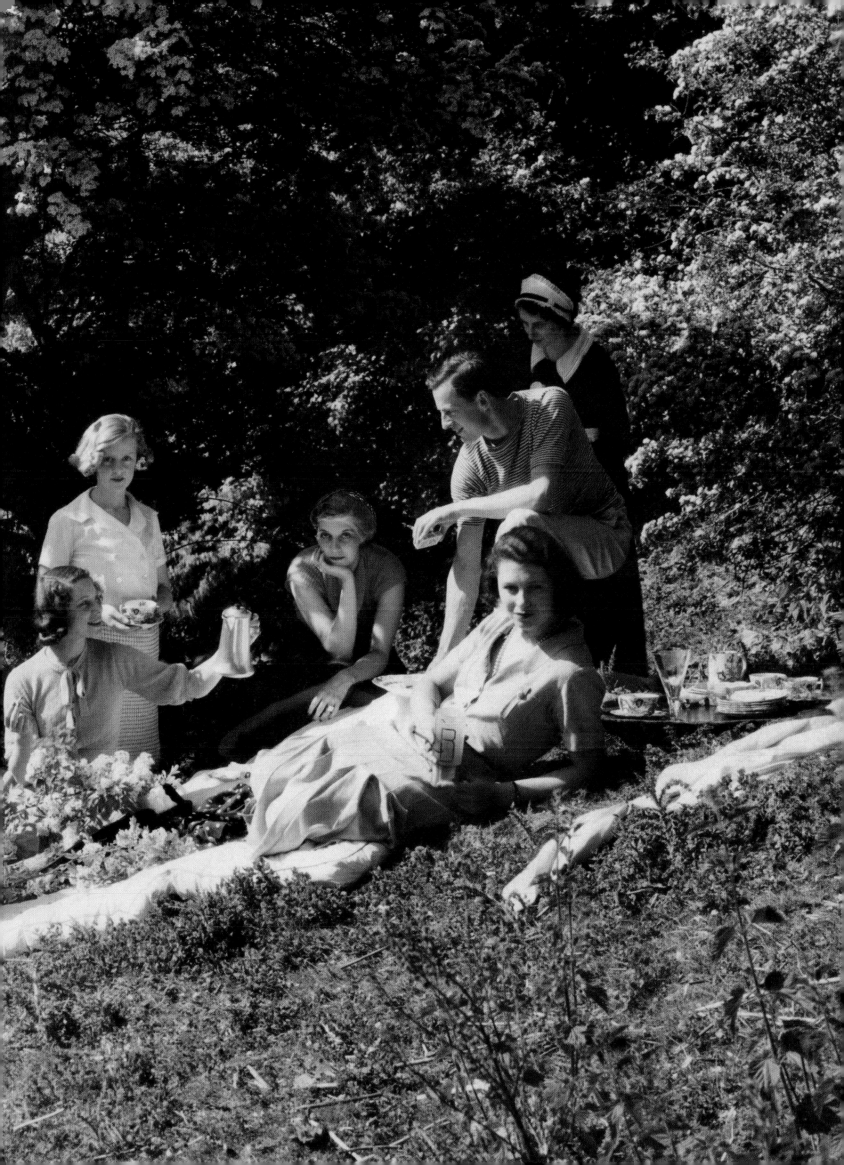

which became the new melting pot for artists from all over the globe, galvanized by the brief but intense reign of the Kennedys, who were moreover so French in so many ways.

For many years the aristocracy had lived to a rigid schedule, spending "the season" in their city residences, whether in Paris or London, before migrating to the country for the hunting (and shooting and fishing) season. For the gratin or upper crust, foreign travel revolved essentially around the weddings and funerals of branches of the family in foreign parts. It was a way of life that the better-off bourgeoisie also imitated by buying "a place in the country." But the development of new means of transport, and particularly of the railways and ocean liners, was to bring about a radical change in these habits. Now those who were sufficiently intrepid could set off on voyages to the colonies or cruise to New York aboard transatlantic steamers. North Africa became a favored destination for some, such as the Faucigny-Lucinge uncle Léo d'Erlanger, who gave elegant parties at Sidi Bou-Said. In the 1930s, Horst and Hoyningen-Huene built a house at Hammamet, later to become the hub of the art and fashion scenes. But after the Second World War especially, it was Tangier—haunt of Paul Bowles, his wife Jane, and the doomed writers of the Beat Generation—that became *the* place for the "in" crowd. There Stephen Tennant, David Herbert, and Cecil Beaton rubbed shoulders with the young Truman Capote, and Barbara Hutton hosted a perpetual round of parties that never managed, all the same, to distract her from her existential ennui.

Café society also seized eagerly on the notion—both British and French—of country house parties. Some of these houses were family homes, such as Verrières for Louise de Vilmorin, Gambais for Jacques de Lacretelle and Pierre David-Weill, Wilsford for Stephen Tennant, Renishaw for the Sitwells, and Faringdon for Lord Berners. Others were bought so that their owners could live out their decorative fantasies, such as Groussay for Beistegui, Grosrouvre for the Cabrols, Lèves for Madeleine Castaing, Saint-Vigor (Viroflay) for Henri Samuel, Monkton House for Edward James, and Ashcombe and later Redditch House for Cecil Beaton. Others again were intended exclusively for entertaining in the country, such as Saint-Loup-de-Naud for Violet Trefusis, Saint-Firmin for the Duff Coopers, Le Temple de la Gloire for the British Fascist leader Oswald Mosley and his wife Diana, and the Moulin de la Tuilerie de Gif-sur-Yvette for the Duke and Duchess of Windsor. Often the proximity of the various houses served to strengthen the links between their owners.

These country house weekends were microcosms of the cosmopolitan eclecticism of café society. The guest list for one of Beaton's house parties at Ashcombe might include the Faucigny-Lucinges, Greta Garbo, Christian Bérard, Oliver Messel, Sybil Colefax, David Herbert, Natalie Paley, Tilly Losch, Mona Williams, Lord Berners, Pavel Tchelitchew, the Sitwells, and Lady Abdy. The same company also gathered to enjoy the hospitality of Lord Berners, where they might be joined by Gertrude Stein, Schiaparelli, Winnaretta de Polignac, Lee Miller, and Nancy Mitford. Charles de Beistegui, meanwhile, hosted weekends in Paris or Venice or at Groussay, where he had a theater built for the entertainment of his friends on their country weekends. Despite all this, the *dramatis personae* of café society remained urban city-dwellers to the manicured tips of their fingers: to them "the country" was just another setting, albeit rather more exotic, in which to pursue their accustomed social activities. Most were more or less oblivious to their natural surroundings, whether wild or cultivated. A rare exception was Charles de Noailles, who excelled in the art of gardening and spent most of his time at L'Ermitage de Pompadour, near Fontainebleau. In the post-war years this vogue reached the United States, where Mona Williams and Mme Jacques Balsan (*née* Consuelo Vanderbilt) both had country houses on Long Island and villas on Palm Beach. While Mme Balsan re-created a French chateau on Long Island, the American photographer Horst turned his house on Oyster Bay into a meeting place for members of café society in exile.

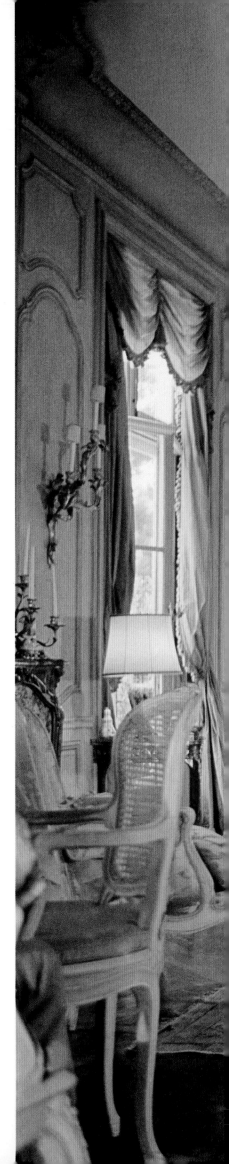

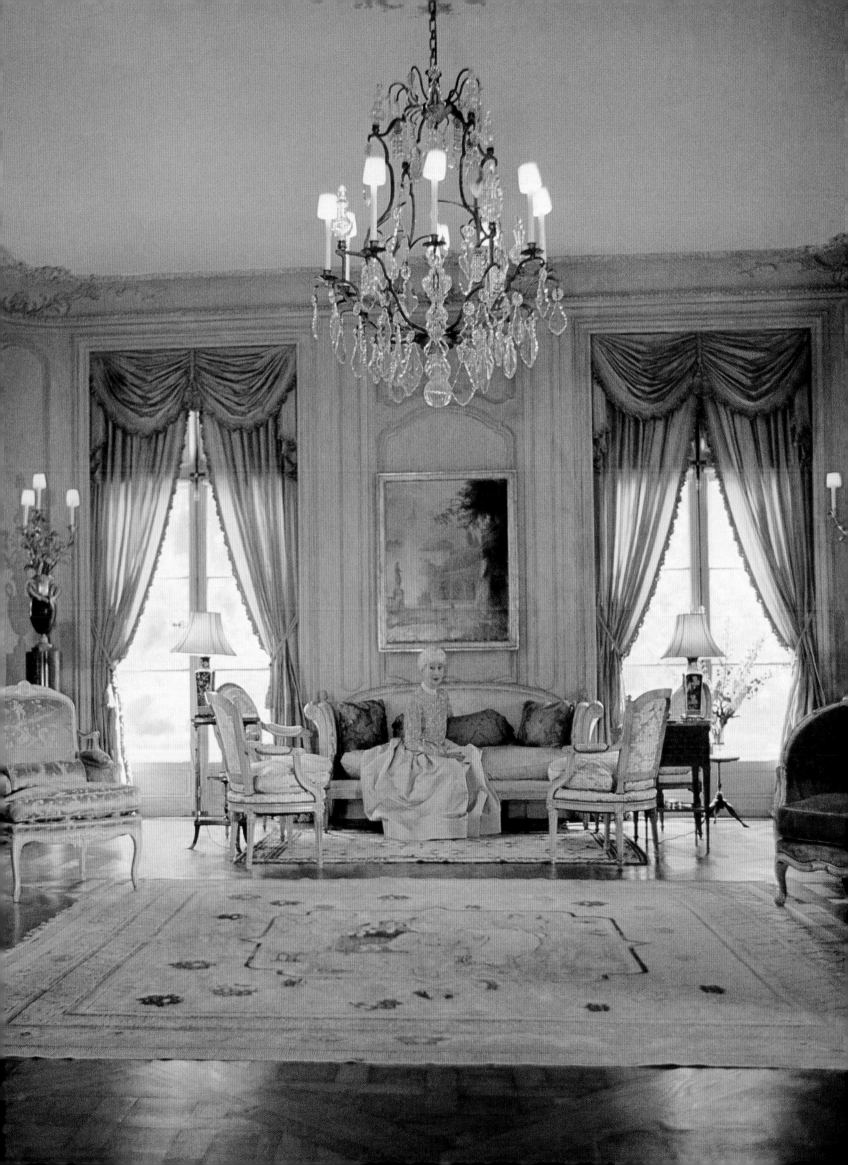

The New Resorts

Already a magnet for artists, socialites, and the fashionable elite, the Riviera, for which the novelist Stéphen Liégeard coined the name Côte d'Azur in 1887, was one of the most favored resorts of café society. It had a long pedigree as a winter resort for an extremely affluent clientele, who came to restore their health in the winter sunshine while indulging in amusements devised for their pleasure. From the late nineteenth century the English aristocracy had been besotted with Cannes and Nice—hence the "Promenade des Anglais"—to the extent that Edward VII had earned the soubriquet "king of the Côte d'Azur." Among other royalty, Leopold II of Belgium built a sumptuous villa (the Villa Leopolda) at Saint-Jean-Cap-Ferrat, which served as a romantic hideaway for his affair with Cléo de Mérode. The Russian aristocracy, meanwhile, established its winter quarters at Nice, which after the Revolution served as a refuge for numerous families, some of whose offspring would swell the numbers of café society. Many artists also came to the Riviera in the late nineteenth century, attracted by the exceptional quality of the Mediterranean light. Thus Bonnard, Matisse, Picasso, Valloton, Picabia, Chagall, and La Fresnaye all worked there, some of them coming and going, others staying all year.

In the 1920s the Côte d'Azur became seriously fashionable, especially in summer. Among the reasons for this was the development of means of transport, including sea and air links, the Paris-Lyon-Méditérranée railway line and—for the British upper crust particularly—the legendary "Train Bleu," an express service from Calais to the Mediterranean. Now it was possible for the fortunate few to make more frequent trips to indulge in the fashionable pastimes of sailing and other summer sports, as well as sun- and sea-bathing—all endorsed by no less influential a figure than Coco Chanel herself. The vogue for summer resorts on the Côte d'Azur was launched above all by Americans of the "lost generation," centered on Gerald and Sarah Murphy at Eden Roc on the Cap d'Ail and afterward at the Villa America at La Garoupe, where the Cole Porters were regular tenants of the chateau. There they were joined by Hemingway, Dos Passos, and of course Zelda and Scott Fitzgerald, who made it his setting for *Tender is the Night*. In another vein, the Villa Noailles, built at Hyères by Mallet-Stevens, reflected in its pared-down architecture and geometric forms the modernist, functional tenets espoused by this gilded generation, who spent the summer indulging the pleasures of the flesh in these halcyon surroundings.

Throughout the inter-war period, prominent society figures rented or built prestigious houses on the Riviera. The British tradition continued with the arrival of the Duke and Duchess of Windsor, who regularly rented the Château de la Croë at Cap d'Antibes, built for Lady Pomeroy Burton by Armand-Albert Rateau in 1927. In their entourage came numerous usurped sovereigns and princes, as well as maharajahs in their full glory and the Aga Khan. And in their wake, influential figures with sumptuous establishments offered lavish hospitality to artists and socialites throughout the season. Thus glittering circles reconstituted themselves around Somerset Maugham at the Villa Mauresque at Saint-Jean-Cap-Ferrat, around Francine Weisweiller at Santo Sospir, and around Lady Kenmare and her son Roderick Cameron at La Fiorentina. Salons also re-assembled at the Pecci-

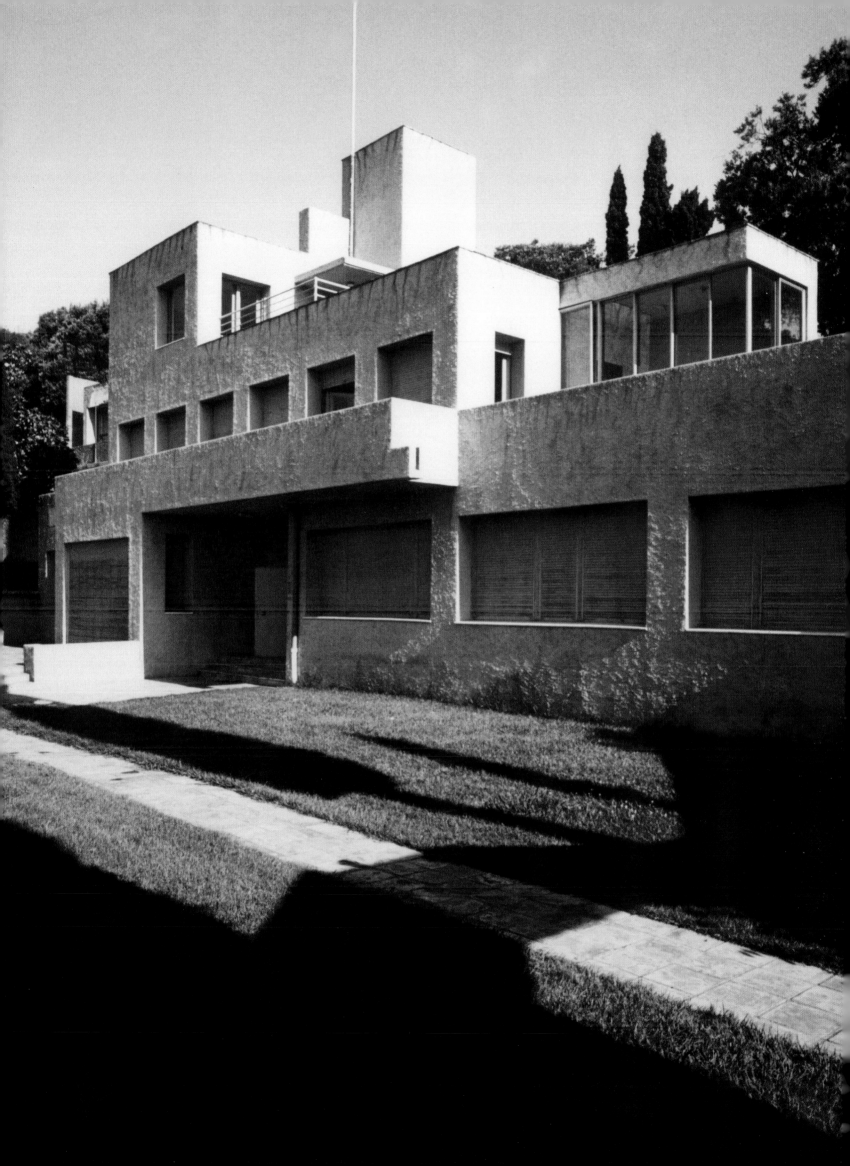

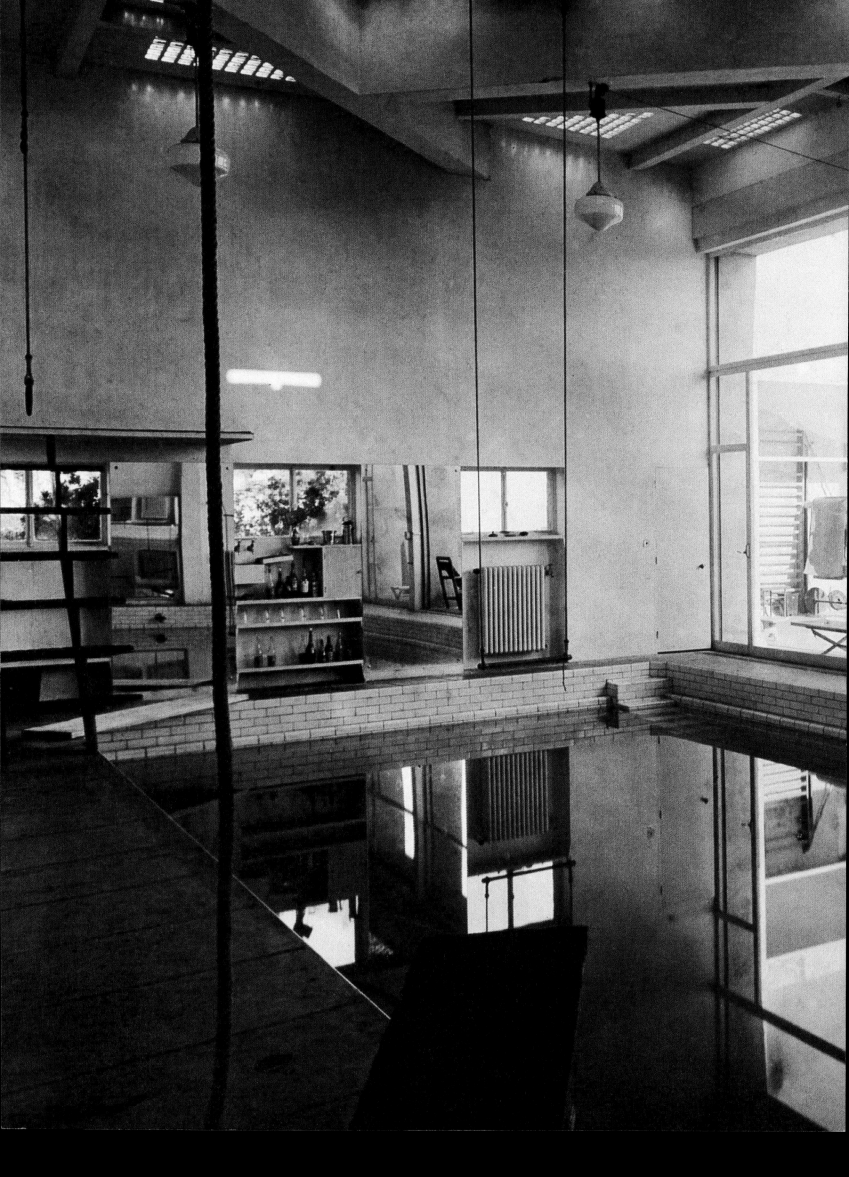

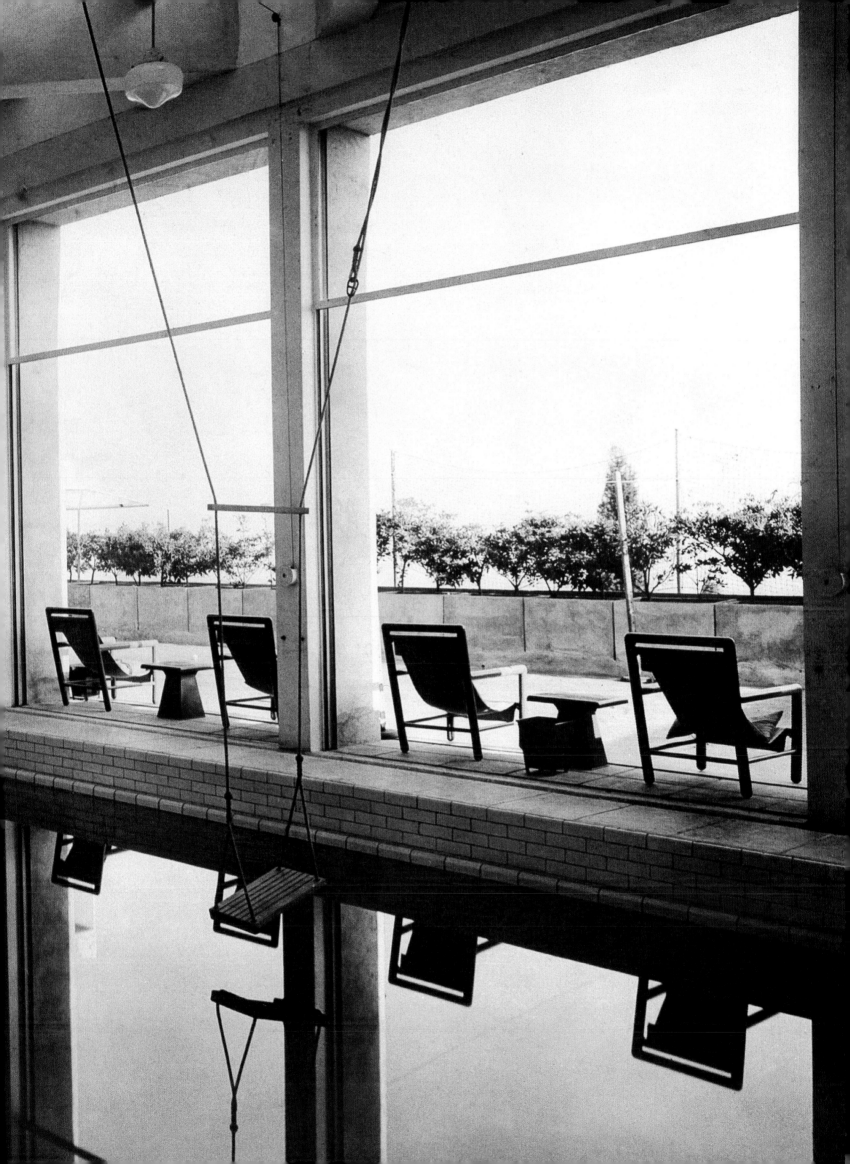

Blunts' La Rondine at Cap d'Ail, at Florence Gould's Le Patio at Juan-les-Pins, and at Marie-Blanche de Polignac's Bastide du Roy at Antibes. The Marquis de Cuevas invited his ballet troupe to Les Délices at Cannes, while Paul-Louis Weiller entertained at La Reine Jeanne at Bormes-les-Mimosas; a little further along the coast, Denise Bourdet offered hospitality at the Villa Blanche at Tamaris, while Comtesse Pastré received at the Château de Montredon at Marseille. Others, of course, simply moored their yachts for the duration.

The presence of so many patrons and collectors of art led to a blossoming of artistic activity. Society artists who worked on the Riviera, such as Kees Van Dongen, Jean-Gabriel Domergue, and even Raoul Dufy, were joined by a heterogeneous array of talent including Picasso, who was sought out by everyone who was anyone; Cocteau, who graced the residences of all and sundry before finding sanctuary with Francine Weisweiller; and Bérard, who was to be found at the Villa Blanche with Denise Bourdet. Writers flocked to their high priestess, Florence Gould, unless they had their own residence, like Paul Morand at Villefranche-sur-Mer. Musicians feasted at the table of Marie-Blanche de Polignac. Monte Carlo, meanwhile, was at this period the world capital of the ballet. Having captured the interest of the Prince of Monaco, Diaghilev moved the Ballets Russes there in 1911, and there they remained until his death. Colonel Vassily de Basil and René Blum founded the Ballets Russes de Monte Carlo in 1933, continuing until 1946, the year when Serge Lifar, expelled from the Paris Opera for collaborating with the enemy, arrived to take over its direction for a few years, before joining forces with the Marquis de Cuevas.

This flurry of activity on the art and social scenes could not fail to trigger equal excitement in the worlds of fashion and elegance. Beach and resort wear became wildly fashionable, and local couture and ready-to-wear houses were soon joined by Paris couturiers who opened their own boutiques: Chanel and the Soeurs Callot in Nice, Molyneux in Monte Carlo, and Jeanne Lanvin in Cannes. In 1927, Chanel launched the fashion for ladies' trousers and beach pajamas. Architects and interior designers, finally, also took inspiration from this whole new lifestyle. The Chateau de la Croë, built by Rateau in strict Victorian classical style for a wealthy English couple, was redecorated by Elsie de Wolfe at the request of the Duke and Duchess of Windsor. De Wolfe enlisted the help of Stéphane Boudin of Jansen, their favorite interior decorator. Architecture on the Cote d'Azur in general fell into two fundamentally distinct camps: on the one hand lay the modernism of Le Corbusier, Eileen Gray, and Mallet-Stevens; on the other, the flamboyance of Emilio Terry, who built a residence for Baron Roland de l'Epée at Valbonne in the purest Louis XVII style (as he dubbed it). Subsequently he refurbished the Château de Clavery at Grasse for François de Gouy d'Arcy, who entertained Bérard, Auric, Cocteau, and Jean Hugo there. He also drew up plans for the refurbishment of the Château de la Croë after it had passed into the hands of Stavros Niarchos, but these were never carried out. From Saint-Jean-Cap-Ferrat to Antibes via Cannes, café society re-created its world and its mores on the shores of the Mediterranean.

This taste for life by the sea was to find its ultimate expression in the rise of cruising. But it was not any love of the sea—let alone the high seas—that prompted this craze for sumptuous yachts among the inner circles of café society. With characteristic waspishness, Philippe Jullian summed up this new area of rivalry, generally peaceful though not above stooping to skulduggery, that now broke out on the seas and oceans, where the Duke of Westminster's *Cutie Shark* was pitted against Daisy Fellowes' *Sister Ann*, Arturo Lopez's *Gaviota* took on Niarchos's *Creole*, and Aristotle Onassis's *Christina* exchanged broadsides with Harrison Williams' *Warrior* and Alexander Korda's *Elsewhere*—not to mention

Pages 158–9
Villa Noailles, Hyères, designed by the architect Robert Mallet-Stevens for Charles and Marie-Laure de Noailles, in 1924.

Preceding pages
The indoor swimming pool at the Villa Noailles, 1929.

Facing page
The Windsors and Cabrols at the Château de la Crôe. From the scrapbook of the Baron de Cabrol, 1946.

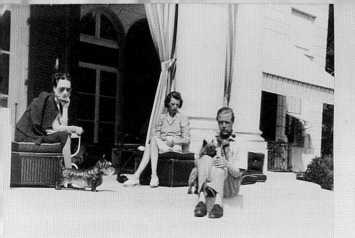

LA CRÖE
CAP D'ANTIBES
A.M.

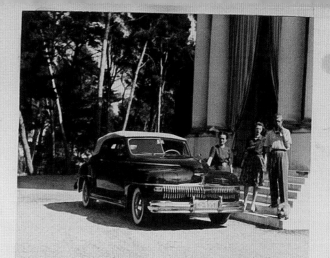

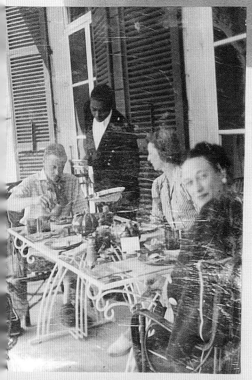

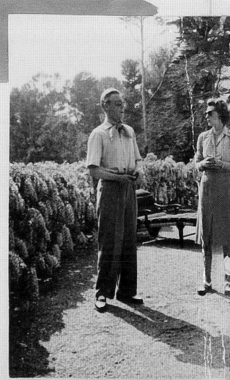

Séjour à La Cröe 10 au 22 Avril 46

flotillas of less imposing vessels, or of floating palaces belonging to owners who were of less account:

"Yachts based in Venice or Monaco are spared by the lavishness of their internal appointments and the quality of their guests from any sporting activity. Those on board neighboring yachts observe each other, not without a certain irony. Onassis's transatlantic yacht is judged ostentatious, the Gauguins and Cézannes on Niarchos's air-conditioned rival vessel out of place, and the Louis XVI bronzes and satins of the *Gaviota* frankly beyond the pale for the bona fide old seadog; Mrs. Fellowes' *Sister Ann*, meanwhile has retained the stylishness of mahogany and gleaming brass."[2] While technical advances encouraged the growth of shipboard hospitality—some yachts, such as the *Sister Ann*, being able to put on tremendous speed—they ensured above all that cruises could safely be enjoyed at a level of comfort comparable to that expected on terra firma. Thus these floating palaces benefited from interior decorations to rival in quality those of the residences in which their owners entertained throughout the rest of the year. Geffroy decorated the *Gaviota* in the same way as he had refurbished his Neuilly mansion for Arturo Lopez or the Hôtel Lambert for Alexis de Redé.

Under these conditions, cruising became a way of life. In his memoirs, Alexis de Redé recalled how he would go off cruising on the *Gaviota* with the Lopezes for two-and-a-half months every year. Winter cruises generally sailed around Cuba or the West Indies, with guests and owners traveling out by plane. The eight or nine guests who could be accommodated on board would generally include regulars such as Lilia Ralli, Clé-Clé de Maillé and her friend the Duc de Cadaval, and Princess Cora Caetani. A crew of twenty-six, including two chefs and three stewards, was at their disposal. At each port of call, cars would take the guests off on excursions, giving them an opportunity to visit the local aristocracy, or even—if they were lucky—royalty. Favorite summer destinations were the islands of the Mediterranean or Scandinavia. Ever eager for new distractions, Elsa Maxwell had the idea of organizing cruises, and in 1955 borrowed Niarchos's new liner *Achilleus* for an international society Greek cruise. The Duchess of Windsor, a great aficionado of cruising, disdainfully dubbed this happy enterprise "Elsa's Zoo."

Having made nautical sports fashionable, café society now set about doing the same for winter sports. Hitherto these had been the preserve of a wealthy elite, who though undoubtedly elegant were also athletic and smitten with snowy peaks. The British were the first to display an infatuation with French ski stations, especially Chamonix. After the First World War, Mélanie de Rothschild made Megève fashionable by commissioning Henry-Jacques Le Même to build a mansion disguised as a chalet at Le Mont d'Arbois. Soon after, her friend the Princesse de Bourbon-Parme, daughter of the arms dealer Sir Basil Zaharoff, followed suit. The fashion was launched. But it was above all after the Second World War that café society really took to winter sports, here too transporting its own urban lifestyle to the mountains, lock, stock, and barrel. Saint-Moritz became the capital of international snobbery, which for a few weeks every year relocated its activities to the Palace Hotel and danced at the Corviglia Club. Seen there would be Arturo Lopez and Alexis de Redé, Elsa Maxwell, Jean Cocteau and Francine Weisweiller, the Niarchoses, the Brandolinis, Mme Fath, Tennessee Williams . . . and so the list goes on.

Facing page
Cruise on board of
La Créole. Daisy de Cabrol
(top). Anne-Marie François-
Poncet, Fred de Cabrol and
Bunny Esterhazy (bottom).
From the scrapbook of the
Baron de Cabrol, 1956.

Following pages
A costume party during
a cruise on the *Gaviota*,
July 7–24, 1956.
Elsa Maxwell is on the right.
From the scrapbook of
the Baron de Cabrol.

2. Philippe Jullian, *Dictionnaire du snobisme*, Paris: Plon: 1958, p. 176.

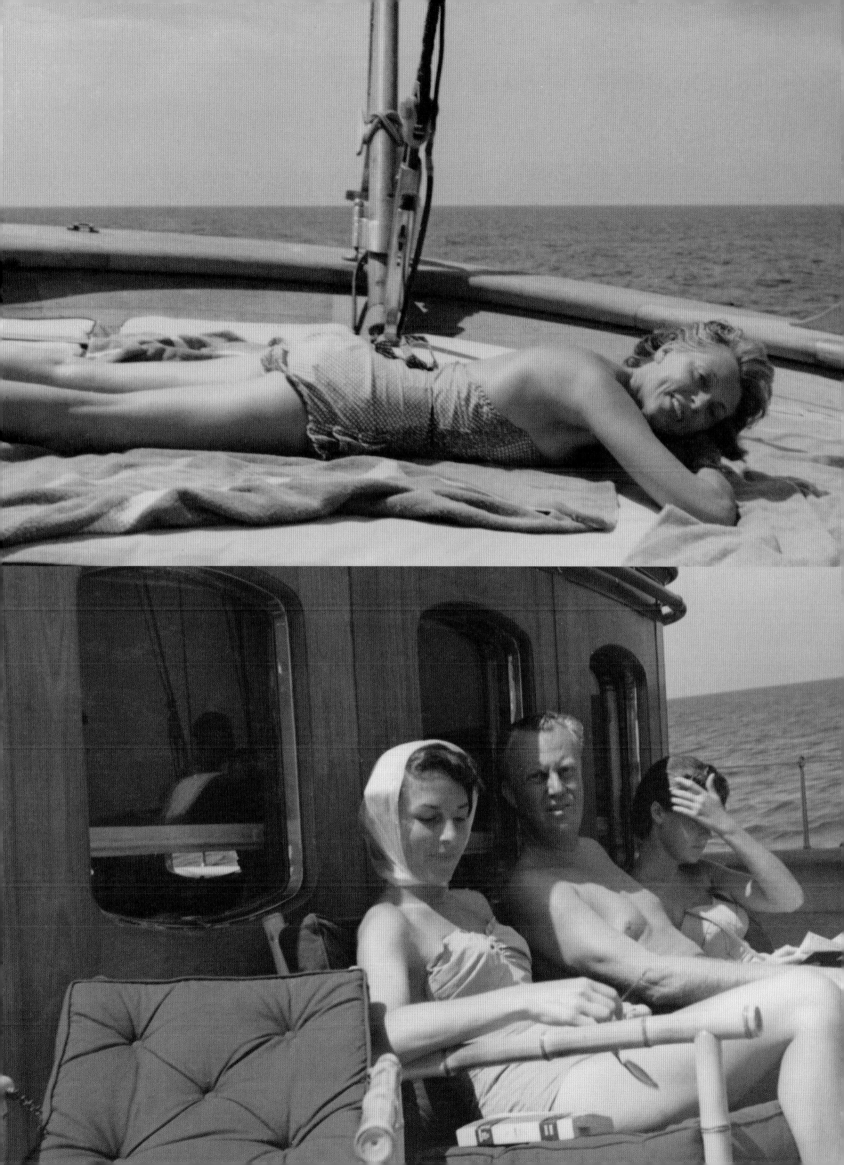

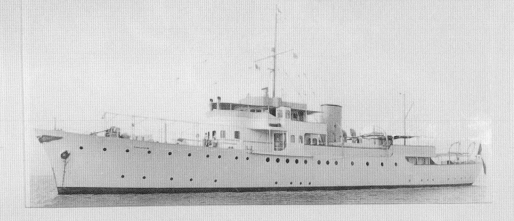

inka Strauss D.

Angleterre Molta
F.

Le Gaviota D.

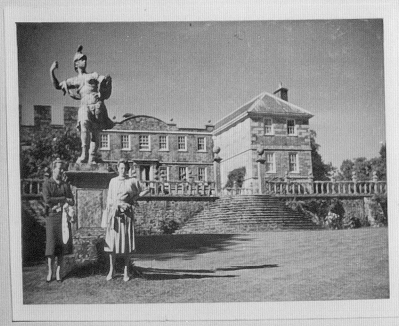

Ghislaine de Polignac D.

Sir Robert Abdy
Arturo Lopez

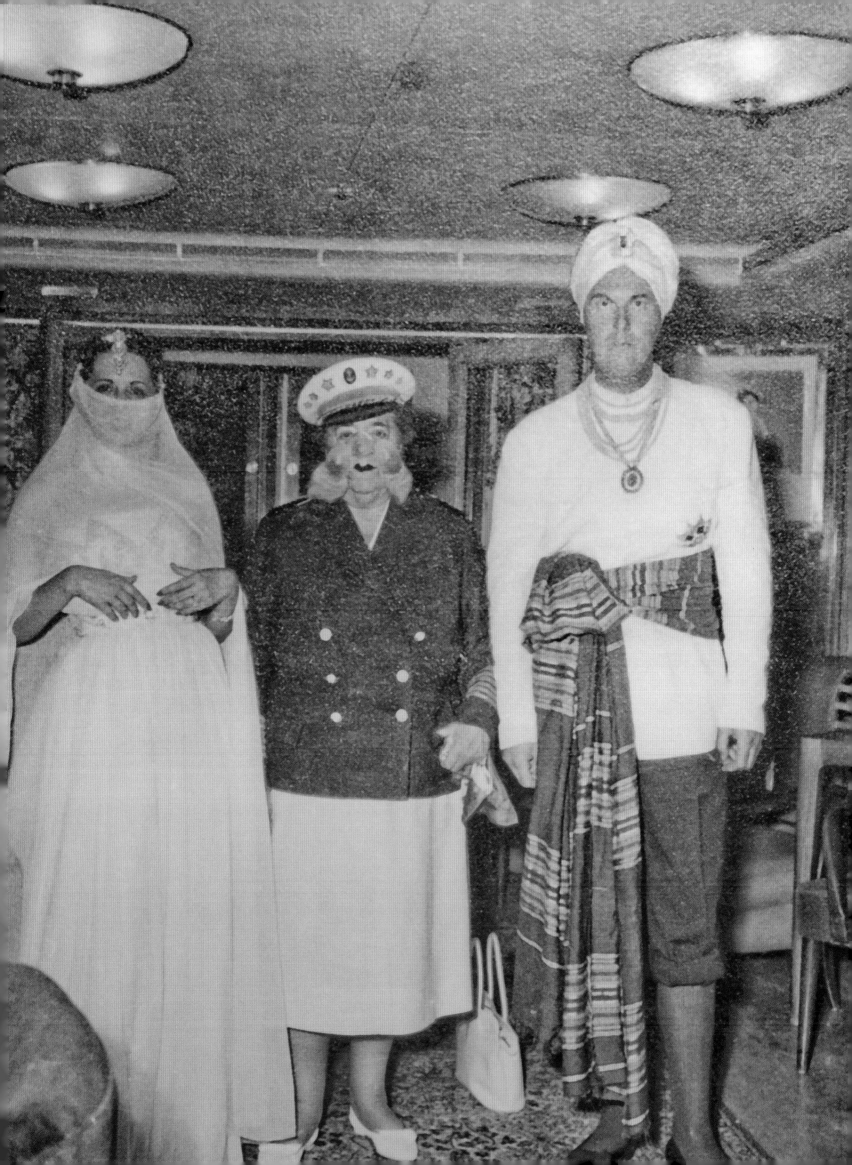

Immortal Italy

Café society was enthralled by Italy. Venice was of course the perfect setting for masked balls, and its Lido rivaled the Riviera for the delights of sun, sea, yachts, and designer beach wear. Tuscany was already a magnet for a sophisticated British elite in search of aesthetic pleasures, far removed from the more obvious charms of the coast. Some members of café society contrived to move effortlessly between the two, notably Cecil Beaton, Diana Cooper, and Philippe Jullian, who were as at home on the Lido as in the Tuscan hills. A very select few preferred Rome to both, such as Lord Berners in his house with the inimitable address of 1 Foro Romano (it stood on the Roman Forum), or Capri, where Mona Bismarck kept open house during the summer at Il Fortino, built on the site of a palace belonging to the Emperor Tiberius.

Tuscany and its history brought out the aesthetic side of members of café society, many of whom made regular pilgrimages to meet Bernard Berenson, the leading authority on Renaissance art, who offered them generous tips on their collections of old masters along with wonderful hospitality—at once soothing and stimulating—in his glorious villa I Tatti. There was also a breed of Englishman to whom Tuscany had been "home" for generations. In his *Memoirs of an Aesthete*, Harold Acton described this English community, living for at least part of the year in rented palazzi where they entertained Tuscan high society, observing that on reading any travel diary written after the Battle of Waterloo, such as Lady Blessington's *The Idler in Italy* of 1839–40, one was struck by the permanence of this cosmopolitan community.[3] The economic crisis of the 1930s and the devaluation of the pound in 1931 was to put an end to this, as only those with the most robust fortunes could afford to stay. Otherwise those who stayed on tended to be from the ultimate in snobbery and aestheticism from the *haute bohème* fringes of café society, living out their bohemian lifestyle amid the ancient stones and beautiful gardens to which they cleaved with such thrilling passion.

The other high spot of Tuscany, in addition to Berenson's I Tatti, was La Pietra, the villa of Sir Harold Acton, the aesthete and writer who divided his time between Britain, Italy, and China, and who was also a great friend of Marie-Laure de Noailles and Nancy Mitford, whose biographer he became. Another important destination was the Castello di Montegufoni, home for part of the year to the writers Sacheverell, Osbert, and Edith Sitwell, immortalized in Cecil Beaton's famous photographs. The last of these distinguished pied-à-terres was L'Ombrellino, which Violet Trefusis, writer and socialite, inherited from her mother Alice Keppel, the most famous mistress of Edward VII. This colorful coterie of mordantly witty friends and rivals was a constant presence on the fringes of café society,

3. Harold Acton, *Memoirs of an Aesthete*, London: Faber, 2008.

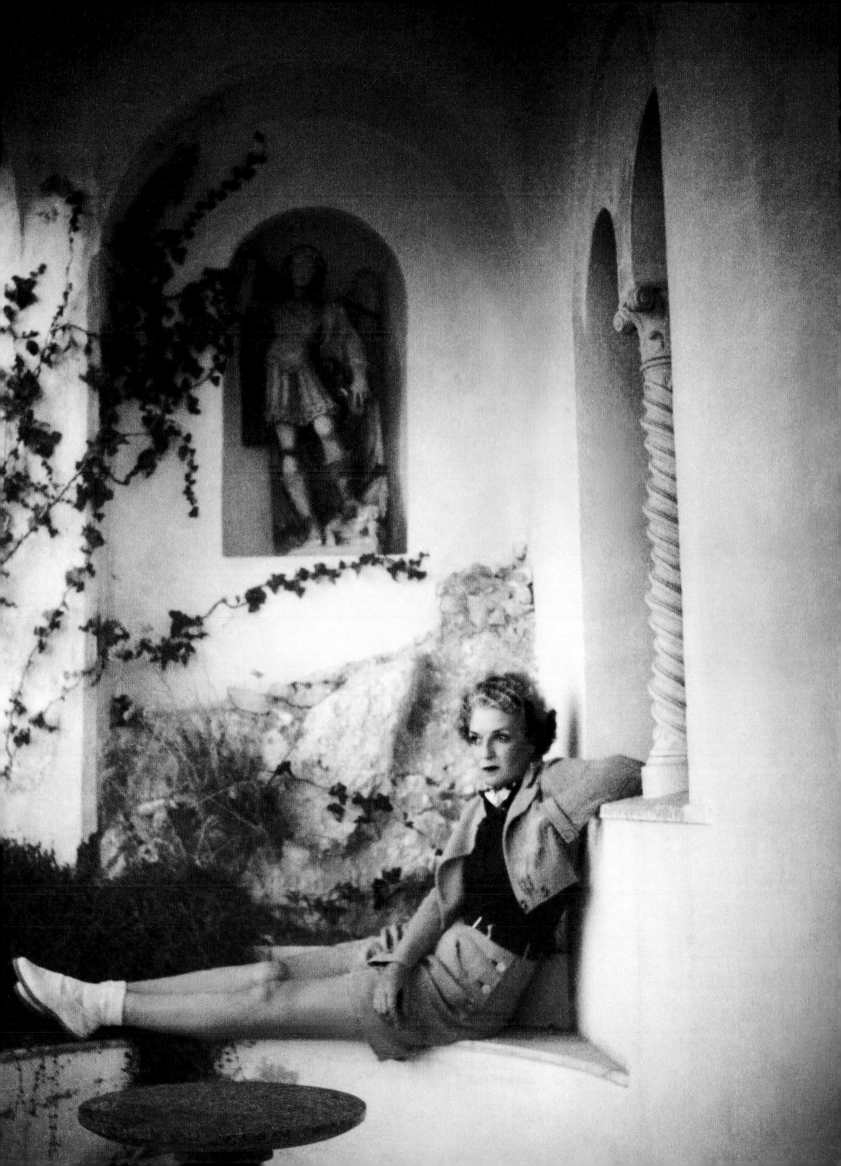

and—largely through Violet Trefusis's longstanding affair with Vita Sackville-West, who herself famously had an affair with Virginia Woolf—formed a link with the Bloomsbury Group. When in Tuscany, this British circle (which included two former lovers of Oscar Wilde, Reggie Temple and Reggie Turner, as well as—in the 1960s—aesthetes such as John Pope-Hennessy, art historian and director of the British Museum) entertained feverishly, in an atmosphere described by Somerset Maugham a few years earlier in *The Circle*, published in 1921.

Italy, Tuscany and—above all—Venice. To café society, Venice was the be all and end all, the *ne plus ultra*. The ball given at the Fenice opera house in 1927 by Catherine d'Erlanger ran up the curtain on a phenomenon that would reach a climactic end with the Beistegui Ball in 1951. Venice had of course always attracted free spirits, eccentrics, and firebrands, those seeking an escape from existential ennui or yearning to revel in the doomed delights of a city caught up in the perpetual throes of its own death, and that flattered their taste for decadence. Artists, socialites, and snobs had always rubbed shoulders there, in an atmosphere of all-embracing cosmopolitanism. Over the years, with the Orient Express adding to its exotic charms, the city had assumed an allure that was almost mythical. By the 1920s, it offered virtually everything that the nascent café society required in one of its seasonal capitals, fit to rival even the Côte d'Azur.

Here again, the Ballets Russes had paved the way. Every one of its chief protagonists was a presence in Venice; Diaghilev was to die there and be buried on the island cemetery of San Michele in 1929. Following his coffin was his entire troupe of lovers and collaborators, from Boris Kochno to Serge Lifar and Igor Markevitch, as well as those who had encouraged, inspired, and supported him, especially Misia Sert, Coco Chanel, and the ever-present Catherine d'Erlanger, who organized the funeral. By this time, however, Venice had rather fallen out of fashion except among a few circles of the initiated: now everyone who mattered was drawn increasingly to the Côte d'Azur. Venetian society always fled the city in summer in any case, in order to avoid the heat and mosquitoes. High society in La Serenissima was split into two warring factions, each bent on wresting influence from the other. The first, led by Contessa Annina Morosini, was made up of old Venetian society. In her youth, "the Morosini," as she was known, had been one of the glories of the city, her celebrated beauty gaining her lovers of great prestige, including Kaiser Wilhelm II, who was otherwise little susceptible to feminine charms. According to Cecil Beaton, "at the time she was living at the Ca d'Oro, [he] addressed one of his letters to her simply:

To The Most Beautiful Woman
In The Most Beautiful House
In The Most Beautiful City In The World.

The letter is said to have reached its destination."[4]

The daughter of a banker from Genoa, Annina married the last of the Morosini, the admiral and doge who gave Venice her last naval victory. As a widow she continued to enjoy huge prestige, even after her legendary beauty had faded.

Her younger rival was a wealthy American from New Jersey who had become Princess di San Faustino, and who had decided to make the Lido fashionable. According to Elsa Maxwell, one might have been forgiven for mistaking her for a poor relation of one of her friends, when in fact she was ten times richer than any of those wealthy ladies. Jane Campbell, Princess di San Faustino, had been an icon of taste in Roman society, but after her husband's death she affected always to wear the same outfit, consisting of a head-hugging widow's cap, long grey or white skirts that trailed on the ground and a veil. While she looked like an ethereal vision out of a medieval painting, however, when exasperated by poseurs she would swear like a fishwife.

4. Cecil Beaton, *Self Portrait with Friends*, London: Pimlico, 1979, p. 293.

Preceding page
Mona Bismarck in her villa on Capri. Photograph by Cecil Beaton, 1932.

Facing page
The Cabrols on holiday at Mona Bismarck's villa, Il Fortino, on Capri. From the scrapbook of the Baron de Cabrol, 1949.

Following pages
The Lido, Venice. From the scrapbook of the Baron de Cabrol, 1950.

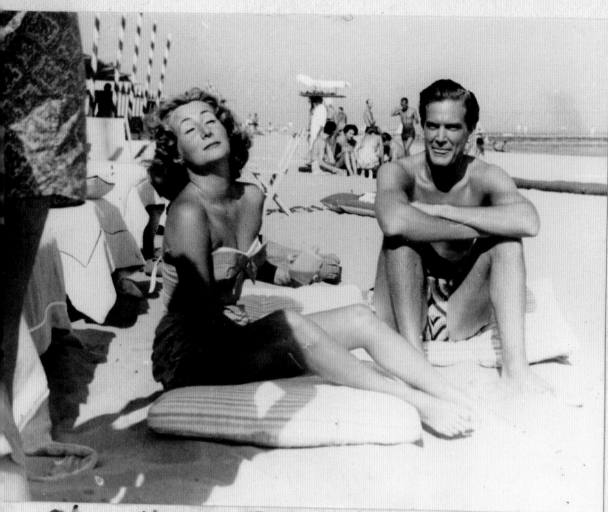

Christiana Brandolini

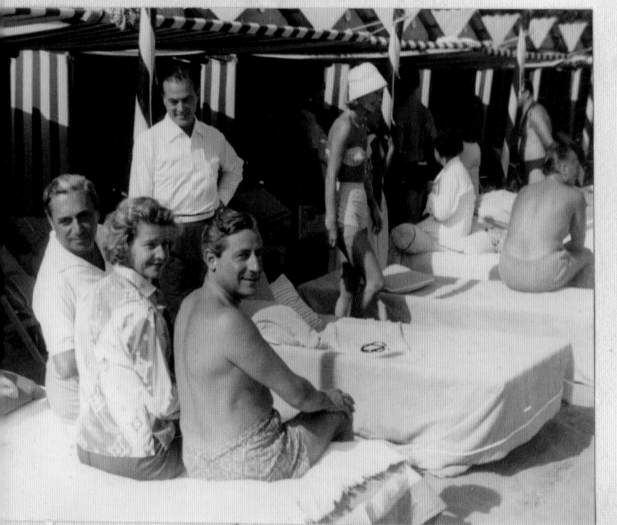

Odette Pol Roger Olivier Messel Stavros Niarchos

Fulco

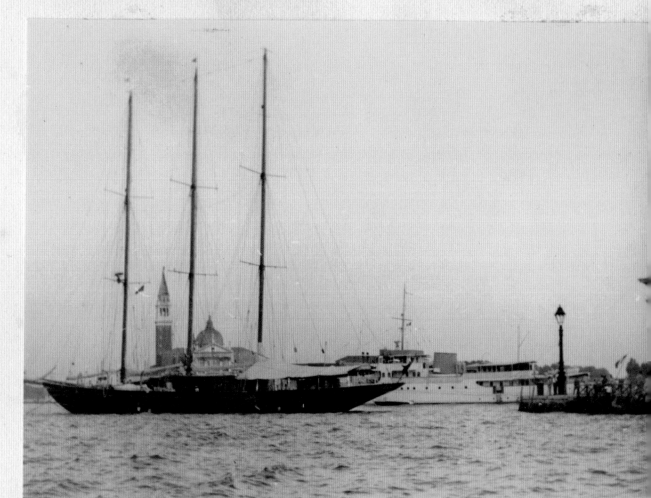

le Créole le gaviota

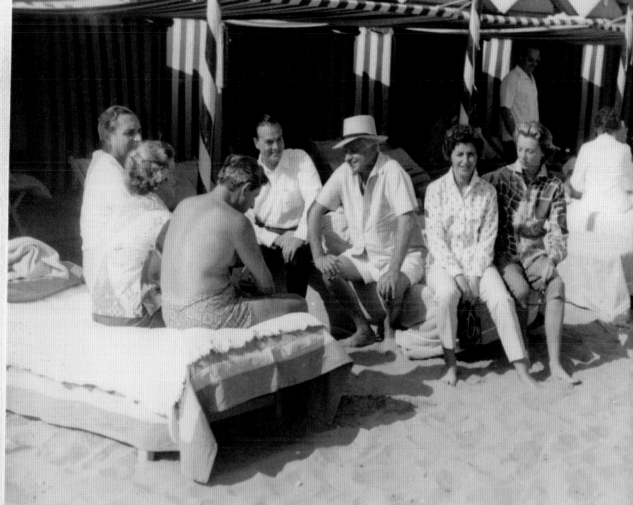

Fulco Olivier Messel
Odette Starros Charlie Eugenie Niarchos

This redoubtable figure ruled not only Roman society but also the lido in Venice with a rod of iron.[5] It so happened that at this point Elsa Maxwell, who had been commissioned to attract a smart crowd to Monte Carlo in the summer, was asked by Brandolini, mayor of Venice, to do the same for the Serenissima, and managed to unite both camps in order to relaunch the city as a chic society destination.

Success was not long in coming. Gabriella and Andrea Robilant, descendants of Mocenigo, the victor of Lepanto, whose palazzo they occupied on the Grand Canal, were to play their part in it. Catherine d'Erlanger, meanwhile, who possessed an apartment in Venice, but whose chief glory was Palladio's celebrated Villa Malcontenta, entertained everyone who mattered in high society at the time, as Paul Morand recalled: "Under the roof of the Villa Malcontenta were the dozen or so legendary figures apart from whom—with the exception of Jean-Louis de Faucigny-Lucinge, Lifar and Kochno—there was nobody."[6] Among those who encouraged this revival of interest in the city were also Catherine d'Erlanger's daughter, Baba de Faucigny-Lucinge; Margaret and Maud Kahn (granddaughters of the financier Otto Kahn); Cole Porter, who rented the Palazzo Barbaro and then the Palazzo Rezzonico in order to throw large parties; Winnaretta de Polignac; the Duff Coopers; Fulco di Verdura; and Natalie Paley. After the war they all resumed their lives as before, and were joined by Beistegui, the Cabrols, Niarchos, and Princess Chavchavadze, who rented a floor of the Palazzo Polignac every year. Lili Volpy, finally installed in the palazzo from which her husband had managed to help revive the Venetian economy, threw a perpetual round of grand parties, as did Marlon Brando and Cristina Brandolini.

For decades smart life in Venice followed an unchanging ritual, as described by Jean-Louis de Faucigny-Lucinge: "While a number of worthy families continued to live among themselves, others had yielded to the seductive charms of foreigners, and during the season led the life of international high society. But between the wars this life of pleasure was subject to a code of insouciance, laid down to the smallest detail. . . . In the morning one would go by boat to the Lido. There everyone would have their tent. Some people lunched at tables, served by their gondoliers who had brought the meal, others went to the *Taverna*. Everyone knew each other, paid each other visits on the beach, going from one tent to another, gossiping while playing at cards, taking a siesta after lunch, and even bathing in water that was then very clean. . . . In the middle of the afternoon, the beach would empty. One had to head back into town, for as the sun set the Piazza San Marco would become 'the largest salon in Europe,' where everyone who counted in Venice would meet up. Certain tables at Florian's would be occupied, according to a codified strategy, by ladies who were known with just cause as the 'Venetian contessas.'. . . . Then, after sparkling chatter under the sky, everyone would return to their house or hotel room to don their battledress for the evening. And much later, in the night, at the damp foot of the palazzo walls, one would see the gondolas waiting, swaying gently, the gondoliers wearing broad sashes in the colors of the families they served."[7]

One lone figure bestrides the period, vivid in her originality, leaving her mark on Venice without ever allowing herself to be caught up in the games of café society: Peggy Guggenheim, who after the war established herself in the Palazzo Venier dei Leoni, which before her had been occupied by Doris Castlerosse (apart from Lilia Ralli, Cecil Beaton's only grand heterosexual affair) and the infamous Marchesa Luisa Casati. Through her patronage of artists, with whom she always maintained very personal relationships, Peggy Guggenheim created a collection that was unrivaled. It also served, incidentally, to highlight by contrast the ephemeral and superficial nature of the smart society set who came to Venice purely to keep boredom at bay.

5. Elsa Maxwell, *I Married the World: Reminiscences*, London, William Heinemann, 1955.
6. Paul Morand, *Venises*, Paris: Gallimard, 1995, p. 113.
7. Jean-Louis de Faucigny-Lucinge, *Un gentilhomme cosmopolite*, Paris: Perrin, 1990, p. 141.

Facing page
Charles de Beistegui's motoscafo on the Grand Canal, Venice. From the scrapbook of the Baron de Cabrol, 1948.

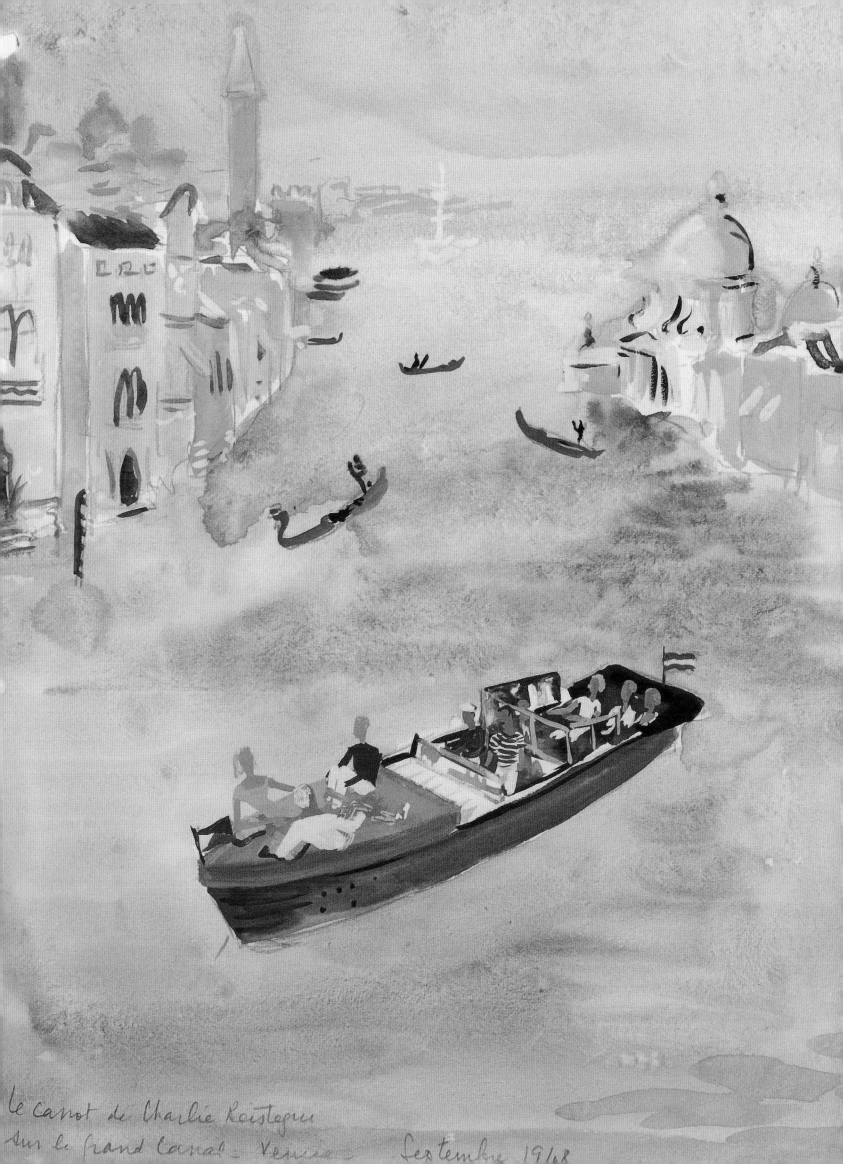

le canot de Charlie Roistegui
sur le grand canal = Venise = Septembre 1948

The Triumph of the Minor Arts

In this atmosphere of intense artistic rivalry, it is scarcely surprising that the minor arts should have flourished in spectacular fashion, on a stage that until then had been dominated exclusively by the fine arts. The personalities of café society were first and foremost the artists of their own lives. Frequently narcissistic, capricious, sybaritic aesthetes with the means to indulge every taste, whim, and fantasy, they were extravagantly profligate in their spending. For them the only value of money lay in what it could buy. This was not yet a society where money was to become a means of securing social advantage, in which sponsorship was to supplant the gratification of pleasure. These were individuals who enjoyed putting their lives and their passions in the spotlight, and from this there flowed naturally an emphatic taste for interior decoration, appearance, and fashion. Many also valued particularly all that was most ephemeral and impermanent in these fields. Thus in the 1960s Beistegui disbanded the collections that he had amassed at the Palazzo Labia in Venice a decade earlier. Some even tried their hand as practicing artists: Marie-Laure de Noailles was by turns a poet and painter; Princess Paley was first a model, then a film actress; Étienne de Beaumont and Fulco di Verdura designed jewelry, as did Daisy Fellowes, who also wrote occasionally; Marie-Blanche de Polignac was a pupil of Nadia Boulanger; and Lord Berners wrote operas and painted. Conversely, couturiers such as Chanel and Schiaparelli, photographers such as Cecil Beaton, actresses such as Greta Garbo, and dancers such as Tilly Losch all became admitted to high society.

By putting their lives in the spotlight, café society members thus encouraged a blossoming of the minor arts. Photography, especially society portraits and fashion shots, flourished thanks largely to *Harper's Bazaar* and the glossy magazines of the Condé Nast group—including *Vogue*, naturally, to which Beaton, Hoyningen-Huene, Horst, Ostier, and Durst attached themselves. Even Robert Doisneau, better known for his realist work, tried his hand at fashion photography in the late 1940s. It was to prove the launch pad for numerous professional photographers, transforming them into celebrities. The genre assumed an importance that had been unprecedented in the time of earlier photographers such as Baron de Meyer. Through these photographs, the public at large became familiar with figures whose names had hitherto never spread beyond a handful of fashionable circles in Paris or abroad.

Interior decoration, another of the arts described as minor, enabled the most prominent figures in café society to create bespoke settings for their parties. It also lent material form to their fantasies: the Grand Siècle at its most grandiose at the Hôtel Lambert, restored in the 1950s by Alexis de Redé, with celebrated new additions including Geffroy's library, or surrealism at its most undiluted in Edward James's London residence. There carpets woven with patterns imitating the wet paw prints of James's pet dog or the footprints of his wife

Preceding pages
From the scrapbook of the Baron de Cabrol, 1948.

Facing page
Colette Marchand in *Le Combat*, choreographed by Roland Petit and designed by Marie-Laure de Noailles. Paris, 1949.

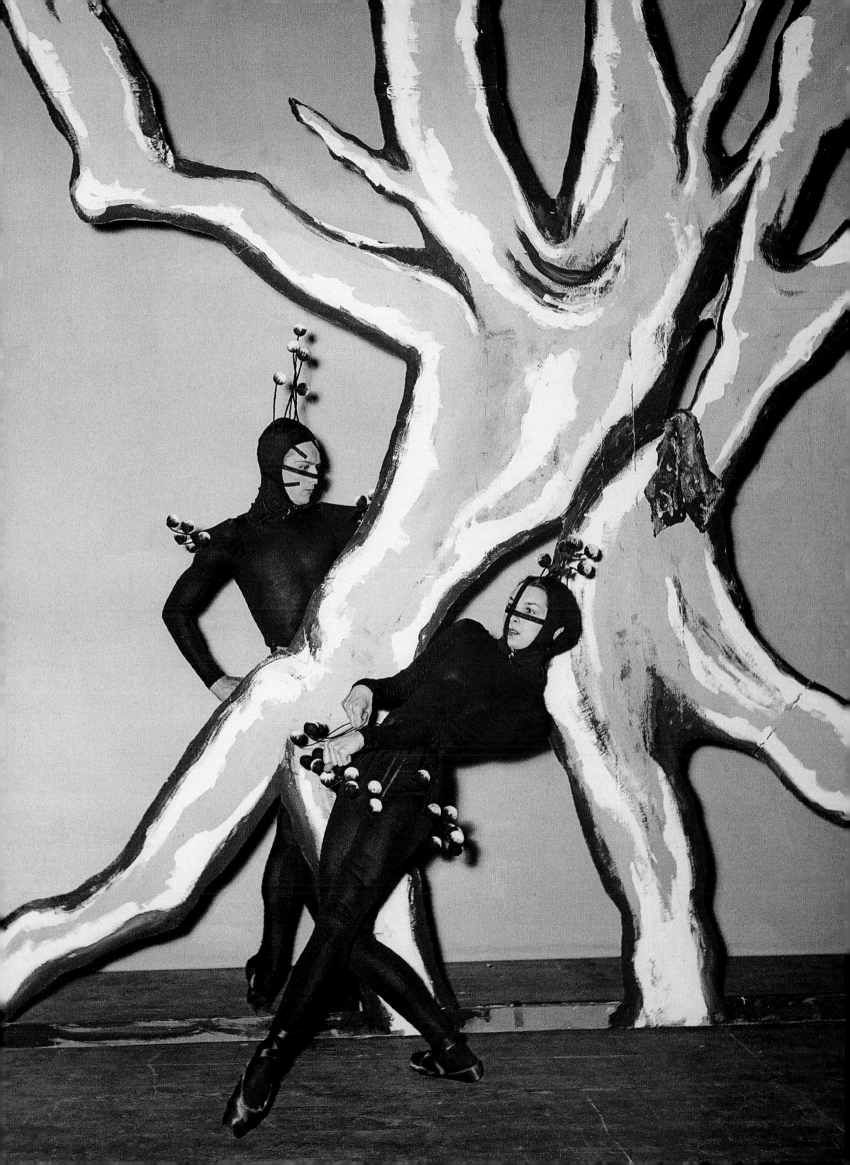

Tilly Losch jostled with the giant scarlet lips of Salvador Dalí's Mae West sofa, or a bed with a black glass canopy etched with the stars of the firmament. A similarly surrealist decor prevailed in the apartment on the Champs-Elysées commissioned by Beistegui from Le Corbusier.

Generally speaking, tastes tended toward eclecticism, and the form this eclecticism took would vary markedly according to the personality of the collector. Some society figures, including not only Beistegui and Terry but also the Baron de Cabrol and Oliver Messel, who designed decors both for the theater and for private residences in England—were actively involved in interior design, both for themselves and for a few select friends. Others, also firmly established in society like the designer Elsie de Wolfe, produced interiors that mirrored their own personalities, such as Stéphane Boudin of Jansen, who excelled in his own "Windsor" style.

This was also the period in which haute couture reached its apotheosis. Every year, the Duchess of Windsor, Mona Bismarck, Daisy Fellowes, Patricia Lopez, Barbara Hutton, Babe Paley, Marella Agnelli, and a few other *grandes élégantes* vied with each other on the list of the world's ten best-dressed women. Month after month, the glossy magazines followed the nuances of their style, which in turn set new fashions. These were women who could launch couturiers, and who with important orders could seal their reputations, as was the case with Chanel and Schiaparelli, as well as Balenciaga, Mainbocher, Dior, Fath, and later Givenchy and Saint Laurent. Their whims influenced the designers, and new garments were often born of a direct dialogue between couturier and client. Mona Bismarck had a close relationship with Balenciaga, and Daisy Fellowes with Schiaparelli and then Givenchy; and Jacqueline de Ribes went so far as to start her own fashion house. Society clients also influenced haute jewelry, notably through the influence of Jeanne Toussaint at Cartier.

In supporting the artists who played a major role in the minor arts, café society also encouraged artists of minor standing but who were influential in the major arts. In painting, for instance, the society portraitists who came into vogue carried the torch lit by artists such as Helleu, Blanche, and Boldini at the beginning of the century. The most talented of these was undoubtedly Christian Bérard, while Bernard Boutet de Monvel, Alejo Vidal-Quadras, René Bouché, and Mogens Tvede enjoyed critical praise. Serebriakoff and his ilk, meanwhile, perpetuated the nineteenth-century tradition of *portraits d'intérieur* celebrated by Mario Praz, depicting in minute detail the interiors of the great Schneider, Rothschild, or Beistegui residences. Serebriakoff also chronicled the grandest balls, following in a tradition stretching back to the Ancien Régime, or creating magnificent *plans de table* for the Baron de Redé. And theater and opera sets and even fashion drawings offered opportunities for the new romantics—including not only Christian Bérard but also Eugène Berman and Paul Tchelitchew—to excel themselves.

In music, Winnaretta and Marie-Blanche de Polignac, as well as the Noailles, commissioned works from musicians of the group of Six and Igor Markevitch, while musicians such as Maurice Gendron, Robert Veyron-Lacroix, and Jacques Février were seen at all the most glittering balls and soirées. In the 1950s, Ned Rorem brought an American touch to this very Parisian milieu.[1] Finally, a handful of writers gravitated toward café society without ever really becoming part of it, including Jean Cocteau, Paul Morand, Philippe Jullian, and Marcel Schneider, while the photographer Cecil Beaton chronicled it in his diaries, which covered a period of some sixty years.

1. Ned Rorem, *Paris Diary and New York Diary, 1951–1961,* New York: Da Capo Press Inc., 1998.

Facing page
The rooftop apartment overlooking the Champs-Elysées designed for Charles de Beistegui by Le Corbusier, in 1930.

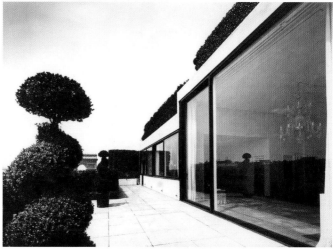
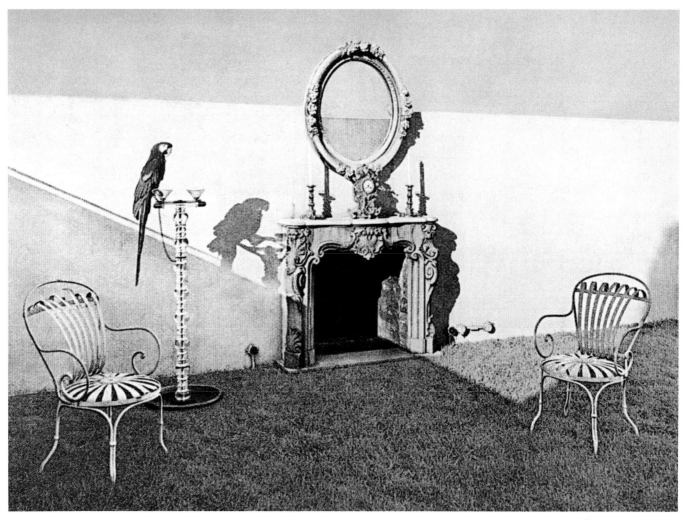

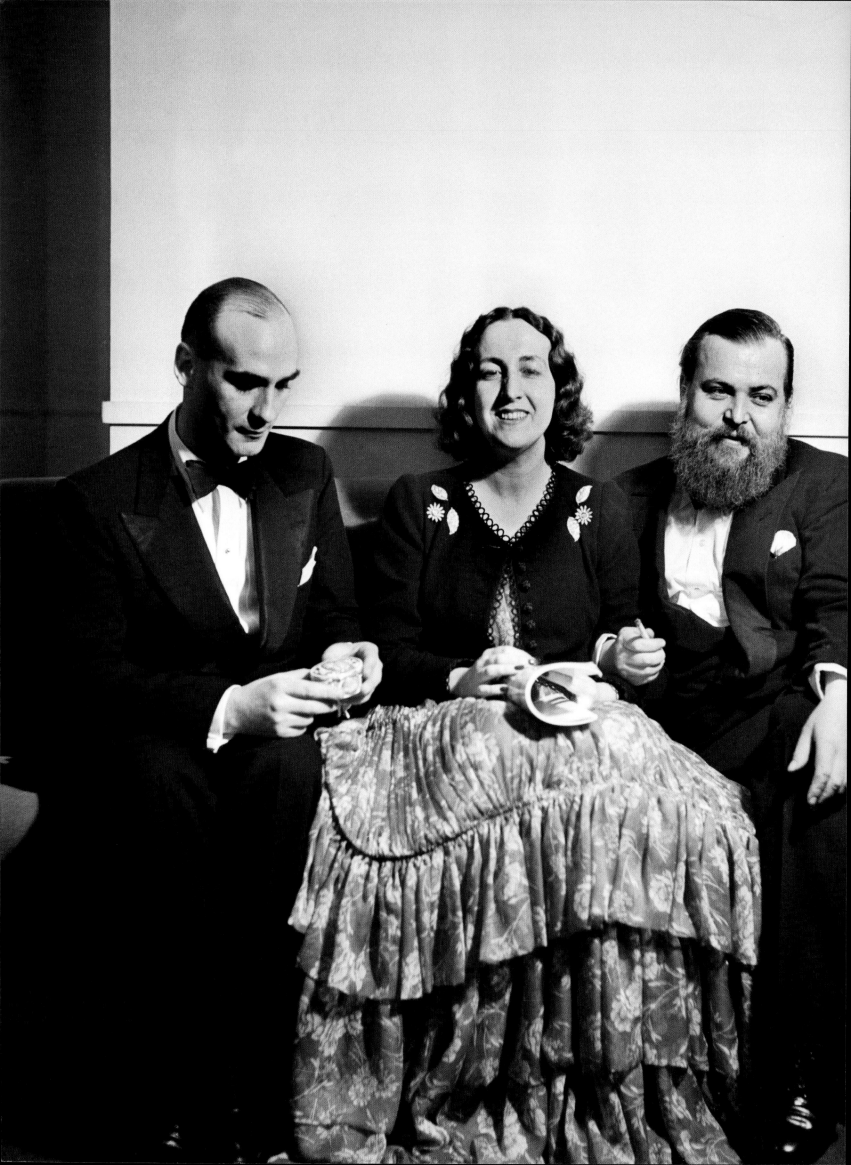

The extraordinary effervescence of the artistic scene in this period depended in large part on the defining role of patrons, benefactors and supporters of the arts, who were frequently motivated by whim or caprice, by sudden *coups de foudre*, or even by dazzling flashes of intuition. Certain society ladies, such as Marie-Laure de Noailles and Peggy Guggenheim, flirted with amorous relationships with the artists they espoused. Edward James, for his part, was a benefactor to the surrealists, and especially Dalí, whose entire output he bought for a period. As a patron Paul-Louis Weiller was a true all-rounder, supporting particularly artists of the theater and cinema and writers, and with a special passion for historic buildings. In addition to his own numerous residences, Versailles was the happy beneficiary of this enthusiasm, emerging from its long hibernation to be restored to life under the direction of Gérald Van der Kemp, with an impressive restoration program and a campaign to refurnish the palace with its original furniture. The work was accomplished thanks to the generosity of his wife Florence's many American friends, as well as that of Arturo Lopez and Barbara Hutton.

Café society—this world of languid insouciance, willful provocation, and wanton luxury—could flourish only in a society that was fragile, brittle, under threat; a society that had lost its way and abandoned its traditional values; a society that tried, in Philippe Jullian's words, "to mix the freedom of a brothel with the outward appearance of an embassy."[2] The recurrent crises of the twentieth century contributed greatly to this turmoil: café society found many recruits among those who had fled the Russian Revolution (including Natalie Paley, Kochno, Hoyningen-Huene, Lifar, and Serebriakoff), as well as Central European Jews seeking refuge from the Nazis. The temporary or permanent exile of many Europeans during the Second World War increased its cosmopolitan nature, and created even closer bonds between the social and intellectual elites on both sides of the Atlantic. After the war, the return of prosperity and of easy money—in the decades known in France as the "Thirty Glorious Years"—sounded the death knell of this world, and ushered in a new order. The years 1918–68 were merely, it has been said, a period of transition, but it was a period of transition that, like the Régence, was to leave an indelible impression. Every era of brilliance must inevitably suffer a decline, and the descent of café society into "Nescafé Society" was to be swift. Who today remembers Arturo Lopez, Daisy Fellowes, Diana Cooper, or Charles de Beistegui, or even Alexis de Redé, who died more recently? Now and then, perhaps, a high-profile auction sale reminds us of their names. Nowadays, Patricia Lopez, Daisy de Cabrol, Ghislaine de Polignac, and Jacqueline de Ribes are the last discreet witnesses of a world whose memory will live on as a final eruption of the spirit of the Grand Siècle, to be rapidly submerged by the triumph of the middle classes and the consumer society. In its brilliance, its creative vitality, its provocative originality, and its unambiguous relationship with money, café society gave rise *a posteriori* to the image of a golden age, a paradise lost, in which nothing had more point than the pointless, nothing was more profound than the superficial, and elegance and a certain *art de vivre* took precedence above all else, for the pleasure of a few and the happiness of all.

Facing page
Boris Kochno,
Marie-Laure de Noailles,
and Christian Bérard, 1938.

Following pages
Lord Berners painting a
portrait of Mrs. P. Betjeman
with her Arab thoroughbred
at Faringdon, his ancestral
home in Berkshire, 1938.

2. Philippe Jullian, *The Snob Spotter's Guide*, London: Weidenfeld and Nicolson, 1958, p. 36.

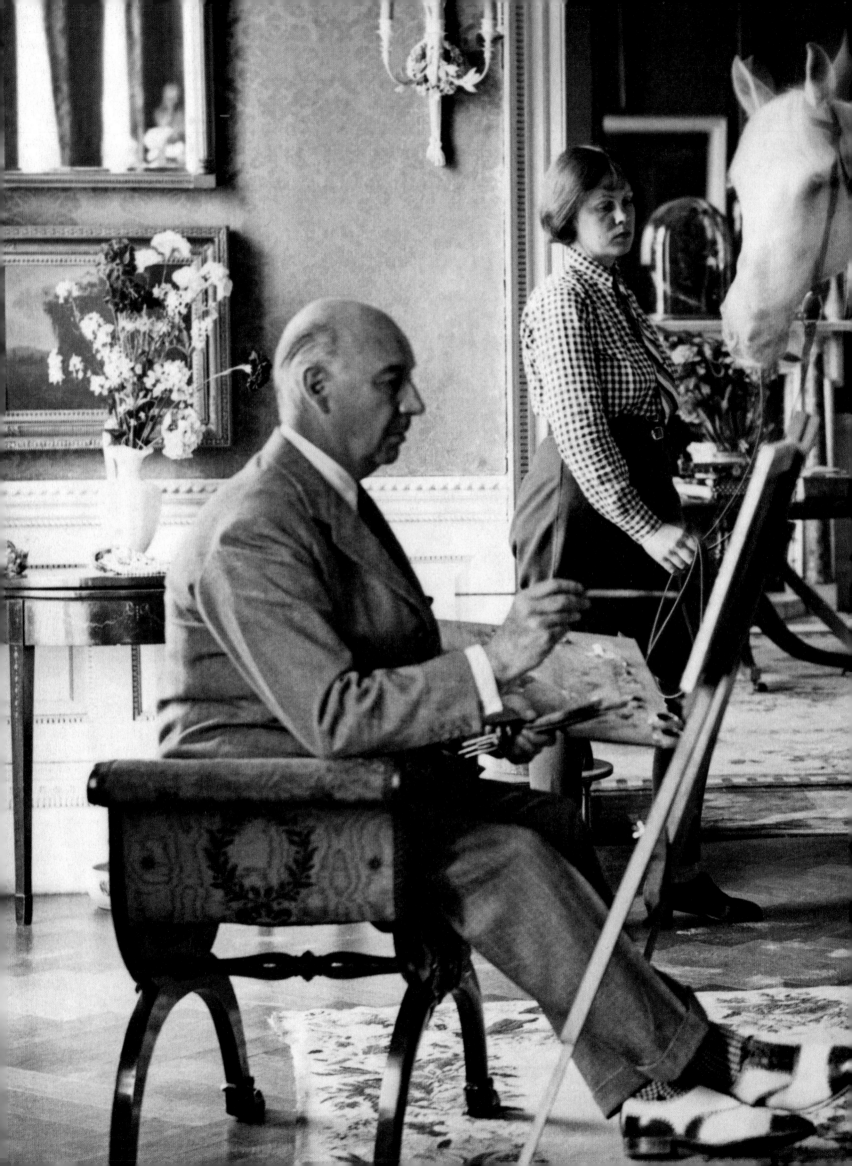

Interior Decoration

"In the last fifty years forms and styles, in both the major and the minor arts, have been in a constant state of flux," observed Cecil Beaton. "A certain painter, decorator or colour might be in vogue for little more than a season. As a result of this unsettled taste interior decorators have come into their own during the past thirty years."[1]

The emergence of interior decorators is a recent phenomenon. For centuries the architect who designed a mansion or house would also design the interior decorations. Furniture was generally contemporary or from the previous generation. Whatever the case, unity of style could be more or less taken for granted. In the nineteenth century, upholsterers added a new touch that was not yet quite that of the decorator, and it was with the Goncourt brothers, Oscar Wilde, and Huysmans' *Des Esseintes* (modeled on Robert de Montesquiou) that the notion of interior decoration entered the canon. Very soon, society figures started to involve themselves in the decoration and furnishing of residences belonging to their friends. In Britain, this was the case with Lady Colefax and Syrie Maugham, in France with Boni de Castellane, and in America and later Europe with Elsie de Wolfe. And it was in their wake that the first true interior decorators appeared. They flourished in the 1930s and decorated the interiors of café society. Some of them, such as Georges Geffroy, became full-blown members, to the point where Evelyn Waugh lamented that one couldn't tell tradesmen from guests. Gradually, interior decoration became an art in its own right, a minor one admittedly, but one that became the object of a veritable cult. Some figures, such as Baron Frédéric de Cabrol, were simultaneously men of society and professional decorators.

In one of his lectures on the fine arts, the philosopher Alain noted that furnishing a house was an art that lay between architecture and fashion. In order to display themselves to best advantage, the members of café society required settings to match their personalities, their imaginations, even their follies, which explains why many of them created their own decorative schemes or worked directly with their interior decorator friends. Beistegui is perhaps the most representative example of the type, whose creations evolved with the century. Starting out with a minimalist apartment, a true "machine for living" commissioned from Le Corbusier, he lost no time in redecorating it in surrealist style, with the help of his friend and partner Emilio Terry. Then he devoted his efforts essentially to the *haut décor* style, in his *hôtel particulier* on rue de Constantine, at the Château de Groussay and

1. Cecil Beaton, *The Glass of Fashion*, London: Weidenfeld and Nicolson, 1954, p. 203.

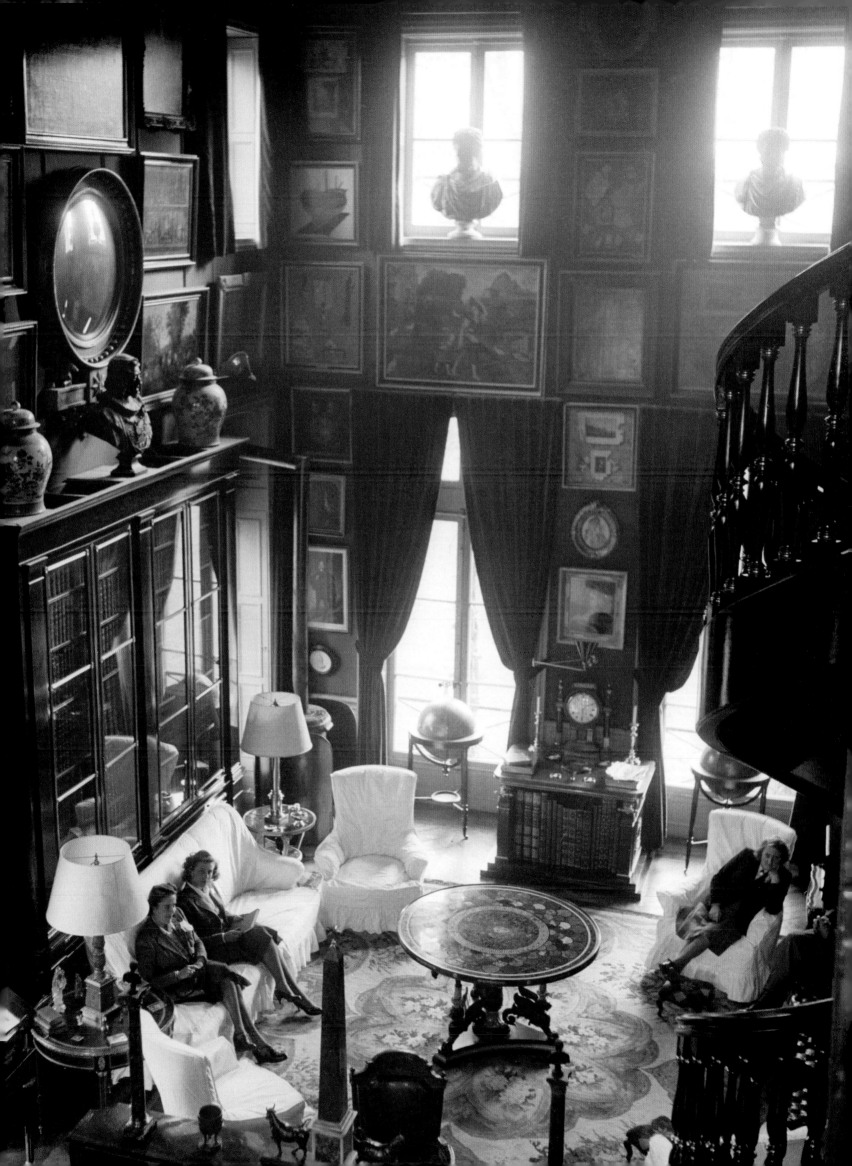

at the Palazzo Labia. In these settings his parties grew more flamboyant, and their interior decorations flattered his taste for the grandiose. Aided by Terry and Geffroy, he also gave advice to Alexis de Redé for his library at the Hôtel Lambert and to Duff Cooper for the library of the British embassy. For his part, the millionaire Edward James, occasional poet and above all benefactor to many artists, excelled himself in his baroque and surrealist decorative schemes for his London house on Wimpole Street and his country residence, Monkton House in Sussex, before building his own hallucinatory palace in the Mexican jungle.

Meanwhile a clutch of young dandies who were in thrall to the baroque, consisting of Cecil Beaton, Oliver Messel, Martin Battersby, and Felix Harbod, vied with each other in creating highly theatrical decorative schemes. These influences were clear to see in Beaton's successive country houses, Ashcombe and Reddish House, in Stephen Tennant's Wilsford Manor, and in the Dorchester Hotel in London, where Messel's decorations remain a classic of their type. The Sitwells also exercised a profound influence on the period with their mixture of Gothic and Italianate. Fulco di Verdura designed a highly original apartment in New York. Everyone in café society turned to the services of interior decorators, choosing them to flatter their own tastes. Some decorating firms were able to create interiors in every style, such as Alavoine and Jansen, using craftsmen skilled in every area of expertise. Jansen also possessed a particular style, developed under the direction of the great specialist in the field, Stéphane Boudin, and dubbed by Emilio Terry "*tous les Louis*," or "Louis XX." It was a style that found particular favor with the Duke and Duchess of Windsor, who commissioned Boudin to decorate their successive Paris residences.

Meanwhile a clutch of young dandies who were in thrall to the baroque, consisting of Cecil Beaton, Oliver Messel, Martin Battersby, and Felix Harbod, vied with each other in creating highly theatrical decorative schemes.

After the war, Madeleine Castaing offered her clients an eclectic style mingling nineteenth-century French and English references. The more recently clients had risen in society and the newer their country of origin, as for instance the millionaires of South America, the greater their taste for styles that were weighty with history, grandeur, and drama; the longer their pedigree, by contrast, the more dependably their tastes tended toward the avant-garde. The 1930s marked the beginning of a period when it became more chic to create something contemporary than to look back to historical styles. In this the Noailles were in the very vanguard of fashion, commissioning Mallet-Stevens to design, build, and decorate the villa at Hyères, and asking Jean-Michel Frank, a close friend of Bérard, to hang the salon in their mansion on place des Etats-Unis with squares of parchment and to furnish it with shagreen furniture. At the same time, Syrie Maugham launched her famous "all-white salon," and Elsie de Wolfe was finding considerable success with her equally famous beige. Pale shades became all the rage.

Preceding page
Charles de Beistegui's library
at the Château de Groussay,
designed by Emilio Terry.
Photograph by Cecil Beaton,
late 1930s.

Facing page
The Baron and
Baronne de Cabrol in their
apartment on avenue Foch,
decorated by Frédéric de
Cabrol. Photograph by
Robert Doisneau published
in French *Vogue*, 1951.

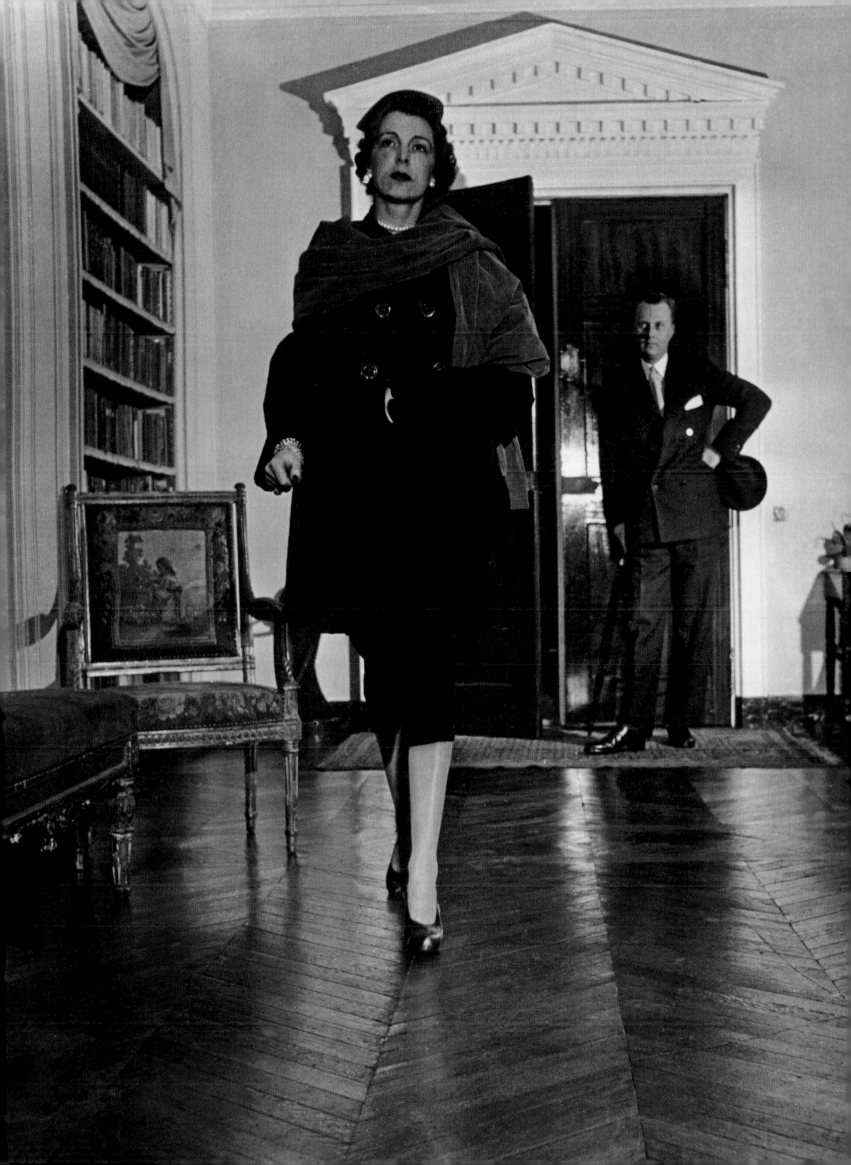

A few names were to become particularly influential, with their tastes and schemes everywhere on view. With her *House in Good Taste,* published in numerous editions and translations throughout the world, Elsie de Wolfe set the tone. Christian Bérard, an omnipresent figure in portraiture, theater design, and fashion as well as in interior decoration, was influential not only through his tastes but also through his decorative schemes, which could be seen in the residences of the Duchess of Windsor, Diana Vreeland, Elsa Schiaparelli, Marie-Blanche de Polignac, and Horst. Prominent in his wake was Jean-Michel Frank, to whom the Noailles introduced the Giacometti brothers whom they had "discovered." The brothers found firm favor with Edward James, and their works became highly sought after by decorators such as Geffroy and Samuel. In partnership with the cabinet-maker Chanaux, Jean-Michel Frank opened a gallery at 140 rue du Faubourg-Saint-Honoré where he cultivated an austere, pared-down style that prompted Cocteau to remark, during a visit to his apartment on rue de Verneuil, "Charming boy. Really charming. Such a shame he's been burgled."[2]

It is hard to claim that there was such a thing as a café society style, even if, in *Les Styles,* Philippe Jullian described a variant of it: "Despite the obvious color scheme, one should not be aware of the hand of the interior decorator; 'hobbies' fill the tables; Fabergé for the really very rich; small paintings by Mexican followers of Dalí or fashionable imitators of Leonor Fini, jostling with photographs of Barbara and Arturo. Abstraction is too intellectual. With the addition of a few trinkets, a décor such as this could be reproduced on a yacht or at the Ritz. There are two fundamental principles: apparent clutter but underlying symmetry; and originality, but always in the style of the Duchess of Windsor, Nicky de Gunzburg, Fulco di Verdura, or Mona Bismarck."[3]

Along with interior decoration, this was the time when collecting, hunting for antiques, and the art world all came into vogue. Indeed this was one of Jullian's favorite subjects in *Les Collectionneurs, Apollon et Cie, Les Meubles equivoques,* and *Mémoires d'une bergère.* In his evocative books, with their barbed descriptions of interiors, he echoed the spirit of Osbert Lancaster in *Homes Sweet Homes* and *Here of All Places,* published in England a few years earlier. Some aesthetes had the details of their interiors immortalized by Serebriakoff. Many magazines also took a keen interest in interior decoration, including *Connaissance des arts, Plaisirs de France,* and *Décoration.* Not to be outdone, in 1947 Condé Nast started *House and Garden,* which was to become as influential internationally in the world of interior decoration as *Vogue* was in fashion. Horst was one of the photographers to work for *House and Garden,* which commissioned a notable reportage from him on the Long Island residence of Mme Jacques Balsan. When Diana Vreeland joined *Vogue* in the early 1960s, she asked him to photograph interiors belonging to a number of prominent figures, most of whom were among the last survivors of café society: Pauline de Rothschild, the Duke and Duchess of Windsor, Mona Bismarck, Babe Paley, Antenor Patino, and Chanel—a final tribute to the taste of a vanishing era.

Facing page
Elsa Schiaparelli at home in Paris, 1947.

Following pages
The salon of the Vicomte and Vicomtesse de Noailles, lined with parchment by Jean-Michel Frank, in their *hôtel particulier* on place des États-Unis, Paris, 1964.

2. Jacques Porel, *Fils de Réjane*, Paris: Plon, 1951, p. 293.
3. Philippe Jullian, *Les Styles*, Paris: Gallimard, 1992, p. 112.

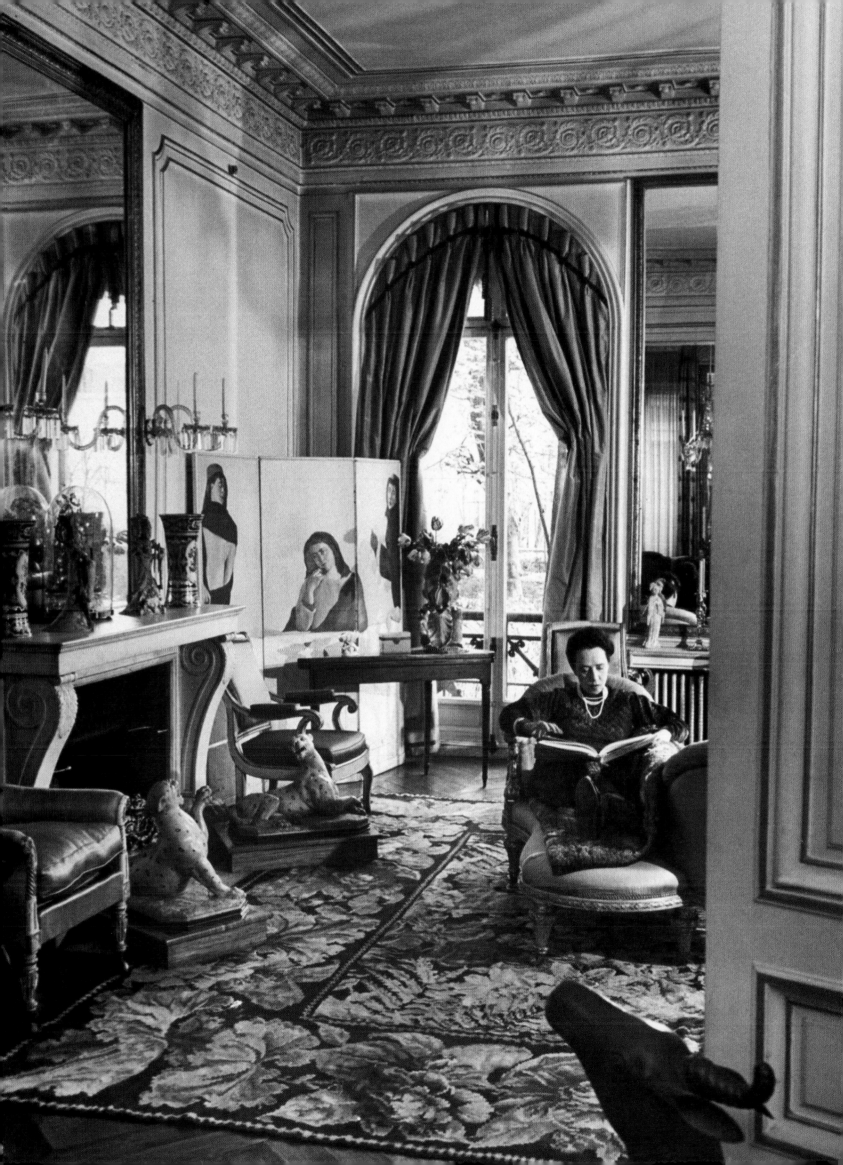

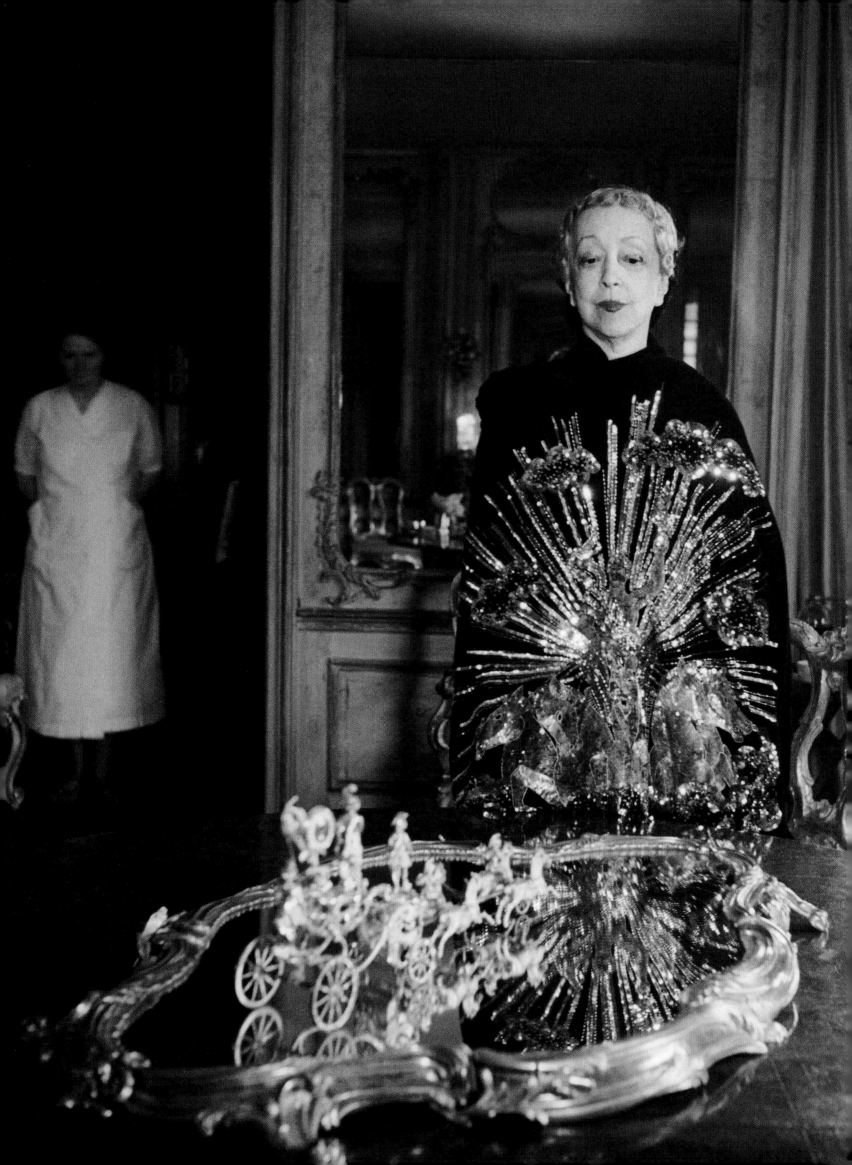

Lady Mendl

Lady Mendl, *née* Ella Anderson de Wolfe, was one of the key figures of café society. It was she more than anyone else who perfected the eclectic mixing of genres in every field, the fundamental feature of the world she inhabited and on which she had such a determining influence. Even her origins were mixed: born in New York on December 20, 1865 but of English roots (her grandfather was the best friend of Lord Byron), Elsie de Wolfe grew up in the city of her birth and afterward in Edinburgh, before being presented at the court of Queen Victoria in 1883. She first tasted success as an interior decorator in New York, married an Englishman in 1926, and spent most of her long life in Paris and Versailles, where she died on July 12, 1950.

Her life was a model of cosmopolitanism, and she was equally at home in a variety of milieus. Born into "good" American society, she became a society hostess in whose salon monarchs who had lost their crowns mingled with artists, film stars, and everyone of account among the wealthiest, snobbiest bourgeoisie of France, Britain, and America. Her personal life was also varied: married at sixty-one to Sir Charles Mendl, a diplomat at the British embassy in Paris, she built a large part of her professional success on her relationships with women, which she made little attempt to conceal. And her activities were equally varied: after unsuccessful attempts at a career as a stage actress, Elsie de Wolfe was one of the first society ladies to capitalize on her talents as a hostess to create a professional activity and build a considerable fortune, whether through her work as an interior decorator or through her talents at organizing prestigious parties. The social whirl, money, power, sex: for Elsie de Wolfe they were all intertwined. Through her tireless round of activities, she became the hub of a chic cosmopolitan world, whose tastes she codified and nurtured with new talents. In 1946, for example, it was she who introduced the young Alexis de Redé—whom she had met in America during the war—to Paris high society.

In fact Elsie de Wolfe's life took a number of twists and turns, which—with her consummate ability to exploit new possibilities—she invariably turned to her advantage. In her youth she entered the theater in order to further her social ambitions. Showing little talent for acting, she decided to move into theater production, and until 1905 she directed her own theater company and organized tours across the United States. It was the theater that above all introduced her to the great love of her life, Elisabeth Marbury, who supported her throughout all her later activities. Elisabeth was a ground-breaking theatrical and literary agent who was also one of the most important American theatrical impresarios of her time. As agent for the French Academy of Letters and the Société de Gens de Lettres, she was able to give Elsie an entrée into the upper echelons of French society. From 1887 the two women became a couple, forming a close and stormy relationship that was to last until Elisabeth's death in 1933, when she left her entire estate to Elsie de Wolfe, by then

Lady Mendl. In the 1890s they bought Washington Irving's house in New York, which Elsie redecorated with such success that numerous society ladies, with Edith Wharton in the vanguard, asked for her help in decorating their own houses. Thus she embarked on a career in which she was to excel.

Elsie lost no time in opening a gallery on Fifth Avenue; decorating the Colony Club (New York's first club for women); having cards printed bearing her emblem of a wolf holding a flower in its paw; and writing numerous articles that would lay the foundations of a new style in interior decoration, far removed from the Victorian style then in vogue in America. Most important of all, in 1913 she published *The House in Good Taste*, which was to become the bible of interior decoration. In 1907, meanwhile, she had acquired the famous Villa Trianon at Versailles, the former residence of the Duc de Nemours, which was to become both a showcase for her publicity campaign on the French public, and the setting for the parties that she gave until shortly before her death, even when confined to a wheelchair by acute arthritis. Shortly before the First World War, she set up house at Versailles not only with Elisabeth Marbury but also with Ann Morgan, heiress to the Pierpont fortune, forming an eccentric *ménage à trois* dubbed the "Versailles triangle" that would henceforth lay down the law in matters of taste and entertaining.

The Elsie de Wolfe style was aimed principally at Americans living in New York or Paris. Strongly inspired by the aesthetic doctrines of Oscar Wilde, it mingled comfort with eighteenth-century French style to create a new style dubbed the "old French look." It was a look that depended on a pastel palette, and especially the famous beige that she used with ubiquity, sometimes in juxtaposition with leopard skin or chintz covers. On first seeing the Parthenon, she was said to have exclaimed, "Oh! My beige!" During the First World War, her activities were both singular and exemplary. With Ann Morgan she set up an ambulance corps, then with Baroness Henri de Rothschild she ran the Ambrine hospital at Compiègne, where her work with the victims of major burns and gas earned her the Croix de Guerre and the Légion d'Honneur.

In addition to the Villa Trianon, in 1929 she also decorated apartments for herself in the sumptuous residence of Roland Bonaparte on avenue d'Iéna. Between them, these two residences served as settings in which she could entertain the whole world. She had learned useful lessons from Boni de Castellane: as Jean-Louis de Faucigny-Lucinge noted, "She mingled her clients, current and future, with hand-picked members of international high society, as all these American nouveaux-riches were thrilled to meet people out of the top drawer."[1] Her close friends included the Duke and Duchess of Windsor, Daisy Fellowes, Pola Negri, André de Fouquières, and Cécile Sorel, and the parties she gave were like those of Edouard Bourdet's princess in *La Fleur des pois*, who turned her address book to her material advantage. But they were always a success, even so, as she always knew how to do something new in order to hold people's interest. In 1930, for example, she hatched the idea for "murder parties," a type of party game that was entirely new. Her parties were famous not only for their aesthetic success and for their carefully crafted guest lists, but also for the meticulous perfectionism that underlay every aspect of their organization. Nothing was left to chance in the their decorative schemes, table settings, buffet decorations, menus, choice of drinks, or guest placements. Beaton described her "fetishistic concern for trivialities" in both entertaining and decorating, and her "genius for taking infinite pains": "Only when the scene was set, the perfumes burnt in the censers, and the last candle lit was the element of spontaneity encouraged. On her appearance, too, she lavished much fervour and fantasy. Having been at thirty a vaguely plain woman with a marmoset face and only a pair of bright brown eyes to break the anonimity, Lady Mendl improved her

looks throughout the years. By special dieting, by turning somersaults and standing on her head, she maintained a svelteness of figure throughout her life. She introduced pale blue or heliotrope-coloured hair and was one of the earliest, most successful devotees of facial surgery. In later years there was much speculation about her age, for she seemed to have become ever younger and prettier; and when she was over eighty Lady Mendl came into her own as a beauty, acquiring an almost mystical look of serenity."[2]

Below
Lady Mendl in her salon.
Photograph by
François Kollar, 1939.

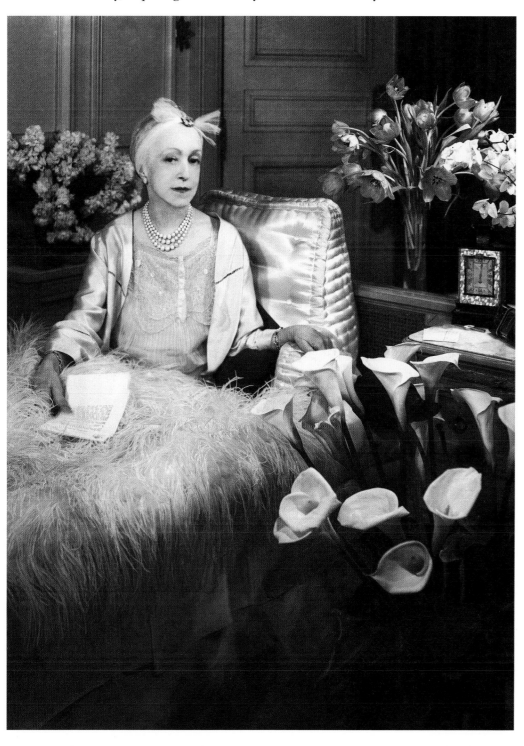

1. Jean-Louis de Faucigny-Lucinge, *Un gentilhomme cosmopolite*, Paris: Perrin, 1990, p. 88.
2. Cecil Beaton, *The Glass of Fashion*, London: Weidenfeld and Nicolson, 1954, pp. 206–7.

Georges Geffroy

Georges Geffroy was both a major figure in café society and one of the great interior decorators of the period. Infatuated with the eighteenth century, and particularly with the Louis XVI and Directoire styles, he was above all a man of fashion and a dandy. His clients became friends, except when his friends became clients. They included the Duff Coopers, who asked him to decorate the British embassy and their chateau at Saint-Firmin in the Oise, as well as Pierre David-Weill at Gambais, the Baroness de Montesquiou at Neuilly, and Alexis de Redé. On some projects he worked with friends who were also society figures, such as Charles de Beistegui[1] and Emilio Terry.

A purist and aesthete who was also a meticulous craftsman, Geffroy worked on only one project at a time, oversaw everything personally, accompanied his clients on visits to antique dealers, and helped them to refine their tastes in accordance with his own, which tended to the use of extremely subtle fabrics and *trompe-l'oeil* effects. He excelled in the design of libraries and staircases. Sometimes his researches propelled him toward drama and ostentation, but always tempered by just the right amount of chic and good taste. His apartment on rue de Rivoli, looking out over the Tuileries and decorated with furniture by Jacob, Riesener, and Weisweiller, was his finest advertisement. To the end of his life he remained a refined and recherché interior decorator, as well as an omnipresent figure in Paris society.

Facing page
Georges Geffroy at his desk. Photograph by Robert Randall published in French Vogue, 1949.

1. Notably for the libraries of the British embassy and the Hôtel Lambert.

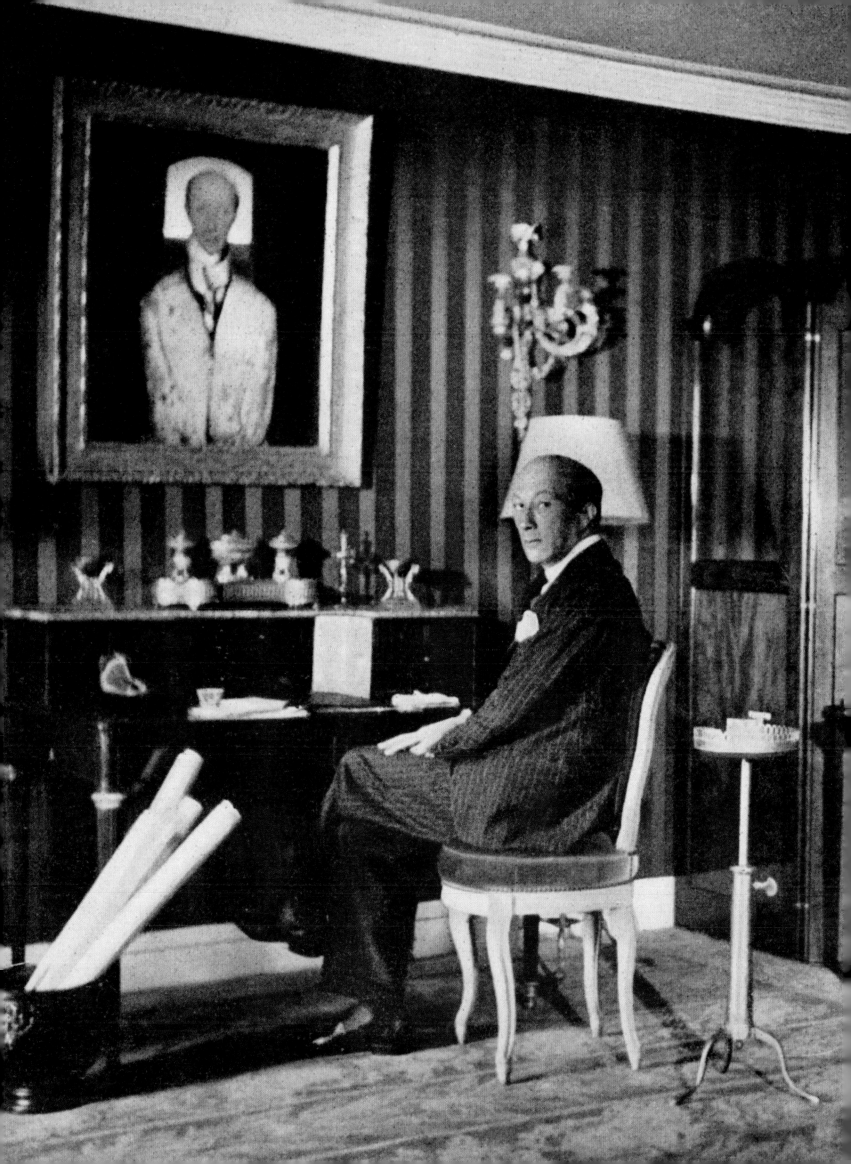

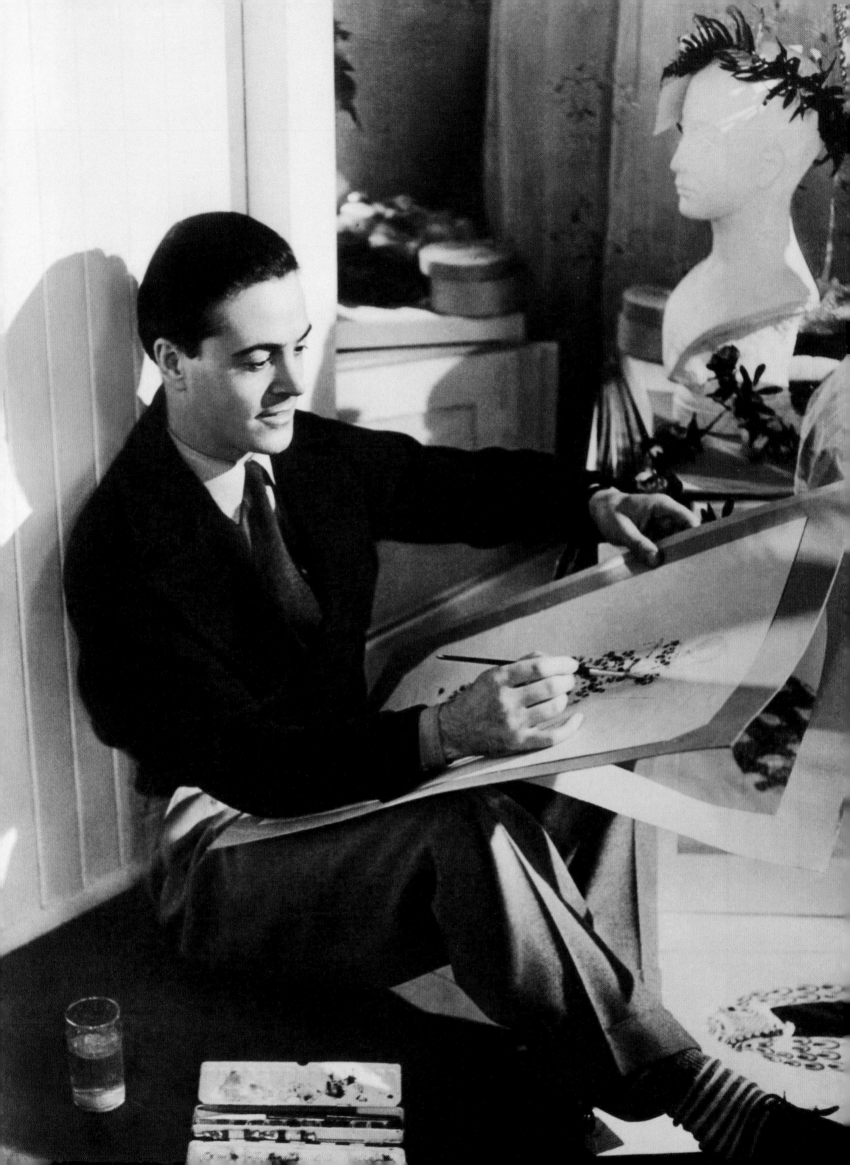

Oliver Messel

Facing page
Oliver Messel designing
the sets and costumes for
A *Midsummer Night's Dream,*
1959.

In the 1930s and 1940s, Oliver Messel was one of the most celebrated designers of theatrical sets and costumes in Britain and beyond. In this, as well as in his private life, he was a rival to Cecil Beaton. Born into a wealthy, well-connected family in 1904, he went to Eton (where his fellow pupils included Evelyn Waugh and Harold Acton) and the Slade School of Fine Art. He started out as a portrait painter, before designing the masks for the London production of the Diaghilev ballet *Zéphyr et Flore* in 1925 and afterward masks, costumes, and sets for C.B. Cochran's revues. He found success in 1932 with his costumes for *Miracle* by Max Reinhardt, with performances by Tilly Losch and Diana Cooper. Messel became friends with Noël Coward and Lord Berners, who included him in his book *The Girls of Radcliff Hall*, published in 1937, which described—in the guise of schoolgirls—the rivalry between Beaton and Messel for the affections of the painter Peter Watson, whom Beaton was trying to steal from his friend.

After the Second World War Messel pursued his career in Britain and the United States, where he designed a number of Hollywood films, including *The Thief of Bagdad* by Ludwig Berger (1940) and *Suddenly Last Summer* by Joseph L. Mankiewicz (1959). He also designed operas for Covent Garden and Glyndebourne. In 1953 he pulled off a *coup d'éclat* with his flamboyant rococo designs for the redecoration of the Dorchester Hotel in London. Gradually he began to spend more and more time at his house on the Caribbean island of Mustique, a favorite retreat of Princess Margaret, who married Messel's nephew Anthony Armstrong-Jones, later Lord Snowdon. There, and in Barbados he continued to decorate numerous millionaire residences until his death in 1978.

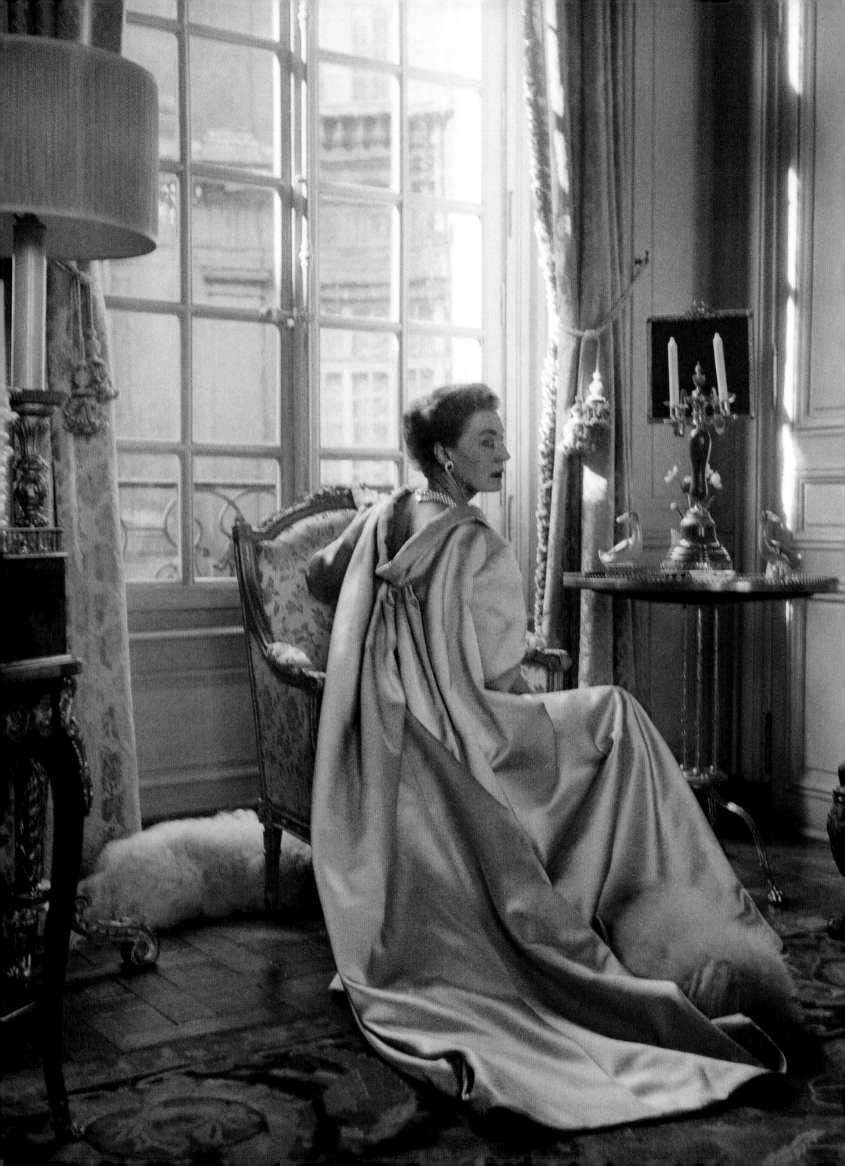

Fashion: Couturiers and Jewelers

Through the sheer numbers of their orders and their privileged relationships with couturiers, members of café society were to raise fashion to the status of a major art. Never had haute couture and jewelry played a role of such importance, not only in influencing the tastes of the public (a phenomenon that was to persist to a lesser degree), but also in social and artistic life. This was the period in which couturiers shed the status of simple suppliers in order to become prominent personalities, envied and courted, and in some cases viewed as true artists and style gurus. As Philippe Jullian noted, Charlie James "made only ten gowns a year, of which five were for Mrs. Harrison Williams. Pure genius. Then came Balenciaga, who didn't dress just anybody. Dior was Louis XIV."[1]

Society ladies dressed in haute couture and posed for glossy magazines, before being supplanted by film stars. The annual list of the world's ten best-dressed women provoked fierce rivalry. Professional models also made their appearance, often in their turn becoming figures in café society. All this competition was made possible by the rise of the great fashion magazines: *Vogue, Harper's Bazaar,* and in France *Le Jardin des modes* all commissioned designers, writers, and photographers of unrivaled talent. These magazines were ruled with a rod of iron by women of formidable character who knew how to impose their tastes, such as Carmel Snow, Edna Chase, Bettina Ballard, and Diana Vreeland.

Haute couture is a fairly recent phenomenon: the first true modern couturier was the English-born Frederick Worth, who dressed court and society ladies of the Second Empire. The rise of capitalism; the ambition of Napoleon III and Empress Eugénie to create a court to rival the most prestigious royal courts of Europe; and technical advances leading to the development of the sewing machine and new fabrics: all these acted as a stimulus to fashion. Gradually, wealthy women were routinely dressed by the great couturiers, to the point where Mme Menier (of chocolate fame) had the daily purchase of a new gown written into her marriage contract. Jacques Doucet, Paul Poiret, and Jeanne Lanvin were the first in this new profession, with an influence that soon spread beyond national boundaries. The image of French elegance to which they gave substance drew fashionable women to Paris from all corners of the globe, precisely at the point when the couture business was both simplifying and diversifying.

After the First World War, Chanel introduced numerous changes in the world of fashion. She was the first couturier to become a prominent member of café society,

1. Philippe Jullian, *The Snob Spotter's Guide*, London: Weidenfeld and Nicolson, 1958, p. 55.

both through her lifestyle—including affairs with Grand Duke Dimitri, half-brother of Natalie Paley, and the Duke of Westminster (known as "Bendor")—and through her friendships with society artists such as Bérard, Beaton, and Horst. After being snubbed for a period by the arch snob Étienne de Beaumont, she harnessed her talents, and those of Fulco di Verdura, to the launch of a line of costume jewelry. Meanwhile she had also diversified into perfume, launching her famous Nº 5 in 1921. In fashion, she was the first to liberate women completely from the various fetters and straitjackets into which they had traditionally been laced and bound. Her flowing lines and use of tweed and jersey were to revolutionize the female wardrobe. Chanel opened boutiques in all the most fashionable resorts, including Deauville, Biarritz, and Cannes. Introduced to Diaghilev by her great friend Misia Sert, she commissioned the revival of *Firebird* with new choreography by Massine, then designed the costumes for Cocteau's *Antigone* (with sets by Picasso) in 1922, for Diaghilev's *Le Train bleu* to a scenario by Cocteau in 1924, and for George Balanchine's *Apollon Musagète* in 1929.

Through the sheer numbers of their orders and their privileged relationships with couturiers, members of café society were to raise fashion to the status of a major art.

From 1930 Chanel worked under contract to Samuel Goldwyn at United Artists, dressing Hollywood stars. Her decorative schemes for her successive Paris apartments, on rue du Faubourg-Saint-Honoré, or at the Ritz, were landmarks in interior decoration, introducing her strikingly avant-garde style of beige sofas, Negro porte-torchères, and Coromandel lacquer screens. Numerous other couture houses were to spring up in her wake: Jean Patou in 1919, Nina Ricci in 1932, Robert Piguet in 1933, Madame Grès in 1935, and Desses and Balenciaga in 1937. As Madeleine Vionnet, Callet Soeurs, Edward Molyneux, and Marcel Rochas reached their apogee, Jeanne Lanvin was on the rise, to be followed by her daughter Marie-Blanche de Polignac. From 1929 the American couturier Mainbocher (Main Rousseau Bocher) made his name in Paris, above all as couturier to Wallis Simpson, who commissioned her "Wallis blue" wedding dress from him in 1936.

Chanel's great rival was an even more formidable figure in café society: Elsa Schiaparelli. Born into a learned and aristocratic Roman family, Schiaparelli set out to conquer Paris with her extraordinarily avant-garde fabrics and surrealist couture, including Dalí's dress motifs and the famous shoe hat worn by Daisy Fellowes. After reaching its heyday in 1938-9, haute couture suffered a few years of relative eclipse during the Second World War. Schiaparelli emigrated to America, while Chanel, Vionnet, and Mainbocher closed their doors (though only temporarily in Chanel's case). The Liberation saw the emergence of a new generation of couturiers: Jacques Fath, who had opened his couture house in 1937, Pierre Balmain who started in 1945, and above all Christian Dior, prophet of the New Look. They were followed by Antonio Canovas de Castillo, Hubert de Givenchy, and Pierre Cardin.

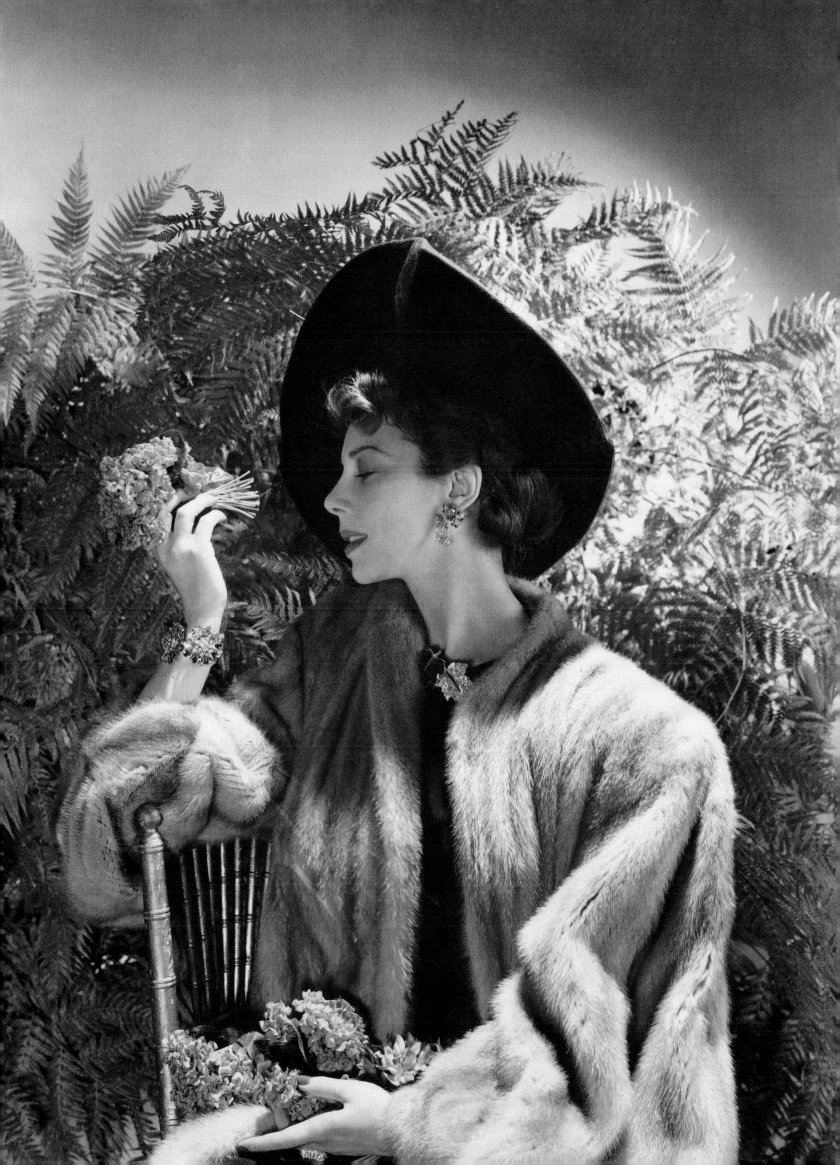

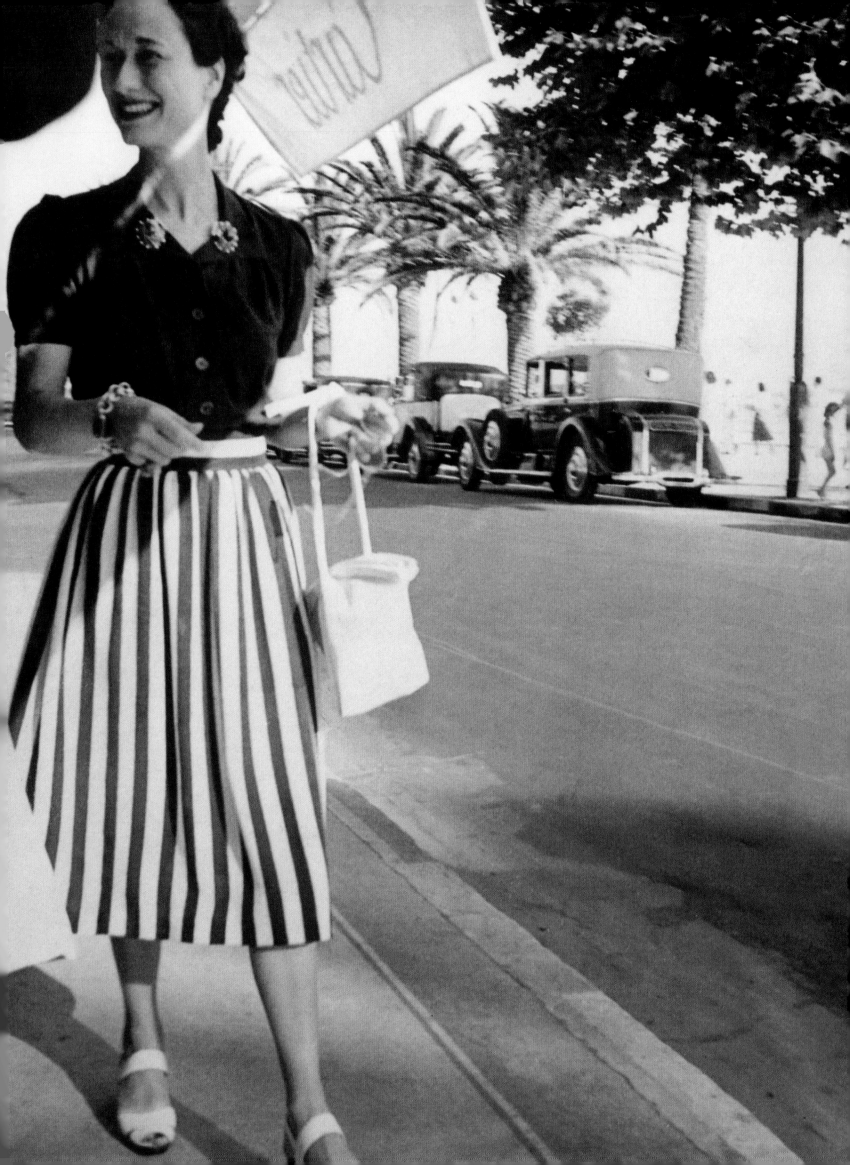

The last-born offspring of café society, and the herald of a new era, was Yves Saint Laurent, who was ushered into society by his designs for Alexis de Redé's Bal des Têtes in 1957. These couturiers were outstanding figures of their time, frequenting the latest artists in vogue, hosting large parties (like Jacques Fath), or becoming the darlings of particular salons (like Hubert de Givenchy, who made his debut as a protégé of Marie-Louise Bousquet). With clients such as Mona Bismarck, Daisy Fellowes, and Barbara Hutton they enjoyed close relationships that sometimes developed into friendships. For the couturiers, faithful clients such as these assumed the status of muses. Gradually, couturiers also started designing for film stars. Thus the woman who came to embody the elegance of Givenchy was Audrey Hepburn—prompting Philippe Jullian to remark: "Yesterday, Molyneux was known as the Duchess of Kent's dressmaker: today Givenchy is famous as Audrey Hepburn's dressmaker."[2]

> Throughout the twentieth century, however, it was the creativeness of Paris jewelry that led the world, with Cartier setting the tone—a tone that included innovations spanning all the great creative movements of the era.

Haute jewelry also enjoyed its heyday in the era of café society. Indeed in some ways, most notably in its cosmopolitan appeal, it had anticipated it. This was a domain that relied on a quintessentially international market, pairing extremely wealthy clients with stones of outstanding quality in settings created by artists of high repute. Although it had for many years been the preserve of courtiers and aristocrats, for whom it created ceremonial pieces and regalia, tiaras, and parures, the growing influence of American wealth as the nineteenth century progressed was to change all this. While the United States produced its own gold in California, sapphires in Montana, and tourmalines in Maine, wealthy collectors kept a close eye on auction sales of jewelry belonging to members of the European aristocracy, many of whom found themselves increasingly in need of funds. The opening of a Paris branch of Tiffany in 1850 underlined this desire for an American jewelry house to seize the opportunities offered, just as the establishment of Cartier in New York in 1909 was prompted by the need to be in closer proximity to a wealthy clientele. Thus at the sale of the French crown jewels in 1887, Tiffany was the successful bidder for one third of the lots. And so it was that on her marriage to the Duke of Marlborough, Consuelo Vanderbilt received a string of pearls that had belonged to the Empress Eugénie and been bought from Tiffany.

Throughout the twentieth century, however, it was the creativeness of Paris jewelry that led the world, with Cartier setting the tone—a tone that included innovations spanning all the great creative movements of the era. In the 1930s and 1940s Cartier diversified its models, with increasing reference (at the instigation of Jeanne Toussaint) to floral and especially animal subjects, which the Duchess of Windsor would raise to the height of fashion with her trademark panther and pink flamingo. Cartier embraced successively

Facing page
The Duchess of Windsor passing the Cartier shop window in Cannes, 1938.

2. Ibid.

a rich variety of styles: Russian, Egyptian, Persian, and Indian, Chinese and Japanese, and of course art deco. But above all it worked to order for major clients, with whom it set up a genuine dialogue over designs and settings. Clients such as Daisy Fellowes and Lady Mendl displayed such fertile imaginations that they eventually changed tastes in haute jewelry just as they did in couture. Other important clients such as the Duchess of Windsor, Mrs. Cole Porter, and Barbara Hutton influenced tastes indirectly, launching fashions simply by what they wore. *Vogue* and *Harper's Bazaar* devoted a great deal of interest to both fashion and jewelry. Jewelers, meanwhile, multiplied their creations to include evening bags, powder compacts, lipsticks, cigarette holders, cigarette cases, lighters, and matchbox holders, all in gold, platinum, enamel, or encrusted with jewels, both for women and for men. Sophisticated individuals such as Alexis de Redé were eager clients for such trinkets.

Couturiers also worked very closely with jewelers. From the outset, Chanel considered jewelry as an indispensable complement to her clothes. The jewelry she created was nevertheless primarily of decorative value, unlike traditional haute jewelry, and she was as happy to commission designs from Étienne de Beaumont and Fulco di Verdura as from Iribe. Schiaparelli, for her part, worked extensively with Jean Schlumberger, a fellow devotee of surrealism, for her accessories and buttons. The shifting of commercial networks from London and Paris to New York, as wealthy American clients went home to sit out the war and other clients sought refuge there, persuaded Schlumberger and Fulco di Verdura to move permanently to the States.

It was through the splendor of their jewelry that the maharajas of the Indian subcontinent gained entry to café society. Making frequent trips to Europe to have their exceptional stones set in the novel Western ways in which Cartier excelled, they created a vogue for Indian-style jewelry that found favor with Daisy Fellowes, Lady Mendl, and the Duchess of Windsor. The highly westernized Jagatjit Singh, Maharaja of Kapurthala (1872–1949), a friend of both Roosevelt and Clemenceau, was one of Cartier's largest clients and also one of its most prolific suppliers of precious stones. On his annual tours of Europe he was particularly impressed by what he saw in France, and even built a palace modeled on Versailles in India. His daughter-in-law Naram was frequently photographed by *Vogue* for both her elegance and her jewels. With their sumptuous ways of life and jewelry collections, the maharajas of Patala and Indore also exercised an exotic fascination over café society, which at the same time viewed them with a degree of disdain that was at once amused and envious, prompted by a lifestyle redolent of another age and another world. The Maharaja of Nawanagar, for example, kept a black servant whose sole function it was to wear the princely collection of pearls next to his gleaming skin in order to preserve their luster and orient!

Facing page
Daisy Fellowes wearing her fabulous "Hindu" necklace made by Cartier. Photograph by Cecil Beaton, 1937.

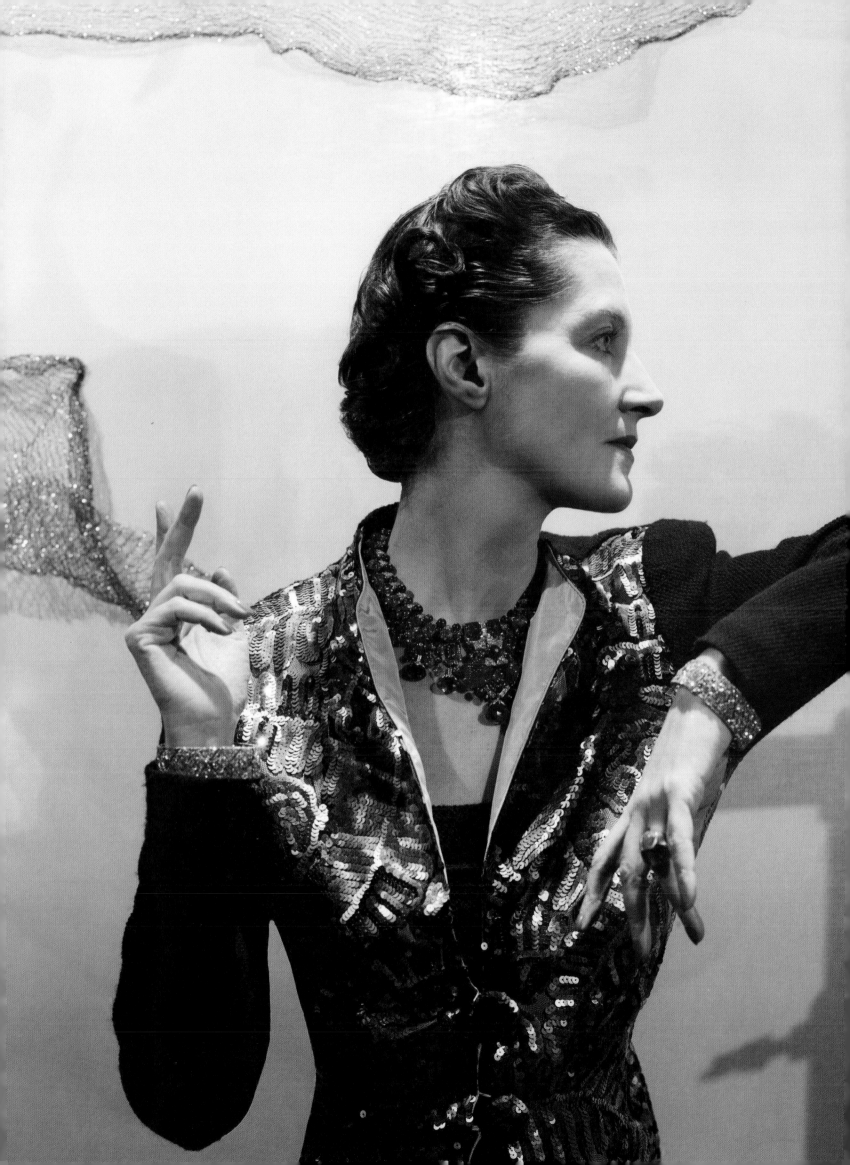

Elsa Schiaparelli

Elsa Schiaparelli was a key figure in café society. For her, couture was an art form, while for her rival Chanel it was a craft. Born into a learned Roman family, with a father who was a renowned scholar and Sanskrit specialist and a distinguished astronomer uncle who discovered the *canali* on Mars, she was highly imaginative and wayward, presenting a combination of bohemian chic and intellectual accomplishment that earned her a unique place in what was by any measure a singular profession. After a few nomadic years spent between Europe and America, and an unhappy marriage from which she had a daughter Gogo—a member of café society after the war and mother of Marisa Berenson—she settled in Paris in 1922 with her indispensable friend Gabrielle Picabia. There she moved in surrealist circles, having already got to know Marcel Duchamp and Man Ray in New York. Her couture items were immediately successful, and in 1935 she opened a boutique at 21 place Vendôme, which she had decorated by Jean-Michel Frank and Diego Giacometti.

The influence of her surrealist friends could be seen in printed fabrics designed by Cocteau and Dalí, as well as in her selection of fashion accessories, including the famous shoe hat and telephone bag. Jean Schlumberger, meanwhile, designed buttons and jewelry for her outfits. Her clients were the most extravagant and elegant of their time, with pride of place going to Daisy Fellowes. Schiaparelli also enjoyed using surprising materials such as Rhodophane (a transparent plastic), metal, and transparent porcelain. She was close to artists such as Tchelitchew and Bérard, who covered the walls of her apartments with their works, and entertained her café society friends with pasta parties that were well ahead of their time. If one word were to sum her up, it would have to be "shocking," the name she chose for her favorite shade of pink, her perfume, and her autobiography.

Above
Elsa Schiaparelli.
Photograph by Man Ray,
1934.

Facing page
Wallis Simpson, future
Duchess of Windsor, wearing
the "lobster" dress designed
by Elsa Schiaparelli and
Salvador Dalí. Photograph
by Cecil Beaton, 1937.

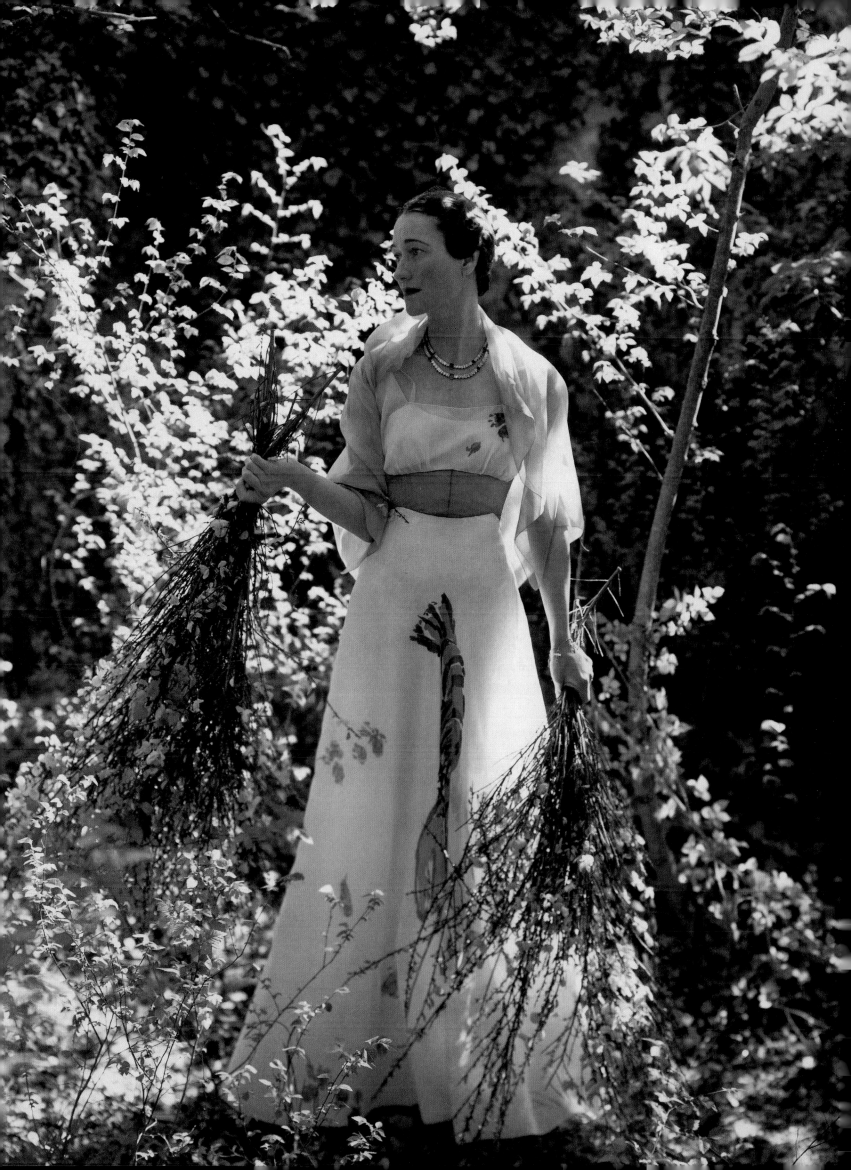

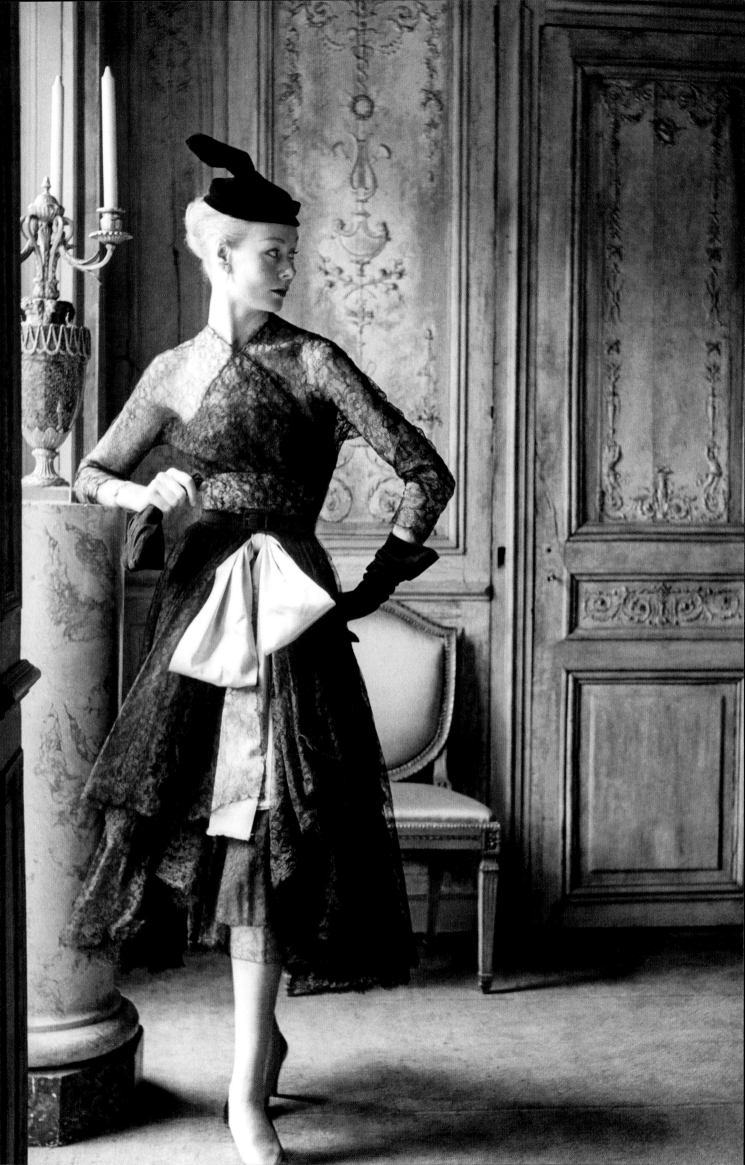

Cristóbal Balenciaga

Few couturiers lived in a style that was less typical of café society than the Spanish couturier Cristóbal Balenciaga. Yet he dressed some of its most iconic figures, including notably Mona Bismarck, who commissioned her wardrobe almost exclusively from him, the Duchess of Windsor and Patricia Lopez-Willshaw. But he himself lived simply, going out rarely and entertaining never, shunning the paparazzi and refusing even to make an appearance at the end of his couture shows. A solitary individual with a prodigious capacity for work, he was also discreet and generous. Givenchy, who had been his pupil, used to say of him: "No one knew how many families depended on him financially. Cristóbal gave a large part of his salary to penniless creatures who lived off his monthly payments and in some cases perhaps took advantage of his compassion. He was a man who was absolutely straight. Everything was clear-cut in his life, just as in his creations."[1]

His life story was one of beguiling simplicity. He was born in 1895 in a little fishing village on the Basque coast, where his father had a small pleasure boat and his mother was a seamstress. As they came out of church after mass one Sunday when he was a boy, young Cristóbal was overcome with admiration for the marquesa who was the foremost local aristocrat and exclaimed, "How elegant you are!" The marquesa gave him permission to copy the beautiful Drecoll suit that she was wearing, along with some lengths of fabric. Thus a vocation was born. He saved up and opened a modest dressmaking business in San Sebastian. It was 1937 before he moved to Paris, where he was an immediate success. His style was to be highly influential for the next thirty years. Beaton described his unique qualities: "In the world of present-day dressmakers, Balenciaga stands apart, like some Elizabethan malcontent meditating upon the foibles and follies of fashion, yet committed to acting and creating in the very world which he creates with a classical Spanish eye. . . . If Dior is the Watteau of dressmaking—full of nuances, chic, delicate and timely—then Balenciaga is fashion's Picasso. For like that painter, underneath all his experiments with the modern, Balenciaga has a deep respect for tradition and a pure classic line."[2]

Austere and shunning society, Balenciaga certainly dressed the most elegant women of his time, but he dealt only with those elected—in the mystical sense of the term—to be so. One of his tenets was that no dressmaker could make a woman chic if she was not chic herself, and that to achieve true elegance a woman should be dressed by one couturier and one only—as was the case with many of his clients. His creed, again as reported by Beaton, was that a couturier could not create a woman's true personality, but only "dress the thoroughbred." His abrupt withdrawal from the fashion world in 1968 left those clients whom he had dressed for years, like Mona Bismarck, quite distraught. He lived in discreet retirement until his death in 1972, when his artistic mantle was assumed by Givenchy.

1. Jean-Noël Liaut, *Hubert de Givenchy*, Paris: Grasset, 2000, p. 110.
2. Cecil Beaton, *The Glass of Fashion*, London: Weidenfeld and Nicolson, 1954, p. 259.

Jeanne Toussaint and Cartier

Jeanne Toussaint, who joined Cartier in 1918, was to have a profound influence on Cartier jewelry, adapting it to suit the tastes of café society, which were markedly different from those of the royalty who, since Edward VII had granted them his seal of approval, had formed the important and prestigious nucleus of their clientele. It was Toussaint who launched the celebrated panther motif that was so favored by the Duchess of Windsor. Following this with numerous other exotic animals, she created the "Toussaint style," and for over thirty years oversaw the creation of the most sophisticated pieces, offering many of her own suggestions. "My own inability to draw has given me the freedom to appreciate the work of others," she used to say. She viewed jewelry as above all a branch of fashion, to which she used the designs of Schiaparelli, Chanel, or Balenciaga as backdrops.

Cecil Beaton offered the following description of her artistic approach: "As a result of [her] love for strange settings and juxtapositions of stones, unique jewellery, never before seen, has made its appearance in the world of fashion. Madame Toussaint can unite different elements with an utterly fresh approach, yet her work is still bounded by the classical. Her sense of equilibrium and proportion is so strong that anything she creates represents safely good taste. For this artist, the stone is irrelevant: she does not consider it a jewel, a bijou, until it has been wonderfully set and presented."[1]

She entertained little in her apartment on place d'Iéna, but invariably invited the essential few. "Madame Toussaint's apartment, to which only a few enlightened souls are invited, reveals another aspect of her very sensitive but rugged feminine taste. No colour scheme assails the eye, nothing is blatant, no feature stands out; yet everything is calculated down to the smallest detail. Hers is a quiet authority that takes one into its confidence by degrees; one must seek out the details of a harmonious whole. This apartment is like a secret that only a few are privileged to share with its owner."[2] She was a true character, always her own person yet also very much part of café society, who inspired painters such as Helleu, Iribe, and Bérard.

1. Cecil Beaton, *The Glass of Fashion*, London: Weidenfeld and Nicolson, 1954, p. 273.
2. Ibid., p. 274.

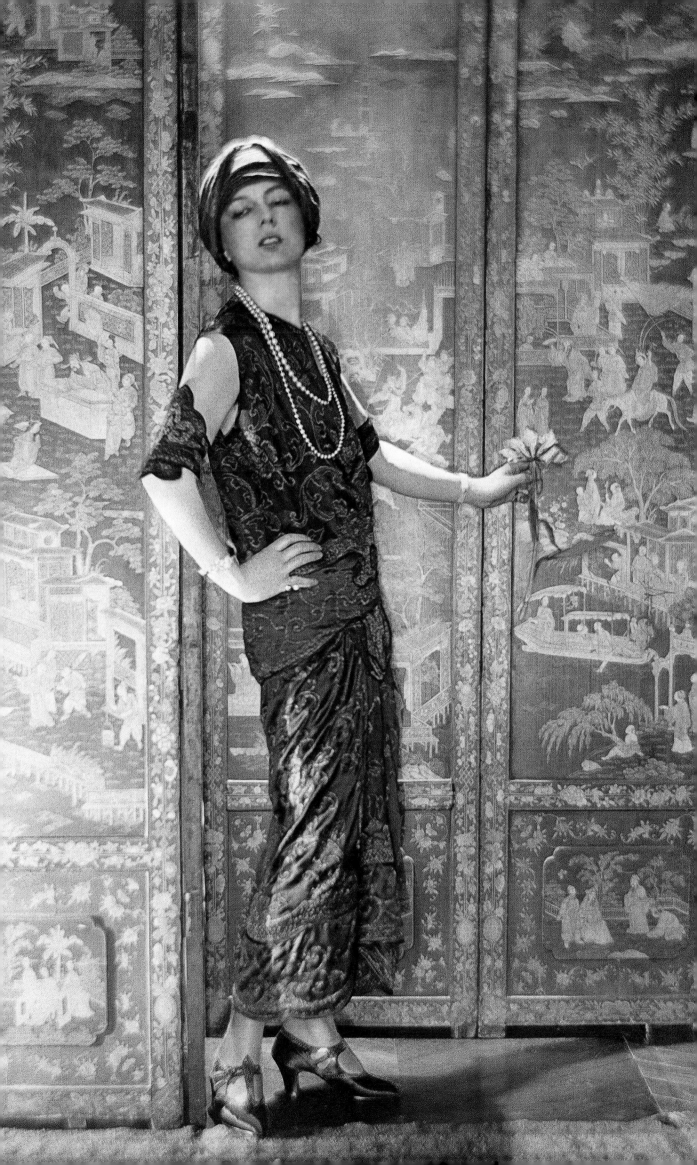

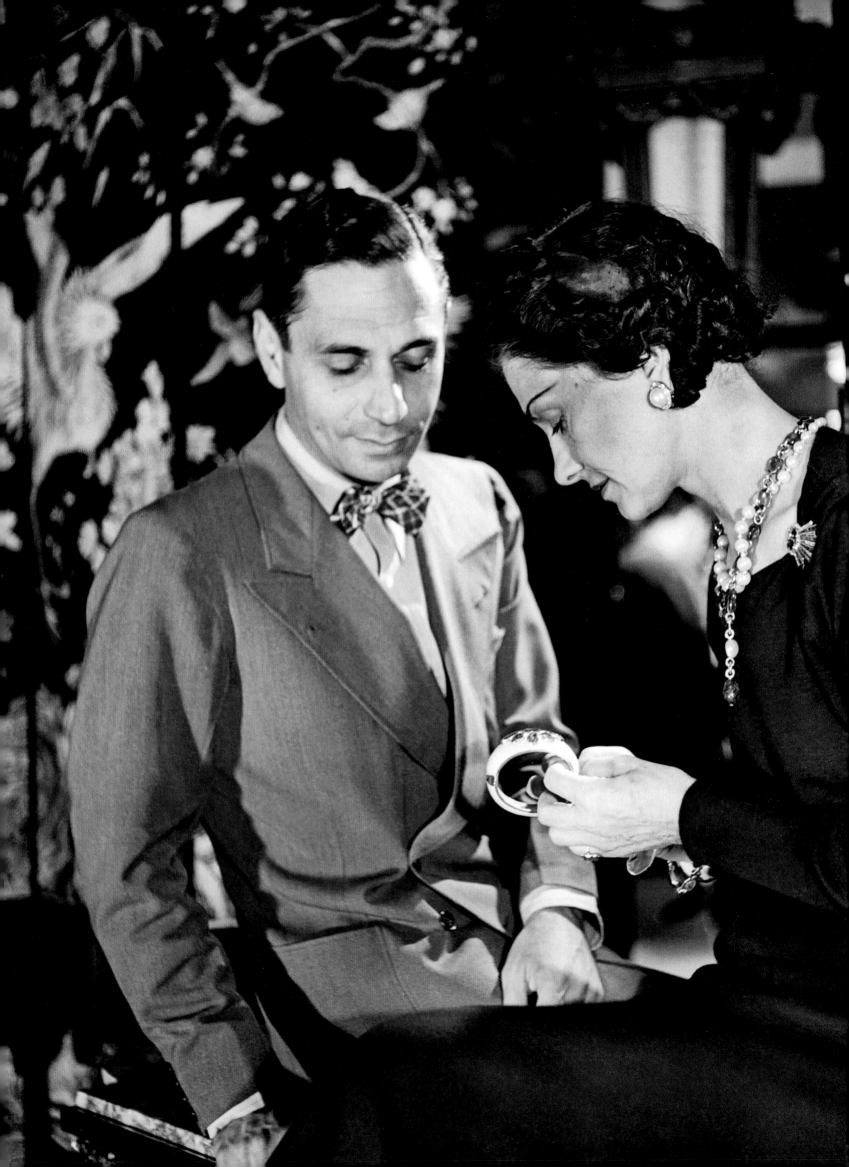

Fulco di Verdura

How does a Sicilian duke become a jewelry designer? This was the unlikely trajectory of Fulco Santostefano della Cerda, Duke of Verdura and Marquis of Murata la Cerda, who was born in 1899 at the Villa Niscemi outside Palermo and died in New York in 1978. His early life, which he described in a childhood memoir,[1] unfolded in a setting and atmosphere worthy of Visconti's film of *The Leopard*—which is perhaps hardly surprising, since Giuseppe di Lampedusa was Fulco's cousin. It was a world that was already vanishing when Fulco was a child, in which aristocratic families with pedigrees stretching back to the Middle Ages spoke English rather than Italian, and lived in grandiose residences crowded with furniture, ornaments, and enormous plants, more like mausoleums than country houses. The heavy rituals and ceremonial according to which each day was lived were by this time out of step with the owners' fortunes. Although living in this archaic cocoon, the Sicilian nobility nevertheless kept in touch with influential figures in the wider world, and it was this that gave the young Fulco the opportunity to make friendships that would prove instrumental in fundamentally changing his life. Prominent among these friends were the Cole Porters, whom he met during their honeymoon in Sicily in 1919, and who later introduced him to Chanel. On a trip to Venice at this time he also became acquainted with Sacheverell Sitwell, Gabriella de Robilant, and the Faucigny-Lucinges.

His relationship with his father became extremely strained, especially after one of his lovers caused a scandal by threatening him with a firearm during a stay at the Grand Hotel in Rome. On his father's death in 1923 he inherited the family title, while also learning that the family fortunes could no longer maintain his accustomed lifestyle. This had the effect of freeing him from all constraints and encouraging him to make a life elsewhere and to forge a career—a rare phenomenon among the aristocracy, for whom an interest in art might be a distraction or entertainment, but never under any circumstances a means of earning a living. In 1927 he moved to Paris, at the invitation of the Faucigny-Lucinges, who put him up on rue Boissière. Thus it was that he met everyone who mattered in the early days of café society, inviting them all to a grand ball at his palazzo in Palermo. The guest list included the Cole Porters, Louise de Vilmorin, Elsie de Wolfe, the Noailles, Princess Caetani, Baron Lo Monaco, and Charles de Beistegui, and the event was to be his farewell to Sicily.

Subsequently Baba de Faucigny found Fulco a job with an antique dealer, funded by her cousin Harry d'Erlanger. After meeting Chanel, he went to work for her first of all as a dress designer; very soon, however, charmed by the breadth of his culture and his multi-faceted talents, the great couturier asked him to design jewelry for her instead of Étienne de Beaumont, whom she suspected of disloyalty in running a rival business on his own account. By this time Beaumont had for several years been in charge of Chanel jewelry, which was designed to complement her clothes. In this he was helped by a bevy of society style icons and taste-makers, such as Misia

1. Fulco di Verdura, *Une enfance sicilienne*, translated by Edmonde Charles-Roux, Paris: Grasset, 1981.

Sert, Elsie de Wolfe, Sybil Colefax, and May d'Harcourt. For her part, Chanel liked to attract the talents of society ladies, including Lady Abdy for handbags, Grand Duchess Marie for embroidery, and Pauline de Saint-Sauveur for perfumes. Fulco was soon to work wonders as a designer. His baroque, brilliantly colored creations, using tourmalines, aquamarines, and other large stones then rarely used in jewelry, perfectly complemented the new direction espoused by Chanel, who had been strongly influenced by her affair with Grand Duke Dimitri, as she would soon be again by her liaison with the Duke of Westminster. Verdura was never going to be satisfied with playing second fiddle, however, and decided to set up his own business. Just at this point, several of his closest friends, including Natalie Paley and Nicky de Gunzburg, were thinking about emigrating to America in order to embark on the conquest of Hollywood; this gave Verdura the idea of designing jewelry for films. Nicky de Gunzburg's Schönbrunn Ball, which he gave in the Bois de Boulogne in 1934, was in a way the trio's farewell party before they left for the New World.

In 1934, therefore, he moved definitively to the United States, and initially to Hollywood, where success eluded him. In the transitory world of the cinema, the major stars—uncertain of their future—preferred to use names that were universally known and whose work was immediately identifiable, such as Cartier and Van Cleef. So he returned to New York, where Diana Vreeland introduced him to a jeweler named Paul Flato, who was a year younger than him but very much in vogue since he had set up his own jewelry house in 1928. He was particularly famous for his solitaire diamonds in the shape of ice cubes. They were not to work together for long, however, as once again Fulco was restless in a subordinate position. After a brief return to rue Cambon in Paris, summoned by Chanel after the death of Paul Iribe, in 1939 Verdura opened his own business at 712 Fifth Avenue, in the same block as the famous decorating establishment L. Alavoine & Co. Henceforth Verdura was able to develop his own collections in complete freedom. In 1941, thanks to Caress Crosby, he collaborated with Salvador Dalí to create a line of "Freudian jewelry". Ten years later he opened a Paris branch in an apartment found for him by Charles de Noailles at 9 rue Boissy-d'Anglas. Although he had gained a large clientele in America (including Diana Vreeland, Mrs. Paul Mellon, Anita Loos, and Babe Paley) and fitted in perfectly in New York, where the decoration of his various apartments was influential, Verdura was still nostalgic for Europe and for Paris. He loved working in Paris, with outstanding craftsmen such as Drouet and Verger. Until his death, his life was to be punctuated with stays in Europe, where he lived the life of café society. In Paris he always stayed at the Hôtel Lotti on rue de Castiglione and dined on the Left Bank at La Méditerranée on place de l'Odéon or Le Mont Blanc on rue Las Cases. When in Italy he was no longer based in Sicily, where the family residences, already in a poor state of repair, had been badly damaged by wartime bombardment, but instead paid annual visits to the Pecci-Blunts at La Marlia, or to Beistegui in Venice. He also adored going off on cruises with Cecil Beaton or the Alain de Rothschilds.

He spent most of his time in London, however, the city in which Tom Parr, whom he met in 1954 at Lady Kenmare's Villa Fiorentina on the Riviera, lived and worked. Tom had just set up an interior decorating business with David Hicks, which he soon left for Colefax and Fowler, where he was president until his retirement in 1995. Their relationship was to last until Verdura's death, when Tom took his ashes back to Sicily. It was also in London that, as he was leaving a dinner given by Daisy Fellowes in Belgrave Square, he suffered a serious road accident that was gradually to erode his health. In the 1950s, Verdura started to paint, thereby returning to a youthful passion. Caricatures of his friends were his forte, along with humorous miniatures. It was this light wit, ever present in his conversation and his creations, that encapsulated the charm of a man who himself embodied all that the Old World could bring to the New: a name sonorous with history, immense knowledge, education, and natural chic.

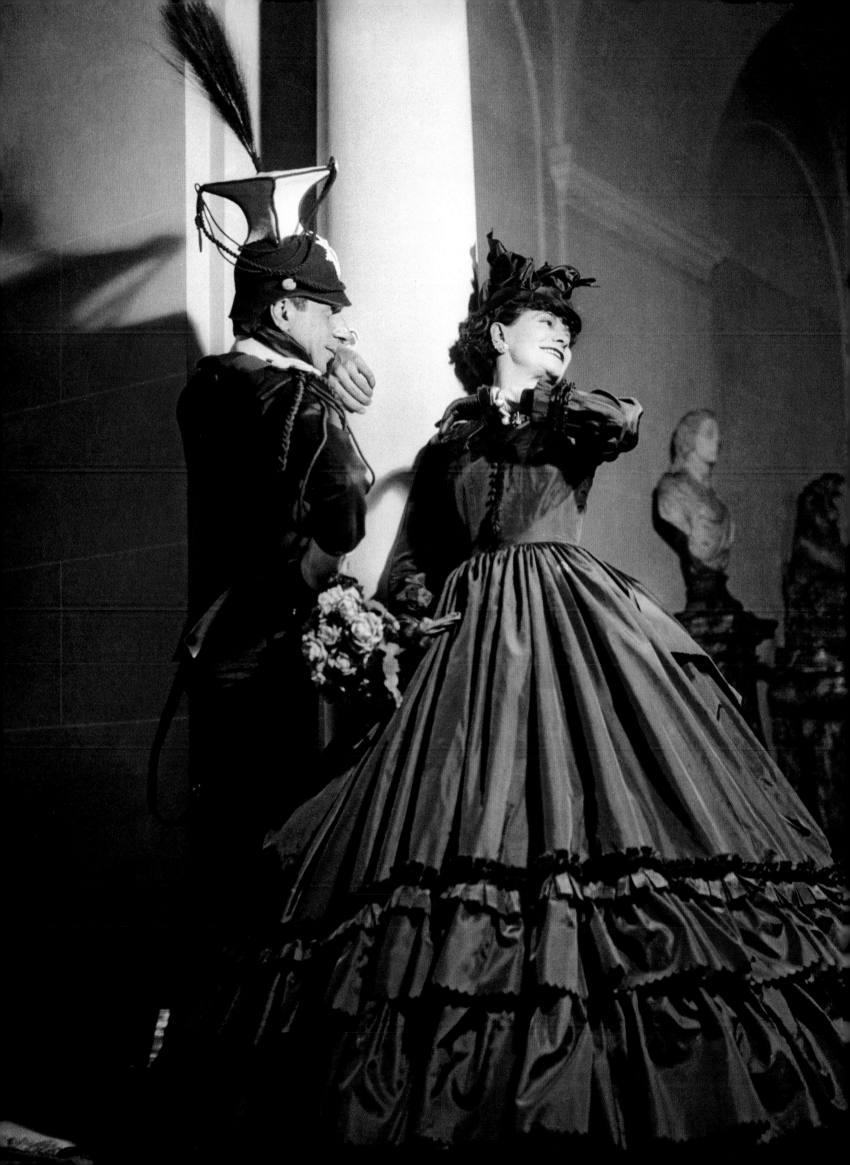

Fashion Editors and Models

Not far removed from the ferment of creativity that was the worlds of couture and jewelry stood the select coterie of powerful women who held sway over fashion, taste, and feminine elegance, as described by Cecil Beaton: "Apart from the several reigning dressmakers who occupy the central throne, there are grouped about them, as for a photographic sitting, the creators of accessory fashions; and, still close to the throne, are the blood relations connected by the ties of *Vogue, Harper's Bazaar, Femina, Mademoiselle* and the dozen-odd magazines whose important business it is to promulgate the modes of the moment."[1]

The American magazines *Vogue* and *Harper's Bazaar* clearly played a role of fundamental importance in the history of café society. They promulgated its tastes, related the lifestyles of its key figures, reported its major events and had recourse to the talents of its artists. A single issue of *Vogue* just after the war, for instance, carried articles by Louise de Vilmorin, illustrations by Christian Bérard, Marcel Vertès, Jean-Denis Malclès, and Lilia de Nobile, and photographs by Beaton, Horst, and Doisneau. The editors knew how to deploy all these talents in order to offer their readers all that they judged best and most interesting in contemporary fashion. At the same time they also knew how to select what would be considered as the acme of feminine elegance in any particular year, and above all they knew how to impose their own unswerving tastes. After the war, they occupied prominent front-row seats at the Paris shows, haute couture's shop window to the world. With their editorials they could make or break a new couturier's career.

Mrs. Edna Woolman Chase reigned over *Vogue*, where she arrived in 1895, for more than six decades. Having learned her trade under Condé Nast and Mrs. Chase, Carmel Snow presided over *Harper's Bazaar* from 1943 to 1958. With Richard Avedon, Diana Vreeland, and Alexey Brodovitch, she put together a top-flight team to rival *Vogue*. Diana Vreeland, who worked for *Vogue* before writing for *Harper's Bazaar*, was undoubtedly the most representative of café society, not only in her tastes but also in her lifestyle and connections. These magazines were also shrewd judges of who among the key figures of international high society they should recruit on to their staff. Thus Marie-Louise Bousquet turned her salon into the Paris office of *Harper's Bazaar*, for which she ran the French desk. Having exercised her formidable influence over the selection of candidates for the Académie Française under the Third Republic, she now sealed the fates of young couturiers. While *Vogue* had secured the services of Daisy Fellowes in Paris before the war, in the post-war period Nicky de Gunzburg was a major figure on American *Vogue*.

Facing page
Carmel Snow and Alexey
Brodovitch in the offices of
Harper's Bazaar, 1952.

1. Cecil Beaton, *The Glass of Fashion*, London: Weidenfeld and Nicolson, 1954, pp. 268–9.

Edmonde Charles-Roux, finally, from a distinguished Marseille shipping family, helped to create *Elle*, and for sixteen years edited French *Vogue* with consummate skill. A member of Louise de Vilmorin's circle and friend of Chanel, whose biographer she became, she was also a successful writer, who not only won the Prix Goncourt but also sat on the board of the Académie and eventually presided over it. A friend of Comtesse Pastré, she took part in the creation of the Aix Festival and wrote numerous ballet scenarios for Roland Petit.

During the café society years, fashion photographers were considered as bona fide artists. Until the war, their work—that of the Seeberger brothers, for instance—came close to reportage, documenting society events at which the latest haute couture creations were worn. It was society ladies who still made the headlines, even if some couturiers were starting to employ professional models. But all that changed after the war, when being a model became viewed as a proper career in its own right, gaining recognition at the same time as the stars of stage and screen started to edge out the queens of high society as muses or icons of fashion. "Film stars are much better advertisements than duchesses, and young couturiers who have not been schooled under Bérard's influence know nothing of society. Nowadays they even ban clients who are rude to the fitters. It is still considered good form, however, to tell the press that such-and-such a collection was inspired by Patricia Lopez or Mrs. Lowell Guinness."[2] In fact the greatest change in the post-war fashion world, beyond the battle between society ladies and stars, was the emergence of professional models, many of whom became members of café society.

"For the first time the modeling profession, until then devalued by negative prejudices, offered the public at large an opportunity to dream. Ambassadors for the prestige of France, muses of the great couturiers and photographers, they now—it was believed—led lives of glamor and ease before marrying someone famous!"[3] Where did this craze for models come from? From the cinema, of course, the most popular of popular arts and the standard measure of the public's passions and fantasies: to the many who were not part of the fashionable elite, the silver screen offered an opportunity to escape their daily routine and to live their dreams—in their imagination, at least. From *Cover Girl* in 1944 to *Blow Up*, Antonioni's masterpiece from 1966, via *Falbala* (1945), *Mannequin de Paris* (1956), and *Funny Face* (1957), not forgetting the *Nathalie* films (1957 and 1959), in which Martine Carol played a top model-turned-detective, and the satirical *Who are You, Polly Maggoo?* (1965), the list was a long one.

As the press started to scrutinize everything models said and did, so they also began to feature in popular novels[4] and television programs. So prestigious did they become that it was only a matter of time before they attracted the attentions of prominent men, whether aristocrats, opinion-formers, or famous figures in the arts. There followed a flurry of marriages: Fiona Campbell-Walter and Baron Thyssen, Jean Dawnay and Prince Galitzine, Sophie and Anatole Litvak, Eliette and Herbert von Karajan, and Bronwen Pugh and Lord Astor. And this is to name only a few. But the undisputed champion in the marriage stakes was the Anglo-Indian beauty Nina Dyer, who married both Baron Thyssen and Prince Sadruddin Khan. Her suicide in the early summer of 1965 revealed a more complex reality behind the veneer, however. As Jean-Noël Liaut observed in *Modèles et mannequins*, "There could be cracks in the sleek, glittering façade."[5]

Facing page
Richard Avedon
photographing the model
Suzy Parker, New York,
1959.

Following pages
Marie-Louise Bousquet and
Carmel Snow, editors-in-chief
of French and American
Harper's Bazaar, at the Dior
show, 1955.

2. Josée de Chambrun, *Pierre Laval vu par sa fille d'après ses carnets intimes*, Paris: Le Cherche Midi, 2002.
3. Jean-Noël Liaut, *Modèles et mannequins*, Paris: Editions Filipachi, 1994, p. 10.
4. Franck Marshall, *Nathalie princesse mannequin de Paris*, Paris: Librairie des Champs-Elysées, 1956, is just one example, which inspired the two *Nathalie* films.
5. Jean-Noël Liaut, *Modèles et mannequins*, op. cit.

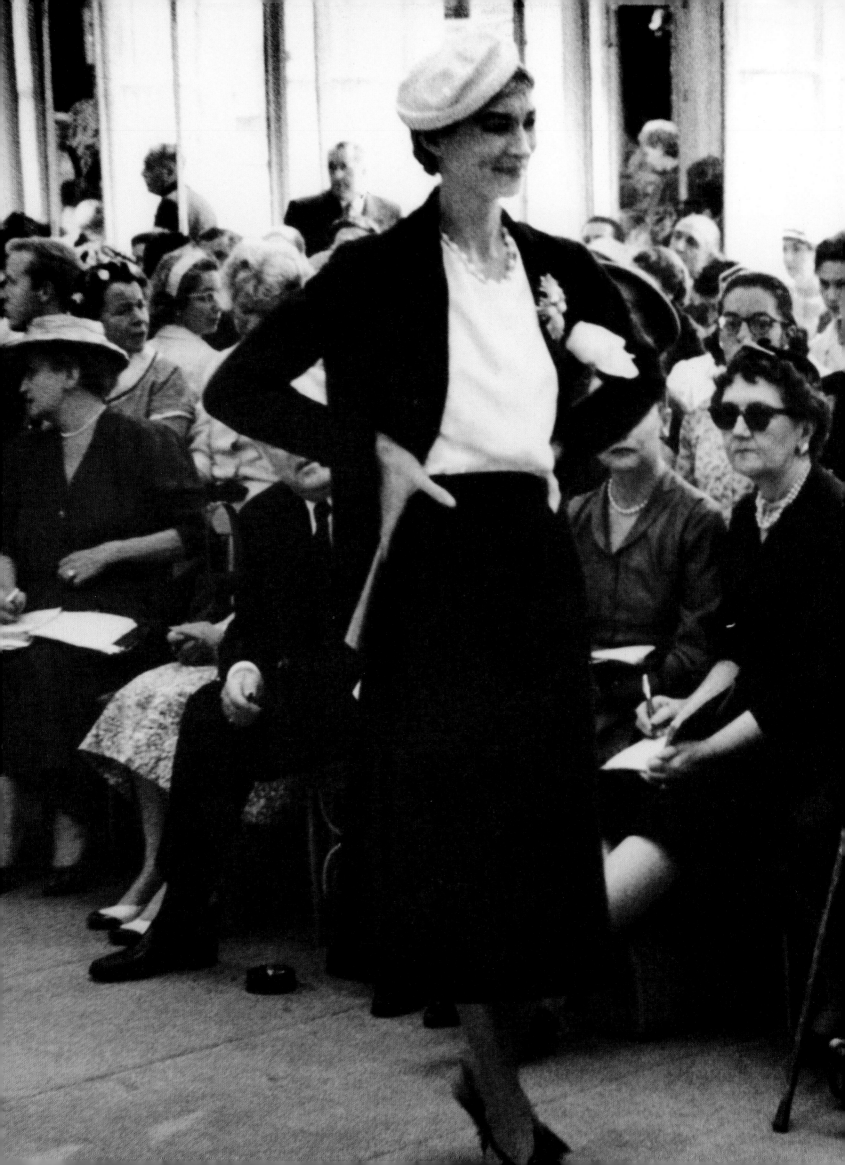

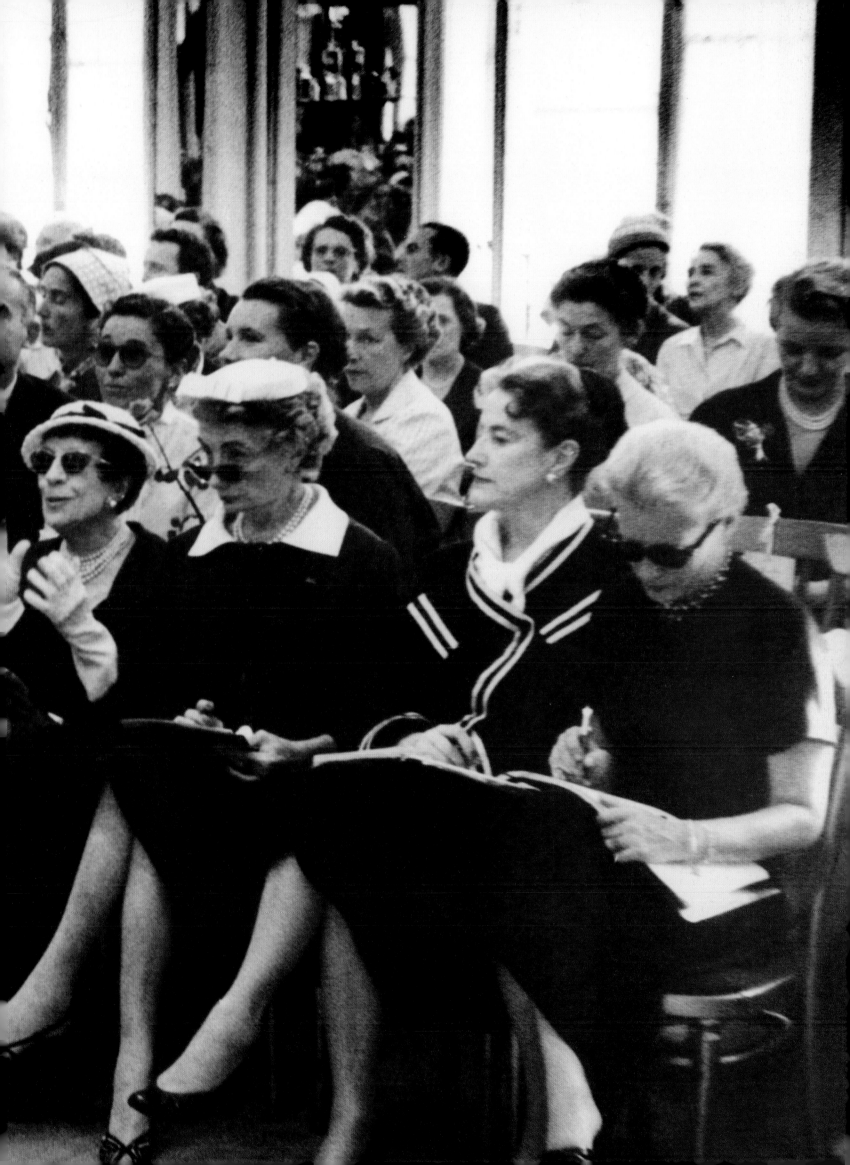

The career of the model Bettina, by contrast, was a success story. Born Simone Bodin, as a girl she came from Normandy to Paris to pursue a career as a fashion designer, but circumstances conspired to make her a model instead. Almost immediately she was spotted by Jacques Fath, who gave her the name Bettina and created numerous designs for her. She was also photographed for the greatest couturiers—including Dior, Balmain, and Grès—by the greatest photographers, such as the Seeberger brothers, Blumenfeld, Clarke, Maywald, Penn, and Ostier. Having created her own free and natural style that seemed barely posed, for a few years she worked essentially for *Vogue, Harper's Bazaar,* and *Elle,* becoming a runway model again only for the launch of her friend Givenchy, for whom she also looked after press and publicity, and who created his iconic Bettina blouse for her. In 1955 she took a break from her career to concentrate on her private life. Tragically, her great love affair with Ali Khan ended when he was killed at her side in a car accident, just a few days before their planned marriage. Still today she is a prominent figure in Paris life.

Mimi d'Arcangues, who was the incarnation of cosmopolitan elegance in the 1950s, in contrast to the typically Parisienne look of her rivals, was the great-granddaughter of one of the founders of Brazil. Brought up in the diplomatic worlds of Europe and South America, in 1955 she met the dashing Guy d'Arcangues at the *feria* in Seville. Descended from an illustrious Basque family, d'Arcangues was seen at every society party of the period. Mimi accomplished wonders at his side, encouraging him to write before becoming a model for Chanel in the late 1950s. She also had a part in Roger Vadim's film *Les Liaisons dangereuses.*

Couturiers often employed society ladies to develop their public relations and to look after a highly select clientele. Between the wars, Russian princesses played an important part in fulfilling these important functions, and in encouraging society ladies—many of whom viewed these duties as rather demeaning—to view them with greater favor. Elsa Schiaparelli employed several, as did Sonia Magaloff (herself the daughter of a Georgian princess), Bettina Bergery (wife of Gaston, wartime ambassador to Russia and Turkey), Princess Cora Caetani, and Françoise de Langlade (who later married Oscar de la Renta).

One of the most vivid figures in fashion was Maxime de la Falaise. Brought up in Sussex, India, and the Riviera, she was quintessentially cosmopolitan, and above all loved to be provocative. Her father, Sir Oswald Birley, was portrait painter to the British court; a close friend of Gandhi, he was the only artist granted permission to paint his portrait. Maxime married Comte Alain de la Falaise, brother-in-law of Gloria Swanson and a close associate of the surrealists, particularly Max Ernst and Man Ray, and she was herself both a model and stylist for Schiaparelli. A celebrated cook, she wrote a handful of recipe books that gained worldwide fame, then designed some porcelain for Tiffany. In becoming a fashion muse and marrying Thadée Klossowski, son of the painter Balthus, her daughter Loulou carried on a family tradition.

Among the eccentrics who gravitated to the great couturiers was also Poppy Kirk, daughter of an American diplomat, famed for her romantic liaisons with Paulina Terry, one of the daughters of the tragic Maharaja Duleep Singh of the Punjab, Princess Alix Dikushu de Rohan and Mercedes de Acosta, sister of "the fabulous Mrs. Lydig," as Cecil Beaton called her.

Facing page
Maxime de la Falaise
modeling British fashion
in London, 1954.

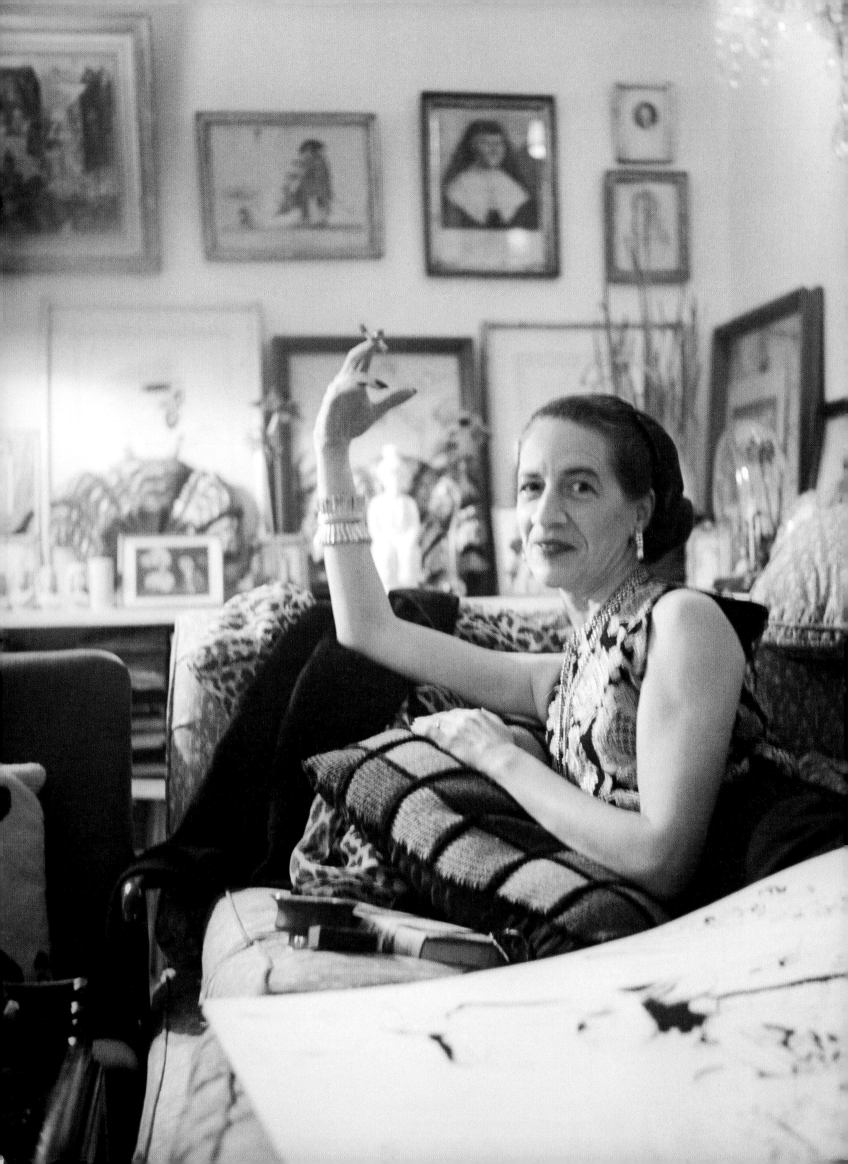

Diana Vreeland

The high priestess of fashion in café society was beyond question Diana Vreeland. Other women played an important part in the fashion press and helped to form the tastes of the modern woman, such as Carmel Snow, her employer Edna Chase, and Bettina Ballard, but Diana Vreeland was herself a major figure in café society and was often caricatured as such in books and films, most famously in *Funny Face*, with Audrey Hepburn and Fred Astaire. She was entirely the creation of her own steely social ambition, controlled snobbery, and showy chic. She was not without certain advantages before she started, however. Even her origins had a useful air of *trompe-l'oeil* about them: born in Paris in 1903, she left France at the age of two, and—although she returned almost every year of her life, sometimes several times, and was decorated with the Légion d'Honneur—never spoke French and never really lived in Paris. Her parents lived a cosmopolitan lifestyle: after a brief stay in Paris, her Scottish father, Frederick Dalziel, spent his life in the United States but never became a naturalized American. He pursued an honorable though undistinguished career as a businessman. The dazzle and social ambition all came from her socialite mother, Emily Key Hoffman, a woman of strong character and a modest fortune. When the family returned to New York, it was she who oversaw the entrée into society of Diana and her sister Alexandra, making sure they were seen everywhere that mattered, in circles that took pride in mixing with the Astors and Vanderbilts.

Although her own background was wealthy, Mrs. Dalziel's expenditure on her daughters' social lives outstripped her means. So began one of the constants in Diana's life: giving the impression of being richer than one actually was, living an exceptional lifestyle and displaying the elegance associated with people of power and influence. Perfect etiquette would follow. Diana was enrolled in all the best dance schools, and even took lessons from Michel Fokine, celebrated dancer with the Ballets Russes. Her first contact with the world of fashion came through Condé Nast's daughter Natica, a friend in her teenage years. Diana's chic earned her invitations to fashionable parties, and she became even more assiduous in cultivating her elegance and style, which—unlike her sister's—were not those of a classic beauty. She was later to make her prominent nose an element in the "toucan" look lauded by Pierre Bergé in his memoirs. Her unconventional charms succeeded in attracting one of the most handsome young men in New York, Thomas Reed Vreeland. This young Yale graduate was starting out on a career in banking that was to prove, like that of his father-in-law, worthy but dull. His handsome looks led to dalliances with numerous women, but like a faithful fashion accessory he was always a distinguished presence at his wife's side on grand occasions.

Diana and Reed were married in 1923, and had two sons, Thomas in 1925 and Frederick in 1927. In 1929, Reed was transferred to London, where the family lived in great style at

17 Hanover Terrace in Regent's Park. Diana had meanwhile received a comfortable legacy in her grandmother's will, which enabled the couple to embark on a life of elegance, mixing with aristocrats and artists. Their closest friends were now Georgia and Sacheverell Sitwell, Theo and Edwina d'Erlanger, and Cecil Beaton, who was already working for *Vogue*. To support her hectic and costly life as a society lady, Diana decided to launch a business venture, a thing rarely done in good society at the time, even if a clutch of illustrious pioneers had shown the way, such as Elsie de Wolfe, Syrie Maugham, and Sybil Colefax in the world of interior decoration. Diana opened a boutique selling ladies' lingerie near Berkeley Square, making trips to Paris to find her model garments, which she then had made by Spanish nuns in a London convent. Most of her clients were also her friends, including Mrs. Harrison Williams, Edwina d'Erlanger and her sister Mrs. Mary Currier, and Mrs. Leslie Benson. Diana herself recounted how Wallis Simpson came to pick her lingerie for her first assignations with the future Duke of Windsor.

To support her hectic and costly life as a society lady, Diana decided to launch a business venture, a thing rarely done in good society at the time.

In 1933 the Vreelands moved to Ouchy, near Lausanne, for the sake of Reed's health, before returning definitively to New York. Having left the city as a young bride, Diana returned as a woman of society, even of high society. She had completely changed her look. During her time in London she had made constant trips to Paris, where she dressed herself and became acquainted with Chanel, Schiaparelli, Christian Bérard, and the Faucigny-Lucinges, who were cousins of her friends the d'Erlangers. Thus it was that she made her return to New York as a beacon of Paris fashion. She even decided, as related by Eleanor Dwight,[1] that her first name should now be pronounced the French way. Her new look was a triumphant success in fashionable circles, and she was constantly photographed for *Vogue, Town and Country,* and *Harper's Bazaar.* The last of these, under Carmel Snow, in 1936 asked her to write a column entitled "Why Don't You . . . ?," which was an immediate success, becoming a veritable phenomenon in society circles. Offering her readers a mix of practical advice, humor, and rank snobbery, Vreeland injected her column with a style and tone that were fresh and tart, developing a gift for one-liners and *bons mots* designed to provoke: "Elegance is refusal"; "We all need a splash of bad taste, no taste is what I'm against"; "The bikini is the most important thing since the atom bomb"; "Never fear being vulgar, just boring."

 Although Vreeland's influence at *Harper's Bazaar* during and after the war was of crucial importance, she always remained in second place on a magazine ruled with a rod of iron by Carmel Snow. Vreeland might have more quirkiness, more awareness of what was new, more wit, but Carmel was still the boss. An anecdote told by Eleanor Dwight neatly sums

Page 228
Diana Vreeland at home.
Photograph by Cecil Beaton,
1954.

Facing page
Slim Hawks, wife of the film
director Howard Hawks,
Diana Vreeland, and her
husband at a New Year's Eve
party thrown by Kitty Miller
on Park Avenue, New York,
1952.

1. Eleanor Dwight, *Diana Vreeland*, New York: Harper Collins, 2002, p. 43.

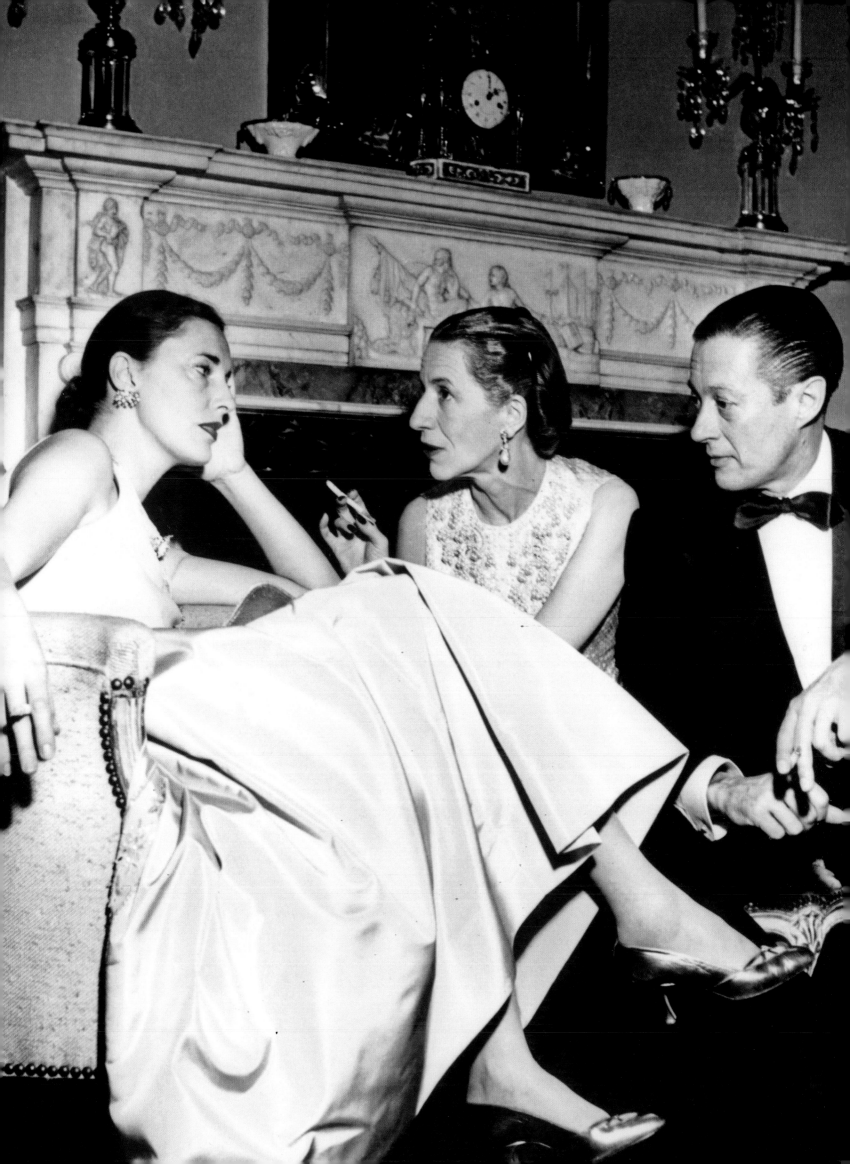

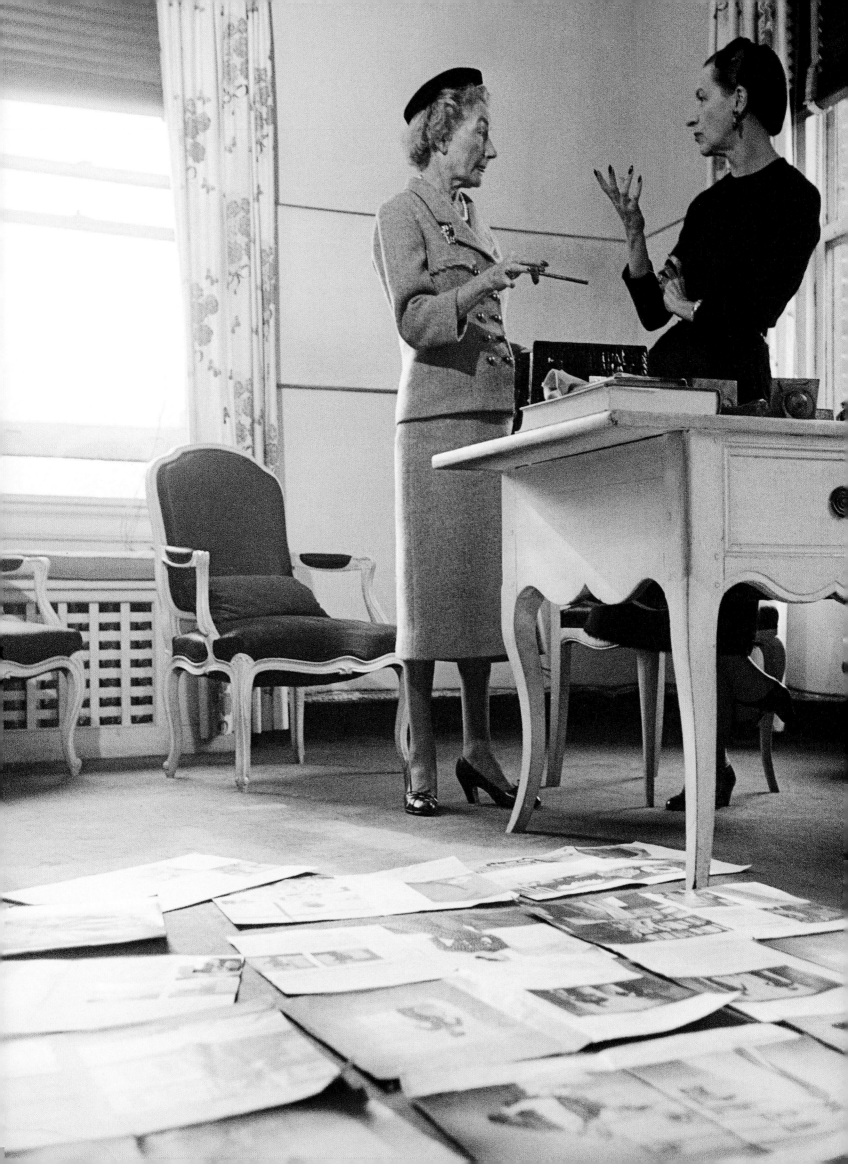

up their relationship: "she would say, with a flourish and a wave of the hand, 'the whole June issue should be magenta. This year everything is in magenta.' But Carmel would reply, 'Well maybe two pages in magenta or four pages in magenta'. [...] Carmel was dressed by Balenciaga, and Diana by Mainbocher and Chanel."[2] Diana was flamboyant in manner, with a booming voice, while Carmel was quiet and reserved. Diana always wore jangling necklaces and bracelets, Carmel a little hat. Working alongside these two women, so different in every way, was a third character who was equally emphatic, the artistic director Alexey Brodovitch. A visionary who adored the avant-garde, Vreeland pushed the magazine to the limits of innovation, sometimes—with her tendency to forget it was first and foremost a business that had to balance its books—disconcerting its advertisers. She was nothing like other fashion editors. Richard Avedon, who worked a great deal with her, summed up the difference: "Before her, the fashion editor was a society lady putting hats on other society ladies. [...] Her references were always to the past [...] the early nineteenth century. 'She was not interested in photographer's imaginations,' [...] It wasn't she who followed fashion, fashion followed her."[3]

"I know what they're going to wear before they wear it, what they're going to eat before they eat it," pronounced Vreeland. From 1953 she breathed new life into the image of society women as seen in the pages of *Harper's Bazaar*, featuring figures such as Jacqueline de Ribes, Marella Agnelli, and Gloria Vanderbilt. She herself became one of the most prominent figures in international society and on the fashion scene. The 1956 redecoration of her New York apartment on Park Avenue by Billy Baldwin was an event in itself. Her brief to him was to create a "garden in hell," with red, her favorite color, as the dominant shade; as she remarked, "I can't imagine anyone becoming bored with red—it would be like becoming bored with the person you love."

Nonetheless, when Carmel Snow retired in 1957, the Hearst family passed her over, appointing as editor Carmel's niece Nancy White. Disappointed, Diana quipped: "We needed an artist and they sent us a house-painter." At this time she also advised Jackie Kennedy in her role as the new First Lady. It came as no surprise when she was appointed editor of *Vogue* in 1962. A friend of Andy Warhol, she championed and supported new art movements such as Pop Art and Op Art, as well as the emergence of kitsch. She commissioned photographers such as Richard Avedon, Helmut Newton, and David Bailey, and employed a new generation of models including Jean Shrimpton, Veruschka, and Twiggy. In 1971 she left *Vogue* and became consultant to the Costume Institute at the Metropolitan Museum of Art.

Facing page
Carmel Snow and Diana Vreeland in the offices of *Harper's Bazaar*, New York, 1952.

2. Ibid., p. 81.
3. Quoted by Eleanor Dwight, ibid., p. 82.

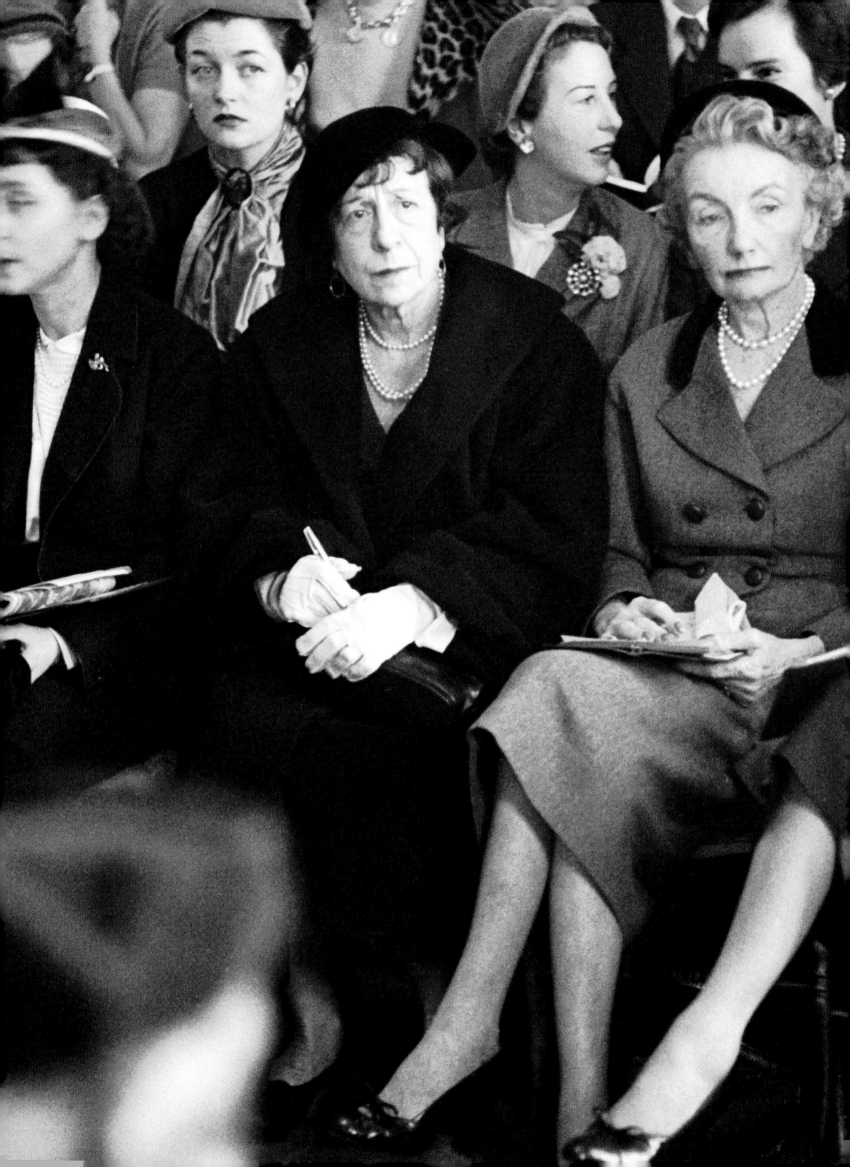

Marie-Louise Bousquet

When asked for his definition of Paris, Bernard Buffet reported in *Les Grandes Animatrices de Paris*, Christian Dior replied simply: "Marie-Louise Bousquet."[1] And many a non-member of café society would have echoed him. It was the unusual destiny of Marie-Louise Vallantin (1874–1967) to reign successively over two very different faces of Paris. As a young woman she was one of the ruling spirits of the Paris of the Academy and Academicians. In his *Journal inutile*, Paul Morand reported Mme Pouquet's description of her as, "A little woman with whom one must do a certain number of agreeable things if one wants to become a member of the Academy."[2] In her later years, and even into advanced old age, she was in addition one of the driving forces of café society in Paris, a role that provoked further waspish comment from Paul Morand: "Later on I lost sight of Marie-Louise who became Americanized and snobbish and entertained all the American queers in Paris in her little apartment on place du Palais-Bourbon."[3]

In its early part, Marie-Louise's life revolved around the great French institutions, and she mixed with all the most influential figures of the Third Republic. She was married to Jacques Bousquet, a playwright who was best known for the satirical revues that he co-wrote with Rip. Although she was no great beauty and limped as a result of what Beaton called a "game leg," she enjoyed a certain success with men of influence. Indeed, it was the love she inspired in the Academician Henri de Régnier that enabled her to found the salon which became an antechamber to the Academy in the period between the wars. Paul Valéry and François Mauriac were among the men and women of letters who every Wednesday crowded into her little house on rue Boissière. Jean-Louis de Faucigny-Lucinge recalled that she possessed "a roguish side to her, very gay, calling you *tu* straight off, sitting on your lap. She was simply made to charm distinguished elderly Academicians."[4] Another prestigious admirer ensured that many ambassadors were also regular visitors: Philippe Berthelot, all-powerful secretary general at the quai d'Orsay, made it his habit to call on her every morning on his way to the office. And scattered among the diplomats looking for advancement were a few oracles of international high society, such as Marthe Bibesco and Edmé de La Rochefoucauld.

The Marie-Louise Bousquet of the post-war years was a very different matter. After the death of her husband, she was forced to work to maintain her position in society. The society intellectual morphed into a beacon of café society, moving from the sixteenth

1. *Les Grandes Animatrices de Paris*, Paris: Editions Del Duca, 1967.
2. Paul Morand, *Journal inutile 1968–1972*, Paris: Gallimard, 2001, p. 703.
3. Ibid.
4. Jean-Louis de Faucigny-Lucinge, *Un gentilhomme cosmopolite*, Paris: Perrin, 1990, p. 90.

arrondissement to 3 place du Palais-Bourbon, where her neighbors were Emilio Terry and the Chambruns. Josée Chambrun, Pierre Laval's daughter, provided her with financial support for her society activities. Her salon day moved from Wednesday to Thursday, and this was not the only change: "One saw less and less of Paul Valéry and more and more of Cecil Beaton," noted Jean-Louis de Faucigny-Lucinge.[5] She now entertained numerous Americans, including Thornton Wilder, Truman Capote, Irving Shaw, and John Steinbeck, although Maurice Druon, Michel Déon, and Bernard Buffet were also regulars. Marie-Louise Bousquet now ran the Paris desk of *Harper's Bazaar.* After reigning over the Academy, now she would make or break fashions. Dior and Balenciaga were among her inner circle. At Givenchy's debut in 1951 she fell on her knees before him and cried, "*Mon amour,* I salute you, you are the future of French haute couture!"[6] Mediocre talents, on the other hand, could be brought down by her. From the Liberation until her death, she knew everyone who was anyone in café society. As a general rule, and in defiance of encroaching age, she loved everything new, creative, or challenging. And having squirreled away over fifty years' worth of gossip, she used to like to observe, "If I decided to talk, I could blow up the whole of Paris."[7]

As a general rule, and in defiance of encroaching age, she loved everything new, creative, or challenging.

Cecil Beaton painted an eloquent portrait of this second Marie-Louise Bousquet, high priestess of the world in which he moved: "To fashion, Marie-Louise Bousquet is a brilliant asset, not merely because she is present at the birth of the new in the minor and major arts, but because she is often the midwife herself."[8] Such admiring words did not stop him telling the story, in his own gently barbed way that was so very café society, of how on one occasion Marie-Louise, magnificently attired in a Balenciaga gown, asked him if the seams of her stockings were straight. To which he replied that the seams were straight—it was the legs that were crooked![9]

5. Ibid., p. 92.
6. Jean-Noël Liaut, *Hubert de Givenchy*, Paris: Grasset, 2000, p. 78.
7. Pierre Barillet, *A la ville comme à la scène*, Paris: Edition de Fallois, 2004, p. 49.
8. Cecil Beaton, *The Glass of Fashion*, London: Weidenfeld and Nicolson, 1954, p. 270.
9. Hugo Vickers, *Cecil Beaton*, Phoenix Press, p. 398.

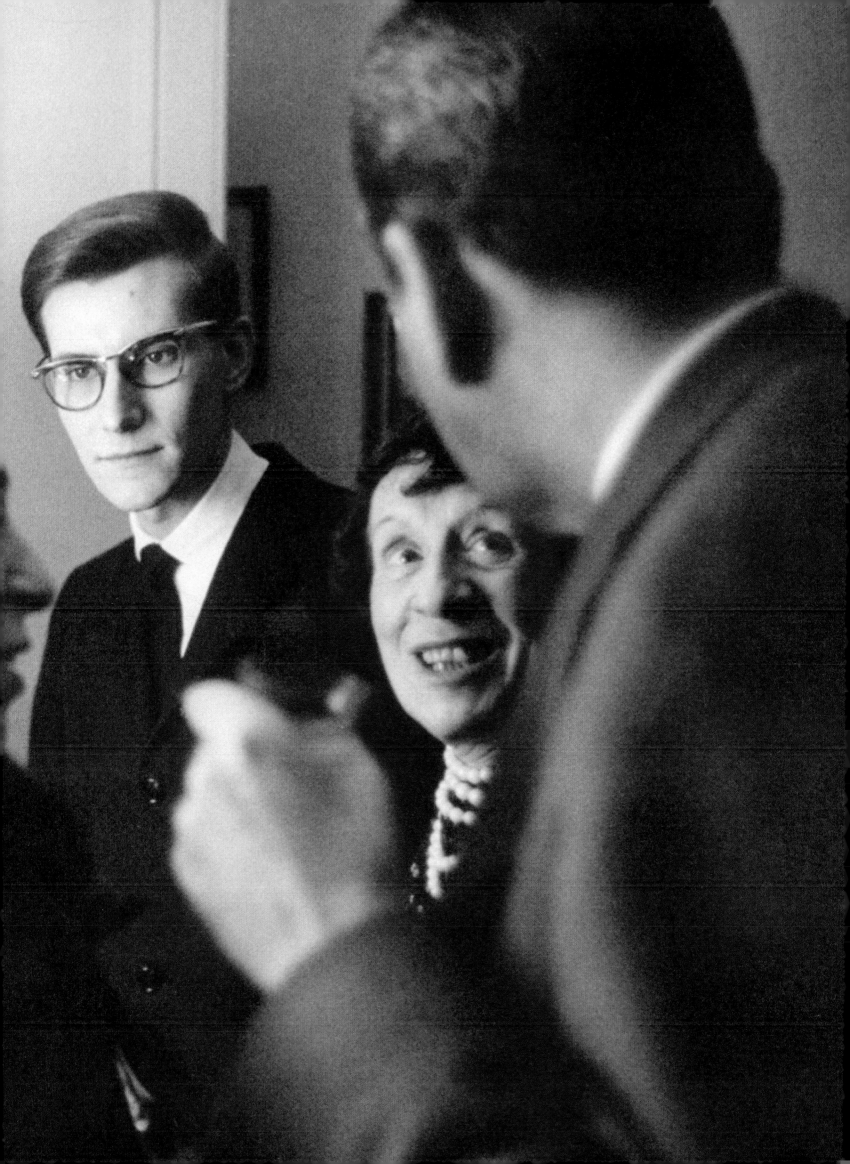

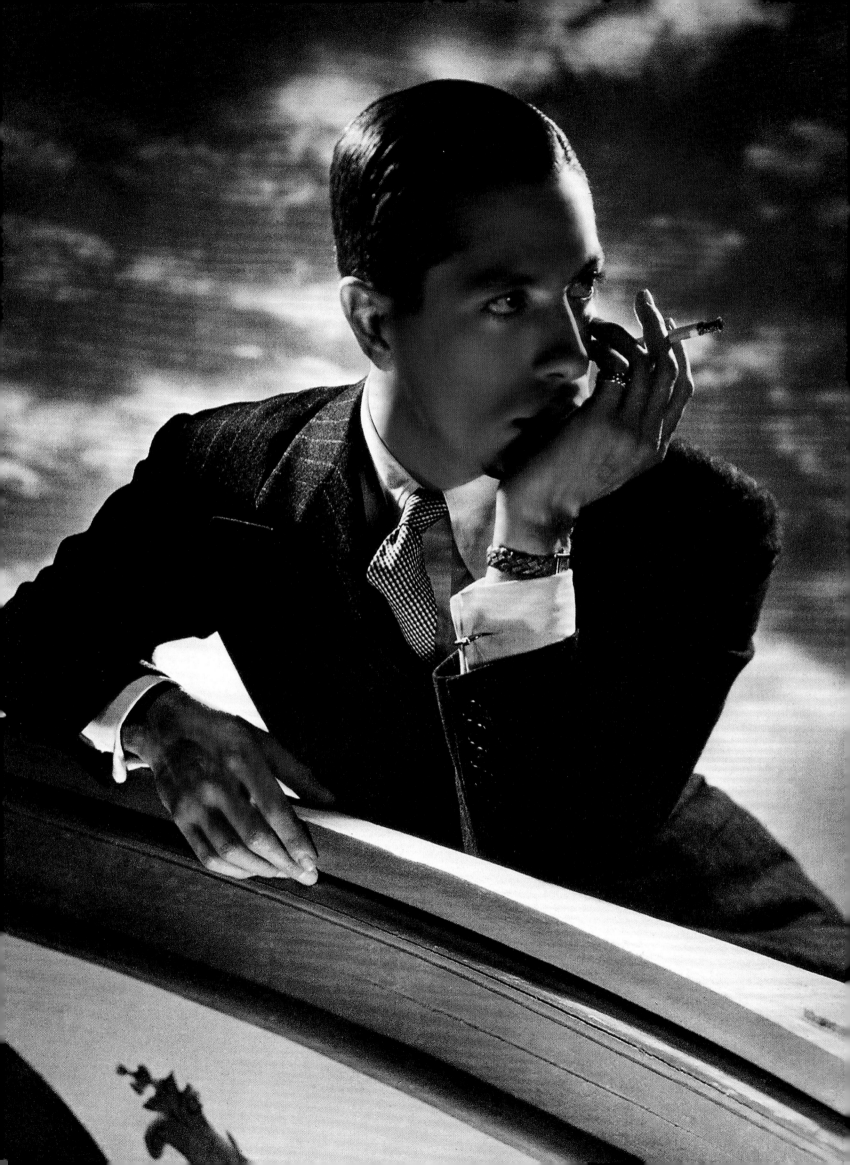

Nicky de Gunzburg

Nicky de Gunzburg was the embodiment of all things café society: its cosmopolitanism, its need to push taste to the very limits of refinement, and its underlying existential angst. The Gunzburgs, an old Russian Jewish family, were intimates and bankers to the tsars from the early nineteenth century. Having contributed to the financing of Russia's major infrastructure, notably its railway system, they were ennobled in the 1870s. Constantly involved in a variety of cultural activities, they financed the protection of Jewish culture—in a country where pogroms were not uncommon—and were patrons of the Ballets Russes from the beginning. It was therefore into a wealthy, cultivated family that Nicolas de Gunzburg was born in Paris on December 12, 1904. His father, banker to the tsar, was Russian, his mother Polish-Brazilian—a combination that was to endow him with the saturnine, exotic, tormented air that was his great charm.

After a childhood spent in England Nicky returned to France, where his father's properties included the Hôtel Crillon. As a young man in the 1920s and 1930s he was active in society: well-bred, athletic (he excelled at skiing and golf), and the acme of elegance, he was described by Alexander Liberman, owner of Condé Nast, as "one of the most civilized men in Paris." A close friend of the Noailles and the Faucigny-Lucinges, he was a supporter of the avant-garde and gave memorable balls, notably the "Bal des Valses" or "A Night at Schöenbrunn" that he organized with Elsa Maxwell in 1934, in a charming house he had rented in the Bois de Boulogne. Unable to resist any new experience and fascinated by the beginnings of cinema, he financed one of the first great horror films made by the Danish film maker Carl Theodor, *Vampyr*, in which he himself played the main character under the stage name Julian West. This was just one example of the profound fascination with the macabre that was to possess him throughout his life, and that was later to find expression in the decoration of his New York apartment, with its lavish use of the *memento mori*. The journalist Susan Train described his habit of dressing in unrelieved black like a mortician, which, in combination with his wonderfully caustic sense of humor, made him a rather disconcerting figure for those who were unfamiliar with his ways. Today the qualities of the Theodor film are evident; at the time, however, it was a commercial flop—a failure that was all the more melancholy for the recent death of Nicky's father and his attendant discovery that the family was drowning in debt.

In 1934 Nicky decided to move to America, settling first of all in Hollywood, doubtless unable to resist the lure of the film studios, and afterward in New York. There he was to live for the rest of his life, alongside other European luminaries of café society such as Natalie Paley and Fulco di Verdura, exiles who had turned New York into, in Philippe Jullian's words, "the last port of Europe." Henceforth, Gunzburg would devote his talents to fashion and interior decoration. His name, his elegant appearance and his faultless sense

of style were to fascinate New York high society, which elevated him into an arbiter and icon of taste. His decorative scheme for his New York apartment was hugely influential on interior decorators of the stature of Billy Baldwin, who was particularly impressed by the library hung with hundreds of minuscule paintings against walls covered in green serge. Among Gunzburg's many decorative projects were the New York salons of Maison Dior (a mélange of Provençal, Louis XVI, and Edwardian styles),[1] which he designed in 1948.

> He was a major player in this world, managing to keep right to the end the tinder dry sense of humor that made him such a welcome guest in café society.

But it was as an editor of fashion magazines—with over twenty years at *Harper's Bazaar, Town and Country,* and *Vogue*—that Gunzburg was to achieve fame, influence the tastes of his era, and become a vector of café society. His own tastes were simple, even austere, but he was responsible for launching Bill Blass, Oscar de la Renta, and above all Calvin Klein. Right up to his death, on February 20, 1981, he was a major player in this world, managing to keep right to the end the tinder dry sense of humor that made him such a welcome guest in café society: feeling the approach of death at New York Hospital, he asked if he could put on his black boots, as he had to leave soon. Nicky de Gunzburg was a man of enormous elegance and a supreme aesthete who also, like other café society figures such as Elsie de Wolfe and Elsa Maxwell, knew how to make use of his name in order to prosper in business. Philippe Jullian summed him up thus: "As for Nicky, he's the Figaro of New York. He disguises publicity as gossip and sells confidences to the newspapers only once he has been paid to listen to them. . . . As you well know, dear Percy, that's what we call public relations."[2]

Facing page
Nicky de Gunzburg in the costume of Archduke Rudolf of Austria, designed by Valentine Hugo for the Bal des Valses. Photograph by Horst P. Horst, 1934.

1. Patricia Corbett in *Verdura: The Life and Work of a Master Jeweller*, London: Thames & Hudson, 2002, p. 144.
2. Philippe Jullian, *Café-Society*, Paris: Albin Michel, 1962, p. 32.

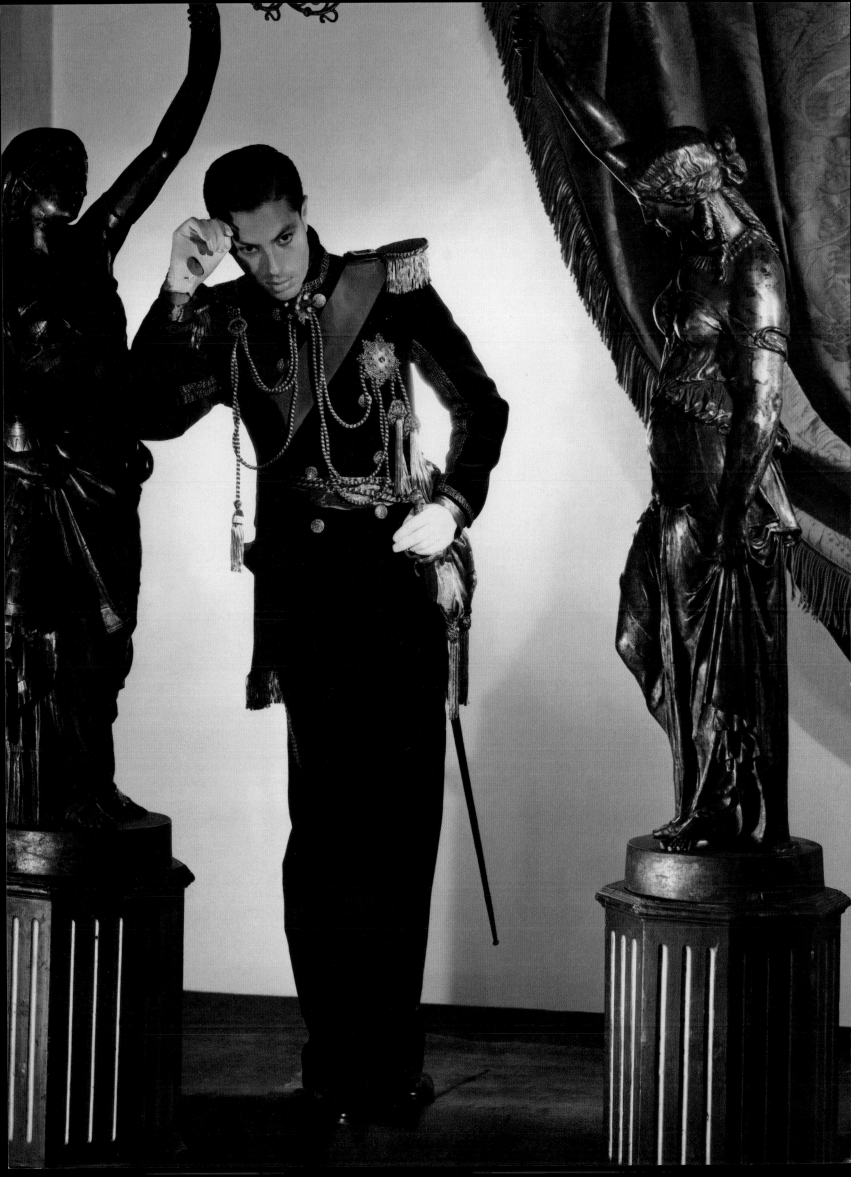

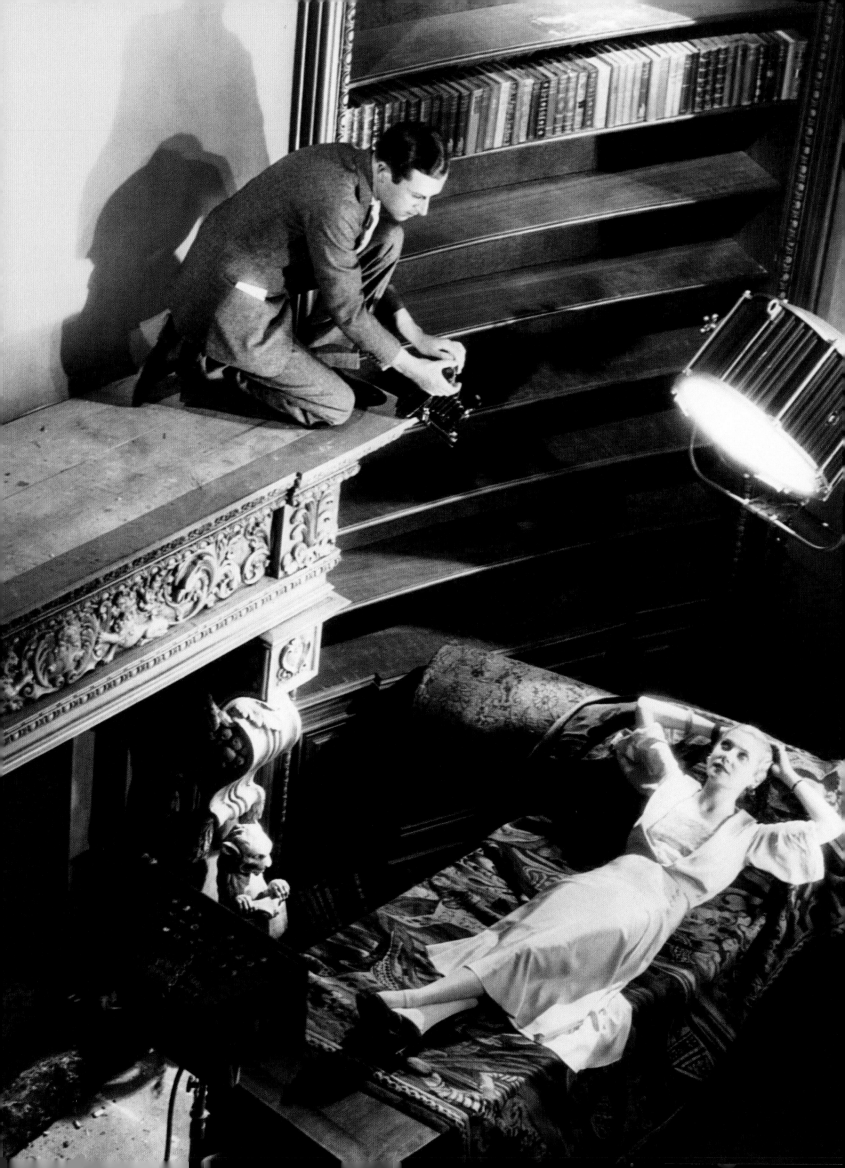

Photography

As creative rivalry grew between the most prestigious fashion magazines, so portrait and fashion photography were to flourish, as the "glossies" fostered the emergence of a number of outstanding talents. Like painting and drawing, which it came more and more to rival, photography offered members of society—and especially those of café society—whose images were constantly appearing in the media a fresh medium for their narcissism. Linked to the rise of haute couture, jewelry, and the fashion press, photography became an art in its own right, and even transformed some of its practitioners into members of café society. Adolf de Meyer, Cecil Beaton, and Horst P. Horst all became prominent society figures, while André Durst was famous for the glittering balls he gave between the wars.

As soon as this new art form emerged in the mid-nineteenth century, portraiture became its chief expression. Although clothes played a role of great importance in portraits at this time, the pictures were not fashion photographs but rather images of fashionably dressed subjects. It was not until the early twentieth century that the first photographs taken in the most fashionable spots—at the races, on the beach at Deauville or Biarritz, or on the ski slopes at Saint-Moritz—began to appear. The Seeberger brothers, Rol and Taponnier, created veritable art reportages on society life, which were given prominent coverage in the pages of *Vogue, L'Officiel de la couture de la mode de Paris, le Jardin des modes, Excelsior-modes,* and numerous other magazines that appeared and disappeared at speed. Over time, the photograph graduated from being a simple document or straightforward portrait to become a true work of art. This was particularly true of the work of Adolf de Meyer, a pioneer of the pictorialist movement that stood in opposition to documentary realism. The most prominent photographer in *Vogue* for a period, de Meyer suggested the lines of garments and the airiness of fabrics through effects of hazy softness and gauzy transparency. Despite all these developments, photographs nevertheless remained a rare sight in magazines devoted to fashion design until the 1920s. Gradually, however, the concentration in Paris both of the great couturiers and of outstanding photographers of all backgrounds—drawn by the prestige of the capital of fashion and the arts—encouraged the success of fashion photography. *Vogue* launched a Paris edition, and *Harper's Bazaar* gave frequent commissions to Paris photographers.

In 1929, the Paris studio of *Vogue* was directed by Hoyningen-Huene, whose assistant, lover, and model was Horst P. Horst. Through their creative approach and their references to both ancient civilizations and the avant-garde, these two photographers were to raise *Vogue* to the status of one of the world's most prestigious magazines. On a trip to England, they persuaded Beaton to join them in a regular collaboration with Condé Nast. In their wake,

André Durst and Erwin Blumenfeld imposed their own styles. The surrealist movement strongly influenced fashion photography at this time, and Man Ray, who had started his career with the couturier Paul Poiret, worked for *Femina, Harper's Bazaar,* and *Vogue.* Even a photographer as classic as Beaton was influenced by this trend in the 1930s, for example photographing Schiaparelli's "chest of drawers" dress, inspired by Dalí (a frequent guest at Beaton's country house, Ashcombe, at this time), in a dream-like landscape recalling Dalí's paintings. Surrealism provided a modernist setting to take the place of the neo-classical idealism of Hoyningen-Huene. Lee Miller, who worked with Man Ray before she married Roland Penrose, champion of surrealism in England, also brought a surrealist influence with her work.

In 1929, the Paris studio of *Vogue* was directed by Hoyningen-Huene, whose assistant, lover, and model was Horst P. Horst.

In the 1940s and 1950s, fashion photography and society photography enjoyed a veritable triumph in the glossy magazines, finally supplanting fashion drawings for good. Even a photographer such as Robert Doisneau worked for *Vogue* in the early 1950s, notably photographing the balls at the Hôtel Lambert. André Ostier, Arik Nepo, and François Kollar were all important society figures who took portraits of the luminaries of café society. From 1950, new talents began to appear with new ideas, such as Richard Avedon at *Harper's Bazaar.* This new generation specialized in shots that were light and piquant, taken in ingenious locations. At *Vogue,* meanwhile, Irving Penn infused his studio work with a profound serenity, and his shots taken in natural light against neutral backgrounds were to bring a new dimension to the medium.

Facing page
The photographer Horst P. Horst and a model posing in Izod bathing suits for George Hoyningen-Huene, c. 1930.

Following pages
Portrait of the photographer Cecil Beaton, c. 1935.

244

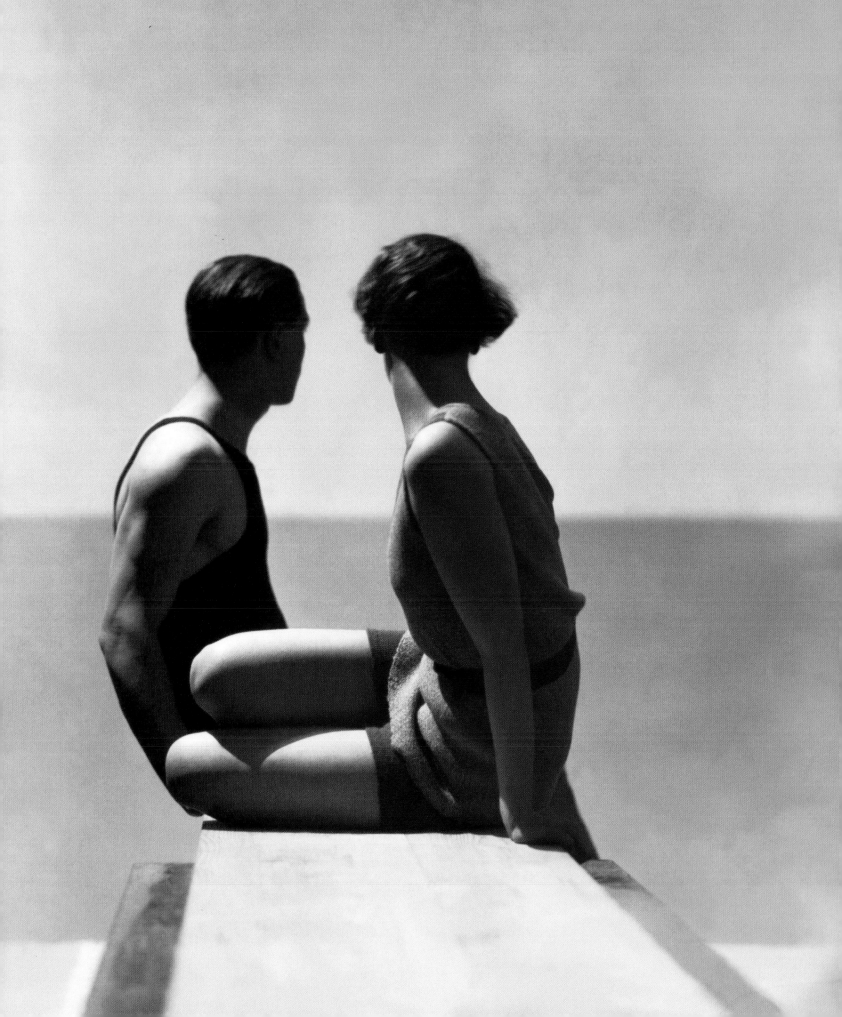

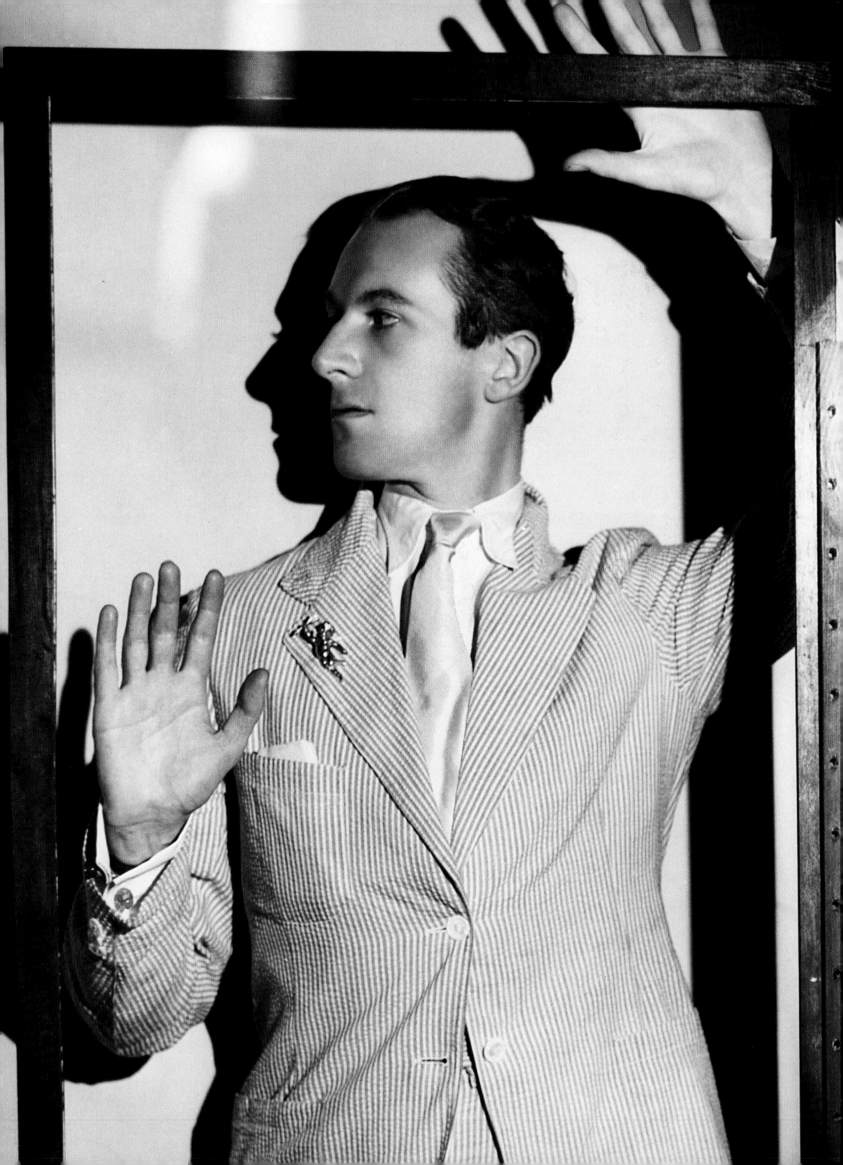

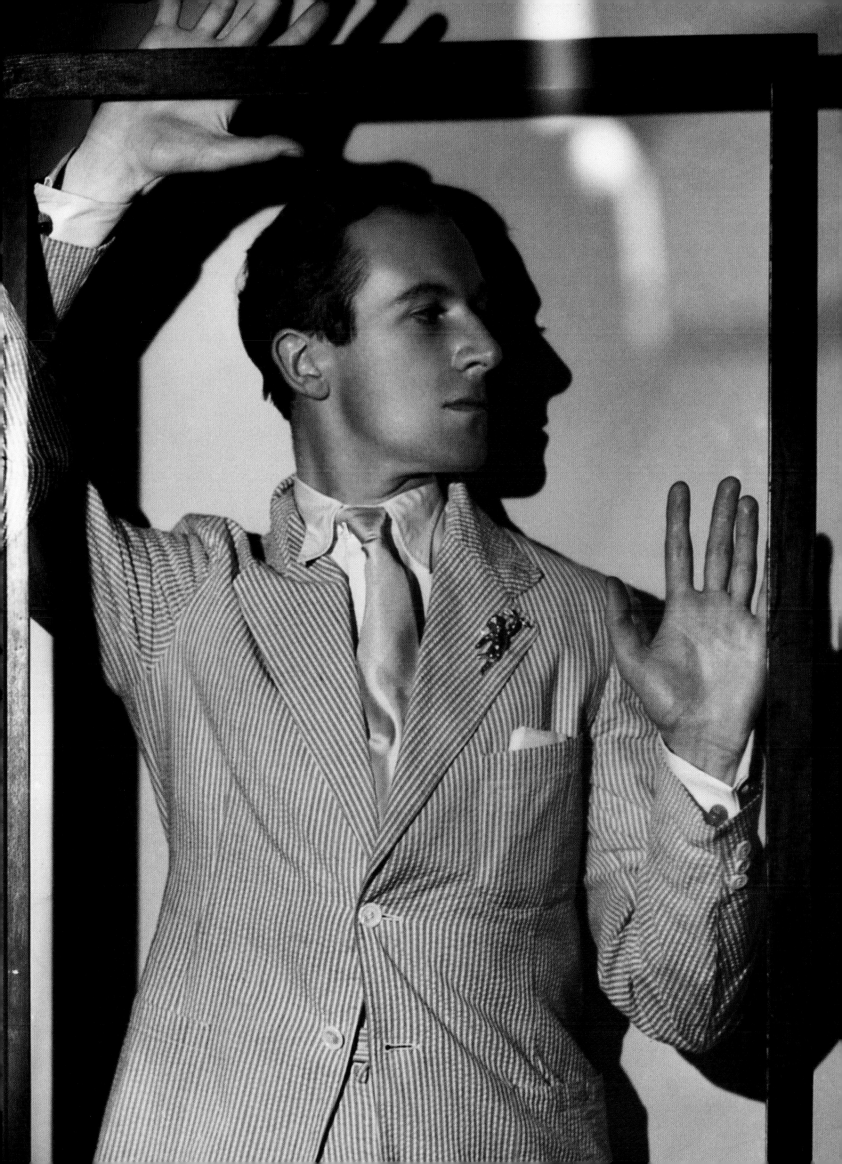

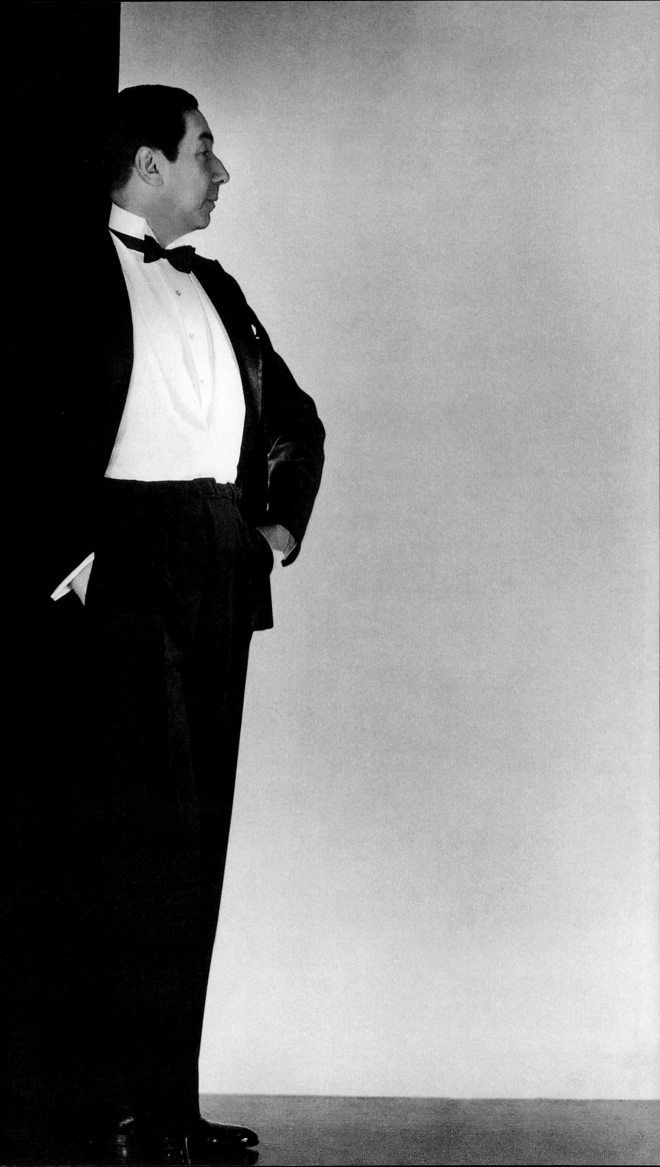

Baron Adolf de Meyer

Adolf de Meyer was the first great fashion photographer to capture the manners and mores of café society. After a childhood divided between Paris and Germany, he started staging exhibitions of his amateur photography from the age of twenty-six. Then he went to live in London, where he was elected a member of the Royal Photographic Society. There he formed a firm friendship with Alfred Stieglitz, who helped him to publish his work. So considerable was his reputation that in 1914 Condé Nast engaged him as the first full-time photographer on *Vogue* and *Vanity Fair*, which he left in 1921 for *Harper's Bazaar*. When, in 1934, *Bazaar* changed its editorial line, he left the magazine and went to Hollywood, where he became a fashionable celebrity.

De Meyer was one of the major figures in the pictorialist movement, a reaction to the realism of documentary photographers of the time, who were concerned to capture every detail. The pictorialists worked with the specific qualities of photography as a medium, sometimes using sophisticated techniques to create effects recalling charcoal or pastel, and setting out to reveal the world not through the mechanical lens of the camera but rather through the lens of the human eye. Influenced by the aesthetics of John Ruskin and Whistler, de Meyer evoked the world of fashion through diaphanous, hazy effects, creating images that were outstanding examples of the photographer's art. His technique of using diffuse light and motionless groups recalling the still life in painting was to remain highly influential until the late 1920s, when Hoyningen-Huene, Horst P. Horst, and Beaton began to celebrate movement with a new feel for color. A friend of Elsie de Wolfe and Misia Sert, de Meyer was an enthusiastic admirer of the Ballets Russes. He was responsible for a remarkable series of photographs of Nijinsky's *L'Après-midi d'un faune*. De Meyer and his wife Olga were an out-of-the-ordinary and highly visible couple. Born in London in 1871, Olga Caracciolo was the daughter of the Duchessa di Castelluccio and—according to the skillfully sustained rumor—the Prince of Wales and future Edward VII, who was her godfather (and who had a long list of other putative love children to his name, including Edward James and Violet Trefusis). Her first husband was an Italian prince, and her close links with the English king enabled her to ensure the elevation of her second husband to the rank of baron. In her youth, her beauty and elegance had been celebrated by the great society portraitists of the *fin-de-siècle*, including Whistler, Boldini, Helleu, Sickert, Sargent, and Blanche. She was also prolific in her purchases of Cartier jewelry.

Elegant and well-connected though they were, the de Meyers had rather too strong a whiff of the distasteful about them, as Jean-Louis de Faucigny-Lucinge explained in his memoirs: "They were known as Pédéraste and Médisante. Médisante had had a noisy and ill-fated romance with Aunt Winnie de Polignac. Around the couple there hung a mist of blackmail and drugs. Under the influence of a guru, they had succumbed well before it became the fashion to the twilight of oriental mysticism."[1] Beaton remembered him thus: "He was a great snob, and if he photographed a certain woman, the implication was that she had attained a high position in the social scene.... He was the first of the editor-photographers and would take a hand in choosing the dresses.... The Baron brought many innovations to photography."[2]

1. Jean-Louis de Faucigny-Lucinge, *Un gentilhomme cosmopolite*, Paris: Perrin, 1990.
2. Cecil Beaton, *The Glass of Fashion*, London: Weidenfeld and Nicolson, 1954, p. 80.

Facing page
Baron de Meyer. Photograph by Horst P. Horst published in French *Vogue*, 1932.

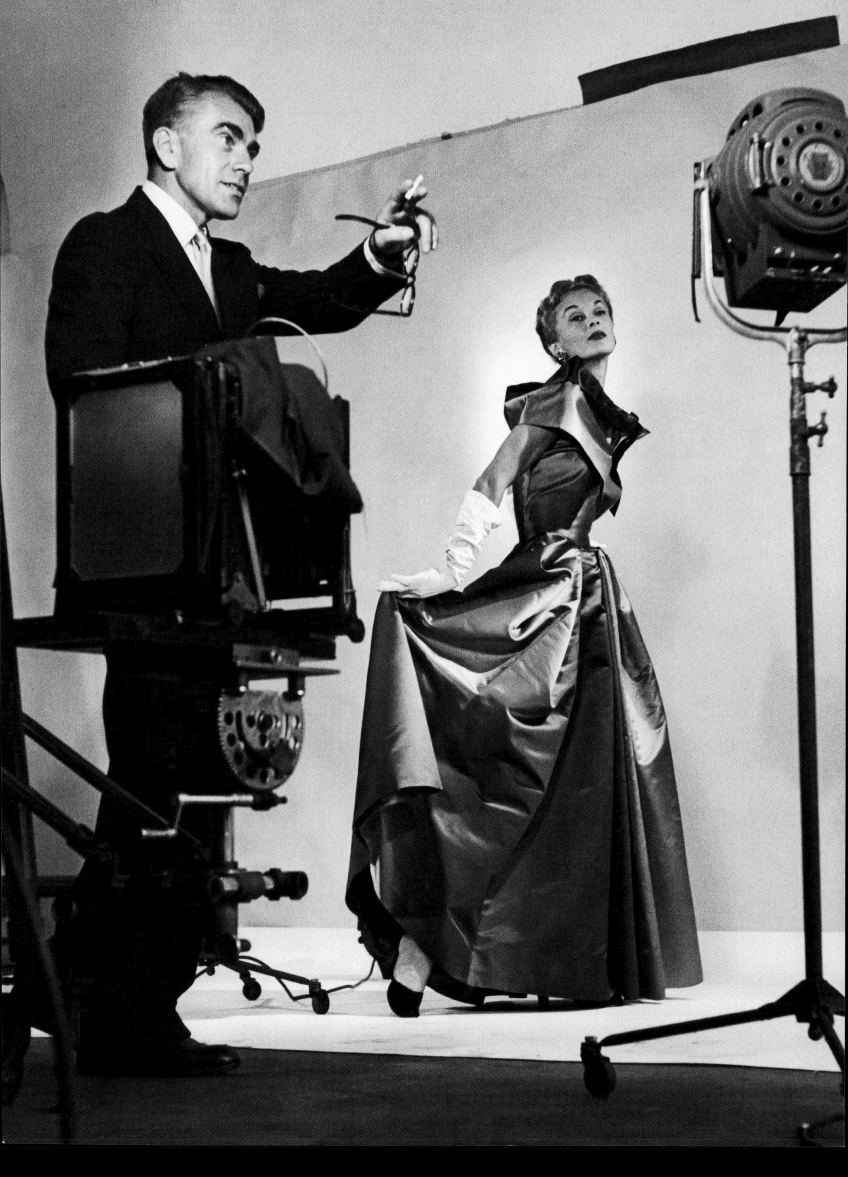

Horst P. Horst

Horst Paul Albert Bohrman, born in Thuringia in 1906, would only become Horst P. Horst, photographer and prominent member of café society, in 1941. In that year he became a naturalized American, after living for a few years in Paris, from which he never stayed away for long. Horst was both a protagonist and privileged observer of the age in which his talent was to blossom and reach full fruition, in the process of which he played a large part in elevating photography to the status of a fully fledged art form. Although it would be too much to claim that he revolutionized photography, he nevertheless played an important role—through his conception and perception of beauty—in perfecting it. He drew on his studies of Greek sculpture and classical painting in his art, notably in the poses and attitudes of his models, and in his particular attention to their hands. The fashion he photographed was the stuff of dreams.

It was chance, in fact, that led Horst to art photography. He was born into a prosperous and cultured merchant family in Weissenfels. His father, owner of a large ironmongery business, was an influential freemason who corresponded with the German philosopher Keyserling and the Indian poet Rabindranath Tagore. At the Weimar home of one of his aunts, Horst met young artists from the Bauhaus who opened his eyes to the avant-garde. As a student of architecture in Hamburg, he wrote to Le Corbusier to ask if he could do a work placement in his studio in Paris. This experience was to prove a turning point in the young man's life, turning him away from architecture and encouraging him to leave Germany for good. Horst found the famous architect aloof and disagreeable and was bored in his studio, which at the time happened to be working on the decorative scheme for the Champs-Elysées apartment of one of the future great names of café society: Charles de Beistegui. By contrast he threw himself into the freedoms that Paris—fizzing with creativity in the late 1920s—had to offer a young man of charm and beauty. He spent a lot of time in Montparnasse, visited galleries and museums, and formed friendships with Julien Green and Robert de Saint-Jean. Most important of all, on a café terrace in 1930 he met George Hoyningen-Huene, star photographer for *Vogue*. The great love affair that ensued would decide his vocation and give him full entrée to the nascent café society.

Working initially as a model for Hoyningen-Huene, he soon began to act as his assistant for erecting backdrops and lighting them. They lived next door to each other, traveled together, and most significantly went to visit Cecil Beaton (then working for English *Vogue*) at Ashcombe. On their return to Paris, Hoyningen-Huene introduced Horst to Mehemed Agha, artistic director of *Vogue* in New York, who engaging him on a short apprenticeship offered him a job as photographer on French *Vogue*. His first photograph was published in November 1931. From then until the end of his life, except for a brief interlude at *Harper's Bazaar*, Horst was official photographer to the various editions of

Vogue. In 1932, with Hoyningen-Huene as director, he made a short film with Natalie Paley, who was becoming one of his closest friends. "Not merely was the film avant-garde, it had no title, no plot, and was never shown anywhere."[1] Horst's career as a photographer did not take off properly until 1934, when Hoyningen-Huene went to Hollywood and Horst replaced him as the star photographer on Paris *Vogue*. In 1939, sensing the approach of war, Horst moved to New York, where after acquiring American citizenship he later became a war photographer.

From then until the end of his life, except for a brief interlude at *Harper's Bazaar*, Horst was official photographer to the various editions of *Vogue*.

After the war he returned to his position on *Vogue*, working for the American edition and making frequent trips to Paris to see friends and the couture shows. He also published photographs of plants, a specialty he had developed during the war. In 1947 he formed a lasting relationship with the English diplomat Valentine Crawford, who would write the texts to albums of photographs Horst published, notably after his travels to Lebanon, Syria, and above all Persepolis. Crawford would also write Horst's biography, published in 1984. When *Vogue* closed its New York studio in 1951, Horst set up his own in Tchelitchew's former apartment on East Side. During the café society years, none of its members, whether in Europe or America, was to escape his lens. At the same time he diversified into travel photography, undertaking journeys that were not without their perils—as when he and Valentine were arrested on suspicion of espionage near the border between Soviet Russia and Iran.

In 1961, Diana Vreeland offered him a last opportunity to capture the final throes of café society from a different angle, when she commissioned from him a series of photographic reportages on the homes of international high society. Horst carried on photographing fashion, interiors, and flowers until the final years of his life, before gradually losing his sight. He died in Florida in 1999.

Facing page
Advertising shot by Horst
P. Horst for the New York
luxury department store
Bergdorf Goodman, 1935.

1. William A. Ewing, *Hoyningen-Huene*, Paris: Thames & Hudson, 1998, p. 34.

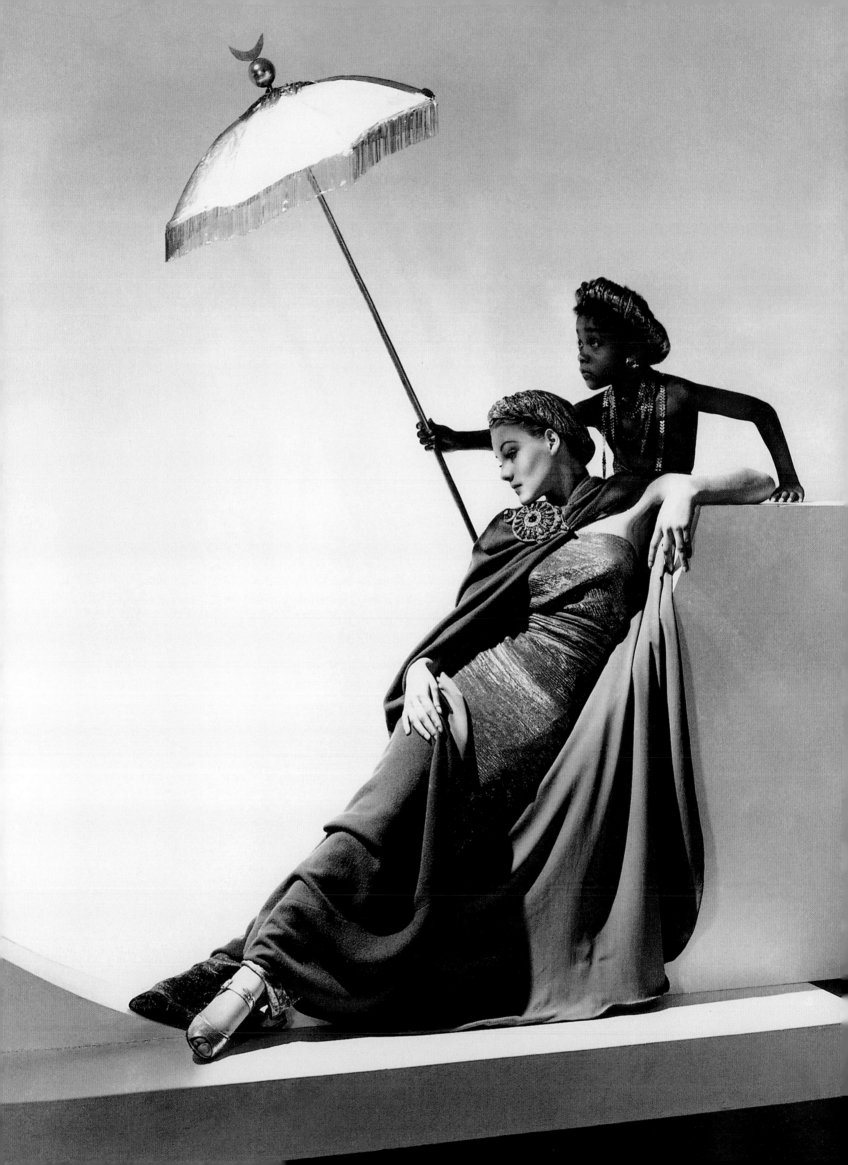

Lee Miller

The surrealist muse Lee Miller was also a photographer whose career unfolded on the fringes of café society. Initially a *Vogue* model for Steichen and Hoyningen-Huene, she left her native America in 1929 for Paris, where she met Man Ray, with whom she lived and worked. Gradually, however, she cast off his influence to embark on her own path as a photographer. Moving in avant-garde circles, she played the part of the statue in Cocteau's film *Le Sang d'un poète*, financed by the Noailles. In 1932 she went back to New York, where she started a studio that was an immediate success; then in 1934 she married Aziz Eloui Bey, a wealthy Egyptian businessman who had formerly been married to Nimet, a model for Man Ray, Hoyningen-Huene, and Horst. Lee Miller spent four years living in Cairo with her husband, during which she took some remarkable photographs in the desert and on archaeological sites.

In 1937 she met the English writer and surrealist poet Roland Penrose, whom she married ten years later. From time to time she worked for *Vogue*, developing a highly realist documentary style. In 1944 she was the only woman to obtain accreditation as a war correspondent with the British army, as Horst was with the American army. She worked for *Vogue* until 1948, when she stopped working as a photographer altogether.

Facing page
Lee Miller, self-portrait, 1932.

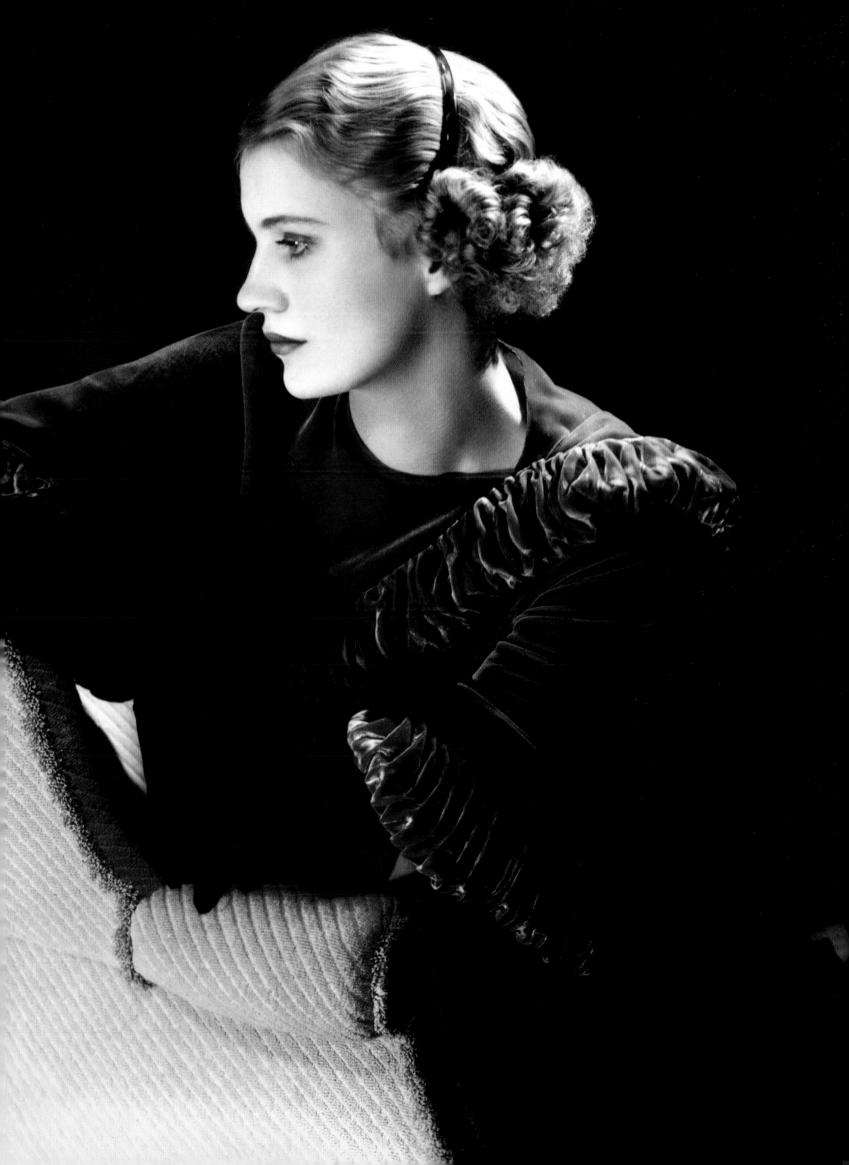

André Ostier

An indefatigable presence at every society occasion, André Ostier was a photographer who was very café society, both in his person and in his work. Born into a Parisian bourgeois family in 1906, he studied at Janson-de-Sailly and then at Sciences-Po before opening a bookshop and gallery called "ALP" (*à la page*) on avenue de Friedland, where he exhibited work by Max Jacob and Le Corbusier, among others. At the same time he traveled widely, writing articles on London by night, carnival in Munich, and being young in Oxford, which were published in various magazines. Becoming increasingly aware of the growing importance of photography, from 1938 he began to get his fashion photographs published, notably in *Marie-Claire*. In 1946, the American musician Virgil Thomson, back in Paris after the triumphal American reception of his opera written with Gertrude Stein, *Four Saints in Three Acts*, composed a musical portrait of the photographer.

During the war Ostier worked principally on the Riviera and in the south of France, sending reportages—notably on the artists Maillol (in Banyuls), Bonnard (at Le Canet), and Matisse (in Nice)—back to the Paris press. On his return to Paris in 1944 he was imprisoned for acts of resistance. After the Liberation of Paris he followed and photographed the campaign for the liberation of Alsace, taking André Malraux as his principal subject.

The post-war period saw his real entrée into society and the world of fashion, thanks to his friends Christian Dior and Jacques Fath. Thus he became one of the first to photograph the model Bettina. From then on he was present at every society event, photographing them for *Vogue* and *Femina*; one of his most notable assignments was covering the extraordinary Beistegui Ball in Venice. He also took photographs for a number of fine editions of books including *Les Masques de Leonor Fini* by André-Pierre de Mandiargue (1951), *Le Bizarre Sculpture di Francesco Pianta* by Mario Praz, and later the English edition of *The World of Marcel Proust* by André Maurois.

Facing page
The Duke and Duchess
of Windsor.
Photograph by
André Ostier, 1957.

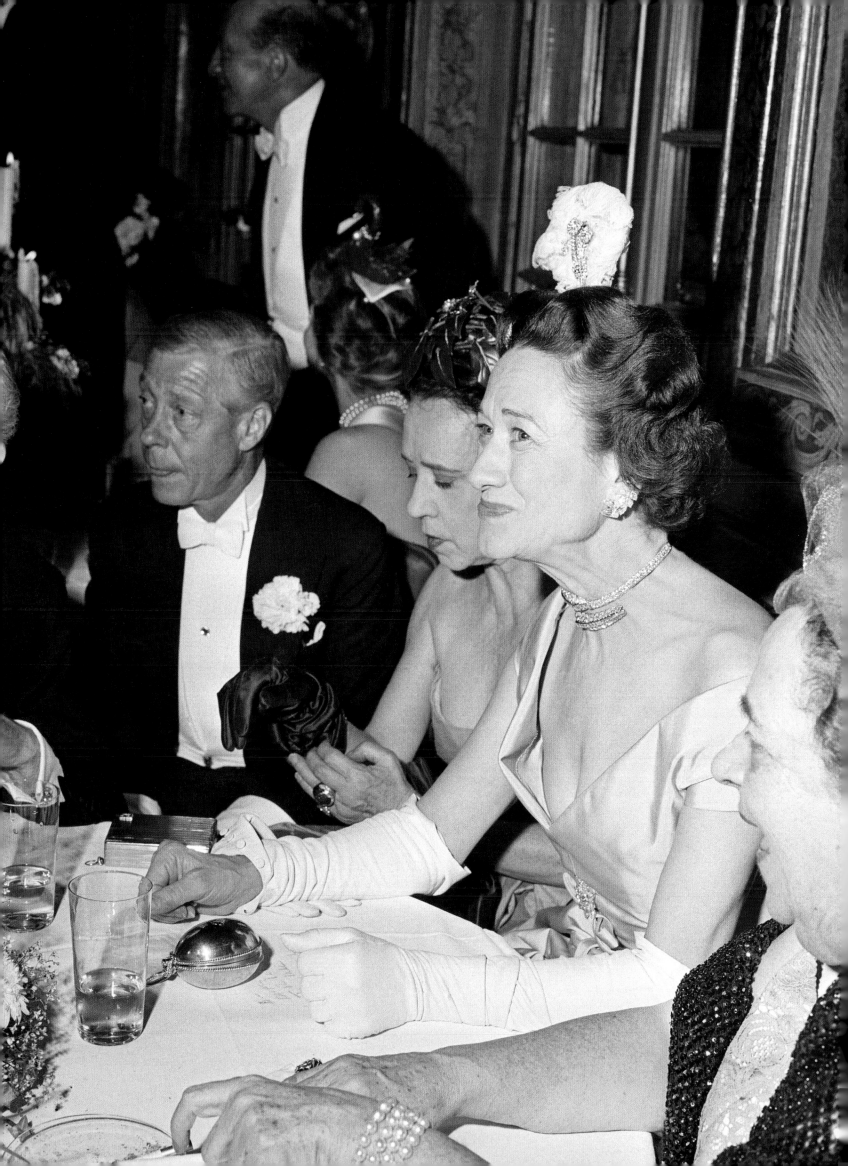

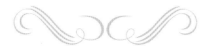

Painting

While photographers, interior decorators, and musicians were all intimately bound up with café society, very few painters were involved in its activities, by contrast, even on the outer fringes. The exception was the central figure of Christian Bérard, portrait painter, decorator, fashion designer, and café society personality *par excellence*, a fixture at every grand ball and dinner. Yet painting lay at the heart of café society, whether as a means of immortalizing its flamboyant and narcissistic protagonists, or for recording the splendor of their parties, decors, and toilettes. A figure of the prestige of Marie-Laure de Noailles was painted by Bérard, Picasso, Balthus, Marie Laurencin, Dalí, and Dominguez, and Daisy Fellowes and Mona Bismarck were also familiar models to painters of the period.

The art of the society portrait reached its apogee in café society, as did also—to a lesser extent—the painting of interiors, decors, and fashion designs. All these genres were closely linked with the café society lifestyle, constantly in quest of its own reflection, and ever the object of fascinated curiosity from a wide public who followed every look and gesture of these icons of style and taste. Outside this circle, "café society paintings" were rather looked down upon as the products of a genre that was not merely minor but also frivolous. Artists who produced such works were regarded purely as creatures of society, such as Boutet de Monvel and Philippe Jullian, or as entertaining *bon viveurs*, such as Bérard. In his preface to *La Peinture mondaine de 1860 à 1960*,[1] Karl Lagerfeld summed up this attitude: "Painting and society are two words that, when used together, get a bad press nowadays. 'Great' painting is offended by the connotations of the word 'society.' Yet over the centuries great painters have always painted the major figures of this world." The society portrait, which left such an indelible mark on café society, is part of a long tradition of which the family portrait, essentially aristocratic, was for many years the chief incarnation. The prosperous middle classes skillfully slotted into this tradition in order to create roots for themselves and to make their image known beyond the immediate family circle, in official, society, or recreational contexts.

If a few masters of the genre, such as Sargent, Boldini, Blanche, and Helleu, had had a profound influence on it around the beginning of the twentieth century, with café society it was to experience major changes of direction. With the increasingly wide social spectrum embraced by café society, the range of subjects grew steadily. Still predominant among sitters were of course aristocrats, as well as prominent members of the upper and middle classes; but now they were joined by millionaires of lower social standing, and by figures from the worlds of theatre, film, and fashion. While the society portrait had for centuries been a European phenomenon,

Facing page
Bérard during the rehearsal
of *La Folle de Chaillot*,
by Jean Giraudoux,
at the theatre of l'Athénée,
1945.

1. Patrick Chaleyssin, *La Peinture mondaine de 1860 à 1960*, Paris: Célia Editions, 1993.

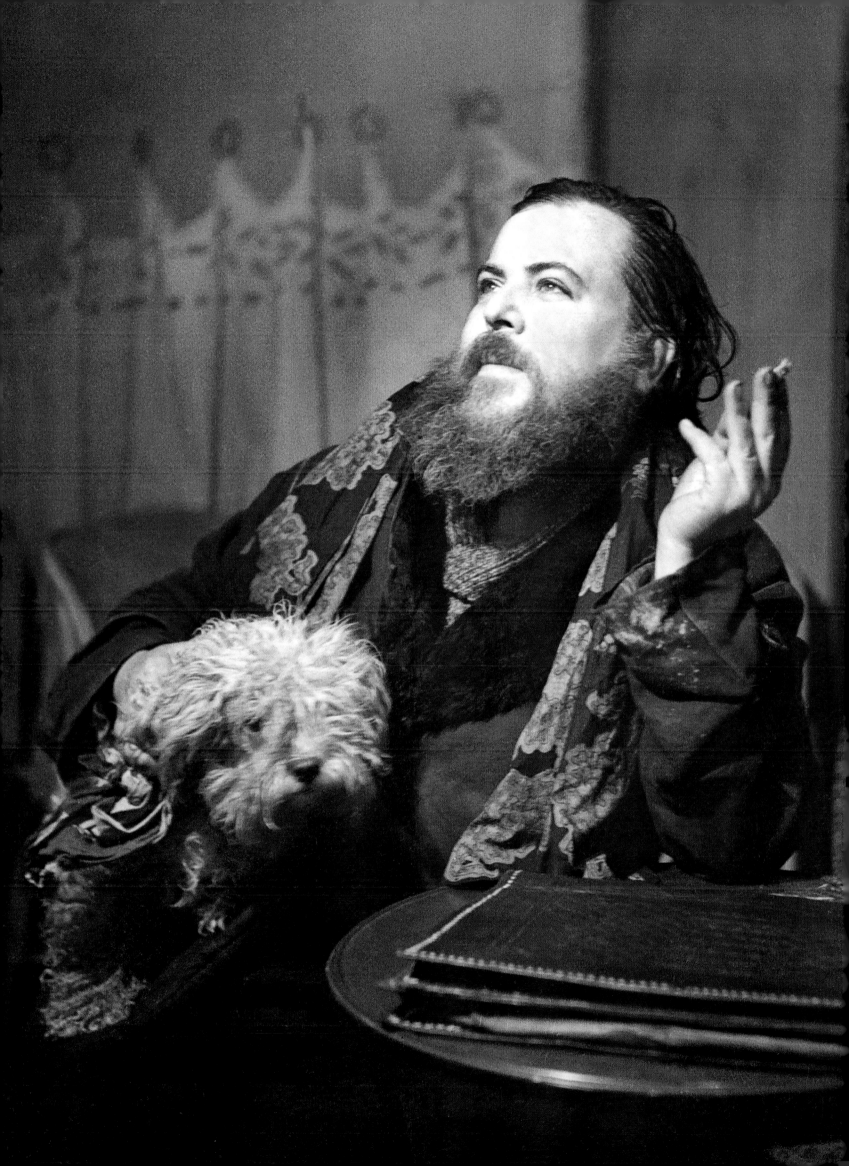

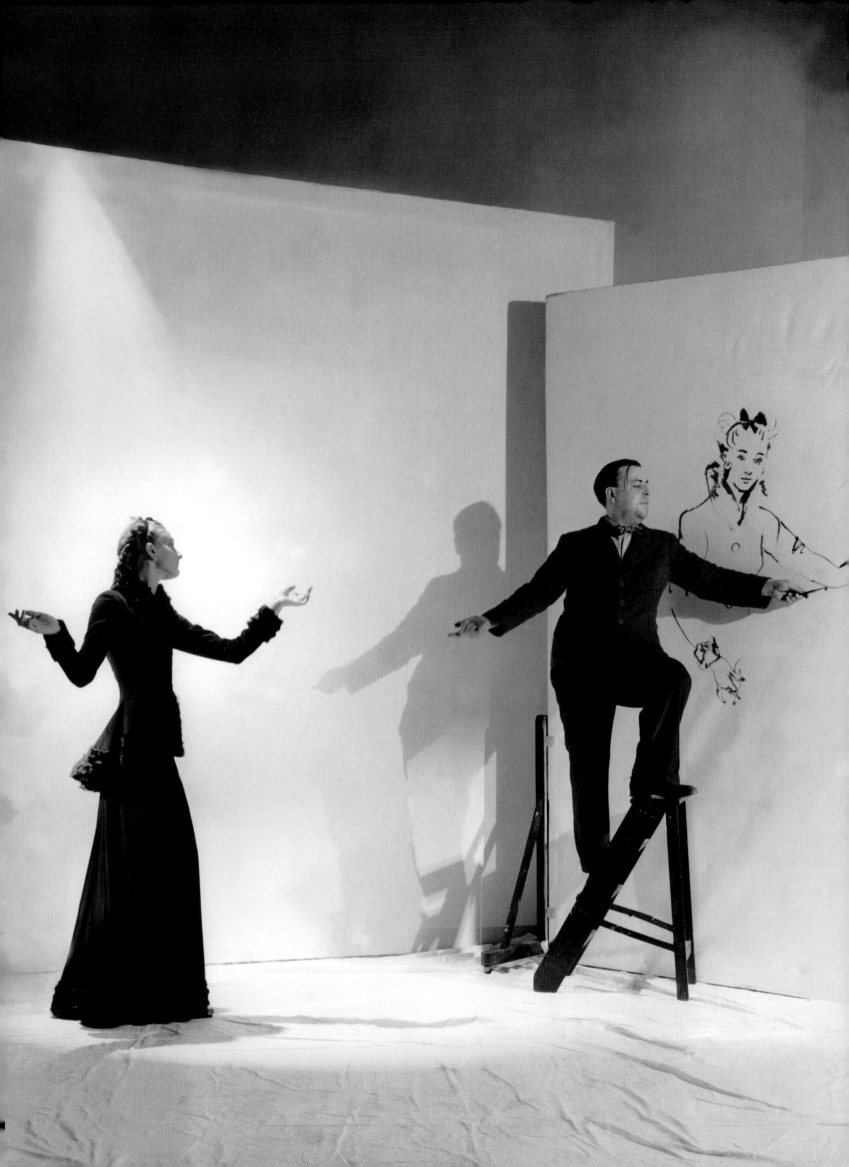

from the 1920s the Americans above all, as well as the new colonial elites, became besotted with the idea. The evolution of the work of Boutet de Monvel is revealing in this respect. At the start of his career he painted the portraits only of European aristocrats; then from 1929 he specialized in American millionaires, with a special place for the Maharaja of Indore, one of his regular clients. In some instances these portraits featured characters who were distinctly on the fringes of good society, even if they were occasionally seen in it, as with Jean-Gabriel Domergue's paintings of pin-ups.

In the years after the First World War, society portraiture—hitherto dominated by images of women—took an increasing interest in the male portrait. Some men who were leading lights of café society had their portraits painted on numerous occasions, such as Étienne de Beaumont, the Marquis de Cuevas, and Alexis de Redé. Female painters such as Tamara de Lempicka and Romaine Brooks introduced a lesbian strand, meanwhile, with favored models including Suzy Solidor, Natalie Barney, and Elisabeth de Clermont-Tonnerre. The female portrait persisted, depicting women who were now more liberated in every respect. From the 1920s, under the influence of Poiret and above all Chanel, women's bodies were no longer sculpted by their clothing; corsets disappeared, allowing much greater freedom of movement and choice of poses—though without necessarily going to the extremes of abandon suggested by a painter such as Tamara de Lempicka.

The art of portraiture often tended to flatter the subject, with the painter tempering his or her individuality of style in order to lend the sitter an "official" image that would sit well with the rest of the portraits in the family gallery. But members of café society wanted to be seen as unique and special, and so turned to painters who were more extravert in manner. A single glance is enough to distinguish a Bérard from a Boutet de Monvel or a Van Dongen, a difference in style that implies a divergent approach to the same sitter. This individuality of style in painter's work became all the freer and more original in the 1930s, with the emergence of art photography. Now the painted portrait needed to convey something extra, something a photograph could not capture—though of course many artists, such as Boutet de Monvel, worked largely from photographs.

Patrons and benefactors—those important pillars of the art world—were also to play a major role. If Boutet de Monvel came from a wealthy family, and Bérard, who was invited everywhere, could fall back on the fortune of his mother, heiress to the Henri de Borniol firm of morticians, the same could not be said for Dalí. For years Edward James bought everything he painted in order to support him, and then Marie-Laure de Noailles' circle (including Faucigny-Lucinge, Julien Green and his sister, Robert de Saint-Jean, and Mimi Pecci-Blunt), who had already helped him make *Un Chien andalou*, clubbed together to buy his work. Arturo Lopez, meanwhile, accommodated Dalí's wife Gala in his *hôtel particulier*, before installing her in a suite at the Hôtel Meurice. Marie-Laure de Noailles also supported many other artists, including Oscar Dominguez, rather as Peggy Guggenheim, on the fringes of café society, supported Max Ernst, Yves Tanguy, Jackson Pollock, and a few others from her Venetian palazzo, while also enjoying liaisons with some of them.

Among the portrait painters at the heart of café society were a few of the great names in twentieth-century painting: Picasso, a frequent presence, especially on the Riviera, who painted portraits of great classical beauty of the Beaumonts and Noailles; Balthus, who painted a portrait of Marie-Laure de Noailles that she displayed prominently in her salon on place des Etats-Unis; Foujita;[2] Dalí, naturally; Marie Laurencin; and Leonor Fini. All of these artists worked for café society, were sometimes seen in it, but were never really members of it.

Facing page
Christian Bérard sketching a model. Photograph by Cecil Beaton, c. 1936.

Page 263
Tamara de Lempicka at her easel. Photograph by Willy Maywald, c. 1949.

2. Notable for his portrait of the Marquise de Ganay.

There was also another category of artistic jacks-of-all-trades, who dashed off the odd portrait here and there but who were not really painters. Often they were familiar figures in society circles, and who harbored no illusions about their failings, even if they found a certain charm in them. Jean Cocteau was most prominent among these, with Philippe Jullian and Cecil Beaton. Other painters, by contrast, appeared as the true portraitists of café society by virtue of the sheer volume of work they devoted to it. Although Bérard worked in many genres, his portraits stand out for both their quantity and their quality. Adored by all its iconic figures as well as by every hostess, despite his disheveled—not to say plain grimy—appearance, Bérard was indefatigable in producing portraits of café society. Trained as a student of Vuillard at the Académie Ranson, he found fame beyond society circles thanks to the neo-romantics exhibition that he shared with Tchelitchew and the Berman brothers. For twenty years he and Boris Kochno formed a highly fashionable couple, and he designed numerous parties as well as the stage designs for plays by Giraudoux and Cocteau.

Boutet de Monvel, whose father was also a painter, was another product of the Paris bourgeoisie. Working chiefly in France, and afterward in America, he and his work were the very antithesis of Bérard. Extremely distinguished and good-looking, and always immaculately turned out, he was the very epitome of the elegant Paris gentleman—which did his reputation no harm in America. His classical painting style, of great purity and clarity, could not have been more different from the suggestive, louche quality of Bérard's work. His portraits of Lady Mendl and the Marquis de Cuevas, one of his close friends, are particularly fine. In a similarly elegant vein, the Spanish painter Vidal Quadras, whose wife Marie-Charlotte was one of Givenchy's muses, painted numerous portraits of members of café society, as well as of the royal families of Spain and England, in addition to still lifes and Mediterranean landscapes. His work displays great delicacy and refinement, and he himself was often to be seen in society. On the fringes of café society, meanwhile, were fashionable painters such as Van Dongen and Domergue, both of whom worked on the Riviera, as well as Marie Laurencin and Tamara de Lempicka.

Café society ushered back into vogue the painting of interiors, a genre that had been very popular in the eighteenth and nineteenth centuries, to be rehabilitated by Mario Praz in the first half of the twentieth. The luminaries of café society liked to keep a record of the decorations they had commissioned for their residences, dinners, and parties. The inevitable corollary to their taste for the ephemeral was a desire to preserve these fleeting delights in a more lasting fashion. Serebriakoff was unrivaled in this field, capturing the interiors of Beistegui, the Duchesse de Brissac, the Rothschilds, Baron de Redé, and Arturo Lopez.

The art of fashion design also flourished as never before in the 1930s and 1940s. The Condé Nast magazines and *Harper's Bazaar* commissioned some of the greatest names for work in this field, including Bérard, naturally, but also Marcel Vertès, Lilia de Nobili, Jean Denis Malclès, and René Bouché. By the 1950s, however, it had been eclipsed by art photography. Stage design, finally, offered important opportunities for many café society painters, with all the possibilities offered by the vogue for new plays, and above all operas and ballets. The Ballets Russes led the way, with Benois and Bakst, followed by Picasso and Dufy. With the encouragement of Kochno, Cochran, Colonel de Basil, and the Marquis de Cuevas, the great ballet companies became important patrons of artists including the Bermans, Tchelitchew, Beaton, and Bérard, all of whom were very much in demand. When the Front Populaire government appointed Edouard Bousquet to run the Comédie Française, he duly lost no time in revamping the house style and commissioning Bérard to create what would be some of his most celebrated stage designs. Finally, mention should be made of the paintings of some members of café society, such as Marie-Laure de Noailles and Lord Berners, whose exhibitions enjoyed a certain success in society circles.

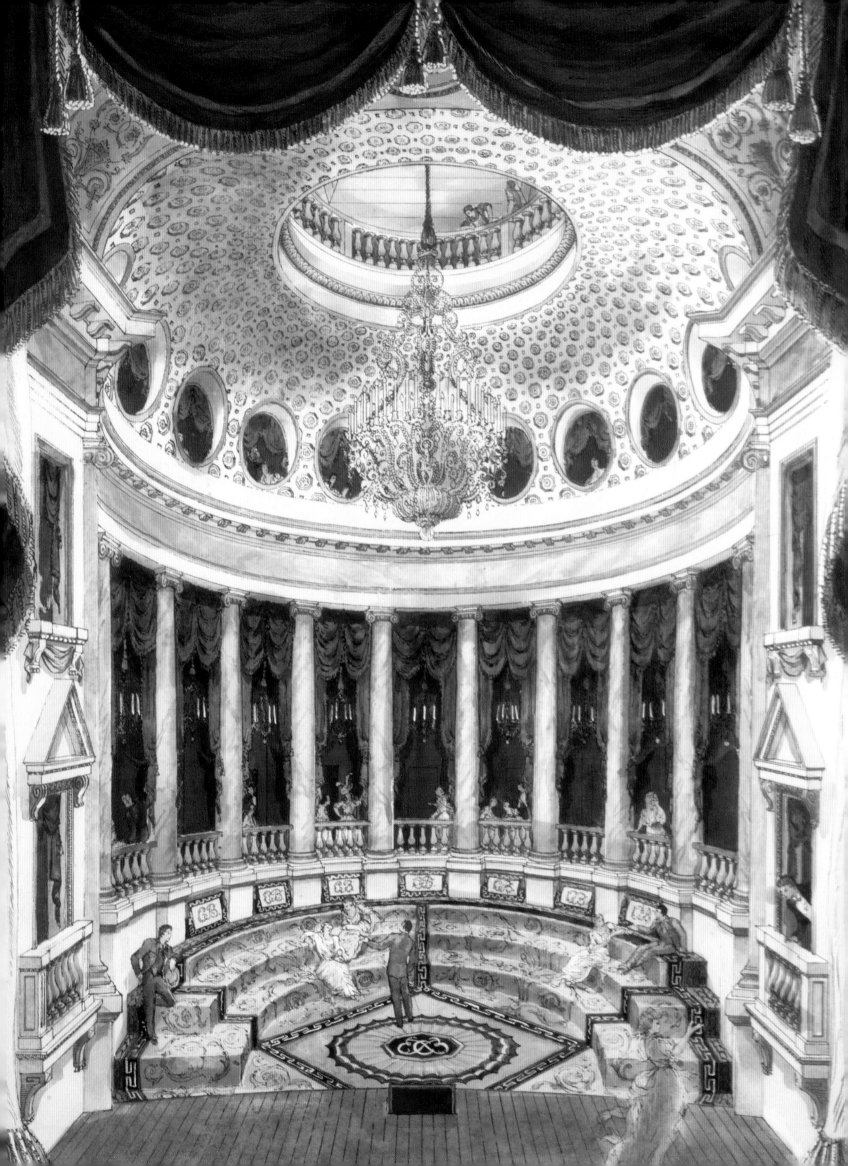

Alexandre Serebriakoff was the meticulous recorder of the interior decorations and celebrations of café society. Thanks to his talents as a painter of interiors, we can now glimpse interiors that only a favored few would have seen in their heyday. From the Renaissance on, many artists painted interiors, but it was in the eighteenth century that the genre came into vogue. From the intimacy of private drawing rooms to the details of royal festivities, it was used to capture the look and atmosphere of any event whose hosts wanted to ensure its future memory. This was a tradition continued by a number of the artists of café society, including Serebriakoff.

Alexandre Serebriakoff was born in Russia in 1907, into a wealthy, cultured family whose world was turned upside down by the Revolution ten years later. His father, a civil engineer working in Siberia, was imprisoned and died of typhus in 1919, and the family had to abandon its estate in Ukraine. Alexandre, his sister Catherine, and their mother Zenaïde sought refuge in Paris, where they lived together until Zenaïde's death in the 1960s. Their lives revolved around art. Great uncle Alexandre was the painter Alexandre Benois, who worked with the Ballets Russes, and his grandfather, Eugène Lanceray, was a celebrated sculptor whose name was descended from a soldier of Napoleon's Grande Armée who stayed in Russia.

Before becoming a painter of interiors, like his sister Catherine, Alexandre tried his hand at a number of different genres. In the mid-1920s he painted numerous views of Paris, which bear witness to his concern to record in meticulous detail a world that he knew was on the verge of disappearing forever. Then he collaborated on the painting of backdrops for films, including some for Abel Gance and Cavalcanti. He also worked on maquettes for stage and ballet productions for Bérard and Kochno, and was interested in decorative design, notably for series of lampshades and cards: among other projects, he designed the *L'Europe française* series for the 1937 Colonial Exhibition in Paris, followed by *La France des vues* and *La France des faiences*, both for the Musée des Arts Décoratifs. But Serebriakoff's true talent shone through his portraits of café society interiors. Over a number of years, he made meticulous paintings of the homes of prominent society figures and of the balls and parties that took place within them. It was a vocation that was born in 1941, when Charles de Beistegui asked him to record the appearance of the rooms at Groussay for posterity. This collaboration with the Mexican millionaire was to run through his career as a watercolorist, as he was also to paint Beistegui's *hôtel particulier* on rue de Constantine, the Palazzo Labia, which he designed with Emilio Terry, and designs for garden buildings for the grounds at Groussay. Alain de Rothschild also called on his talents to preserve the memory of the interiors of the Hôtel Marigny, as did Arturo Lopez for his country mansion at Neuilly and Alexis de Redé for the Hôtel Lambert. Following the example of his friend Charles de Beistegui, who commissioned Serebriakoff to make a record of his ball at the Palazzo Labia in 1951, Alexis de Redé asked him to paint the decorations and guests of his balls, and for grand dinners regularly commissioned him to create *plans de table* that were true works of art.

Facing page
Watercolor sketch for a party decor by Alexandre Serebriakoff, 1950s.

Pavel Tchelitchew

Less sparkling company and less at ease in society than Bérard, the troubled and introverted Pavel Tchelitchew was not a painter of café society, but rather developed within it. He was born into an aristocratic family living outside Moscow in 1898. His father was a follower of the liberal principles of education developed by Tolstoy, and encouraged his son, who was educated by English, French, and German tutors, to pursue his artistic vocation. The fruits of this education were to stay with Tchelitchew throughout his life. According to his great friend Lincoln Kirstein, whose life followed a similar course, "He retained the manners of a nineteenth-century *barine* [a high Russian nobleman]."[1] The Revolution threw the life of this great landowning family into turmoil. Pavel enlisted in the White Army for a few months, before leaving to study with Alexandra Ester in Kiev, where he did his first designs for the stage.

Keeping ahead of the Red Army's advance, Pavel reached Odessa. From there he sailed to Istanbul and then traveled on to Berlin. There he met the American pianist Allen Tanner, with whom he started his first great romantic relationship. In 1923, they decided to move to Paris, moving into the Hôtel Jacob. Jane Heap, a fellow resident, introduced Pavel to Brancusi, Braque, and the Berman brothers, and he enrolled to study drawing with the Cubist painter André Lhote. There he met and became friends with Hoyningen-Huene, whose background bore many similarities to his own. For Hoyningen-Huene, Tchelitchew was "the greatest Russian artist since the icon painters Andrei Roublev, Daniel Chorney, and Theophanes the Greek."[2] Deeply involved in the homosexual and artistic circles of Paris, he became acquainted with Bérard, with whom he maintained a friendly rivalry for many years. Throughout his life, Tchelitchew's relationships with those around him would always be complex.

When he met Gertrude Stein it was to prove a turning point for him. At the 1925 Salon d'Automne, Stein noticed his *Basket of Strawberries*, and bought the entire contents of his studio. Under her influence, his work was to evolve. Until then he had shown a particular predilection for clashing blues and pinks, leading him to call himself the "prince of bad taste." Spending time with the woman who was one of the first patrons of Picasso was to prepare him to follow in the footsteps of the Spanish painter's *Saltimabanques* series. He now painted numerous portraits and scenes of circus performers, in a style similar to Bérard's work of the same period. Gradually a mystical inspiration drew his work in a direction that was increasingly baroque and visionary. At the same time, he was working on stage designs for the Ballets Russes. In 1926, with the Berman brothers, he exhibited

Facing page
Pavel Tchelitchew in his studio. Photograph by John Rawlings, c. 1942.

1. William A. Ewing, *Hoyningen-Huene*, Paris: Thames & Hudson, 1998. p. 31.
2. Ibid., p.32.

at the Galerie Druet in Paris, in an event that was to be the point of departure for the movement that the critic Waldemar George was to call "neo-romanticism," and which also included Bérard.

At Gertrude Stein's apartment on rue de Fleurus, Tchelitchew met the English poet Edith Sitwell, who was to be a muse to him to the end of his life, and with whom he was to have a complex and mutually influential relationship. Fascinated by her strangely medieval appearance, Tchelitchew encouraged her to cultivate what she called her "Plantagenet look." She meanwhile encouraged him to play out the part that suited him so well, the "Russian aristocrat with a tragic destiny, forced to go into exile and to wander the world, and the artist and romantic genius, condemned to suffer nobly for his art." According to his friend Harold Acton, he was the embodiment of a theatrical Russian exile who would never fit into his adopted country.[3]

> At Gertrude Stein's apartment, he met the English poet Edith Sitwell, who was to be a muse to him to the end of his life, and with whom he was to have a complex and mutually influential relationship.

Tchelitchew's rivalry with Bérard came to a head over a commission from Edward James for the Ballets 1933. Faithful to the image created for him by Edith Sitwell, the following year he emigrated with his new lover—the writer and critic Charles Henri Ford—to New York, where he had enjoyed success with an exhibition at the Museum of Modern Art in 1930. There he became one of the stars of the Julian Levy gallery and created designs for numerous ballets, notably Balanchine's American Ballet. During this period his work evolved toward "interior landscapes" inspired by the metamorphoses of the human body. In 1952 he became an American citizen, while continuing to spend every summer in Europe, and especially in France. He died of a heart attack in Rome in 1956.

Facing page
Performance of *Ode*, ballet russe by Serge Diaghilev and designed by Pavel Tchelitchew, 1928.

3. Harold Acton, *Memoirs of an Aesthete*, London: Faber, 2008.

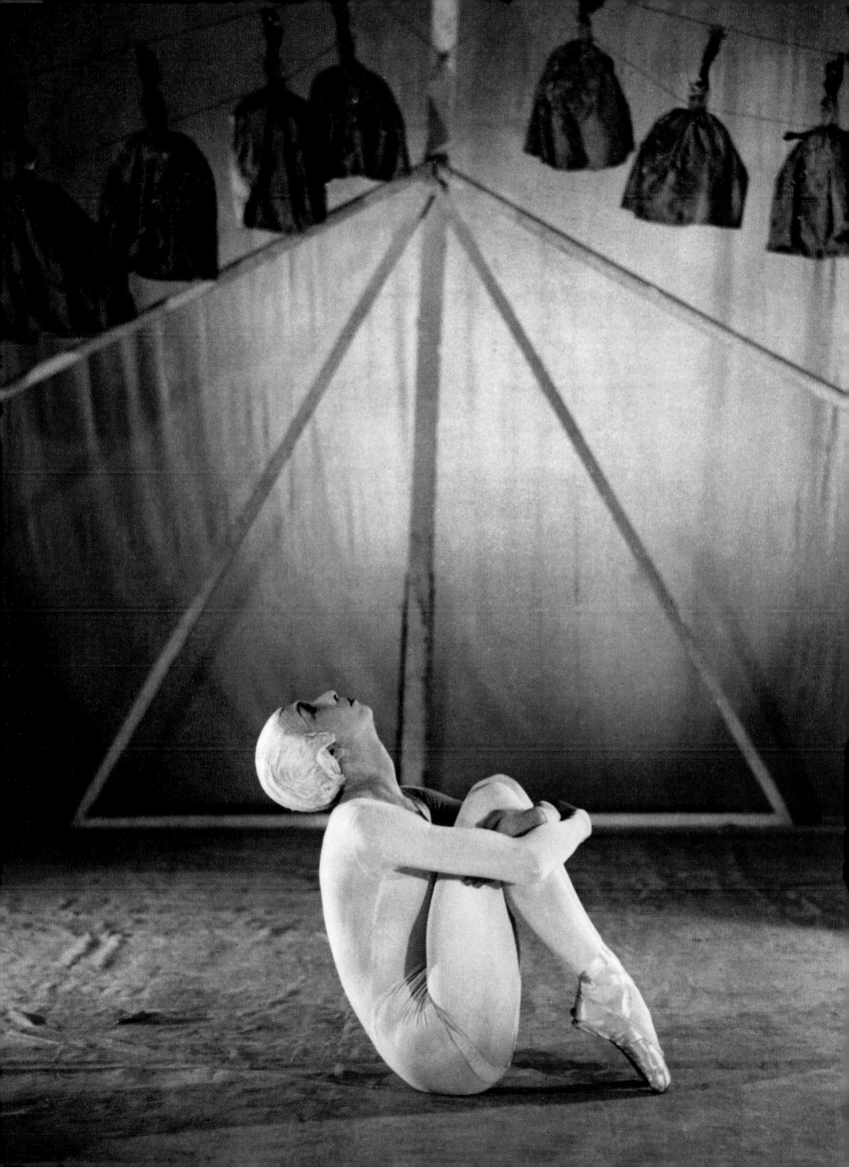

Dancing

10 dessins

par Vertès

Marcel Vertès

Like René Bouché, Marcel Vertès was of Eastern European origin. Born in Hungary in 1895, he trained as an aircraft engineer before enrolling at the School of Fine Arts in Budapest, where his true vocation emerged. In 1921 he moved to Paris, where he worked for the satirical magazine *Rire*, as well as for *La Gazette du bon ton*. In his spare time he attended the Académie Jullian to perfect his skills. He illustrated works by Zola, Colette, and Morand, before exhibiting at the Salon des Humoristes in 1925.

That same year, his career took a major change of direction, as Vertès turned to fashion and left to work for *Vanity Fair* in New York. Subsequently he worked on all the Condé Nast publications, producing illustrations depicting high society with a humorous touch. As well as becoming the star illustrator on *Vogue*, he was also Schiaparelli's preferred designer for publicity for her perfumes, including the famous "Shocking" in 1938. He continued to work for Condé Nast after the war, as well as for *Harper's Bazaar.* Vertès designed the sets and costumes for several Hollywood films, including *Moulin Rouge* in 1952, for which he received an Oscar nomination.

Mogens Tvede

Today Mogens Tvede is all but forgotten, yet for a time he enjoyed fleeting fame, linked exclusively to café society. Born in Denmark, where he gained a solid grounding as a student of architecture, he built a few projects in America before moving to Paris in 1932. There he married Princess Dolly Radziwill, whose prestigious name was to gain him entry into Paris high society. Dolly was a close friend of Bérard, whose cousin Loch Radziwill, Marcel Proust's great love, had been her first husband. Unable to work during the wartime Occupation of France, he devoted his energies to painting, producing society portraits in the style of Jacques-Emile Blanche, though perhaps less accomplished. His sitters were all members of café society, including the Duff Coopers, Louise de Vilmorin, Princess Chavchavadze, and a long list of others. Among them was Henri Sauguet, who described his work for *Vogue*: "Standing before the handful of works that Mogens Tvede has so far painted, we are happily drawn into the intimate world of a few of our contemporaries whose image he has captured with such warmth. Observe them as they live a moment of their day, whether in their bedroom, in a garden, in their library, or surprised at their work. With the close attention of a chronicler, though without allowing anecdotal detail to dominate, Mogens Tvede delineates the essence of this instant of their daily lives."

Ballet

Ballet is a relatively recent phenomenon. In the book that he devoted to what was then becoming a major art, Cecil Beaton recalled that when he went to the theater as a child, no one talked about ballet.[1] Elsewhere he added: "The ballets in the first decade of the twentieth century were, indeed, little more than advantageous vehicles to display the technical efforts of the leading virtuosi. Little artistry went into the presentation of these ballets, and the décor and *mise en scène* were utterly banal."[2] It was only with the creation of the Ballets Russes that the notion of choreography as an art was to emerge. The contribution of the Ballets Russes to the history of twentieth-century art was one of major importance, reaching far beyond the world of dance and choreography. Their creator, Sergei Diaghilev, was an outstanding figure who had been an art publisher before he became the guiding spirit of a phenomenon that was to revolutionize the aesthetics of the time.

"Diaghilev's talents were rare for any period," wrote Beaton. "He was one of the baker's dozen of powerful personalities who have helped to nurture the arts since Renaissance individualism."[3] From 1909, he conquered London, Paris, and New York, one after another. In many respects, and especially in their cosmopolitanism and eclectic mix of genres, the Ballets Russes foreshadowed the aesthetic of café society. Diaghilev himself was the precursor of a profoundly aesthetic type, at ease in every milieu and every country but above all in a few select circles, at the crossroads of all the arts and every possible taste. In addition to the emergence of ballet as an artistic phenomenon in itself, capable of arousing true passions, followed by a public of aficionados and—it has to be admitted—elitist in its appeal, the Ballets Russes created an alchemy that would also be found in café society. For the first time outside a few select circles, such as London's haute bohemia of the late nineteenth century, the company was to find an appreciative public among the most established ranks of high society, who now began to flirt with the avant-garde and rub shoulders with an artistic crowd. In the vanguard were high society figures as formidable as the Comtesse Greffulhe, model for Proust, in France, and Lady Juliet Duff and her mother Lady Rippon in England, who now came into contact with artists other than the favorites at their salons.

The second major area of synthesis came between different areas of the arts and those who performed them. The Ballets Russes presented a spectacle that was all-encompassing, mobilizing the greatest and most forward-looking artists working at the time. The dancers

Facing page
Lydia Sokolova, Anton Dolin, Bronislava Nijinska, and Léon Wolzikowsky in the ballet *Le Train bleu*. Libretto by Jean Cocteau, costumes by Coco Chanel, and stagecloth by Pablo Picasso, 1924.

Following pages
Jean Babilée, Boris Kochno, Jean Cocteau, Nathalie Philippart, Roland Petit, George Wakhévitch during a rehearsal for the ballet *Le Jeune Homme et la mort*. Ballets des Champs-Élysées, choreographed by Roland Petit, 1946.

1. Cecil Beaton, *Ballet*, London: Wingate, 1951, p. 5.
2. Cecil Beaton, *The Glass of Fashion*, London: Weidenfeld and Nicolson, 1954, p. 103.
3. Ibid., p. 100.

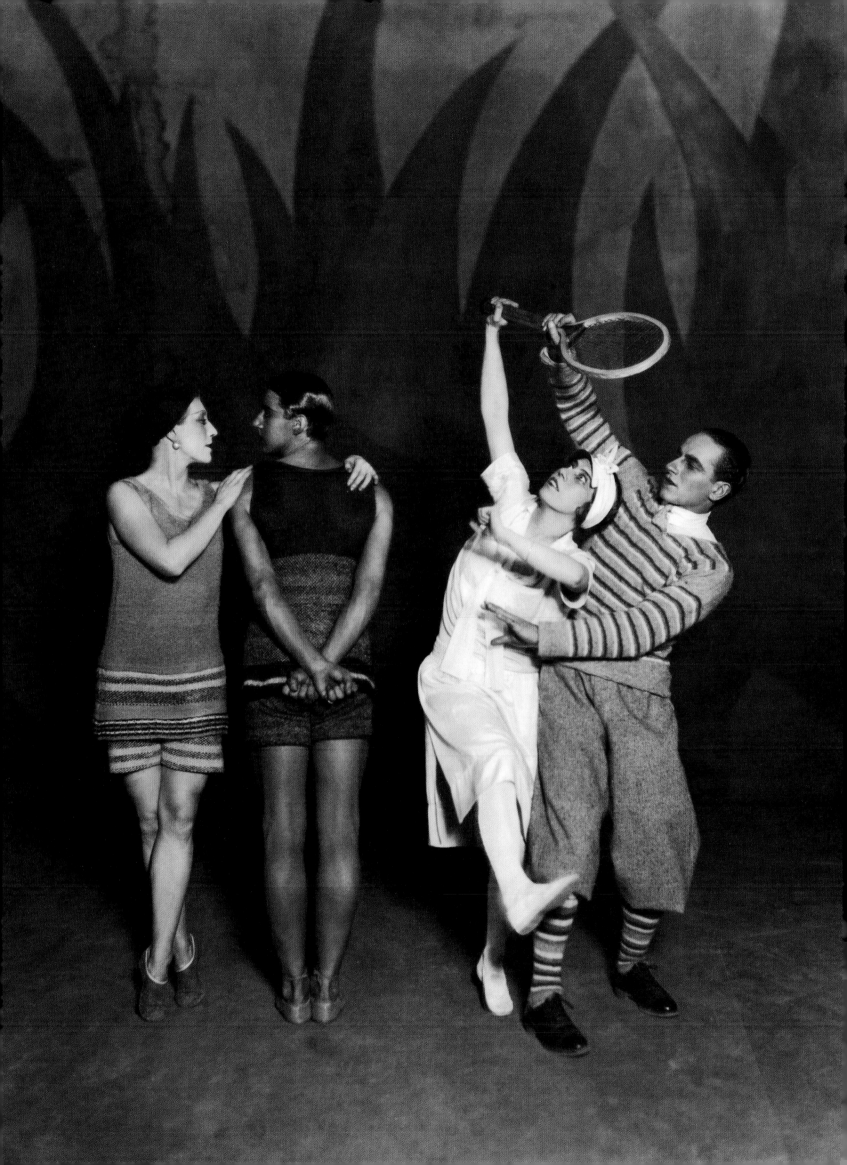

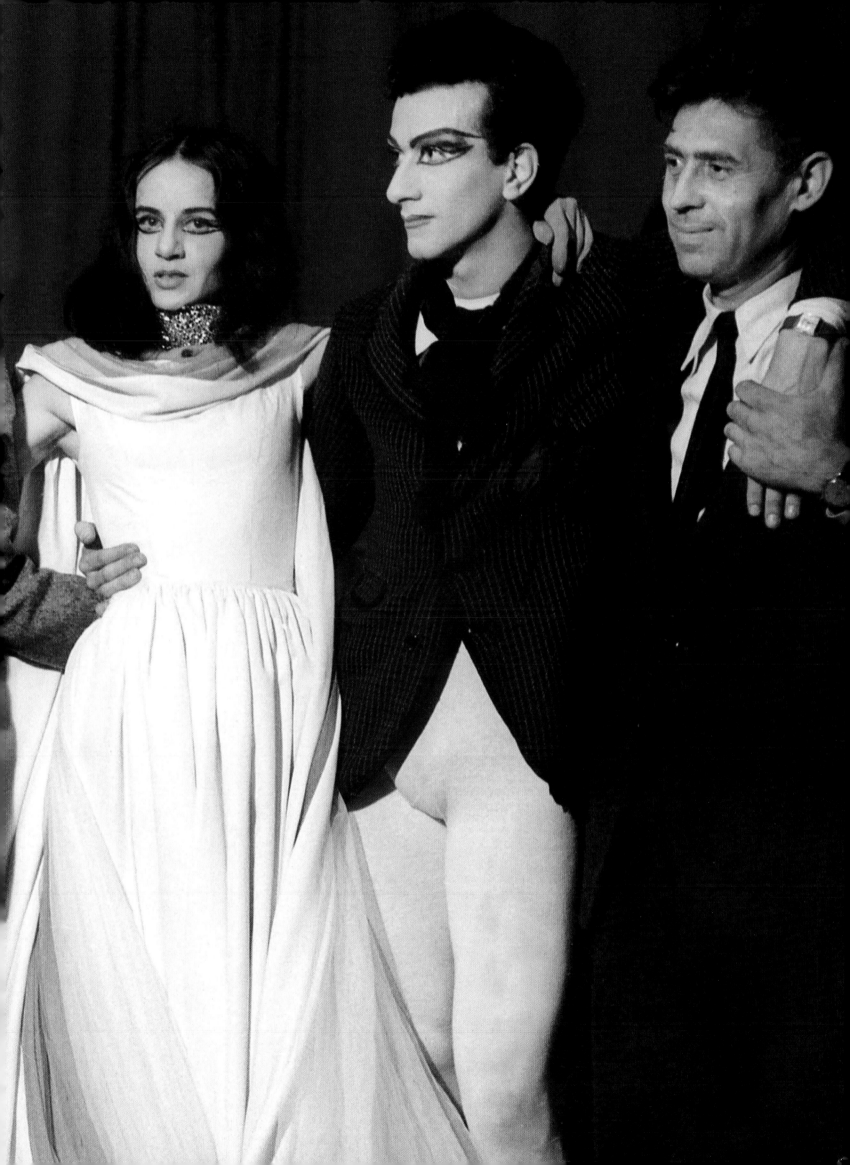

Nijinsky, Karsavina, and Pavlova were at the height of their powers, bringing profoundly new inspiration to an art that was also being raised to unprecedented heights by choreographers such as Fokine, Massine, Lifar, and Kochno, all of whom worked with Diaghilev. Diaghilev also turned to the greatest artists working in the plastic arts: first of all Bakst and Benois, whose work he had published in fine editions, and also José Maria Sert, Picasso, Derain, Rouault, and Cocteau. A sort of fraternity of former lovers grew up around him, creating friendships and a respect for the spirit of the master, both equally firm. Serge Lifar, Boris Kochno, Massine, and the composer Markevitch, later to be highly visible presences in café society, all in their own ways carried the legacy of Diaghilev. The shockwave unleashed by the Ballets Russes was also to touch other artistic fields such as the decorative arts, jewelry, and fashion. The vogue for orientalism that swept the world of couture was seen first in the work of Paul Poiret and then in that of Chanel, in whom this influence was strengthened by her friendship with Misia Sert, muse of Diaghilev, and her affair with Grand Duke Dimitri. The designer Charles Jacqueau made orientalism one of Cartier's major themes. Many Russians were to prosper in jewelry or haute couture in the years between the wars by following in the slipstream of the Ballets Russes. Lastly, the world of interior decoration took up the theme in its turn.

In intellectual circles and among the artistic avant-garde, the influence of the Ballet Russes triggered a lasting surge of popularity for dance that was to peak in the era of café society. Operating initially on the fringes on the Ballets Russes and then in competition with them, Étienne de Beaumont started the Soirées de Paris, and Rolf de Maré the Ballets Suédois. Picasso, Derain, and Bérard were all involved. Several of Diaghilev's choreographers directed the entrées at the private balls given by Étienne de Beaumont and Charles de Beistegui. Ballet in all its forms now became wildly fashionable.

The vogue for the "multiple author ballet" gradually gave way to the "choreographer ballet." Boris Kochno played a major part in this world, often in partnership with his friend Bérard, who designed the decors and costumes. Thus in 1930, Sir Charles B. Cochran entrusted Kochno with the direction of the Cochran Revue ballets. Balanchine and Lifar choreographed the *Revue 1930*, which was designed by Derain and Bérard. Meanwhile Lord Berners composed the music for *Luna Park* for the same company. In 1931, René Blum and Colonel W. de Basil founded the Ballets Russes de Monte Carlo, envisioning themselves as the heirs to Diaghilev. René Blum, brother of Léon, engaged Balanchine as maître de ballet, Bérard and Derain as designers and Kochno as artistic adviser. Tamara Toumanova made her debut with them at the age of thirteen. In 1933, Kochno and Balanchine started the Ballets 1933 company, which in its lifetime of a single summer premiered six new ballets choreographed by Balanchine. This company was financed by Edward James to showcase the talents of his then wife, Tilly Losch. The program was outstanding, comprising *Les Songes* by Darius Milhaud, with backdrop and costumes by André Derain; *The Seven Deadly Sins* by Kurt Weile and Bertold Brecht; *Fastes* by Sauguet, with backdrop and costumes by Derain; Schubert's *Der Wanderer*, with backdrop and costumes by Tchelitchew; *Job*, with a libretto by Maritain; and *Valses*, with backdrop and costumes by Emilio Terry.

In 1945, Roland Petit founded the Ballets des Champs-Elysées, with Gabriel Dussurget, future father of the Aix Festival, as administrator. *Les Forains* by Sauguet ushered in this new era, with backdrop and costumes by Bérard. In the meantime the Marquis de Cuevas had made his appearance, taking over the management of the struggling Ballets de Monte Carlo. Thanks to him, the company was to enjoy a remarkable decade, with outstanding productions including *Pièges de lumière* with a libretto by Philippe Hériat and *Romeo and Juliet* by Berlioz, performed in the Cour Carrée at the Louvre in 1955. The arrival of Nureyev in the West was to mark the end of this era of café society ballet companies.

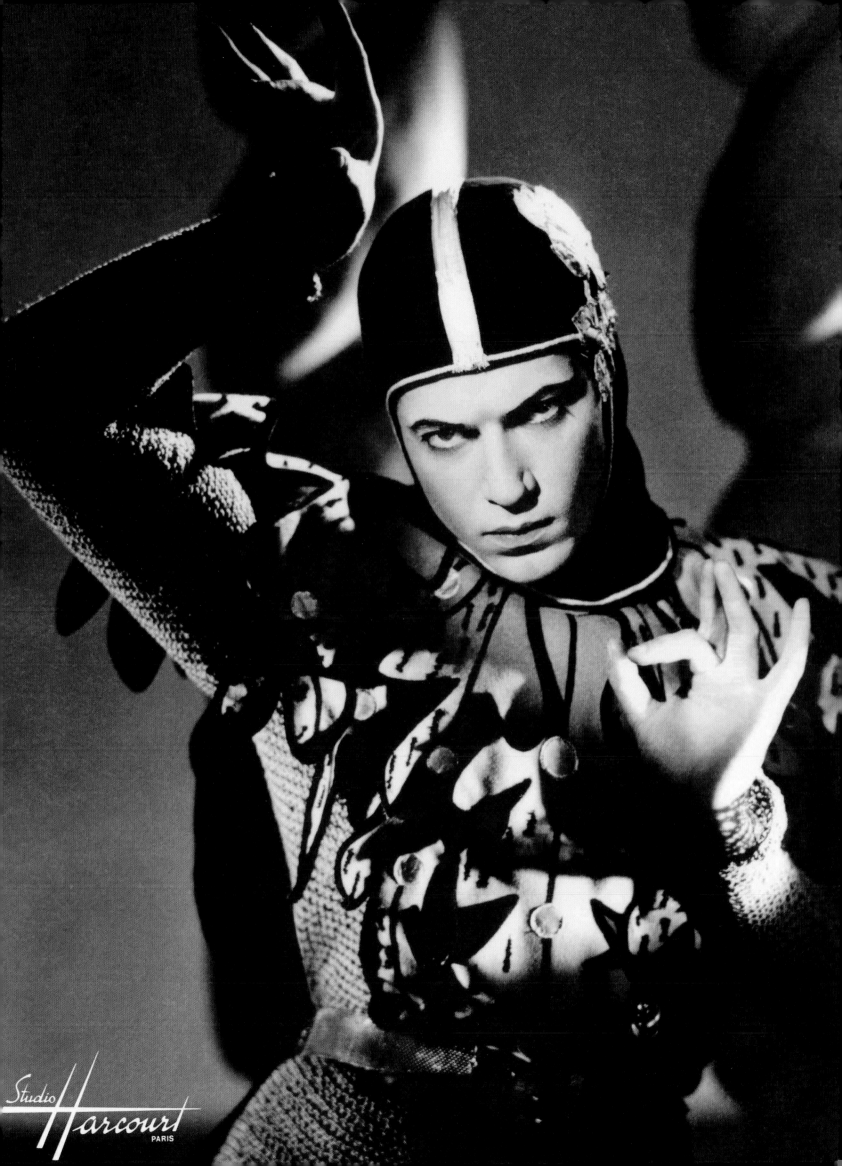

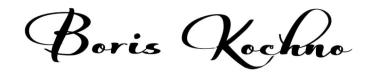

Boris Kochno

Facing page
Boris Kochno (left) and
Christian Bérard (center)
working on the sets for
a ballet, c. 1938.

Page 281
Serge Lifar and Felia
Doubrovska in the Sergei
Prokofiev ballet
The Prodigal Son.
Choreography by George
Balanchine to a libretto by
Boris Kochno, 1929.

Boris Kochno exemplified the deep bonds that linked the Ballets Russes to the beginnings of café society, as well as being one of the most striking representatives of the Slav component of this highly cosmopolitan milieu. He was also one of those ubiquitous and highly visible figures who was seen everywhere. Yet by his own choice he remained in the background: offering advice, discovering new talent, acting as go-between, he rarely—unlike so many of his contemporaries in café society—sought to put himself in the spotlight. Kochno took a back seat both with Diaghilev and with Bérard. After Bérard's death in 1949 he became an observer of—rather than a protagonist in—this milieu in which he forged himself such a special place.

The trajectory of Kochno's career was particularly unusual. He was born into the generation of Russians of distinguished family—his father was a colonel in the hussars and his mother heiress to a wealthy mining dynasty—whose lives were abruptly uprooted by the Revolution. Although he was only eighteen when he left Russia for France, and lived out his entire life in Paris until his death in 1990, he was always a Russian: a Russian in exile, who even kept his Russian nationality. A poet at an early age, on the road to exile he encountered other Russians who were prominent in the arts, notably the painter Pavel Tchelitchew and the composer Vladimir Dukelski, who changed his name to Vernon Duke and forged a career in America. The turning point of Kochno's life came one December evening in 1920, when he went to the Théâtre des Champs-Elysées to see a performance of the Ballets Russes. In the interval he bumped into the painter Soudeikine (whose wife Vera would later marry Stravinsky) who promised to introduce the dazzled young man to Diaghilev, a promise that he kept the following month. Taken with Kochno, Diaghilev engaged him as his secretary, with the following words of advice: "A secretary should know how to make himself indispensable." Taking him at his word, Kochno became one of the last lovers (before Markevitch and Lifar) of Diaghilev, who had just been abandoned by Massine (who was getting married). Before long he was creative advisor to the Ballets Russes.

In 1921 Kochno embarked on a parallel career as a librettist with Stravinsky's opera bouffe *Mavra*, based on a novella by Pushkin, followed in 1924 by *Les Fâcheux* after Molière, with music by Georges Auric, backdrop and costumes by Georges Braque and choreography by Nijinska, as for *Mavra*. He was to write libretti to music by Vernon Duke, Constant Lambert, Auric, Sauguet, and Nicolas Nabokov and to choreographies by Massine and Nijinska, with backdrop and costume designs by Braque, Max Ernst, Joan Miró, Tchelitchew, André Bauchant, Bakst, and Georges Rouault. By now Kochno was caught up in an intense social life as he followed Diaghilev between Paris, London, and

Venice (where Kochno had an affair with Cole Porter in 1925) and formed friendships with Chanel and Misia Sert. The second major turning point in his career came in 1929, when in August of that year, his health undermined by diabetes and a life of excess, Diaghilev died in Venice—leaving Kochno mired in deep rivalry with Diaghilev's last lover, Lifar. The two of them quarreled over his coffin before dividing his estate, consisting largely of works of art, between them. The enmity continued for some time, before they took the decision to wind up the Ballets Russes.

It was also in this year that Kochno met Christian Bérard, whose work he disliked and with whom he had always refused to collaborate in any way. The two men were to live together until Bérard's death twenty years later, sharing an active life in society and a passion for the theater that would see them collaborate with Jouvet, Balanchine, Barrault, and Cocteau. Kochno remained very active, nonetheless, in directing ballets and discovering new talents. He was involved notably in the Cochran Revue (1930), the Ballets Russes de Monte Carlo (1931), Les Ballets 1933 (working with Emilio Terry on the ballet and costumes), and the Ballets des Champs-Elysées (1946), in which Roland Petit made his debut. At the same time he also continued to write numerous libretti, collaborating with Christian Bérard, Jean Hugo, Emilio Terry, André Derain, Beaton, and Balthus for the backdrops and costumes. Throughout this period, Bérard and Kochno became one of the most visible couples in Paris high society, regularly to be seen at soirées hosted by Marie-Laure de Noailles, Marie-Blanche de Polignac, and Étienne de Beaumont (even though the Ballets Russes were his rivals over the Saisons de Paris in 1924), before becoming prominent members of the small, select, and very café society circle that gravitated around Lady Diana Cooper and the British embassy from 1944. The grand balls of the period were greatly indebted to them: while Bérard looked after the decors and costumes, Kochno took care of the choreography. Artists and society figures rubbed shoulders at their apartment at 2 rue Casimir-Delavigne, whose interior decorations—painted by Serebriakoff and photographed by Beaton—attained cult status.

A third turning point in Kochno's life came in 1949, with the demise of both Bérard and the Ballets des Champs-Elysées. More dependent than ever on drink and drugs, Kochno now led a melancholy life, withdrawing into a hermit-like existence at his small house on rue Marie-Stuart, and watching over the collections that were all that was left of a dazzling career. Making occasional sorties for grand events such as the Beistegui Ball in Venice, which he oversaw in 1951, he found his new vocation only in 1970. From then until his death in 1990, he became the great witness to a legendary era, making films and staging exhibitions devoted to the two men of his life: Diaghilev and Bérard.

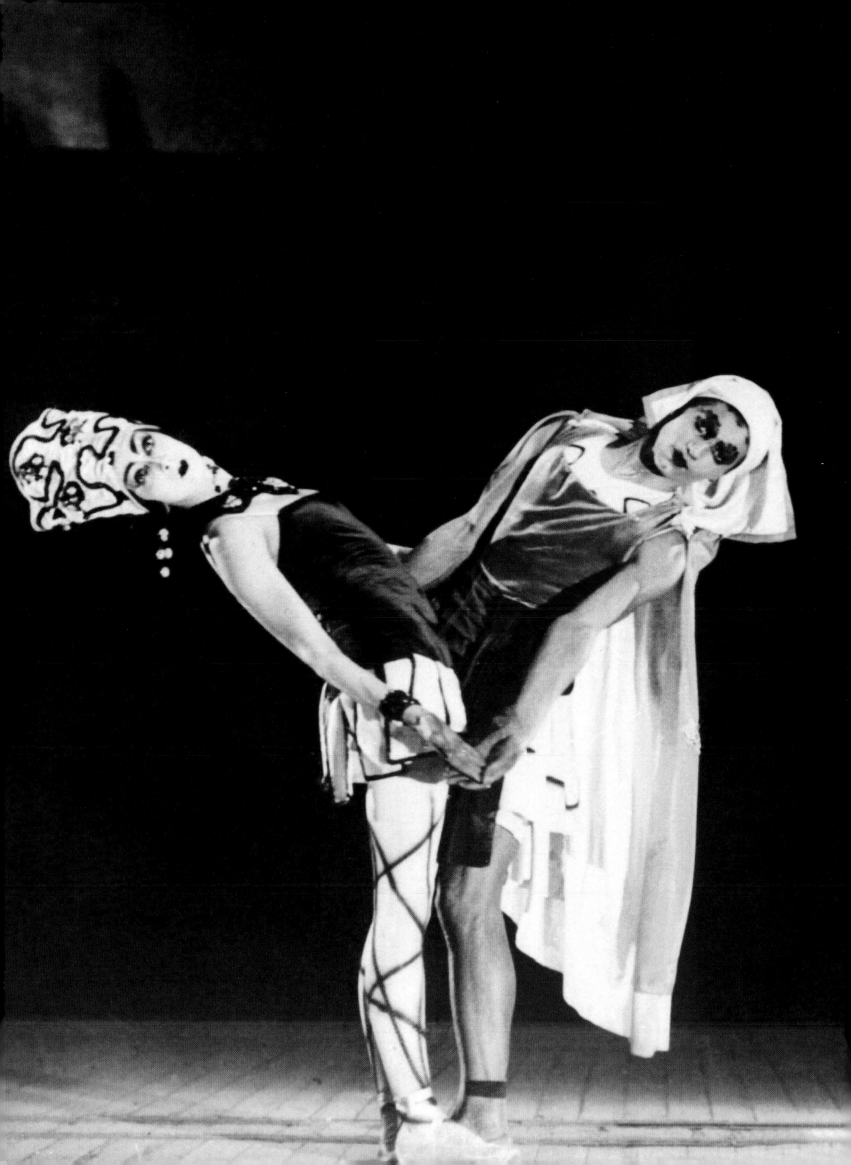

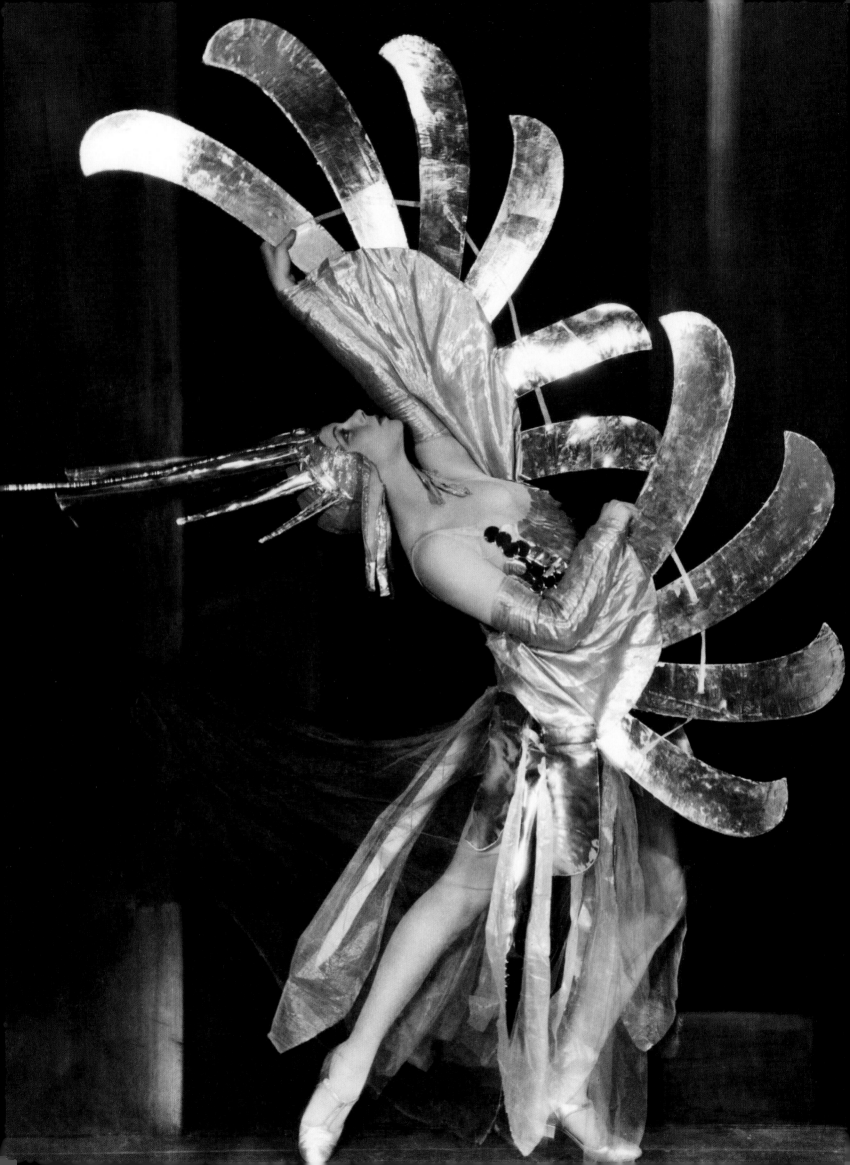

Tilly Losch

Born in Vienna, Tilly Losch was a dancer at the ballet school of the Vienna Opera at a very early age; there she caught the eye of the director, Richard Strauss, who began to entrust her with steadily larger roles. In 1927, Max Reinhardt engaged her for *A Midsummer Night's Dream*, then in 1932 offered her the role of the nun in *The Miracle*, for which she also contributed to the choreography. Diana Cooper played the Madonna, and Oliver Messel designed the sets. Soon after this, Losch married the celebrated collector and patron Edward James. Their relationship was a stormy one, but James was besotted with Losch, had apartments decorated in spectacular fashion for her, and even founded a ballet company for her benefit: Les Ballets 1933, famous for creating Weill and Brecht's *Seven Deadly Sins*. The two principal roles were taken by Losch and Lotte Lenya, and the choreography was by Balanchine and Kochno. Marie-Laure de Noailles played the go-between in the affair, as it was she who introduced James to Kochno and Balanchine. Although the company barely survived the tempestuous marital problems of Losch and James, this production was nevertheless its masterpiece.

Following a sensational divorce, the bewitching Viennese dancer, whose enigmatic, sensual features numerous great photographers (including Horst, Hoyningen-Huene, and Beaton) and painters (Bérard, Messel, and Tchelitchew) tried to capture, performed in numerous ballets, notably those staged by Cochran, as well as in musical comedies by Cole Porter. She also acted in Hollywood movies including *The Garden of Allah* (1936) and *Duel in the Sun* (1946). Meanwhile she married again, this time to Lord Carnarvon, son of the man who famously discovered the tomb of Tutankhamun. After the war, divorced once more, she devoted her energies essentially to painting, in which she was supported by Cecil Beaton.

Facing page
Tilly Losch in the ballet
Wake Up and Dream,
produced by
Charles B. Cochran.
Music by Cole Porter, 1929.

Music

Although few musicians or composers were members of café society, music was a major interest of some of its coteries. Some patrons and benefactors went beyond the parameters of fashionable taste to support musicians and display a genuine interest in music. The musicians who frequented café society fell into three groups, who sometimes overlapped in various salons: the French, the English, and the Americans. In France, the Groupe des Six,[1] closely linked with Cocteau and Christian Bérard, lay at the heart of the nexus. Some of its members were Parisians such as Henri Sauguet, Francis Poulenc and especially Georges Auric, whose wife Nora, an occasional painter of society portraits, was a prominent socialite generally seen on the arm of her escort, Guy de Lesseps.

These musicians were to be seen at the salons of Marie-Laure de Noailles, Marie-Blanche de Polignac, Charles de Beistegui, and Louise de Vilmorin. Often they were joined by performers such as Maurice Gendron and Robert Veyron-Lacroix, especially at the Noailles salon. Most of the composers worked for the Ballets Russes, with a special place reserved for the composer and orchestra leader Igor Markevitch. This lover of Diaghilev also had a sensational affair with Marie-Laure de Noailles in the 1930s: she ran away to Switzerland with him, and as a result was placed by her family under the supervision of financial trustees. Markevitch was also a frequent presence at the salons of Winnaretta and Marie-Blanche de Polignac, who commissioned a number of his works. His career owed a great deal both to his society connections and to his personal charm. A pupil of Nadia Boulanger and Alfred Cortot, Markevitch subsequently worked with Cocteau, Kochno, and Lifar, and in 1936 he married Nijinsky's daughter Kyra. His memories, published in *Etre et avoir été,*[2] are a valuable record of the musical world of the 1930s and 1940s, and of the close relationship between the artistic tastes of art patrons and their private lives.

In England, certain composers had very close links with members of café society. William Walton, for instance, formed friendships at Oxford with the poets Sacheverell Sitwell and Siegfried Sassoon. Thanks to the Sitwells, he was close to the Bright Young People and moved in the same circles as Cecil Beaton and Rex Whistler and his friends, as well as Peter Quennell, Noël Coward, and Lytton Strachey, a prominent member of the Bloomsbury Group. Walton and Edith Sitwell came to fame in 1923 with *Façade*, a cycle of poems with a jazz-influenced musical accompaniment, which prompted a good deal of controversy around the idea of modernism. During the war, Walton was given leave

Facing page
The Groupe des Six: Francis Poulenc, Jean Cocteau, Arthur Honegger, Germaine Tailleferre, Louis Durey, and a portrait of Georges Auric, 1931.

Page 286
A musical soirée in the salon of the Vicomte and Vicomtesse de Noailles in the Hôtel Bischoffsheim, Paris. c. 1938.

1. When asked, "Do you know the Groupe des Six?," Ned Rorem invariably replied, "Yes, all five of them."
2. Igor Markevitch, *Etre et avoir été,* Paris: Gallimard, 1980.

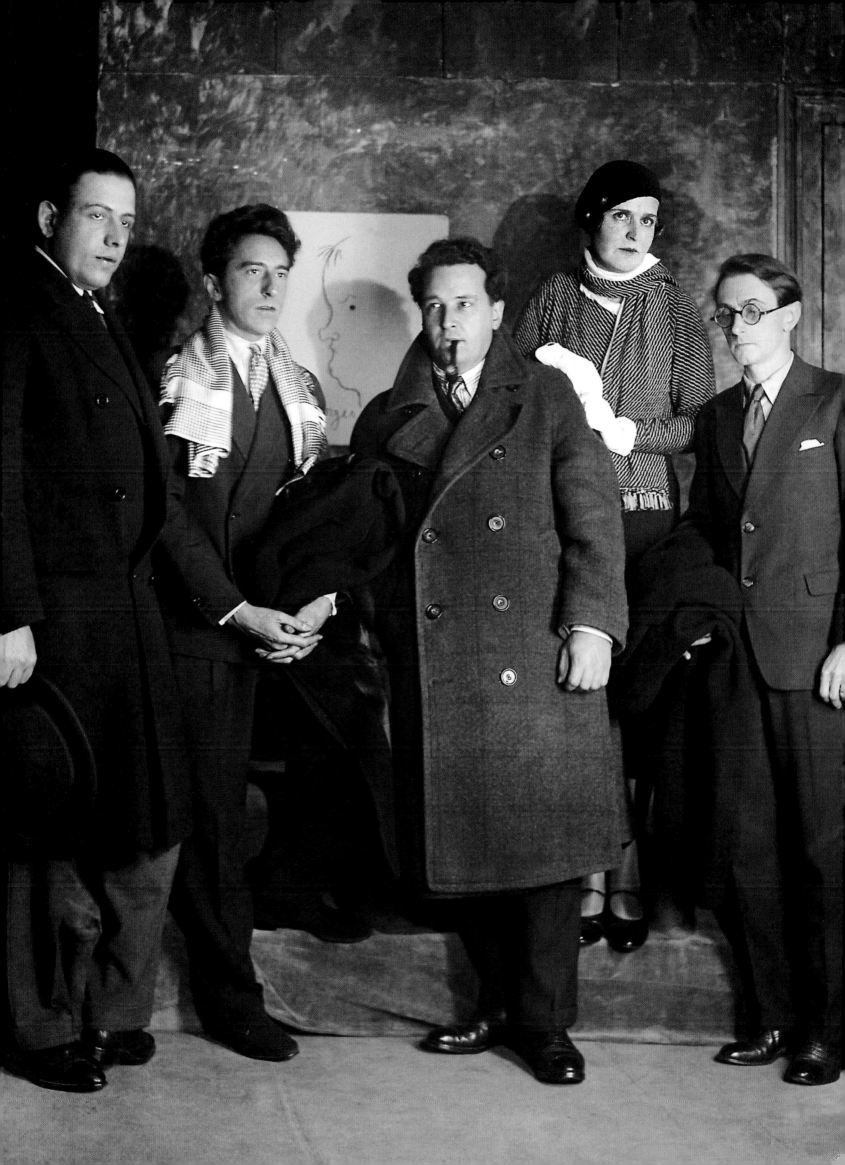

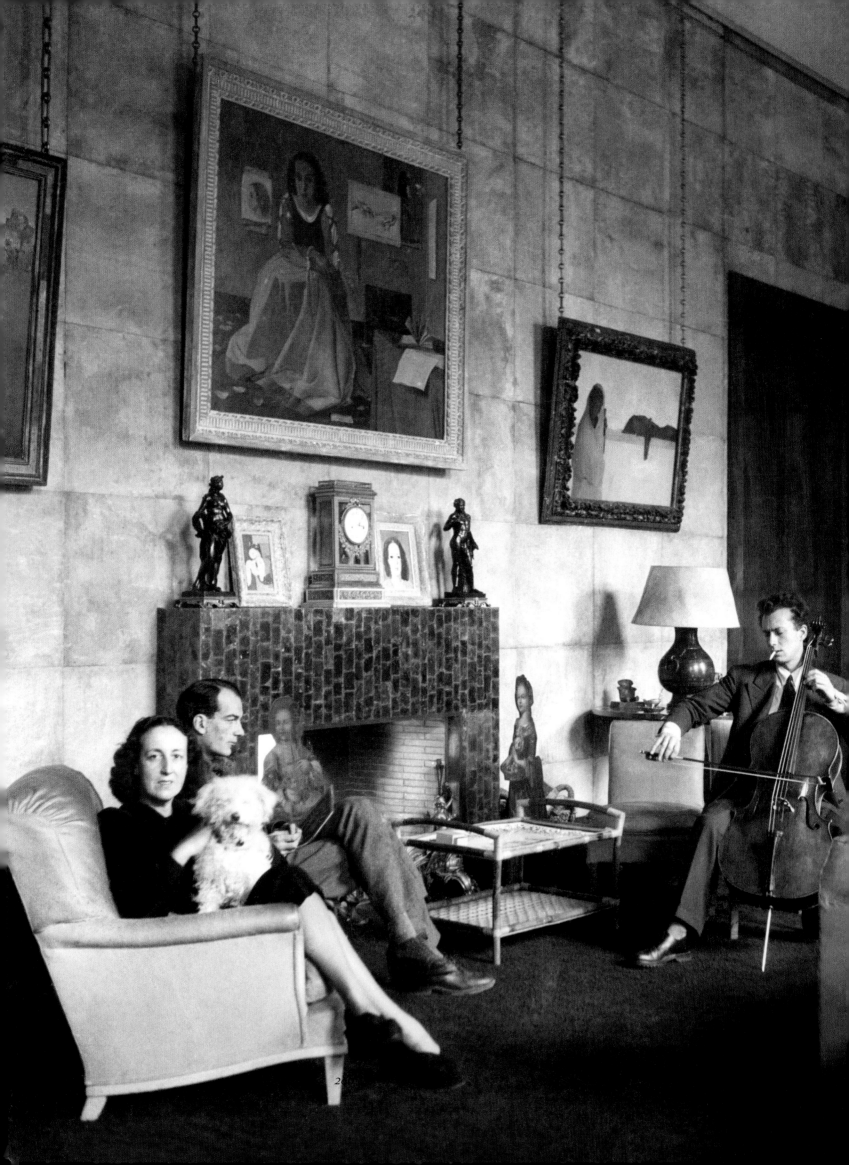

of absence from the army to compose the music for wartime propaganda films, including notably Olivier's *Henry V*, and after the war he distanced himself from café society circles.

Lord Berners, meanwhile, was a famously eccentric figure of protean talents in numerous different fields, including literature, painting, and above all music, the area in which he was most innovative. Born into the old aristocracy, he was schooled at Eton, and as a young dandy spent time in Dresden, Vienna, and Rome, joined the diplomatic service, and was posted to Constantinople and Rome. On his father's death in 1918 he inherited his title, becoming the fourteenth Lord Berners, and a vast estate including Faringdon, the famous country house outside Oxford, where for the rest of his life he would entertain a cosmopolitan mix of figures of distinction, including numerous members of café society. The guest list at his house parties might include the Sitwells, the Mitfords, the Duff Coopers, Cecil Beaton, Oliver Messel, Christian Bérard, Winnaretta de Polignac, Diaghilev, Stravinsky, Rex Whistler, Lee Miller, Gertrude Stein, Elsa Schiaparelli, and George Wells, among many others. Stravinsky, who had been deeply impressed by Berners' first songs in advanced avant-garde style, encouraged him as a composer, and later considered him the finest British composer of the twentieth century. In 1926, Berners achieved considerable success with the music for his first ballet, *The Triumph of Neptune*, to a scenario by Sacheverell Sitwell. The ballet was staged by Diaghilev's Ballets Russes, of which Berners was an ardent admirer. He and Constant Lambert were the only British composers to whom Diaghilev gave commissions. In 1930, Berners composed *Luna Park* for the C.B. Cochran Revue, and *A Wedding Bouquet, Cupid and Psyche*, and *The Sirens* to choreography by Frederick Ashton and with Constant Lambert as musical director. Walton and Lambert were the only British composers whose work Berners respected, and he became close friends with both of them. During the 1940s Berners composed music for films, before abruptly stopping all his creative work and slipping ever deeper into depression until his death in 1950.

The third group of composers in café society was American in origin. Leaving aside for a moment the most emblematic of them all, Cole Porter, whose lighter works often drew on café society for their inspiration, there were many others who were an occasional presence, finding it a useful way of promoting their nascent fame, or simply of earning a living. In the years between the wars, American composers in Paris formed a veritable colony, strongly influenced by the musician and composer Nadia Boulanger, herself very close to Marie-Blanche de Polignac. Even composers as typically American as Aaron Copland and Virgil Thomson, so concerned to give American music its own identity, were marked by their time in Paris. The same was equally true of Walter Piston and Eliot Carter. There were occasions on which Americans collaborated between themselves. Thus Thomson worked on two operas with libretti by Gertrude Stein: *Four Saints in Three Acts* and *The Mother of Us All*. American musicians were also received here and there at the major musical salons.

Ned Rorem's Paris diary describes perfectly the life of a young American just arrived in Paris, introduced to Marie-Laure de Noailles by Henri Sauguet and mixing in the superficial byways of café society. It wasn't hard, he observed, to gain access to the "holy of holies" of Parisian snobbery. All you had to do was get to know one member, and within twenty-four hours (and a single soirée) you knew them all. It was a society that counted a mere seventy-five members or thereabouts (of whom were the musicians were the most chic), and nothing could have been simpler than getting on familiar terms with seventy-five individuals in the space of twenty-four hours.[3] The homosexual Rorem was

3. Ned Rorem, *Paris Diary and New York Diary*, New York: Da Capo Press Inc., 1998, p. 14.

one of the many to embark on a passionate relationship with his benefactress. In his diary he described the role played by women such as Marie-Laure de Noailles and Peggy Guggenheim, who mixed their private lives with their passion for art: He understood, he said, that what she had given him above all was the time and leisure to work. Not merely did she put three pianos at his disposal, sponsor his concerts and clothe, feed and lodge him, but it was also largely thanks to her that he stayed so long in France to compose.[4] Very quickly, through the interlocking networks of café society, in which one moved seamlessly from the salon of Marie-Laure de Noailles to that of Marie-Blanche de Polignac, which also included Leonard Bernstein and Gian Carlo Menotti, young talents could acquire a reputation throughout society circles in Paris, which a socialite such as Lily Volpi or Mimi Pecci-Blunt would then convey to Italy. Through its network of benefactors, café society above all offered a sounding box—as well as financial support—to young composers and performers. The most important of these musical salons, with influence throughout Europe, was that of Winnaretta de Polignac, one of the Singer sewing machine heiresses.[5] The aunt of Daisy Fellowes and related by marriage to Marie-Blanche de Polignac, Winnaretta Singer married Prince Edmond de Polignac, son of the former Président du Conseil to Charles X. She was lesbian and he was homosexual, but they shared a profound and companionable love of music, and from the closing years of the nineteenth century until her death, "Aunt Winnie" presided over a musical salon that was frequented by Proust, who published an article about it. For a few weeks every year the salon migrated to the Polignac palazzo in Venice. Winnaretta, herself a pianist and organist, commissioned numerous works from Igor Stravinsky (*Renard* and *Les Noces*), Erik Satie (*Socrate*), Darius Milhaud (*Orphée*), Manuel de Falla (*El Retable de Maese Pedro*), Igor Markevitch and Francis Poulenc (*Concerto for Two Pianos in D Minor* and *Concerto for Organ and Orchestra*), Jean Wiener (*Concerto américain*) and Germain Tailleferre (*Concerto for Two Pianos*). With the support of other musical patrons, including Gabrielle Chanel, David Weill, Christian Lazard, and Alfred Cortot, the Polignacs founded the Orchestre Symphonique de Paris, the only other large French orchestra apart from that of the Paris Opera, with Ansermet and Fourestier as its first conductors. Winneretta was also a fervent supporter of the Ballets Russes, and it was she who launched the American dancer Isadora Duncan in Paris.

Coincidentally, it was another Polignac (by marriage) who held the other important musical salon: Marie-Blanche de Polignac, daughter of Jeanne Lanvin. Marie-Laure de Noailles also attracted numerous musicians, even though this was not her main passion. The Noailles commissioned Poulenc to write *Aubade*, a concerto with choreography premiered at their *hôtel particulier* on place des Etats-Unis, as well as commissioning the cantata *La Voyante* for the theater at Hyères from Sauguet and an oratorio from Markevitch. After the war they limited themselves to giving concerts in their Italianate rococo ballroom, performed by regular house guests such as Maurice Gendron and Robert Veyron-Lacroix. Based in both Paris and Rome, Mimi Pecci-Blunt also presided over a musical salon of distinction, as did Lily Volpi in her husband's Venetian palazzo. And last but not least, café society also formed a faithful festival audience, whether at traditional institutions such as Bayreuth or Salzburg, or at more recent venues such as Glyndebourne, Spoleto, and above all Aix. Founded on the initiative of Comtesse Pastré, close friend of Chanel and Bérard, with the support of the young Edmonde Charles-Roux, Aix was directed for decades and indelibly shaped by Gabriel Dussurget.

Facing page
Lord Berners with the Ballets Russes dancers Serge Lifar and Alexandra Danilova at a rehearsal for the ballet *The Triumph of Neptune*, composed by Berners, 1927.

4. Ibid.
5. Prompting Cocteau to remark acidly that she loved music the way a sewing machine loves sheets.

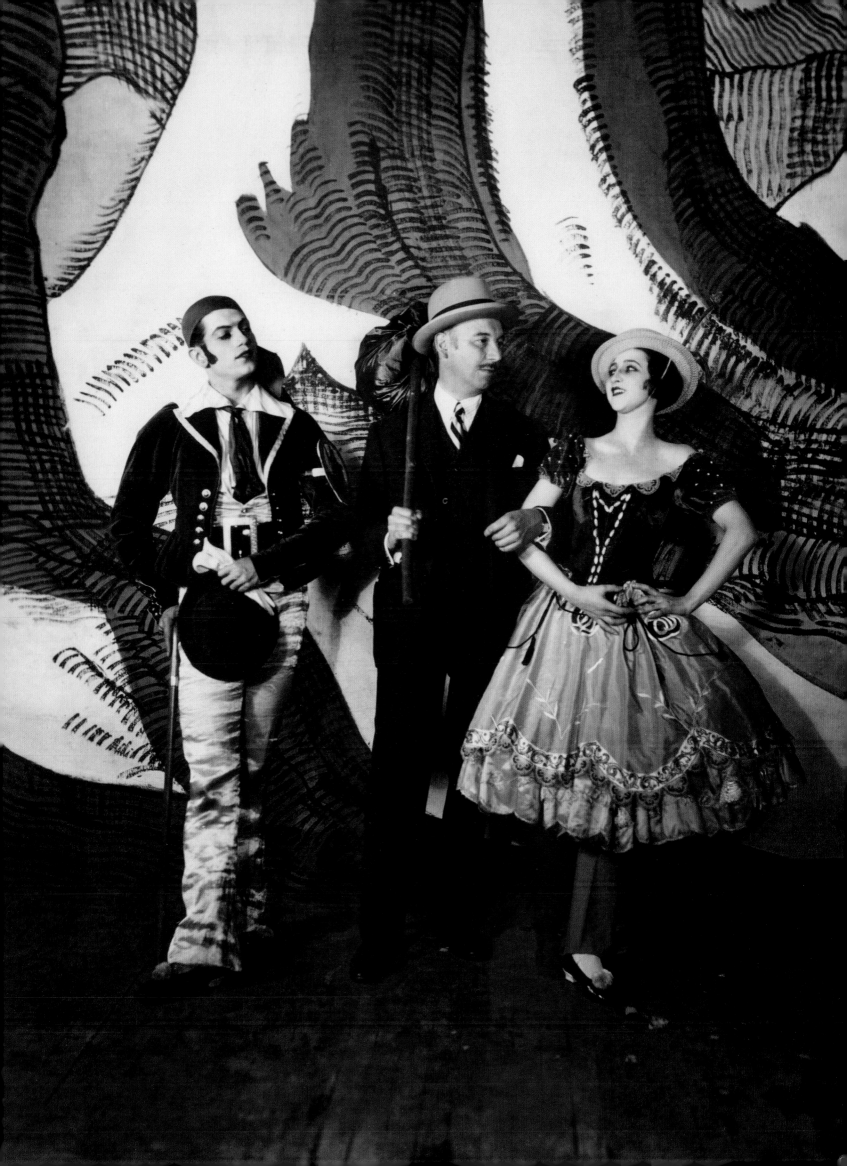

Marie-Blanche de Polignac

Among the many aspects of Marie-Blanche de Polignac's character perhaps the most dominant was her outstanding role as a patron of musicians. Yet at first glance this was not the most obvious thing about her. Born Marguerite di Pietro in 1897, Marie-Blanche was the daughter of the couturier Jeanne Lanvin and an Italian count who was briefly part of her life. The young Marguerite was to play an indirect yet defining role in the couture of her era, as her mother, besotted with her only child, designed numerous dresses for her. "It was in order to fill her with wonder that, as one thing led to another, she filled the whole world with wonder," summed up Louise de Vilmorin in the 1930s. In 1920, Marguerite married Dr. Jacquemaire, grandson of Clemenceau, who died of diphtheria soon after. In 1924 she married again, this time to Comte Jean de Polignac, and changed her name to Marie-Blanche. "With the charming and slightly mannered appearance of Louis XV marquise, coquettish and teasing, she left men all around sighing for her while herself giving very little, faithful as she was to the husband whom she loved," remembered Jean-Louis de Faucigny-Lucinge.[1] Her suitors were numerous, nevertheless, with Edouard Bourdet in prime position.

Marie-Blanche and Jean de Polignac led a very active life in society until his death in 1943, becoming one of the prominent young couples—with the Noailles and the Faucigny-Lucinges—who entertained a great deal and moved in avant-garde circles. Their *hôtel particulier* on rue Barbet-de-Jouy, next door to that of Jeanne Lanvin, and their houses at Kerbastic in Brittany and La Bastide au Roy near Antibes were highly valued meeting places for all those in quest of entertainment or creative inspiration at this period. Cocteau and his circle were very close to Marie-Blanche, united by tastes that could not always be publicly shared: according to Paul Morand, Marie-Blanche was "the most elegant opium-smoker in Paris." Bérard decorated her famous dining room "in the style of Raphael," and Emilio Terry designed her library. Jean Giraudoux, Edouard Bourdet, and of course Jean Cocteau gave advance readings of their plays at her salons, whose walls were hung with canvases by Renoir, Degas, and Vuillard.

But it was in the realm of music, above all, that the influence of the Comtesse de Polignac was most noteworthy. A pupil of Nadia Boulanger, with whom she had contributed to the rehabilitation of Monteverdi's oeuvre, and endowed with a fine voice that enabled her to give wonderful recitals, she presided over a genuinely musical salon, even if she liked to say, "I have no salon, I have only friends." The top floor of her *hôtel particulier* was furnished for this purpose, with two pianos and an organ permanently in place. Poulenc, Auric, Sauguet, Février, Milhaud, Rampal, Fournier, and Gendron were all among her regular guests, joined by numerous foreign musicians who were staying in Paris or passing through, such as Rubinstein, Horowitz, Bernstein, Britten, Menotti, and Rorem. She died in 1958, from a brain tumor that seriously handicapped her last years. At her funeral in the church of Saint-François-Xavier, Nadia Boulanger conducted a performance of Fauré's *Requiem*.

1. Jean-Louis de Faucigny-Lucinge, *Un gentilhomme cosmopolite*, Paris: Perrin, 1990, p. 101.

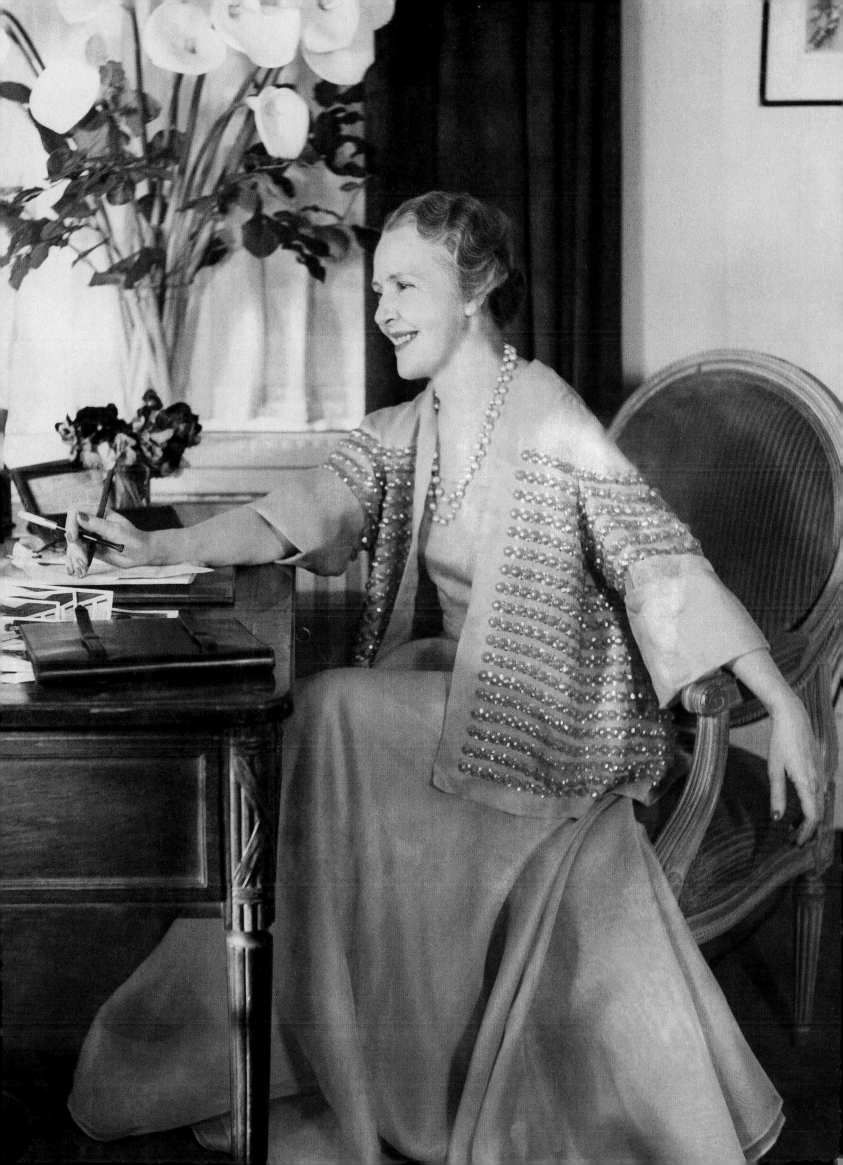

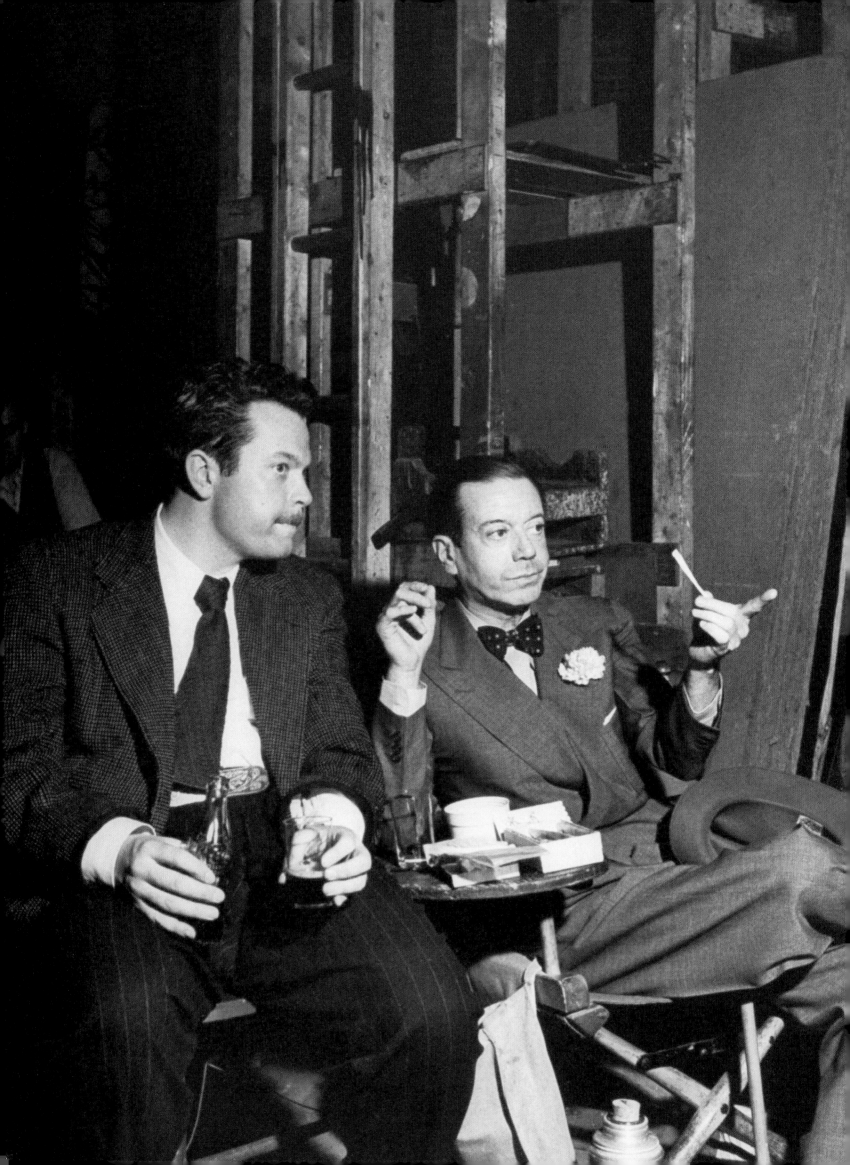

Cole Porter

For many years before he finally attached himself to café society, the life of Cole Porter played out like that of a character in a novel by Scott Fitzgerald. According to his friend Elsa Maxwell, his personality was more interesting than his genius for theatre. Both his temperament and his career flew in the face of the conventional idea of a composer of popular songs. While most songwriters started their careers in the seedy dives of the Bowery or the the equally rundown Tin Pan Alley,[1] Cole Porter dashed off his first success, *Bulldog Yale*, while comfortably installed in a bungalow provided by the university.[2]

Everything in this American composer's life was at once very easy and very difficult. He loved France, and made several extended stays there. Money was never a problem, even if he always spent more than he had. Born into an extremely wealthy family, in Paris in 1919 he married Linda Lee Thomas, an equally wealthy divorcee and member of international high society, who was also considered as one of the great beauties of New York. It was described at the time as the marriage of "the boy with a million dollars to the girl with two million dollars." Highly gifted musically, Porter studied violin and piano from childhood and studied at Harvard School of Music and with Vincent d'Indy at the Schola Cantorum in Paris. Already as a student at Yale he had started to write numerous songs. Nonetheless, his musical career got off to a difficult start. His first musical comedy, which opened on Broadway in 1916, was a total flop, despite being produced by Elisabeth Marbury, one of the greatest impresarios in the world and a close friend of Elsie de Wolfe. Disheartened by this failure, he signed up in the French Foreign Legion and served in North Africa, where he was awarded the Croix de Guerre—more for keeping up the troops' morale, it would appear, than for the feats of valor that the eternally enigmatic Porter later claimed. Returning to Paris, he threw himself into society life, in which he played a prominent part throughout the 1920s.

Porter and his wife lived life in European society at a dizzying pace, giving extraordinary parties in their *hôtel particulier* on rue Monsieur, redecorated for them in the latest style (featuring praline-colored wallpaper, floor-to-ceiling mirrors, and zebra-striped upholstery) by the British couturier Molyneux. The garden, meanwhile, was transformed into a Normandy orchard. The parties thrown against this backdrop were famed for their ultra-Parisian gossip and witty repartee (earning the couple the soubriquet *les coleporteurs*, a play on the French for gossipmonger, *le colporteur*). In summer they rented the Château de la Garoupe near Antibes, home to Gerald and Sara Murphy, who embodied the haute

Facing page
Orson Welles and Cole Porter on the set of *Around the World*, a series for American television, 1946.

Following pages
Cole Porter at a rehearsal on Broadway for his musical comedy *Wait for Baby*, 1936.

Page 297
William Rhinelander Stewart Jr., Elsa Maxwell, and Cole Porter at the Café Basque in New York, at a celebration given in Cole Porter's honor, 1934.

1. The section of West 28th Street between Fifth and Sixth Avenues, famous for its music publishers and songwriters.
2. Elsa Maxwell, *I Married the World: Reminiscences*, London, William Heinemann, 1955.

bohemia of the Riviera. In 1923 they rented the Ca' Rezzonico palazzo in Venice, where they entertained in lavish splendor—with a brief interruption when Porter had to flee the city, accused of organizing orgies with young boys, including the son of the chief of police.

It was at this time that the Cole Porters became close to Elsa Maxwell, who took over the organization of their many festivities. They mixed with all the party-goers, writers, and artists of the American colony in France: Scott and Zelda Fitzgerald, Hemingway, Louis Bromfield, Harry and Caresse Crosby (patrons and close friends of Man Ray and Lee Miller), Howard Sturgis (supposed to be the most learned American in Paris), and Noël Coward (a co-opted member of the American fraternity). They were also seen at grand balls, especially those given by Nicky de Gunzburg. Finally, they also had links with the Faucigny-Lucinges and numerous other prominent members of French café society. Porter's love of all that was frivolous and trivial, of pranks and practical jokes, did not prevent him from composing a great deal, even if few of his compositions were successful at this time. The trigger for his success was to be a commission in 1927 for a musical comedy called *Paris*. The New York producer believed, rightly, that Porter's intimate knowledge of France and Europe would lend the project and his tunes an extra touch of authenticity. Now success was his at last, and he found himself king of Broadway in the 1930s with a string of shows that included some of his most celebrated songs: *Fifty Million Frenchmen, Make Up and Dream, The New Yorkers, Gay Divorce, Anything Goes, Red, Hot and Blue, Dubarry was a Lady,* and *Jubilee*.

From then on, Porter lived more in the United States, though with a lifestyle that remained very cosmopolitan. He made many trips to Europe, and kept close ties with major European figures of café society who had emigrated to America, including Natalie Paley[3] and above all Fulco di Verdura, whom he had met in Palermo in 1919, during his honeymoon with Linda. Fulco di Verdura designed many pieces of jewelry for the couple, who loved haute jewelry and were major clients of Cartier. Porter also mixed with Greta Garbo and her entourage, as well as with most of the great photographers, including Beaton, Horst, and Hoyningen-Huene.

The year 1937 marked a fateful turning point in his life, when a serious riding accident left him with permanent leg injuries. After over thirty operations, one of his legs was finally amputated in 1958. Although constant pain cast a cloud over his fun-loving lifestyle— except during the Second World War—it did not affect his musical prowess in the 1940s, which saw the triumphant success of *Kiss Me, Kate*. Linda's death in 1954 was to leave this ageing child distraught, and the 1950s and 1960s were to be lonely decades for him. Together they had been a café society couple *par excellence*, united by passions other than love, as Cole Porter never hid his preference for men—a taste he indulged with great freedom, as may be glimpsed in some of his musical comedies. He died in Hollywood in 1964, after being awarded an honorary doctorate by Yale.

3. Natalie Paley's husband, Jack Wilson, was the producer of *Kiss Me, Kate*.

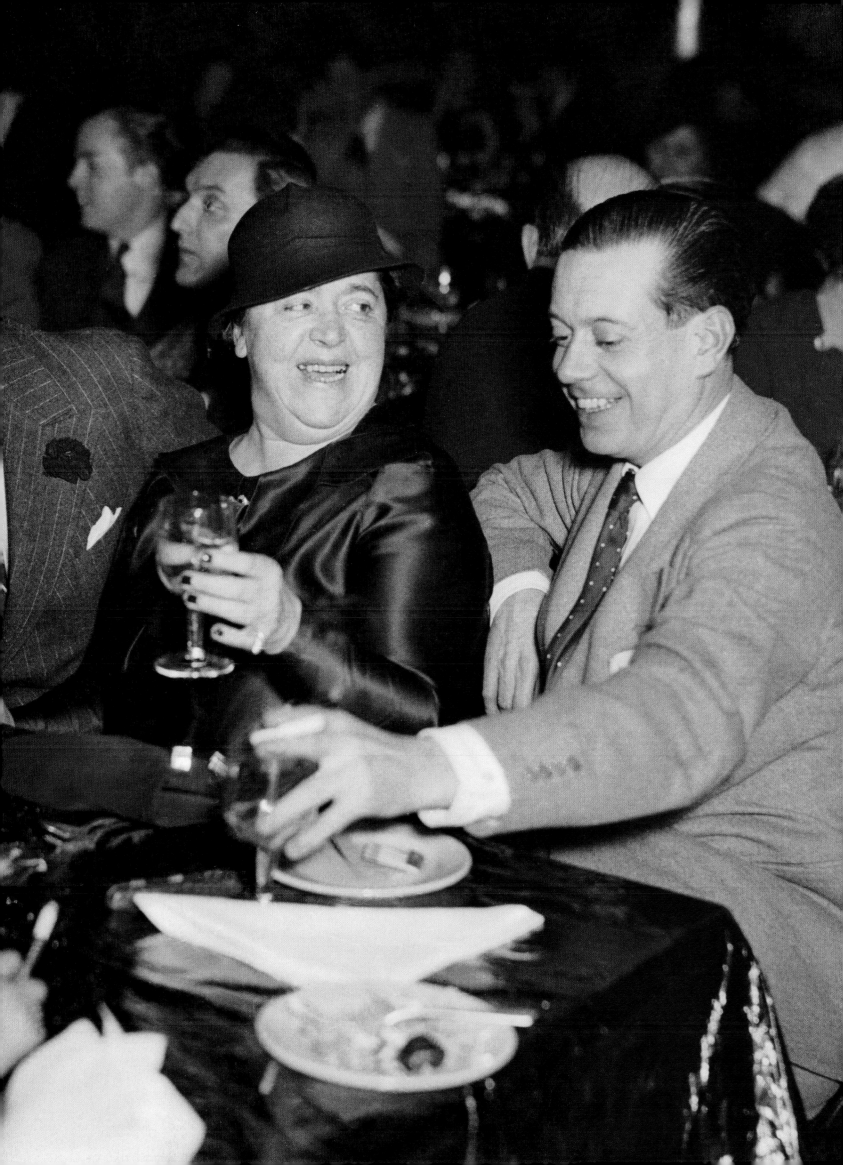

Literature

Although café society features in numerous works of literature, the writer who is undoubtedly most closely associated with it is Philippe Jullian, who brought the name into common currency with his cult success *Café Society*, published in 1962. Yet no one could have predicted that this boy from a modest if literary bourgeois family in Bordeaux would become the chronicler of an international society set that elected Paris as its center of gravity. Jullian was an unusual character, an aficionado of society and of men, who was also deeply modest and discreet, with a lifelong passion for antique furniture, aristocratic women, and a particular form of snobbery—as well as a morbid fascination with decadence and death. He committed suicide in 1977, at the age of fifty-six.

Jullian's trajectory in society is similar to that followed by Proust. Intrigued by society without ever really being taken in by it, he made strenuous efforts to gain an entrée into every salon of the post-war years, largely through the influence of his friend Lefèvre-Pontalis, "orphan" of Louise de Vilmorin. "Insouciance was his form of elegance of mind, impertinence his courage, and cynicism his modesty."[1] As his biographer Ghislain de Diesbach notes, this insouciance, allied with a cruel eloquence and easy wit, was the *sine qua non* for securing an invitation to the most exclusive salons of the era. Jullian began by cultivating Elizabeth Monod, a lifelong friend, followed by a set of young dandies including the dramatist Jean-Pierre Grédy and the writer François Sentein. Very soon he became an assiduous habitué of the salons of Marie-Laure de Noailles and Lise Deharme. Above all, he became the close friend of Daisy Fellowes' daughter Isabelle de La Moussaye. Now launched in society, he counted among his friends Nancy Mitford, the Duff Coopers, and Violet Trefusis, whose biographer he would later become.

Meanwhile, his talents as an illustrator and writer lent him a certain depth, although his weakness for society and the social whirl ensured that his tastes were limited to the minor arts. On his death, one of his friends observed, "As a novelist he made the mistake of thinking that you could be 'Proustian' by means of anecdotes alone, but he soon found his true vocation. As a biographer, engaged and at ease with his subject, he was the equal of the best British writers of the genre, with a superb and inexhaustible breadth of culture, and an encyclopedic knowledge of society to rival the *Bottin* and *Debrett's*. His memoirs would have been fascinating, like the dying breath, around the year 2000, of a society world that had been dead for many years."[2] Jullian's biographies—undoubtedly the best of his literary

Facing page
Salvador Dalí and
his wife Gala (at right)
at Hampton Manor,
residence of their patron
Mrs. Phelps Crosby, 1941.

1. Ghislain de Diesbach, *Un esthète aux enfers, Philippe Jullian*, Paris: Plon, 1993, p. 87.
2. Mathieu Galey, *Journal*, Paris: Grasset, 1989.

works—were devoted to *fin-de-siècle* figures, redolent of a decadence that appealed to his own penchants and a nostalgia for an era that he worshipped: *Edouard VII* (1962), *Robert de Montesquiou* (1965), *Gabriele D'Annunzio* (1971), *Jean Lorrain* (1974), *Sarah Bernhardt* (1977), *Violet Trefusis* (republished 1985), and *Oscar Wilde* (republished 1994). A similar atmosphere pervaded his writings on the art of the early twentieth century, including *Esthètes et magiciens* (1969), *Le Triomphe de L'Art nouveau* (1974), *Le Nu 1900* (1976), and *Les Orientalistes* (1977).

Beyond their shafts of caustic wit and descriptions to be savored, the only real literary interest in Jullian's novels lies in their qualities as romans à clef, depicting from first-hand experience the foibles of a world that was on the brink of extinction, as Proust had done with greater talent. Set in Paris, New York, England, and Italy—all the society haunts with which he was so familiar, in short—they bristle with piquant and ruthlessly observed detail. The shameless snobbery displayed by his characters—the same snobbery that he himself flaunted in his daily life—was to imbue his gleeful *Dictionnaire de snobisme,* published in 1954, with an impeccable list of contributors including Marie-Laure de Noailles, Nancy Mitford, and Violet Trefusis. It appeared in English four years later as *The Snob Spotter's Guide,* with additional contributions from society figures including Cecil Beaton, Hugo Charteris, Salvador Dalí, Philippe Erlanger, and Harold Nicolson. Snobbery, dissected and examined with brio, especially in café society, was of course its major theme. Jullian was one of those who believed that, in the words of Jean-Louis Curtis, "snobbishness was a passion for the stupid, a strategy for the shrewd, and a game for the elite."

As well as being a compendium of Jullian's predilections, *Café Society* is also one of the most comprehensive historical records of this period: "This novel . . . is a virtually uncontrived portrait of the society circles in the 1950s, voracious in their determination to make up for the lost years of the war and living only for pleasure, whether of the senses or of social success."[3] In *Mémoires d'une bergère,* Jullian had already sketched in the broad lines of this set, "whose members moved in shoals, like great fish . . . from Venice to New York via Cannes, Saint-Moritz, and Paris. In their wake swam parasites and hangers-on who supplied partners for bed, card parties, and drinking sessions. Every member trailed an entourage of decorators, gigolos, and canasta-players. Their sole amusement lay in humiliating each other's hangers-on."[4] It was a polyglot society with its own slang, its own vocabulary of superlatives for feelings and diminutives for names, insider expressions, and risqué repartee. When its members were drunk, this lingua franca would degenerate into swearing and obscenities that betrayed the dubious origins of these Balkan princes with fanciful titles, papal grandees born in Smyrna or Tripoli, Greek ship-owners, Texan politicians, or virile Americans attended by the charming husbands of their wealthy female conquests.

Another distinguishing characteristic of the species, astutely observed by Philippe Jullian, was its tendency to compound the "insolence of vice indulged" with a self-deluding belief in its role as arbiters of good taste. In his descriptions of fashionable life in Europe and New York, Jullian perfects the arts of the portrait and the anecdote, displaying a similar flair to Paul Morand for capturing a whole ambience in a few words, allied with the pitiless eye of an eighteenth-century satirist in his demolition of the ridiculous and his denunciation of the pretentious.

Facing page
The poet Edith Sitwell in a four-poster bed at Renishaw. Photograph by Cecil Beaton, c. 1932.

Following page
Jean Cocteau, 1934.

3. Ghislain de Diesbach, op. cit., p. 294.
4. Philippe Jullian, *Mémoires d'une bergère*, Paris: Plon, 1959, p. 113.

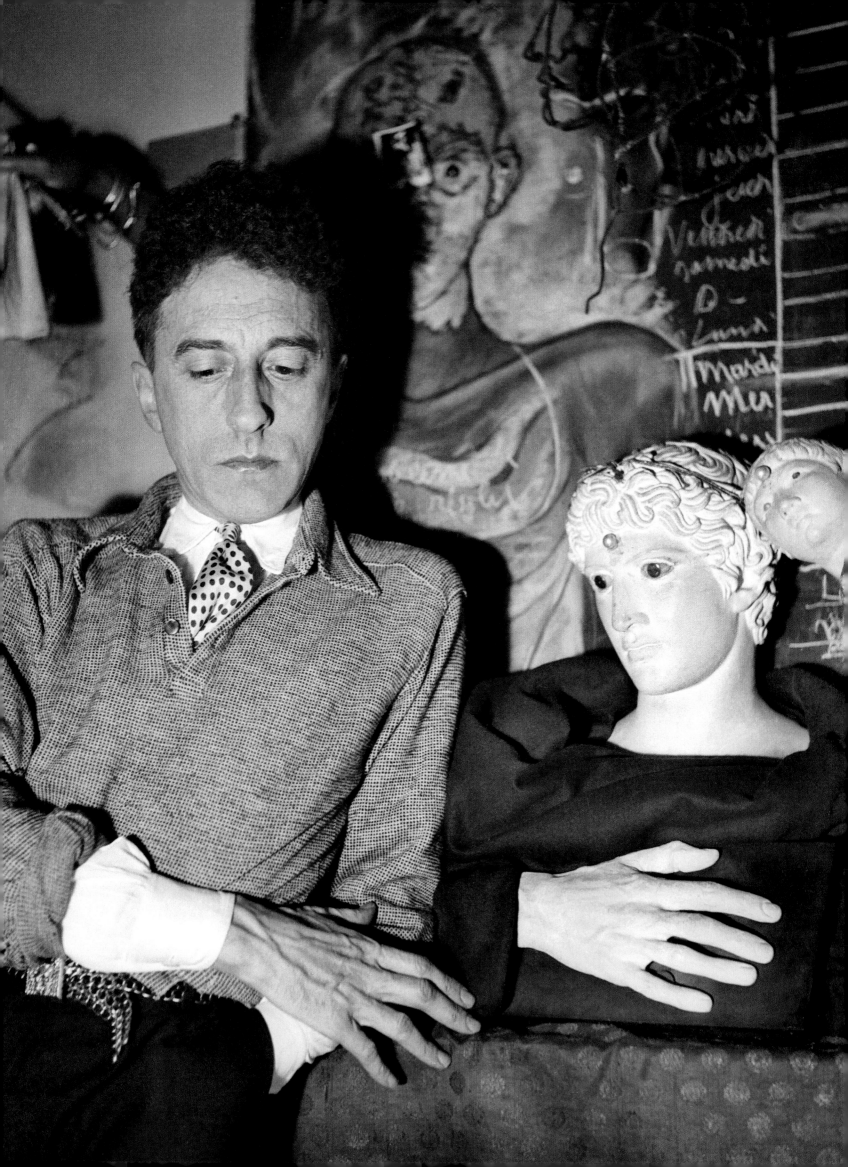

Some critics, while regretting that the identity of some of Jullian's original models eluded their grasp, viewed *Café Society* as an entertaining spectacle, lying somewhere between "the slapstick of the Marx Brothers and the bittersweet lyricism of *Breakfast at Tiffany's*." This is to underestimate the book's moral message, as potent in its way as Doré's engravings to Dante's *Inferno*. The vision that lingers on after a reading of this book is not that of the embers of a dazzling fireworks display, but rather that of a society whose frenzied quest for pleasure spirals into a *danse macabre*, its rhythms whirling ever faster until the dancers collapse and others eagerly take their place. It also offers a picaresque portrait of the manners and mores of the 1950s, which with hindsight are of interest not only as social history but also as an essay on taste, with Jullian's asides revealing, beneath their frivolous tone, a remarkable erudition. His observations on the collections of Miss Edwards or the furniture of Mrs. Drexel are easily as acute and well-informed as his contributions to *Connaissances des arts* or *Architectural Digest*.

Jullian was not the only writer to set his novels in café society. Salvador Dalí's only novel was also a roman à clef containing portraits of numerous café society figures, in which the painter—who was not himself a member but lived off commissions from central figures such as the Noailles, the Faucigny-Lucinges, and Edward James—took the opportunity to settle a few scores. Written during the war, when Dalí had taken refuge in the Marquis de Cuevas's Palm Springs estate, the book featured, under an assortment of borrowed names, not only his pre-war benefactors but also Chanel, Daisy Fellowes, Caresse Crosby, Bettina Bergery, Étienne de Beaumont, and Christian Bérard. He painted a cruel portrait of a world whose whims and caprices he had endured alongside its patronage, obsessed with all that was superficial and concerned only with the latest fashions in interior decoration and clothes, or with the organization of the next lavish ball. This was the same world, revolving around the inimitable figure of Étienne de Beaumont, that Edouard Bourdet satirized in his play *La Fleur des pois* of 1932, featuring a princess who organizes society events for a nouveau riche clientele, in the manner of Elsa Maxwell and Elsie de Wolfe. So incensed was Étienne de Beaumont by the biting parody of himself that he banned Bourdet's wife Denise from his balls, of which she was an ardent aficionado.

The books of Nancy Mitford also cover this terrain that was so familiar to her, with an ostensibly gentler humor that was nonetheless withering in its irony. Nancy was the eldest of the famous Mitford sisters, daughters of the second Baron Redesdale, of whom the other four were Unity, who conceived a passion for Adolf Hitler; Diana, a close friend of the Duchess of Windsor who moved in circles close to café society, and who married first a member of the Guinness family and then (in Goebbels' drawing room and in Hitler's presence) the British fascist leader Oswald Mosley; Deborah, Dowager Duchess of Devonshire and chatelaine of Chatsworth; and Jessica, an ardent anti-fascist and communist who was known as the "red sheep" of the family. Born into the high aristocracy, Nancy became one of the Bright Young People on the London scene between the wars, mixing with dandies and aesthetes such as Cecil Beaton, Evelyn Waugh, and Harold Acton, who became her biographer. A string of unhappy love affairs helped to lend a characteristically acerbic and ironic edge to her writing. After a hopeless infatuation with the homosexual Scottish aristocrat Hamish St Clair-Erskine, she married the fickle Hon. Peter Rodd (known as "Prod") in 1933. Six years later they separated, and Nancy embarked on another hopeless affair, this time with Gaston Palewski ("Colonel") who eventually left her for Violette de Talleyrand, daughter of Anna Gould, Boni de Castellane's first wife. Having met Palewski during the war in London, where he was chief of staff to General de Gaulle (of whom she was an ardent supporter) and where she ran a bookshop of repute, she moved to Paris after the Liberation to be near him.

The Pursuit of Love (1945), *Love in a Cold Climate* (1949), and *Don't Tell Alfred* (1960) are all set in a rarefied world mingling the high aristocracy and café society. *Don't Tell Alfred* was inspired by the tenure of her friends the Duff Coopers at the British embassy in Paris. As well as Beaton, Violet Trefusis, Lord Berners, and Oliver Messel, her wide circle of friends also included Marie-Laure de Noailles, and she was a frequent presence at balls and parties, always impeccably dressed by Dior or Lanvin. She entertained everyone of account at her *hôtel particulier* at 7 rue Monsieur, and later, her health ravaged increasingly by Hodgkins' lymphoma, in her house at Versailles. She also wrote lively biographies, including *Madame de Pompadour* (1954), *Voltaire in Love* (1957), and *Frederick the Great* (1970).

The most scandalous roman à clef of café society was *The Girls of Radcliff Hall*, in which Lord Berners used a girls' boarding school as a device to offer a thinly disguised portrait of the goings-on at his Elizabethan ancestral home, Faringdon. Published in 1953 under the *nom de plume* Adela Quebec, this romp featured (in the guise of schoolgirls) Cecil Beaton and Oliver Messel squabbling over the affections of Peter Watson, as well as David Herbert, Doris Castlerosse, the painters Pavel Tchelitchew and Christian Bérard, and finally Jack Wilson, lover of Noël Coward and future husband of Natalie Paley. Incensed, the interested parties left no stone unturned to ensure that as many copies of the book as possible were destroyed, and today it is hard to find. Many books of this nature, often published privately, appeared here and there, usually penned by non-writers with a view to attacking their rivals. Thus in 1953 Christian Megret, lover of Ghislaine de Polignac, published *Danaé*, containing vicious attacks on Alexis de Redé and Arturo Lopez. Roger Peyrefitte was another prolific author in this genre.

A number of writers, such as Louise de Vilmorin and Violet Trefusis, were more—or at least as much—café society figures than great authors. Others took café society as their inspiration, and others again remained perpetually on its outer edges, flattering and exciting it from its fringes. Prominent among the latter was Jean Cocteau, whose life unfolded between the Proust's upper crust and Jullian's café society. As a child he lived on rue d'Anjou, next door to the Comtesse de Chevigné, Proust's inspiration for Oriane de Guermantes. There he played with her granddaughter Marie-Laure de Noailles, who from her teenage years nurtured an unrequited passion for him and remained a close friend throughout her life. The only real rift between them came over Cocteau's supposed affair with Natalie, another luminary of café society, which was rumored to have resulted in a pregnancy, rapidly aborted. During the café society years, Cocteau mixed with everyone in society and the art worlds in Paris, and was particularly close to Christian Bérard, to the Ballets Russes (Diaghilev threw him the famous challenge, "Jean, surprise me!"), and to Gabrielle Chanel. During his long and amicable relationship with Francine Weisweiller, he also mixed with Arturo Lopez and Alexis de Redé, notably at Saint-Moritz for the winter sports. Always present but always on the fringes, Cocteau was too taken up with his work and his image ever to be truly a member of café society.

Cocteau's English counterpart might have been the poet Edith Sitwell. Though she stood apart from café society, and arguably indeed from the real world, Edith Sitwell had a decisive influence on some of its key figures, such as Cecil Beaton—who took some extraordinary portraits of her, emphasizing her "Plantagenet look"—and the painter Tchelitchew, with whom she maintained a long platonic relationship. Born into an aristocratic English family with both a stately home, Renishaw Hall in Derbyshire, and a castle, the Castello di Montegufoni in Tuscany, she was educated by Helen Rootham, who translated Rimbaud into English and who initiated Sitwell at an early age into the French Symbolist poets who were to have a profound influence on her work. In London,

with Helen Rootham and her brothers Osbert and Sacheverell, she was a prominent figure in the literary avant garde.

In 1923 she created a major literary event with *Façade*, in which she recited a cycle of her poems to a musical accompaniment by William Walton. Her emphatic diction and Walton's eclectic music were mocked by some, but also attracted a great deal of interest in their brand of modernism. She became a friend of Virginia Woolf and Gertrude Stein, and in 1932 moved from London to Paris, where she mixed with Natalie Barney, Adrienne Monnier, and Sylvia Beach. She also often stayed in Tuscany, where she was at the heart of the English expatriate set that included Harold Acton and Violet Trefusis. After the war, her poems sank deeper and deeper into pessimism, reflecting her anguish at the spasms of the Cold War and at her declining health, which in 1955, under the influence of Evelyn Waugh, drove her to convert to Catholicism. The Sitwells formed an aesthetic trio far removed from the sordid realities of the world, who lived only for art and culture, and who were immortalized by the great photographers of their time: Beaton, naturally, and also Horst. Although never very far distant from the majority of its members, the Sitwells formed a sort of anti-model for café society.

Paul Morand might have been a perfect candidate for membership of café society. Born into the Parisian haute bourgeoisie and a childhood friend of Denise Bourdet, he joined the diplomatic service and was soon rubbing shoulders with everyone of account in Europe. His marriage to Princess Soutzo—older than him, a friend of Proust, and a major landowner in her native Romania—accentuated the cosmopolitan side of his character. His dual career as a writer and diplomat kept him at a certain distance from the world of insouciance, indulgence, and pleasure-seeking that was café society, however much he was attracted to it. A guest at all the grand balls, especially those of Étienne de Beaumont, he gave a splendid description of the Beistegui Ball at the Palazzo Labia in *Venises*. For Morand, Venice held many memories of café society, and his diary entries evoke his visits to Catherine d'Erlanger at the Villa Malconenta with the Faucigny-Lucinges and Christian Bérard, as well as his links with the Ballets Russes. He had ambiguous lifelong relationships with Gabrielle Chanel and Misia Sert, which he wrote about in *L'Allure de Chanel*. Cosmopolitan and sophisticated, he was a presence at every important café society event. At the same time he kept a certain distance, which allowed him to flex his caustic wit at the expense of many of its personalities, notably in his *Journal inutile*. Profoundly homophobic and anti-Semitic in a milieu where both homosexuals and Jews were lavishly represented, he maintained an attitude of virulent contempt.

Below
Drawing by Philippe Jullian, late 1950s.

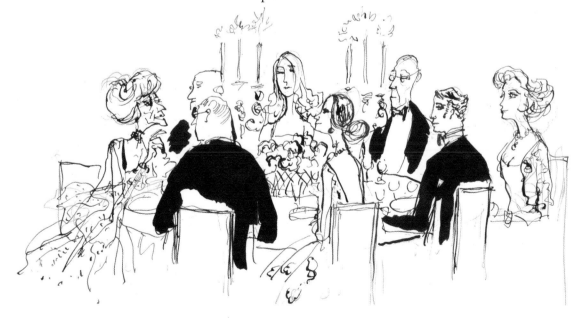

Louise de Vilmorin

Louise de Vilmorin was a character from the eighteenth century who had strayed into the twentieth. Her wit was her hallmark, she adored games of love and chance, and she presided over a salon and wrote as naturally as drawing breath. A letter-writer on a grand scale, she inundated her friends daily not only with letters but also with poems, whose freshness and wit pierced the brittle carapace of the seductress that was such an essential aspect of her character. But above all else she was a novelist. At the age of thirty-two she found success with *Sainte-Unefois*, followed by numerous other novels, some of which were adapted for the cinema: *Le Lit à colonnes* (1941), *Julietta* (1951), *Madame de . . .* (1951), and *La Lettre dans un taxi* (1958). Yet she constantly struggled to shake off a reputation for frivolousness that followed her to her death. In his *Journal inutile* entry for January 5, 1970, Paul Morand noted: "Weekly press very chilly towards Louise de Vilmorin. *L'Express*, *L'Observateur* troubled by the fashionable, society aspect. . . . Louise can cultivate the Aragons, Malraux, Seghers, etc., as much as she likes, they're making her pay for *Vogue*-style articles, her Palffy side, her Yankee marriage."[1]

True enough, Louise de Vilmorin was above all a society figure. Born into a renowned family of seed merchants, she had among her tutors the famous Abbé Mugnier, confessor to duchesses and friend of Proust. Briefly married to the American businessman Henry Leigh Hunt, with whom she had three daughters, she lived the lavish lifestyle of a wealthy American wife in the 1920s. Then, through her second marriage to Count Palffy, she lived until 1944 in a castle in the Carpathian mountains, afterward retaining a Mittel Europa style that was particularly striking in her dress. After the war, at the family chateau at Verrières, she presided over a salon in the grandest tradition, thronged by artists, statesmen, and fashionable society figures. This select set had its origins at the British embassy after the Liberation, under the Duff Coopers, who helped them to overcome the reputation they had gained for being over-compliant with the occupying forces. Bérard, Cocteau, and Beaton were her close friends, soon to be joined by Elizabeth Chavchavadze, Jean-François Lefèvre-Pontalis, Sacha de Manziarly, François Valéry (diplomat and son of Paul), and the painter André Beaurepaire. She mingled her friends, who fell in and out of favor, with those of Marie-Laure de Noailles, Charles de Beistegui, and Paul-Louis Weiller, who frequently lent her his houses at Saint-Vigor and Sélestat.

Then there was the welter of lovers, most of them distinguished in one way or another. Engaged as a young woman to Antoine de Saint-Exupéry, she ended her life as the companion of André Malraux, dubbing herself "Marilyn Malraux." In between, in no particular order, came (among others) Gaston Gallimard, Pierre Brisson, Roger Nimier, Orson Welles, Ali Khan, Duff Cooper, and Jean Hugo. As she would say in her teasing, light-hearted way, "Tonight I love you forever."

Like a feminine counterpart of Cocteau, Louise de Vilmorin was interested in every activity. She did some accomplished drawings featuring her emblem, the four-leaf clover; designed jewelry for Cartier; wrote fashion articles, notably in *Vogue*; and took part in television programs. "Money is the ruin of me," she used to say. Extravagant, generous, surrounded by the objets she loved to collect, she also knew how to make the most of her friends with large fortunes at their disposal (as most of them did), rather like Denise Bourdet. What remains of her today? She herself anticipated the answer: "I've said everything in my few writings, I'm a one-off."

1. Paul Morand, *Journal inutile 1968–1972*, Paris: Gallimard, 2001.

Facing page
Louise de Vilmorin in her
house at Verrières, 1960s.

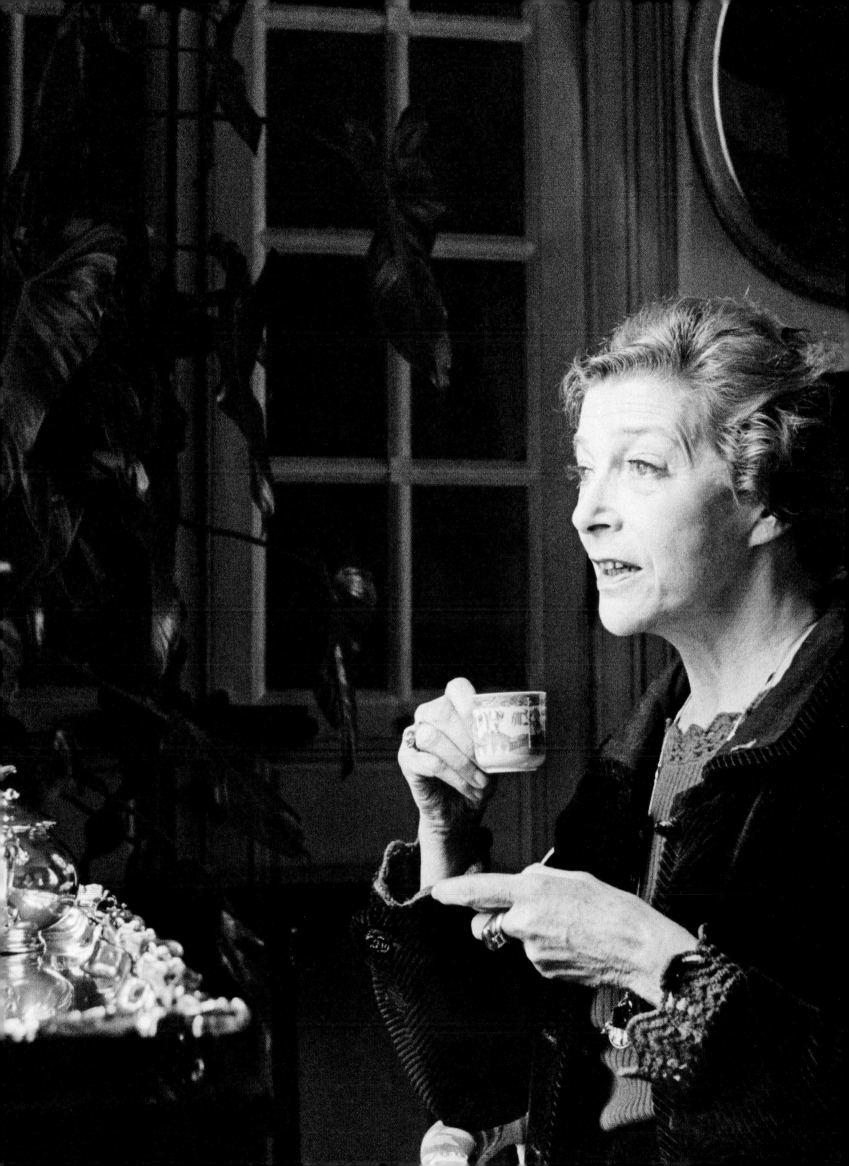

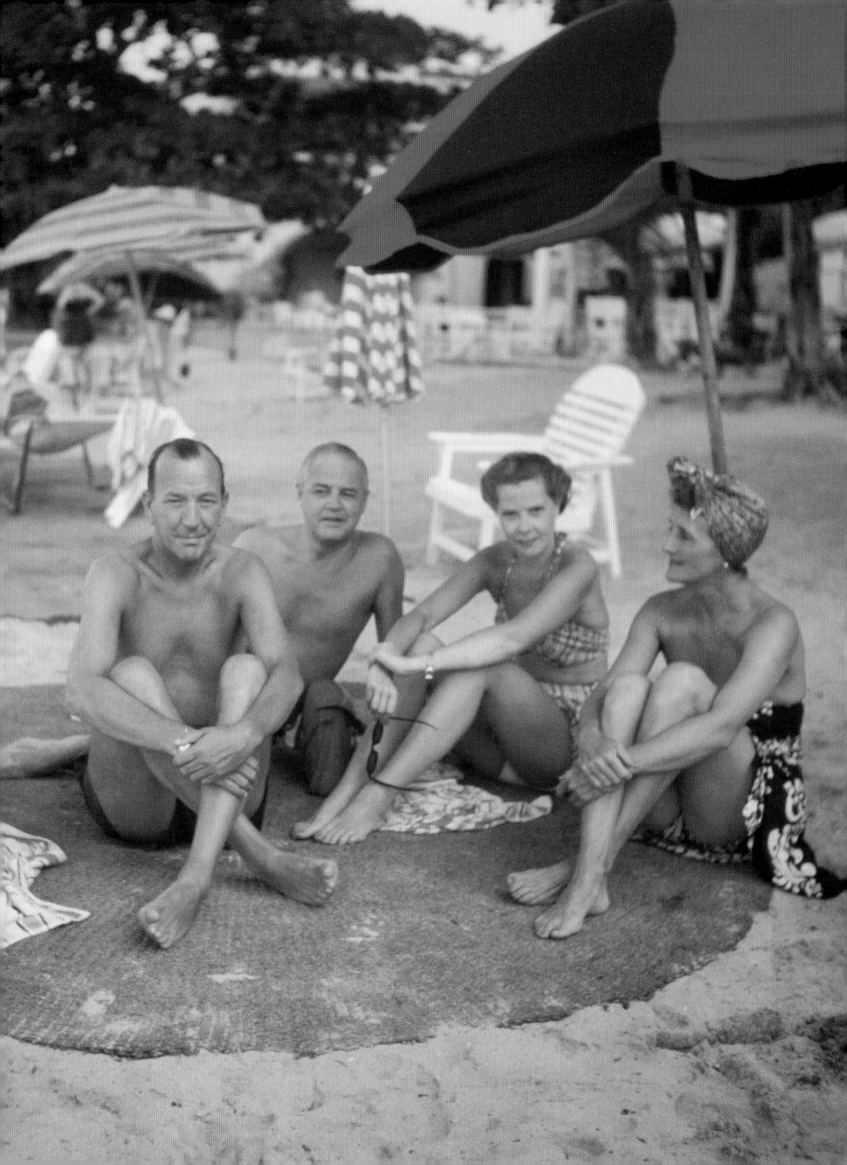

Noël Coward

One of the most fêted British authors in café society, Noël Coward rose from modest beginnings, forging his debonair elegance and sardonic languor by dint of his own talent and application. Born in the London suburb of Teddington in 1899 to a father who was a shiftless piano salesman and a highly ambitious mother, Coward started dancing and singing in local productions at the age of seven, before making his London debut in *The Goldfish*, a show for children, at the age of twelve. He then appeared in a number of West End productions, notably *Peter Pan*, as the protégé of the leading actor-manager Charles Hawtrey. At the same time he made his unusually precocious—especially for a boy from such a modest background—debut in society. At the age of fourteen he was romantically involved with the society painter Philip Streatfeild, who introduced him to Mrs. Astley Cooper and her high society crowd. She took him under her wing and coached him in society manners. At the age of nineteen, he had a liaison with the Duke of Kent, younger brother of the future Duke of Windsor.

Coward played his first major West End role in 1920, starring in his own play *I Leave It to You*, but as producers hesitated to take on such a young actor he decided to try his luck in America. On his return to London he had his first major success with his play *The Vortex* in 1924. Dealing with drug addiction and nymphomania in high society, it caused great controversy, so ensuring Coward's celebrity. During the 1920s and 1930s Coward wrote and performed in a string of successes on both sides of the Atlantic, although his success in France remained modest. A regular guest at the balls of the 1930s, he was seen everywhere in café society. In the mid-1920s he began a long relationship with the American producer Jack Wild, who before descending into alcoholism managed Coward's career with skill and his finances with sleight of hand. Eventually, in the late 1930s, Wild left Coward to marry Natalie Paley. Coward used this story in his writings and became a confidant of the Russian princess.

During the war, Coward ran the British propaganda office in Paris and worked for the Secret Service, before going off (at Churchill's insistence) to entertain the troops. In the post-war years, his light and frothy plays, featuring characters from café society and containing a transparent subtext of his homosexuality, which he never declared openly, made his style appear slightly outmoded. His theatrical successes were sporadic, and he made strenuous efforts to promote the talents of the South African actor Graham Payn, who had taken Wild's place in his affections. In fact Coward found success again with the public, particularly in America, through new media: radio broadcasts, television series, and cabaret turns. He also started to paint. He now divided most of the year between his Swiss chalet and Bermuda, before moving to Jamaica, then a tax haven. Wherever he was, in town or country, on or off stage, he was always impeccably turned out in typically debonair

Facing page
Noël Coward, Graham Payn, Natalie Paley, and Joyce Carey on the beach at Sunset Lodge, Jamaica, 1953.

Page 311
Noël Coward at the piano with Mrs. John C. Wilson and Graham Payn, in Coward's Jamaica residence. Photograph by Cecil Beaton, c. 1951.

fashion, cigarette in one hand, whisky glass in the other, at ease with everyone who was anyone in Paris, where he was a regular guest of the Faucigny-Lucinges, Denise Bourdet, Beistegui, and the British community, including the Windsors and the Duff Coopers. In London he was close to the Queen Mother and maintained a friendly rivalry with Cecil Beaton, who gleefully tracked Coward's swifter physical decline in his diaries. And in New York he mixed with European members of café society, such as Paley, Verdura, and Gunzburg, who had sought refuge there.

Wherever he was, in town or country, on or off stage, he was always impeccably turned out in typically debonair fashion, cigarette in one hand, whisky glass in the other, at ease with everyone who was anyone in Paris.

Throughout his life, Coward had affairs, with sailors, men he met in the street, or celebrities such as Laurence Olivier and Michael Redgrave. Prematurely aged by a flamboyant lifestyle, he died in 1973 at the age of 73. To Beaton's intense jealousy, he was knighted in 1970. He left a legacy of over three hundred songs, sixty plays, twenty-five films and three volumes of autobiography. Gore Vidal related that when Coward declared that he had never slept with a woman, he asked, "Not even Miss Dietrich?" To which Coward replied, "Especially not Miss Dietrich!"

Violet Trefusis

Violet Trefusis conformed to the image of the eccentric English writer in love with "the Continent" almost to the point of parody. Her mother, Alice Keppel, was a great Victorian beauty who conquered countless hearts, and whose social success reached its apogee when she became the mistress of the Prince of Wales, later Edward VII, in 1901. Violet always affected an air of mystery about the circumstances of her birth, conveniently overlooking the fact that by the time her mother became royal favorite Violet herself was already a few months old. She had a pampered childhood, following her mother everywhere, and especially to France, traveling in the royal train to Biarritz. According to Cocteau, the young Violet used to play at bowling a hoop with the royal scepter. As a schoolgirl she fell in love with Vita Sackville-West, who would later become a famous writer and gardener, and the lover of Virginia Woolf. Their affair was to be a long and strenuous one, especially when the two young women both left their husbands (twice) to run away to France together. Mrs. Keppel had insisted on Violet marrying Denys Trefusis, a young man of good family, while Vita had married Harold Nicolson, a prominent diplomat with whom—despite his homosexuality—she had two sons. The younger of these, Nigel Nicolson, famously traced this complex tale in *Portrait of a Marriage*,[1] while Virginia Woolf romanticized Violet and Vita's affair in *Orlando*, in which Violet appeared as Princess Sasha.

From 1923, Violet became the mistress of Winnaretta de Polignac, who introduced her into Paris high society, and especially into the musical circles of which she was a prominent patron. When the relationship ended, Winnaretta gave her, as a sumptuous farewell gift, the medieval tower of Saint-Loup-de-Naud, near Provins. There, at 15 rue du Cherche-Midi in Paris, or at Villa dell'Ombrellino, the fourteenth-century Florentine villa in which Galileo once lived and which Alice Keppel had bought, she entertained numbers of expatriate English eccentrics and lovers of Tuscany, including Harold Acton, the Sitwells, and Lord Berners,[2] as well as socialites and intellectuals such as Cocteau, Colette, Max Jacob, Giraudoux, Karen Blixen, René and Odette Massigli, Philippe Jullian, and even François Mitterrand, a friend toward the end of her life.

Facing page
Violet Trefusis at
the Beaumont Ball, 1939.

Page 315
Violet Trefusis and the Duke
of Windsor. Photograph by
André Ostier.

Violet was constantly reinventing herself: in her selective and fanciful reminiscences, *Don't Look Round*, she describes, for instance, encountering Mussolini on all fours in his office and Edward VII being snubbed by a French governess. Her novels, by contrast, all of them romans à clef, appear to be more firmly based in reality. According to Philippe

1. Nigel Nicolson, *Portrait of a Marriage*, London: Weidenfeld and Nicolson, 1973.
2. During the war it was announced in a London social column that Violet Trefusis and Lord Berners were to marry. Bumping into him one day, Violet said, "Lots of people have telephoned to congratulate me; and you?," to which the noble lord replied, "Not a soul!" He was later supposed to have sent a message to *The Times* announcing that "Lord Berners has left Lesbos for the Isle of Man."

Jullian, "her novels came straight out of her address book." Writing sometimes in English, sometimes in French, she published *Echo* in 1931 and *Broderie anglaise* in 1935, as well as a few other works, all light and acerbic in tone, with a brisk and scathing turn of phrase. In both her conversation and her writing she displayed a caustic wit. When Stanislas de La Rochefoucauld—who had divorced the actress Alice Cocéa and married a member of the San Felice family, princes of Viggiano—remarked, "It's extraordinary, but when I married Alice people thought I was going to become an actor," she replied: "And now that you have married a great lady, Stanislas dear, do people expect you to become a gentleman?"

According to Cocteau, the young Violet used to play at bowling a hoop with the royal scepter. As a schoolgirl she fell in love with Vita Sackville-West, who would later become a famous writer and gardener, and the lover of Virginia Woolf.

Whimsical, capricious, cosmopolitan, immortalized by Nancy Mitford as Lady Montdore in *Love in a Cold Climate*, Violet Trefusis displayed many of the typical traits of café society, whose members she visited and entertained, though her friendship was always matched with an equal degree of contempt for what she viewed as their lack of intellectual qualities. Ever surprising, during the war she made broadcasts for the Free French, and was rewarded with the Légion d'Honneur. In her final years she was close to a young American, John Philips, and to Philippe Jullian, both of whom were to write biographies after her death. Jullian even painted frescoes at Saint-Loup, where she wanted her ashes to remain, with the epitaph, "*Anglaise de naissance, française de coeur*" (English by birth, French by attachment).

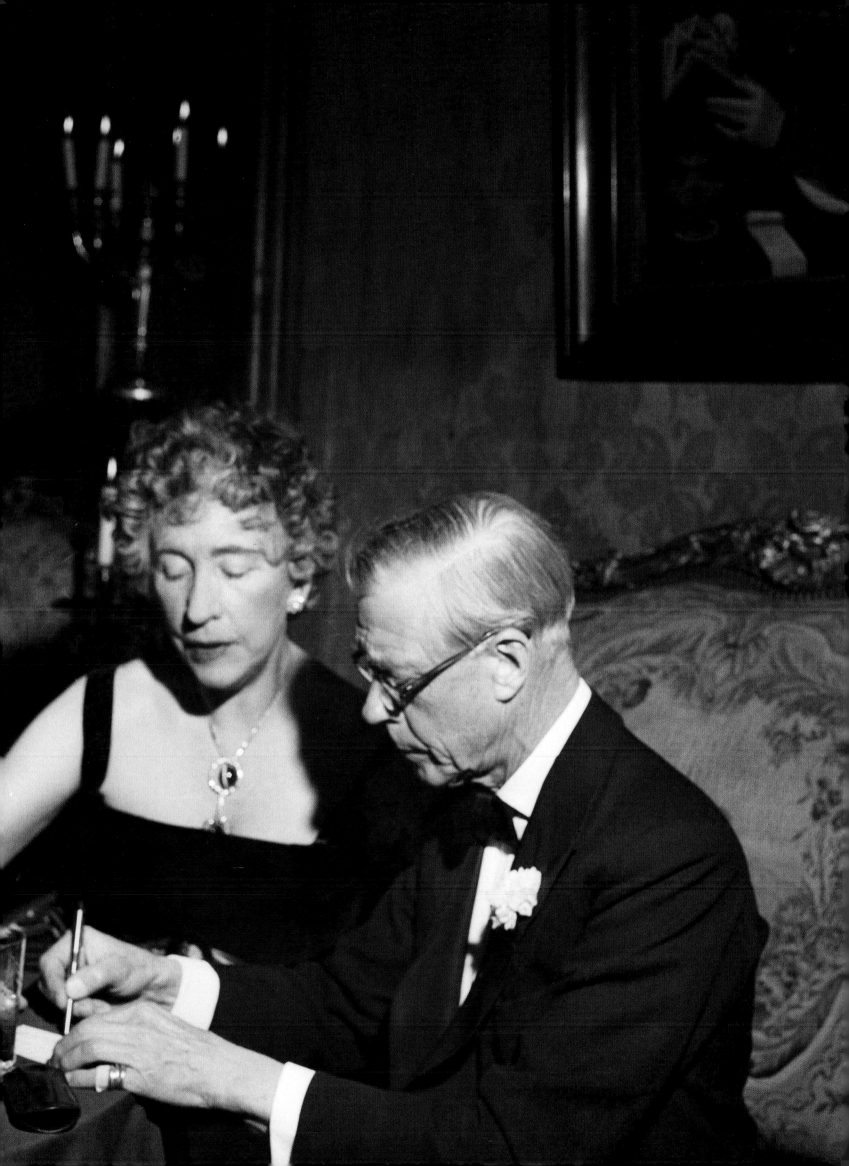

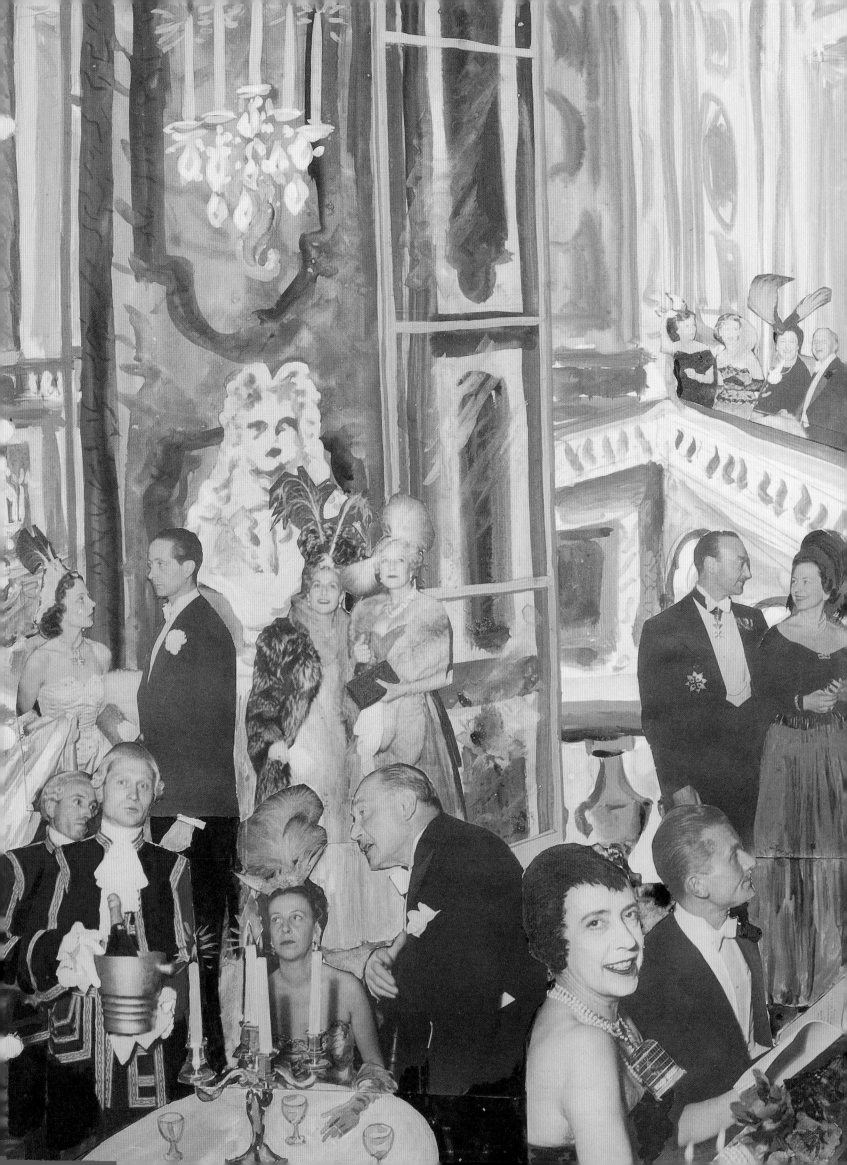

Conclusion

Café society—this world of languid insouciance, willful provocation, and wanton luxury—could flourish only in a society that was fragile, brittle, under threat; a society that had lost its way and abandoned its traditional values. The cumulative crises of the twentieth century played their part in this social upheaval: café society found numerous recruits among those who had fled the Russian Revolution (including Natalie Paley, Kochno, Hoyningen-Huene, Lifar, and Serebriakoff), as well as Central European Jews seeking refuge from the Nazis. The temporary or permanent exile of many Europeans during the Second World War fostered its cosmopolitan nature, and forged yet closer bonds between the social and intellectual elites on both sides of the Atlantic. Post-war prosperity and an age of easy money were to usher in a new order, sounding the death knell of this old world. Yet there are some periods of transition that—like the French Regency period, with which café society had many parallels—are as influential and leave a stamp as indelible as much longer eras. Every age of brilliance must inevitably tarnish and decline, however, and the descent of café society into "Nescafé society" (as Loelia Westminster dubbed it) was swift. Who now, apart from a handful of aesthetes, remembers Arturo Lopez, Daisy Fellowes, Diana Cooper, Charles de Beistegui, or even Alexis de Redé, who died only a few years ago? Now and then, perhaps, a high-profile auction sale reminds us of their names. Who now recalls the society world that revolved around them, or the sumptuous balls where they mingled with glittering names such as Lilia Ralli, Claire-Clémence de Maillé, Lady Abdy, and Chips Channon? Only a few can now bear witness to a world that will be remembered as the last brief flowering of the spirit of the Grand Siècle, before it was swallowed up by the triumph of the bourgeoisie and consumer society.

In its brilliance, its creative vitality, its eccentricity, its desire to shock, and its untroubled affinity with money, café society created a posthumous image of itself as a golden age, a paradise lost, in which nothing had more point than the pointless, nothing was more profound than the superficial, and elegance and an inimitable *art de vivre* took precedence over everything, for the pleasure of a few and the happiness of all.

Facing page
A party given by the Baron and Baronne de Cabrol. From the scrapbook of the Baron de Cabrol.

Bibliography

General works

Harold Acton, *Memoirs of an Aesthete*, London: Faber Finds, 2008.

Harold Acton, *Nancy Mitford*, London: Gibson Square Books Ltd, 2001.

Stéphane-Jacques Addade, *Bernard Boutet de Monvel*, Paris: Éditions de l'Amateur, 2001.

Mark Amory, *Lord Berners, The Last Eccentric*, London: Chatto & Windus, 1998.

Claude Arnaud, *Jean Cocteau*, Paris: Gallimard, 2003.

Margot Asquith, *The Autobiography of Margot Asquith*, London: Thornton Butterworth, 1922.

Pierre Assouline, *Jean Jardin une éminence grise*, Paris: Balland, 1986.

Pierre Barillet, *À la ville comme à la scène*, Paris: Éditions de Fallois, 2004.

Cecil Beaton, *Ashcombe: The Story of a Fifteen-year Lease*, London: The Dovecote Press, 1999.

Cecil Beaton, *Beaton in the Sixties: More Unexpurgated Diaries*, London: Phoenix, 2004.

Cecil Beaton, *Cecil Beaton: Memoirs of the 40s*, New York, McGraw-Hill Book Co, 1972.

Cecil Beaton, *Cinquante ans d'élégances et d'art de vivre*, Paris: Éditions Amiot-Dumont, 1954.

Cecil Beaton, *The Happy Years*, London: Weidenfeld and Nicolson, 1972.

Cecil Beaton, *The Restless Years*, London: Weidenfeld and Nicolson, 1976.

Cecil Beaton, *The Unexpurgated Beaton: The Cecil Beaton Diaries as he wrote them 1970–1980*, London: Phoenix, 2003.

Cecil Beaton, *The Wandering Years*, Boston: Little, Brown & Co., 1961.

Jean de Beaumont, *Au hasard de la chance*, Paris: Julliard, 1987.

Nadine Beauthéac, Joël Laitier, Lydia Fasoli, *L'Art de vivre au temps de Proust*, Paris: Flammarion, 1999.

Laurence Benaïm, *Marie-Laure de Noailles la vicomtesse du bizarre*, Paris: Grasset, 2001.

Laurence Benaïm, *Yves Saint Laurent*, Paris: Grasset & Fasquelle, 1993.

Pierre Bergé, *Les Jours s'en vont je demeure*, Paris: Gallimard, 2003.

Princesse Bibesco, *La Duchesse de Guermantes, Laure de Sade, comtesse de Sévigné*, Paris: Plon, 1950.

Dilys E. Blum, *Elsa Schiaparelli*, Paris: Musée de la Mode et du Textile, UCD Éditions, 2004.

Jean Bothorel, *Louise ou la vie de Louise de Vilmorin*, Paris: Grasset, 1993.

Cyrille Boulay, *Vacances Royales*, Paris: Assouline, April 2003.

Edouard Bourdet, *Théâtre*, Paris: Stock, 1949.

Paul Bowles, *Without Stopping: An Autobiography*, New York: Harper Perennial, 1999.

J. Bryan III and Charles J.V. Murphy, *The Windsor Story*, New York, William Morrow, 1979.

Manuel Burrus, *Paul Morand, voyageur du XXᵉ siècle*, Paris: Librairie Séguier-Vagabondages, 1986.

Stephen Calloway, *L'Époque et son style*, Paris: Flammarion, 1988.

Boni de Castellane, *Mémoires de Boni de Castellane*, Paris: Librairie académique/Perrin, 1986.

Charles Castle, *Oliver Messel*, London: Thames & Hudson, 1986.

Patrick Chaleyssin, *La Peinture mondaine*, Paris: Bibliothèque de l'Image, 1999.

Jean Chalon, *Florence et Louise, les Magnifiques*, Paris: Éditions du Rocher, 1987.

Jean Chalon, *Journal de Paris*, Paris: Plon, 1999.

Jean Chalon, *Portrait d'une séductrice*, Paris: Stock, 1976.

Henry Channon, *Chips: The Diaries of Sir Henry Channon*, London: Weidenfeld & Nicolson, 1967.

Jacques Chazot, *Chazot Jacques*, Paris: Stock, 1975.

Collective work, *Hommage à Boris Kochno 1904–1990*, Opéra National de Paris, Paris: Éditions du Patrimoine, 1990.

Diana Cooper, *Trumpets from the Steep*, London: Penguin Books, 1964.

Duff Cooper, *Au-delà de l'oubli*, Paris: Gallimard, 1960.

Patricia Corbett, *Verdura The Life and Work of a Master Jeweler*, London: Thames & Hudson, 2002.

Gilles Cornut-Gentille and Philippe Michel-Thiriet, *Florence Gould*, Paris: Mercure de France, 1989.

Anne de Courcy, *Diana Mosley*, Paris: Éditions Vintage, 2004.

Salvador Dalí, *Visages cachés*, Paris: Stock, 1973.

Robin Derrick, *People in Vogue: A Century of Portraits*, New York, Little, Brown & Company, 2003.

Hubert Devillez d'Alamont and Jacques de Ricaumont, *Les Grandes Animatrices de Paris*, Paris: Éditions Mondiales, 1966.

Deborah Devonshire, *Les Humeurs d'une châtelaine anglaise*, Paris: Payot, 2006.

Ghislain de Diesbach, *Un esthète aux enfers Philippe Jullian*, Paris: Plon, 1993.

Ghislain de Diesbach, *La Princesse Bibesco*, Paris: Librairie Académique/Perrin, 1986.

Nicholas Drake, *The Fifties in Vogue*, London: Henry Colt & Co, 1987.

Eleanor Dwight, *Diana Vreeland*, New York: Harper Collins Publishers Inc., 2002.

William A. Ewing, *Hoyningen-Huene*, Paris: Thames & Hudson, 1998.

Jean-Louis de Faucigny-Lucinge, *Fêtes mémorables, bals costumés 1922–1972*, Paris: Herscher, 1986.

Jean-Louis de Faucigny-Lucinge, *Un gentilhomme cosmopolite*, Paris: Perrin, 1990.

Timothy Findley, *Le Grand Elysium Hôtel*, Paris: Éditions Robert Laffont, 1986.

Annick Le Floc'hmoan, *Ces Extravagantes Sœurs Mitford*, Paris: Fayard, 2002.

Béatrice Fontanel, *La Vie quotidienne en peinture*, Paris: Éditions de La Martinière, 2005.

André de Fouquières, *Cinquante ans de panache*, Paris: Éditions Pierre Horay Flore, 1951.

Alex Gard, *More Ballet Laughs*, New York: Charles Scribner's Sons, 1946.

Philippe Garner and David Alan Mellor, *Cecil Beaton Photographien 1920–1970*, Munich: Schirmer/Mosel, 1994.

Arthur Gold and Robert Fizdale, *The Life of Misia Sert*, New York: Vintage, 1992.

Peggy Guggenheim, *Ma vie et mes folies*, Paris: Plon, 1987.

Baird Hastings, *Christian Bérard, painter, decorator and designer*, Boston: The Institute of Contemporary Art, 1950.

Janine Hénin, *Paris Haute Couture*, Paris: Éditions Philippe Olivier, 1990.

Henri comte de Paris and Tessa Destais, *L'Histoire en héritage*, Paris: Tallandier, 2003.

David Heyman, *Pauvre petite fille riche*, Paris: Éditions du Club de France Loisirs, 1988.

Philip Hoare, *Serious Pleasures: The Life of Stephen Tennant*, London: Hamish Hamilton, 1990.

Jean Hugo, *Le Regard de la mémoire*, Paris: Acte Sud/Labor, 1983.

Ivan Jablonka, *Les Vérités inavouables de Jean Genet*, Paris: Le Seuil, 2004.

Philippe Jullian, *Café-Society*, Paris: Albin Michel, 1962.

Philippe Jullian, *Les Collectionneurs*, Paris: Flammarion, 1966.

Philippe Jullian, *Dictionnaire du snobisme*, Paris: Plon, 1958.

Philippe Jullian, *Mémoires d'une bergère*, Paris: Plon, 1959.

Philippe Jullian, *My Lord*, Paris: Albin Michel, 1961.

Philippe Jullian, *Les Styles*, Paris: Gallimard, 1992.

Philippe Jullian and Léon-Paul Fargue, *Les Meubles équivoques*, Paris: Grasset, 1947.

Philippe Jullian and John Phillips, *Violet Trefusis Life and Letters*, London: Hamish Hamilton, 1976.

Martin Kazmaier, *Horst: Sixty Years of Photography*, Munich: Schirmer Art Books, 1995.

Boris Kochno, *Christian Bérard*, Paris: Herscher, 1987.

François Kollar, *Le Choix de l'esthétique*, Paris: Éditions La Manufacture, 1995.

Valentine Lawford, *Horst: His Work and his World*, London: Viking, 1985.

Julien Levy, *Eugène Berman*, American Studio Books, 1947.

Jean-Noël Liaut, *Madeleine Castaing, Mécène à Montparnasse, décoratrice à Saint-Germain-Des-Près*, Paris: Payot, February 2008.

Jean-Noël Liaut, *Modèles et mannequins*, Paris: Éditions Filipacchi, 1994.

Jean-Noël Liaut, *Natalie Paley une princesse déchirée*, Paris: Éditions Filipacchi, 1996.

Jean-Noël Liaut, *Hubert de Givenchy*, Paris: Grasset, 2000.

Serge Lifar, *Les Mémoires d'Icare*, Paris: Éditions Sauret, 1993.

James Lord, *Cinq femmes exceptionnelles*, Paris: Plon, 1996.

Herbert R. Lottman, *La Dynastie Rothschild*, Paris: Le Seuil, 1995.

Curzio Malaparte, *Journal d'un étranger à Paris*, Paris: Denoël, 1967.

Klaus Mann, *Le Tournant*, Paris: Éditions Solin, 1984.

Gérard Mannoni, *Le Marquis de Cuevas*, Paris: Lattès, 2003.

Igor Markevitch, *Être et avoir été*, Paris: Gallimard, 1980.

Anne Martin-Fugier, *Les Salons de la IIIᵉ République*, Paris: Perrin, 2003.

Patrick Mauriès, *Louise de Vilmorin*, Paris: Le Promeneur, 2002.

André Maurois, *La Vie de Disraëli*, Paris: Gallimard, 1927.

Elsa Maxwell, *I Married the World: Reminiscences*, London, William Heinemann, 1955.

Suzy Menkes, *The Windsor Style*, London: Grafton Books, 1987.

Bertrand Meyer-Stabley, *Noureev*, Paris: Payot & Rivage, 2003.

Paul Morand, *Journal inutile 1968–1972*, Paris: Gallimard, 2001.

Paul Morand, *Journal inutile 1973–1976*, Paris: Gallimard, 2001. Paul Morand, *Venises*, Paris: Gallimard, 1971.

Jacques Mousseau, *Les Grands*, Paris: Les Amis du Club du Livre, 1959.

Abbé Mugnier, *Journal de l'Abbé Mugnier*, Paris: Mercure de France, 1985.

Hans Nadelhoffer, *Cartier*, Paris: Éditions du Regard, 1984.

Jacques Nels, *Fragments détachés de l'oubli*, Paris: Ramsay, 1989.

Monique Nemer, *Raymond Radiguet*, Paris: Fayard 2002.

Nigel Nicholson, *Portrait of a Marriage: Vita Sackville-West and Harold Nicolson*, Chicago: University of Chicago Press, 1998.

John Julius Norwich, *The Duff Cooper Diaries 1915–51*, London: The Orion Publishing Group/Phoenix, 1951.

Alain Pacadis, *Un jeune homme chic*, Paris: Denoël, 2002.

Roger Peyrefitte, *Les Juifs*, Paris: Flammarion, 1965.

Roger Peyrefitte, *Propos secrets*, Paris: Albin Michel, 1977.

Elisabeth Pineau, *Willy Maywald*, Paris: Editions de l'Amateur, December 2002.

Gabriel-Louis Pringué, *30 ans de diners en ville*, Paris: Éditions Revue Adam, 1948.

Francesco Rapazzini, *Élisabeth de Gramont*, Paris: Fayard, 2004.

Frédéric Raphaël, *Somerset Maugham and his World*, London: Thames & Hudson, 1977.

Ned Rorem, *The Paris Diary*, 1966; Cambridge: Da Capo, 1988 (reissue).

Penelope Rowlands, *A Dash of Daring: Carmel Snow and her life in Fashion, Art and Letters*, New York: Atria Books, 2005.

Judy Rudoe, *Cartier 1900–1939*, Paris: Somogy Éditions, 1997.

Scot D. Ryersson and Michael Orlando Yaccarino, *La Casati: Les multiples vies de la marquise Luisa Casati*, Paris: Assouline, 2002.

Meryle Secrest, *Bernard Berenson*, Paris: Éditions Critérion, 1991.

Miranda Seymour, *Ottoline Morrell: Life on a Grand Scale*, Paris: Éditions Sceptre,1993.

Marcel Schneider, *Le Palais des mirages*, Paris: Grasset, 1992.

Edith Sitwell, *Victoria Glendinning*, London: Phoenix, 1993.

Frances Spalding, *National Portrait Gallery Insights: The Bloomsbury Group*, London: National Portrait Gallery, 2005.

Charles Spencer, *Cecil Beaton: Stage and film designs*, London: Academy Editions, 1994.

Gertrude Stein–Pablo Picasso, *Correspondance*, Paris: Gallimard, 2005.

Annette Tapert and Diana Edkins, *The Power of Style*, New York: Crown Publishers, 1994.

Bruno Tessarech, *Villa Blanche*, Paris: Éditions Meta, 2005.

Violet Trefusis, *Instants de mémoires*, Paris: Éditions Christian de Bartillat, 1992.

Consuelo Vanderbilt Balsan, *The Glitter and the Gold*, London: Harper & Brothers Publishers, 1952.

Fulco di Verdura, *Une enfance sicilienne*, trans. Edmonde Charles-Roux, Paris: Grasset, 1981.

Hugo Vickers, *Cecil Beaton: The Authorised Autobiography*, London: Phoenix, 2002.

Hugo Vickers (ed.), *The Memoirs of the Baron de Redé*, privately published, 2005.

Hugo Vickers, *The Private World of the Duke and Duchess of Windsor*, New York: Abbeville Press, 1996.

Louise de Vilmorin, *Correspondance avec ses amis*, Paris: Gallimard, 2004.

Louise de Vilmorin, *Intimités*, Paris: Gallimard, 2001.

Louise de Vilmorin, Duff and Diana Cooper, *Correspondance à trois*, Paris: Gallimard, February 2008.

Diana Vreeland, *D. V.*, New York: Alfred A. Knopf, 1984.

Philip Ziegler, *Diana Cooper*, London: Hamish Hamilton, 1981.

Philip Ziegler, *Osbert Sitwell*, London: Pimlico, 1999.

Exhibition catalogs

1918–1958, La Côte d'Azur et la modernité, collective work, traveling exhibition, Paris: Réunion des Musées Nationaux, June 27–October 20, 1997.

André Ostier photographies, Paris: Fondation Pierre Bergé - Yves Saint Laurent, May 18–July 28, 2006.

Bonnard: L'œuvre d'art, un arrêt du temps, Paris: Musée d'Art Moderne de la Ville de Paris, February 2–May 7, 2006.

Richard Calvocoressi and David Hare, *Lee Miller: Portraits*, London: National Portrait Gallery, February 3–May 30, 2005.

The Diaghilev exhibition from the Edinburgh Festival, ed. Richard Buckle, London: *The Observer*, 1954.

François-Marie Banier, Paris: Gallimard, Maison Européenne de la Photographie, March 26–June 15, 2003.

Horst Portraits, London: National Portrait Gallery, March 1–June 3, 2001.

Jacqueline Kennedy: The White House Years — Selections from the John F. Kennedy Library and Museum, New York: Bulfinch Press, The Metropolitan Museum of Art, May 1–July 29, 2001.

Hugues de La Touche, *La Riviera de Jean Cocteau: escale à Menton*, Nice: ROM Édition, 1996.

Mona Bismarck, Cristóbal Balenciaga, Cecil Beaton, Paris: Fondation Mona Bismarck, January–February 1994. Florence Müller, *Belles en Vogue, Collection photographique Vogue de 1925 à nos jours*, Paris: Éditions du Collectionneur, Le Bon Marché Rive Gauche, February 28–April 10, 2004.

Scènes d'intérieur: Aquarelles des collections Mario Praz et Chigi, Ville de Boulogne-Billancourt/ Académie des Beaux-Arts, Éditions Norma, Bibliothèque Marmottan, November 20–February 15, 2002.

Bertrand Rondot, *Alexandre Serebriakoff, portraitiste d'intérieur*, Société des Amis de Malmaison, Musée National des Châteaux de Malmaison et Bois-Préau, 1994.

The Sitwells and the Arts of the 1920s and 1930s, collective work, London: National Portrait Gallery, 1994.

Sales catalogs

Catalog of ballet and theater material, London: Sotheby Parke Bernet, October 1982.

Catalog of ballet and theater material including costume and decor designs, bronzes, portraits, and books, London: Sotheby Parke Bernet, March 1980.

Château de Groussay, Montfort-l'Amaury, Sotheby's catalog, vols. I, II, and III, June 1999.

Collection du baron de Redé provenant de l'hôtel Lambert, Paris: Sotheby's catalog, vols. I and II, March 2005.

Important 20th Century Decorative Art & Design, New York, Christie's catalog, December 7, 2005.

François Nemer (ed), *Jean Cocteau*, exhibition catalog, Paris: Centre Pompidou, September 2003–January 2004.

Articles

Architectural Digest, "Interior Design Legends," New York: Condé Nast Publications, January 2000.

Thierry Coudert, "Café society: portrait d'une société en pleine mutation," *Magazine Cartier Art*, nᵒ 13, 2006, pp. 44-45.

Photographic credits

AKG Images: 160–1 (Ullstein Bild), 192-3 (photo Guillemot) / Association Willy Maywald–Adagp, Paris, 2010: 36, 263 / Cecil Beaton Studio Archives-Sotheby's Picture Library: 14, 53, 78–9, 81, 83, 90, 93, 106, 110, 114, 154–5, 169, 187, 194, 202, 207, 228, 286 / The Bridgeman Picture Library: 270 / Daisy de Cabrol: 3, 4, 5, 6, 11, 21, 22–3, 24, 27, 31, 50–1, 56, 57, 68–9, 98–9, 117, 125, 138, 150, 152–3, 163, 166–7, 171, 172–3, 175, 189, 316 / Cartier Archives: 206, 215 / Christophel: 60–1 / Condé Nast Publications-*Vogue*, France: 59 (photo George Hoyningen-Huene), 118 (photo Arik Nepo), 199 (photo Robert Randall), 248 (photo Horst P. Horst) / Condé Nast Publications-*Vogue*, USA: 73 (photo John Rawlings), 76 (photo Horst P. Horst), 157 (photo Horst P. Horst) / Corbis: 44 (photo Bettmann), 45–6 (photo Roger Schall), 49 (photo Bettmann), 55 (photo Cecil Beaton/Condé Nast Archives), 64 (photo Bettmann), 67 (photo Bettmann/ Toerring-Jettenbach), 71 (photo Bettmann), 74 (photo Cecil Beaton/Condé Nast Archives), 84 (photo Bettmann), 87 (Hulton-Deutsch collection), 88 (photo Bettmann), 94 (Hulton Archives), 97 (photo Bettmann), 142 (photo Bettmann), 183–4 (Hulton-Deutsch collection), 205 (photo Cecil Beaton/Condé Nast Archives), 211 (photo Cecil Beaton/Condé Nast Archives), 212 (photo Henry Clarke/Condé Nast Archives), 213 (photo Bettmann), 241 (photo Horst P. Horst/Condé Nast Archives), 242 (photo Bettmann), 245 (photo George Hoyningen-Huene/Condé Nast Archives), 246–7 (Hulton-Deutsch collection), 260 (photo Cecil Beaton/Condé Nast Archives), 264 (photo Massimo Listri), 264 (photo John Rawlings/Condé Nast Archives), 291 (photo Horst P. Horst/Condé Nast Archives), 294–5 (photo Bettmann), 297 (photo Bettmann), 301 (photo Cecil Beaton/Condé Nast Archives), 307 (photo Pierre Vauthey/Sygma), 311 (photo Cecil Beaton/Condé Nast Archives) / Thierry Coudert: 17, 28, 34, 113, 130, 133, 165, 305 / Robert Doisneau: 18, 103, 129 / Fondation Le Corbusier: 181h/ Getty Images: 9 (Hulton Archives/Picture Post), 12–3 (photo Cornell Capa/Time Picture Life), 38–9 (Roger-Viollet/ Lipniski), 105 (Hulton Archives), 145 (Hulton Archives), 147 (Time & Life Pictures), 191 (photo Hanswild/Time & Life Pictures), 220 (photo Walter Sanders/Time & Life Pictures), 223 (photo Martha Holmes/Time & Life Pictures), 224–5 (photo John Chillingworth/Hulton Archives), 227 (photo John Chillingworth/Hulton Archives), 231 (photo Slim Aarons/ Hulton Archives), 232 (photo Walter Sanders/Time & Lige Pictures), 234 (photo Nat Farbman/Time & Life Pictures), 237 (photo Loomis Dean/Time & Life Pictures), 250 (photo Roy Stevens/Time & Life Pictures), 273 (photo Sasha/Hulton Archives), 282 (photo Sasha/Hulton Archives), 289 (photo Sasha/Hulton Archives), 292 (photo Al Fenn/Time & Life Pictures), 298 (photo Eric Schall/Time & Life Pictures), 308 (photo Slim Aarons/Hulton Archives) / Horst Estate: 238, 253 / François Kollar/Ministère de la Culture/médiathèque du Patrimoine: 197 / Man Ray Trust-Adagp/Telimage, 2010: 210 / Lee Miller Archives-UK, 2010 (all rights reserved): 255 / Photothèque de la RMN: 159 (photo Jacqueline Salmon), 277 (Ministère de la Culture/médiathèque du Patrimoine) / André Ostier: 121, 137, 140, 148, 257, 314 / Roger-Viollet: 100 (photo Jacques Cuinières), 179, 182 (photo Lipnitzki), 218 (photo Lipnitzki), 219 (photo Lipnitzki), 259, 269, 274–5 (photo Lipnitzki), 277 (photo Lipnitzki), 281, 285 (photo Lipnitzki), 302 (photo Lipnitzki), 312 (photo Lipnitzki) / Rue des Archives: 41 (photo Georgette Chadourne, coll. PFB), 43 (AGIP), 109 (AGIP), 122 (AGIP), 134 (AGIP) / DR: 33, 63, 200.